THE PUBLISHER GRATEFULLY ACKNOWLEDGES THE GENEROUS SUPPORT OF THE AFRICAN AMERICAN STUDIES ENDOWMENT FUND OF THE UNIVERSITY OF CALIFORNIA PRESS FOUNDATION, WHICH WAS ESTABLISHED BY A MAJOR GIFT FROM THE GEORGE GUND FOUNDATION.

SEEING THROUGH RACE

SEEING THROUGH RACE

A REINTERPRETATION OF CIVIL RIGHTS PHOTOGRAPHY

MARTIN A. BERGER

FOREWORD BY DAVID J. GARROW

UNIVERSITY OF CALIFORNIA PRESS BERKELEY LOS ANGELES LONDON

University of California Press, one of the most distinguished university presses in the United States, enriches lives around the world by advancing scholarship in the humanities, social sciences, and natural sciences. Its activities are supported by the UC Press Foundation and by philanthropic contributions from individuals and institutions. For more information, visit www.ucpress.edu.

University of California Press
Berkeley and Los Angeles, California

University of California Press, Ltd.
London, England

Every effort has been made to identify the rightful copyright holders of material not specifically commissioned for use in this publication and to secure permission, where applicable, for reuse of all such material. Credit, if and as available, has been provided for all borrowed material either on-page, on the copyright page, or in an acknowledgment section of the book. Errors or omissions in credit citations or failure to obtain permission if required by copyright law have been either unavoidable or unintentional. The author and publisher welcome any information that would allow them to correct future reprints.

Library of Congress Cataloging-in-Publication Data

Berger, Martin A.
 Seeing through race : a reinterpretation of civil rights photography / Martin A. Berger ; foreword by David J. Garrow.
 p. cm.
 Includes bibliographical references and index.
 ISBN 978-0-520-26863-0 (cloth : alk. paper) — ISBN 978-0-520-26864-7 (pbk. : alk. paper)
 1. Civil rights movements—United States—History—20th century. 2. Whites—United States—Attitudes—History—20th century. 3. African Americans—Civil rights—History—20th century. 4. African Americans—Social conditions—History—20th century. 5. Photography—Social aspects—United States—History—20th century. 6. Documentary photography—Social aspects—United States—History—20th century. 7. Photojournalism—Social aspects—United States—History—20th century. 8. United States—Race relations—History—20th century. I. Title.
 E185.61.B44 2011
 323.1196'073—dc22 2010036230

Manufactured in the United States of America

20 19 18 17 16 15 14 13 12 11
10 9 8 7 6 5 4 3 2 1

The paper used in this publication meets the minimum requirements of ANSI/NISO Z39.48–1992 (R 1997) (*Permanence of Paper*).

FOR ALL THOSE WHO REFUSE TO WAIT

CONTENTS

FOREWORD

Scholarly interest in the importance and effects of photojournalists' depictions of well-known Deep South civil rights protest campaigns of the 1960s reaches back more than thirty years. My own *Protest at Selma: Martin Luther King, Jr., and the Voting Rights Act of 1965* (published 1978) devoted two chapters to comparing and contrasting the photographic coverage of the Selma-area voting rights protests of early 1965 with similar images generated during the 1963 mass demonstrations and confrontations in Birmingham, Alabama. In the years since then, other scholars have further enriched our understanding of the impact of news coverage of the African American freedom struggle on viewers and readers both in the United States and abroad.

To my mind, however, Martin Berger's *Seeing through Race* is the most insightful and analytically original treatment of civil rights photojournalism yet to appear. In this thoroughly researched and persuasively written study, Berger expands our appreciation of the meaning and impact of widely known photographic images. It is a superb work of thoughtful and at times brilliant scholarship that every student of civil rights historiography should read with care and reflection.

Some of the major building blocks of Berger's analysis will not surprise knowledgeable civil rights scholars, yet they will resonate most affirmatively. "The determined efforts of the white press to frame the civil rights movement as nonthreatening," Berger rightly notes of the major national media of the 1960s, "had the collateral result of casting blacks in roles of limited power. With great regularity, iconic photographs show white actors exercising power over blacks."

Famous images of segregationist excess—Birmingham's snarling police dogs and clothes-rending fire hoses, Selma's cattle prods and billy clubs—presented impulsive violence as the face of white racism and cast black protestors as passive victims. As Berger observes, such images minimized "the bravery and accomplishments of blacks," who were risking life and limb in locales where African American assertiveness had historically been reciprocated with bombs and lynch mobs. But such photographs had other effects as well.

Protest at Selma and related works of early civil rights scholarship established the powerful impact such widely distributed images had in mobilizing vocal support for the legislative reforms enacted in the Civil Rights Act of 1964 and the Voting Rights Act of 1965. As Berger writes, the iconic photographs from Birmingham and Selma presented black protestors as victims of unwarranted aggression from violent lawmen and thus generated "white sympathy for blacks, and hence more support for legislative action." Similarly, in an irony perhaps first articulated in President John F. Kennedy's well-known wisecrack that the infamous Birmingham public safety commissioner Eugene "Bull" Connor "has done more for civil rights than almost anybody else,"[1] a scholarly consensus has emerged that Connor and his compatriots must be understood as unwitting "agents of progressive social change."

Yet, as Berger accurately notes, those world-famous images conveyed additional powerful messages that the first generation of civil rights historiography failed to appreciate and understand. For one, the photographs provided an emotionally compelling portrayal of white racism that not only mobilized conscience-stricken viewers against southern violence but simultaneously offered them a powerful definition of racism that absolved them from complicity. As Berger argues, by "picturing 'racists' as the most violent southern thugs," the photographs enabled northern whites to conclude reassuringly that they of course were not racists in any way.

Further, the news media's promulgation of images that emphasized blacks' physical victimization focused "white attention on acts of violence and away from historically rooted inequities," as Berger points out. Indeed, Berger's analysis parallels one of the 1960s' most insightful contemporaneous documents, a lengthy private letter that Martin Luther King Jr. received from his closest and most influential political counselor, white New York attorney Stanley D. Levison, soon after the triumphal Selma to Montgomery mass march. "The coalition of Selma and Montgomery, with its supporting millions," Levison warned King, "is a coalition around a fairly narrow objective. . . . a coalition for moderate change, for gradual improvements which are to be attained without excessive upheavals as it gently alters old patterns. *It is militant only against shocking violence and gross injustice.* It is not for deep radical change."[2]

In a similar vein, Berger suggests not only that northern whites mistook their horror at the behavior of Alabama lawmen for a commitment to racial equality but also that the photographs in the white press "presented story lines that allowed magnanimous and sympathetic whites

to imagine themselves bestowing rights" on vulnerable blacks who merited both protection and sympathy. Berger, however, also contends that northern whites' reactions to the iconic southern civil rights images "both promoted incremental reforms and served as a barrier to systemic change." Some readers may, like me, remain somewhat unpersuaded by this element of Berger's analysis. He contends that the ubiquity of such photographs may have "limited the extent of reform from the start. To the degree that narratives illustrating white power over blacks helped make the images nonthreatening to whites, the photographs impeded efforts to enact—or even imagine—reforms that threatened white racial power."

While Berger concludes in his epilogue that "the most significant social work of civil rights photographs will continue to be the limits they place on the exercise of black power," my view of the nonsouthern barriers encountered by the freedom movement in the mid-1960s remains highly similar to Levison's in his letter to Dr. King: "America today is not ready for a radical restructuring of its economy and social order," and if leaders like King failed to acknowledge that fact, "the movement can head into a cul-de-sac if it can see no real progress without radical alteration of the nation." With customary bluntness, Levison warned King that it would be "certainly poor tactics to present to the nation a prospect of choosing between equality and freedom for Negroes with the revolutionary alteration of our society, or to maintain the status quo with discrimination. The American people are not inclined to change their society in order to free the Negro. They are ready to undertake some, and perhaps major, reform, but not to make a revolution."[3] But even if Berger's argument about the agenda-limiting impact of those images is not indisputably convincing, his broader contention that the photographs have played a major role in perpetuating 1960s constructions of black-white dynamics in the popular imagination is a significant interpretive contribution.

The final major element in Berger's provocative analysis contrasts the most controversial photographic images of the post-1966 "black power" era with the earlier iconic pictures from the Deep South. Especially in Birmingham, the presence of young black children among the victimized protestors generated particular sympathy, Berger believes, because of "the predispositions of whites to see them as innocent and lacking in agency." Even in Selma, he argues, the national news media made "children (or adults possessing childlike qualities) a near requirement for the sympathetic coverage of white-on-black violence." The crucial if disheartening conclusion, according to Berger, is that America's response needs to be seen as "compassion . . . for a nonthreatening individual rather than for blacks per se." Stanley Levison would have heartily concurred.

In contrast, black power era photographs "illustrate black men as self-fashioned and powerful agents," and pictures "that made the agency of blacks all too obvious diminished the odds of reaching otherwise sympathetic whites" because of "the predisposition of whites to see

expressions of black power as aberrant and threatening." The controversy that engulfed, and significantly misportrayed, African American medal winners Tommie Smith and John Carlos following their "black power" salute at the 1968 Olympics encapsulates the contrast that Berger seeks to illuminate. In a social context where black suffering resonated in politically useful but inherently limiting ways, the two strong and successful young African American athletes "delivered their message from a position of power" and were met not with sympathy or understanding but with widespread denunciation and condemnation.

Seeing through Race is a powerful and important work of impressive scholarship and is a study that students of the black freedom movement of the 1960s will read, cite, and widely discuss for many years to come.

DAVID J. GARROW

THE ICONIC PHOTOGRAPHS OF CIVIL RIGHTS

Freelance photographers and reporters . . . realize that by slanting the news and the pictures . . . they can sell more copy and more pictures all over the country.

JIM CLARK, SHERIFF OF SELMA, ALABAMA (1965)

A photograph, which stops a split-second of action, <u>can say anything an editor wants it to say.</u>

ALBERT C. "BUCK" PERSONS, *THE TRUE SELMA STORY: SEX AND CIVIL RIGHTS* (1965)

In early 1963 two young workers from the grassroots civil rights organization the Student Nonviolent Coordinating Committee (SNCC) slipped into Selma, Alabama, to initiate a <u>voter education effort among blacks</u>. Selma was an alluring target for civil rights activists. Situated in Dallas County, it had one of the lowest percentages in the state of black citizens registered to vote. Out of fifteen thousand black adult residents, fewer than three hundred appeared on voter rolls. <u>Nonwhites who attempted to register faced limited registration hours at the county courthouse (on the two days a month that the office was open);</u> "literacy" tests that were designed for their failure; a local sheriff who understood his mandate to include *Control of space* intimidation of and violence against blacks who demanded their rights be honored (and occasionally against white reporters who covered civil rights stories); local judges who freely passed down jail sentences to the nonwhite victims of police violence and who enforced unconstitutional injunctions against black assembly; and a local white population that protected the status quo by firing black activists in their employ and committing violence against them. Despite this daunting environment, the SNCC workers joined with local activists to educate black citizens about their rights, register voters, and stage public protests to publicize the plight of black Americans in Alabama.

The lonely campaign begun by dedicated SNCC workers and their local allies received a boost in early 1965, when Dr. Martin Luther King Jr. brought the Southern Christian Leadership Conference (SCLC), the umbrella civil rights organization he led, to join the struggle.

King's arrival in Selma heartened the local black population and dramatically increased the willingness of middle-class blacks to take up the fight. Protests in the city also attracted greater national media coverage once King announced his involvement, especially after he and hundreds of protesting black schoolchildren were arrested at the end of January. But the campaign's dramatic climax came the next month after the killing of the black activist Jimmie Lee Jackson during a nighttime civil rights march in nearby Marion, Alabama.

The peaceful Marion march descended into chaos after Alabama state troopers and white vigilantes smashed streetlights and disabled or destroyed the film and still cameras of television and newspaper reporters covering the protest. As the city went dark, white law enforcement officers and mobs indiscriminately beat any black activist or bystander within reach. Jackson angered troopers by trying to protect his grandfather and mother from assault by rampaging officers; in retaliation, a trooper shot him in the stomach at point-blank range.[1] News of Jackson's death swept through the state and brought to a head the frustration of Selma's blacks, who were already impatient with the slow pace of voting reforms, the federal government's reticence to take a more active role in the conflict, and the daily violence of the Jim Crow South. Appreciating the depth of community anger about the killing and hoping to channel it into peaceful and productive ends, the SCLC supported local blacks in their decision to stage a protest march from Selma to the state capitol in Montgomery.

The march began at Brown Chapel on Sunday, March 7, with six hundred protestors, led by the activists John Lewis and Hosea Williams. Just six blocks into the journey, as the marchers crossed the Edmund Pettus Bridge, they confronted a solid line of helmeted and armed Alabama state troopers, Dallas County sheriffs, and mounted civilian "possemen" blocking the four-lane road. As Lewis and Williams brought their columns to a halt some fifty feet from the line, the officer in charge, Major John Cloud, declared the protest march an "unlawful assembly" and demanded that the participants "disperse." Not wishing to provoke law enforcement officers by advancing but determined not to retreat, Lewis encouraged the marchers behind him to kneel in prayer. As word of the plan passed through the columns of marchers, Cloud ordered his men to advance on horseback and foot. Firing tear gas and wielding billy clubs and bullwhips, they drove the protestors back over the bridge to their church and homes, as newspaper and television cameras recorded the mayhem. Lewis recalled "how vivid the sounds were as the troopers rushed toward us—the clunk of the troopers' heavy boots, the whoops of rebel yells from the white onlookers, the clip-clop of horses' hooves hitting the hard asphalt of the highway, the voice of a woman shouting, 'Get 'em! *Get* the niggers!'" Between ninety and a hundred marchers were injured. More than fifty sought treatment at a local hospital, seventeen of whom were admitted. One nearly died. The next day, pictures of "Bloody Sunday" appeared in newspapers across the country.[2]

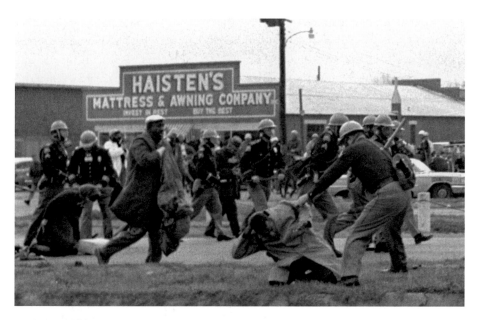

1 Unknown photographer, *State Troopers Swing Billy Clubs to Break Up Civil Rights Voting March in Selma, Alabama,* March 7, 1965. AP/Wide World Photos, New York.

Virtually every major paper outside the South—including the *New York Times,* the *Chicago Tribune,* the *Los Angeles Times,* and the *Washington Post*—carried shocking front-page photographs showing a scrum of troopers in gas masks beating well-dressed black protestors who were offering no discernible resistance (figure 1).[3] In many of the photographs, John Lewis appears in the center foreground wearing his distinctive tan trench coat, with one arm raised protectively to his head, as an officer clubs him to the ground. The published photographs of the confrontation and accompanying news articles make clear that the primary focus of white media outlets was the drama of the clash. Typical of the Selma coverage in the northern white press was the front-page article in the *New York Times,* "Alabama Police Use Gas and Clubs to Rout Negroes." The *Times* report reproduced two photographs of marchers in flight, pursued and struck down by law enforcement officers swinging clubs, and a third showing troopers patrolling the streets in force after the breakup of the march. The article complements the photographic coverage with its dramatic description of black protestors "swept to the ground screaming [with] arms and legs flying." While the white media could have selected any number of stories to tell—on the determination of African Americans to root out the social, economic, and legal impediments to black franchise; their anger at the killing of Jimmie Lee Jackson; or

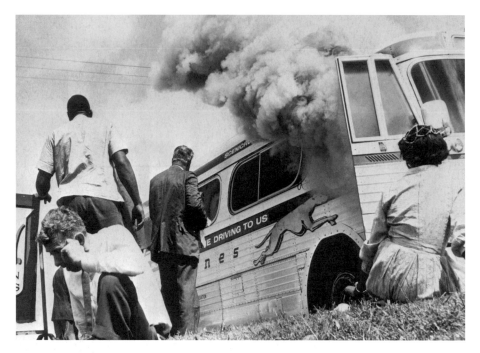

2 Joseph Postiglione, *Firebombed Freedom Riders' Bus Outside Anniston, Alabama,* May 14, 1961. © Bettmann/CORBIS, Seattle, Washington.

their bravery in the face of state-sponsored aggression—they consistently framed the story as a narrative of spectacular violence.[4]

This emphasis was not an anomaly of the Selma campaign. With great consistency, white media outlets in the North published photographs throughout the 1960s that reduced the complex social dynamics of the civil rights movement to easily digested narratives, prominent among them white-on-black violence. A look at a representative sampling of iconic photographs confirms this predilection: white mobs harassing fifteen-year-old Elizabeth Eckford as she integrates Little Rock Central High School in Arkansas in 1957 (see figure 40); sit-ins at segregated department store lunch counters in Greensboro, North Carolina, and Jackson, Mississippi, or Nashville, Tennessee, showing activists taunted and bloodied by mobs of young whites throughout the early 1960s (see figure 9); the dazed and wounded Freedom Riders milling around their abandoned burning bus after segregationists firebombed it near Anniston, Alabama, in 1961 (figure 2); and most famous of all, fire hoses and police dogs turned against peaceful black protestors in Birmingham in 1963 (figures 3 and 4). Since newspapers and

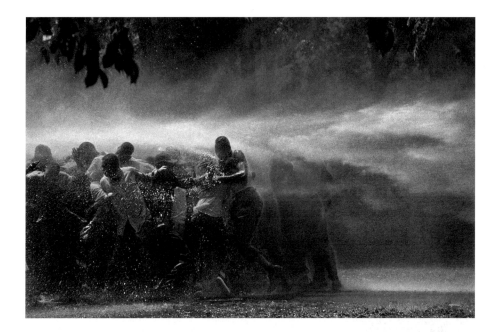

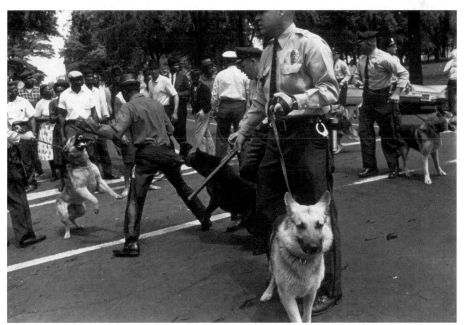

3 (Top) Bob Adelman, *Civil Rights Protestors Being Sprayed by Fire Hoses in Birmingham,* Alabama, May 3, 1963. © Bob Adelman/CORBIS, New York.
4 (Bottom) Charles Moore, *Police Dog Attack,* Birmingham, Alabama, May 3, 1963. © Charles Moore/Black Star, New York.

magazines had a financial interest in boosting sales, their focus on the spectacle of such events is not surprising. After all, graphic photographs of violence tend to be more attention getting—and marketable—than photographs of orderly lines of marchers armed only with protest placards or articles detailing the economic and social inequalities facing blacks.

Black newspapers faced the same pressure to maximize sales that their white competitors did, yet they published many civil rights photographs not reproduced in the white press. Moreover, they did so despite heavy reliance on photographic wire services for much of their coverage of national events. Drawing largely from the same pool of photographs available to the white media, black newspapers and magazines constructed a distinctive visual record of civil rights that was rarely glimpsed by whites. In its reporting on Selma, for instance, the *Chicago Daily Defender,* the largest-circulation black-owned newspaper of the era, published a United Press International photograph showing a jumble of fallen marchers *and* law enforcement officers (figure 5) with the caption, "Negroes and state troopers alike fell to ground in Selma, Ala., as troopers moved in to break up a march."[5] The photographic choices made by black reporters and editors in selecting and framing their stories on the civil rights movement were so distinctive that the journalists could have been reporting on a wholly different conflict. The black press's editorial choices were guided in part by its audiences; naturally enough, its presentation of civil rights protests reflected the interests and outlook of its readers. The same was true, of course, of the choices made by the photographers, reporters, and editors employed by the white press.

In contrast to the many books that focus on what civil rights photographs tell us about blacks, in this book I contemplate what they reveal about whites. Publishers of white newspapers and magazines were well aware of the anxiety that the "Negro question" raised in white Americans during the 1960s. Given the photographs' formulaic presentation of white-on-black violence and the racial stakes for whites in the representation of the civil rights movement, the photographs have at least as much to tell us about whites as about blacks. To illuminate the role that the photographs played in managing whites' anxieties about race, the following chapters analyze how white journalists and their audiences selected, framed, and responded to the most famous scenes of the civil rights era. I do not suggest that famous civil rights photographs were staged or doctored to meet the needs of whites. Most were not. I argue instead that the handful of "iconic" photographs endlessly reproduced in the newspapers and magazines of the period, and in the history books that followed, were selected from among the era's hundreds of thousands of images for a reason: they stuck to a restricted menu of narratives that performed reassuring symbolic work.

In clarifying how the most famous civil rights photographs served whites, I also examine the images' implications for blacks. Because nonwhites stood at the heart of American debates

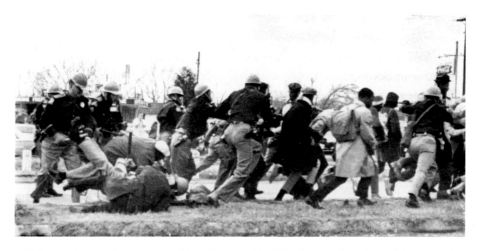

5 Unknown photographer, *Negroes and State Troopers Alike Fell to the Ground in Selma, Alabama,* March 7, 1965. United Press International. Courtesy of the Photograph Collection, Cleveland Public Library, Cleveland, Ohio.

on race, the media could not assuage the racial anxieties of whites without affecting the depiction of blacks. So, for example, the determined efforts of the white press to frame the civil rights movement as nonthreatening had the collateral result of casting blacks in roles of limited power. With great regularity, iconic photographs show white actors exercising power over blacks—dignified black schoolchildren silently suffering the jeers of unruly mobs, well-mannered black students at lunch counters weathering the abuse of mirthful white crowds, and stoic protestors buckling under the assaults of water jets and police dogs. The chapters that follow will make this general claim historically concrete, but here it is enough to acknowledge that most of the photographs that northern whites deemed representative of the struggle showed whites in charge. If, as many scholars of the civil rights era have claimed, photographs of the struggle helped advance social and legislative change, such photographs also limited the extent of reform from the start. To the degree that narratives illustrating white power over blacks helped make the images nonthreatening to whites, the photographs impeded efforts to enact—or even imagine—reforms that threatened white racial power.

This selectivity was not a conspiracy hatched by white media outlets in the North to discredit black agency or weaken the civil rights movement. On the contrary, white reporters and editors with middle-of-the-road and progressive outlooks on race promoted nonthreatening pictures of the movement partly because they believed that such images would best advance the interests of blacks. In the early 1960s, many white media outlets wished to gently promote civil rights

without alienating their white reader base. Few reporters and editors were sufficiently attuned to the dynamics of race to articulate the link between scenes of black agency and the anxiety of whites. All they understood was that they and their readers found certain photographs to be "unaesthetic," "unappealing," or "uninteresting," and these images were typically ones that unambiguously depicted nonwhites in the streets demanding social and economic rights or that baldly advocated for changes likely to undermine white power. Photographs illustrating white-on-black violence proved both visually compelling to whites and capable of nudging society toward racial reforms. In depicting whites in charge, the photographs allowed white viewers to feel secure, and therefore more amenable to change, and in illustrating blacks as victims, they encouraged white sympathy for blacks, and hence more support for legislative action. By placing blacks in the timeworn positions of victim and supplicant, the photographs presented story lines that allowed magnanimous and sympathetic whites to imagine themselves bestowing rights on blacks, given that the dignified and suffering blacks of the photographic record appeared in no position to take anything from white America.

This book concentrates on some of the best-known photographs of the civil rights struggle—those depicting fire hoses and attack dogs turned on peaceful black marchers and bystanders in Birmingham during May of 1963. Each chapter probes a different facet of the Birmingham photographs in the white imagination. Chapter 1 lays out the unspoken rules that policed the eligibility of civil rights images for reproduction in the white press and considers how they drew on a host of nineteenth-century conventions for the depiction of blacks; chapter 2 explores how the photographs, in eliciting strong emotions from whites, both promoted incremental reforms and served as a barrier to systemic change; chapter 3 explores the "perfect" black victims in the white imagination and considers the limitations of the nonviolent direct action practiced by activists in the early 1960s; and chapter 4 examines the civil rights images that whites did not reproduce—some that were simply ignored by the mainstream press and others that were defined in ways that excluded them from the civil rights canon. While centered on the struggle in Birmingham, each chapter draws on a range of iconic photographs to make a broad case for the symbolic and real-world impact of the photographs in American society. I aim to illustrate the racial consequences of the images for blacks, throw light on the beliefs that united the era's reactionary and progressive whites, and show how the photographs helped limit racial reforms in the 1960s; but I also strive to provide a glimpse of other historical possibilities. Through analysis of the distinctive ways in which black activists, reporters, and a few radicalized whites represented the black freedom struggle, I consider the degree to which a conceptual framework then existed in America for picturing a society that was racially just.

1 THE FORMULAS OF DOCUMENTARY PHOTOGRAPHY

I have been gravely disappointed with the white moderate. I have almost reached the regrettable conclusion that the Negro's greatest stumbling block in the stride toward freedom is not the White Citizens Counciler or the Ku Klux Klanner, but the white moderate.

MARTIN LUTHER KING JR., *LETTER FROM BIRMINGHAM JAIL* (1963)

Early in the winter of 1963, Dr. Martin Luther King Jr. met quietly with a group of prominent civil rights activists to discuss prospects for a major protest in Birmingham, Alabama. During the previous year, the Southern Christian Leadership Conference had experienced a discouraging setback at Albany, Georgia, where more than a year of anti-segregationist protests had failed to wring any concessions from the local white establishment. King was determined not to repeat the mistakes of that campaign. Advocates of a Birmingham protest were cheered by what they judged to be the city's favorable conditions for a successful campaign. Not only did they have a strong supporter in Fred Shuttlesworth, a prominent local clergyman and the most important black civil rights leader in Birmingham, but they also had a perfect adversary in the city's public safety commissioner, Eugene "Bull" Connor, one of the most confrontational elected officials in the South.

King believed that the Albany campaign had faltered, in part, because of the media savvy displayed by the city's police chief, Laurie Pritchett. The chief publicly styled himself as a thoughtful and moderate man who met the nonviolence of civil disobedience with his own brand of "nonviolent" law enforcement. This stance made him popular with the white northern reporters assigned to cover the campaign.[1] As a result, the ensuing media coverage was not as sympathetic to the aims of the protestors as King had hoped. Keenly aware that blacks did not wield sufficient political or economic power to end segregation and promote equal opportunity without the support of white allies, King worked hard to organize peaceful protests in Bir-

[handwritten margin note: Reliance on media narrative]

mingham that would garner sympathetic press coverage and prick the consciences of liberal whites in the North. Because most Americans lived in segregated communities, media coverage of black protests provided a rare opportunity for activists to make visible to a national white audience the day-to-day injustices—and routine violence—that blacks encountered. In contrast to Pritchett's restraint and pleasant disposition, Connor's coarseness, penchant for brutality, and appetite for media attention gave King an opening to create visually arresting scenes that could crystallize for whites the stakes of the struggle.[2]

The Birmingham campaign began on April 3, when a few dozen student protestors from Miles College, a local black institution, initiated sit-ins at downtown department store lunch counters. In a process that had become familiar throughout the South since the famous Greensboro, North Carolina, sit-ins in 1960, protestors would occupy a "whites only" lunch counter in a department store, be denied service, stoically weather verbal or physical harassment from hostile white onlookers, and typically face arrest. King used publicity of the first sit-in arrests in Birmingham to advertise six specific goals that the SCLC sought for the city: desegregation of local stores, adoption of fair-hiring practices by local merchants, dismissal of charges against protestors from prior demonstrations, provision of equal employment opportunities for blacks within city government, reopening and desegregation of municipal recreation facilities, and establishment of a biracial committee to further desegregate the city. In the days that followed, the protests grew, with black residents carrying out peaceful daily marches and a boycott of local merchants. The orderly sit-ins and marches were designed to reap national media attention; the boycotts aimed to place economic pressure on the local business community during the normally busy Easter shopping season in the hope that prominent store owners would encourage city leaders to make concessions.[3]

A month into the protest, however, white city and business leaders were holding strong, refusing to negotiate with the protest leaders despite some unflattering (if limited) coverage of the city in the national press and a significant drop-off in business for the downtown stores.[4] Many white residents hoped to wait out the protests, their intransigence rooted in their comfort with the racial status quo and nurtured by the deteriorating bargaining position of the civil rights protestors. By the beginning of May, thousands of black marchers were sitting in overcrowded jails, liberal-leaning white clergy members in Birmingham had openly criticized King in the press for creating conditions that stymied negotiations, protest organizers were having difficulty recruiting new marchers willing to face arrest, and most disturbingly to the SCLC, reporters were starting to lose interest in the campaign and were leaving town. As King remarked to a confidant, "We've got to pick up everything, because the press is leaving."[5]

To "pick up" the protest, organizers made the controversial decision to allow students—drawn from local high, middle, and even elementary schools—to take part in marches. Ap-

preciating how few adults remained willing to volunteer for arrest, as well as the need to maintain community and media interest, James Bevel, the twenty-seven-year-old director of direct action and nonviolent education for the SCLC, proposed the recruitment of children into the movement. He and Diane Nash had for weeks been working quietly with local students, holding workshops to impress upon them their power to bring about reform and to teach them the practical skills to stage effective protest actions.[6] Without immediately committing to the plan, SCLC leaders agreed to let interested young people attend a meeting at the spiritual and organizational center of Birmingham's black community, the Sixteenth Street Baptist Church, at noon on May 2. Struck by the strong student turnout and by the obvious enthusiasm of the city's black youths, King acquiesced to the participation of children, despite the reservations of many SCLC leaders and Birmingham parents.

On the afternoon of May 2, adult leaders took to the street with wave after wave of singing children, cheered on by hundreds of black adults who flanked their route. The "Children's Crusade" had begun. By the end of the day, five hundred young marchers had been carted off to jail, many still singing and waving their civil rights placards. Birmingham was now in the national news. The next day, May 3, events in the city became of international interest. Connor was unable to make further arrests because his jails were overflowing, but he remained unwilling to allow the protestors to march on city hall or pray in the streets. Frustrated that he had no place to put additional prisoners and determined to shut down all forms of black protest, Connor gave orders to disperse peaceful, unarmed protestors with German shepherd police dogs and high-pressure fire hoses. The ensuing spectacle recorded by newspaper, magazine, and television photographers and cameramen—of women in their Sunday dresses knocked off their feet by high-pressure water jets and well-dressed men peacefully standing their ground while mauled by dogs—brought the movement precisely the publicity it desired. As a reporter for the *New York Herald Tribune* noted, the resulting photographs were the most "gripping" images of the civil rights struggle to date.[7] Although the protests would continue and grow for another week, the storm of publicity generated by the inflammatory photographs and news stories about the events of May 3 brought reluctant business and city leaders to the negotiating table and ultimately provided King with one of his most celebrated victories.

Observers in the 1960s and historians in the decades since have consistently credited news photographs of attack dogs and water hoses in Birmingham with wielding a unique power over white America. They laud the images for generating sympathy among northern white liberals for the plight of black protestors in the South, for hardening northern resolve against the excesses of the racist Jim Crow system, and for providing President Kennedy and Congress with the political cover to push through long-stalled civil rights legislation. As King wrote about photography's importance, in his book on the Birmingham struggle, *Why We Can't*

Wait (1964), "The brutality with which officials would have quelled the black individual became impotent when it could not be pursued with stealth and remain unobserved. It was caught—as a fugitive from a penitentiary is often caught—in gigantic circling spotlights. It was imprisoned in a luminous glare revealing the naked truth to the whole world."[8]

Echoing King's assessment, the presidential advisor and historian Arthur Schlesinger noted, "On Saturday, May 4, newspapers across the United States and around the world saw a shocking photograph of a police dog lunging at a Negro. . . . Ordinary citizens, complacent in their assumptions of virtue, were for a season jerked into guilt and responsibility. Bull Connor's police dogs accused the conscience of white America in terms which could no longer be ignored."[9] In the aftermath of Birmingham, the liberal television commentator Eric Sevareid declared that Negroes "have caught up the conscience of the whole people. . . . A newspaper or television picture of a snarling police dog set upon a human being is [now] recorded in the permanent photoelectric file of every human brain." Andrew Young, one of King's chief lieutenants, even claimed that the Civil Rights Act of 1964 was effectively "written in Birmingham."[10]

In the ensuing decades, historians have only amplified such assessments. The photographic historian Vicki Goldberg writes of the photographs' "immediate and stunning impact. By May 1963 it was impossible to be unaware of southern racism. . . . The photographs gave this abstraction a visible image." According to the historian Taylor Branch, "News photographs of the violence seized millions of distant eyes, shattering inner defenses." And he ultimately concludes, "Never before was a country transformed, arguably redeemed by the active moral witness of schoolchildren." Referencing the Civil Rights Act of 1964, the journalist and historian Diane McWhorter has written, "If our history texts listed *Uncle Tom's Cabin* among the four major causes of the Civil War, so had the photograph of the police dog lunging at the black boy been a factor in the Emancipation Proclamation of the twentieth century."[11]

Virtually every commentator notes a link between photographs that visualize for whites the realities of black life and the promotion of social and political reform. It is assumed that the "truth" of the photographic evidence compelled whites to embrace more racially progressive views. That incidents of state-sponsored brutality against peaceful citizens would galvanize support for reform once they were "caught . . . in gigantic circling spotlights" makes sense, yet the reality is more complex. Many media reports of police violence against blacks failed to elicit a reaction from whites. Dogs had been sicced on peaceful black marchers supporting sit-in protestors in Jackson, Mississippi, in 1961 (figure 6); on demonstrators supporting voting rights in Greenwood, Mississippi, in March 1963; and on civil rights march spectators during the opening phase of the Birmingham campaign in April of that year. But white newspaper reports of these earlier dog attacks had been met with white public indifference, even when

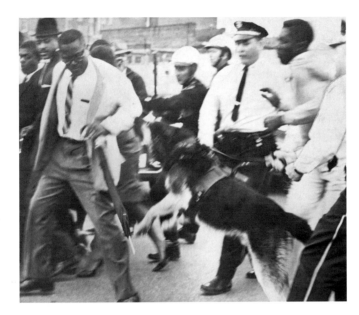

6 Unknown photographer, *A German Shepherd Police Dog Lunges at an Unidentified Negro,* Jackson, Mississippi, March 29, 1961. UPI Telephoto/ © Bettmann/CORBIS, Seattle, Washington.

they were illustrated with stark photographs of the assaults.[12] Moreover, although the infamous May 1963 photographs of rampaging dogs in Birmingham did generate a storm of controversy, they left many whites unsympathetic to the plight of black protestors. In the weeks following the publication of the photographs in newspapers and magazines throughout the country, letters-to-the-editor pages swelled with commentary condemning Birmingham's officials and praising its black residents, but almost as many of the printed letters lauded police "restraint" and criticized black "violence."

On May 17 *Time* magazine published an extensive article on the Birmingham campaign, "Races: Freedom—Now," illustrated with a photograph of a black youth "felled" on a roadway by a hose (figure 7), a black woman "manhandled" by arresting officers (see figure 46), and a dapper Connor with tie and straw hat overseeing his men. In response, readers flooded the magazine with comments. One praised the self-control of the city's police. He asked the editors approvingly, "What other police force would abstain from raw use of force when hundreds of screaming, shouting demonstrators charged down the most crowded sidewalks knocking down anyone who got in their way?" Despite the photographic evidence in *Time,* a letter writer from Birmingham insisted that the magazine had "given an unjust image of the citizens of Birmingham" and added, "We would not stand for such brutality against anyone." In response to an eleven-page photographic essay in *Life* with graphic depictions of Connor's dogs and fire hoses

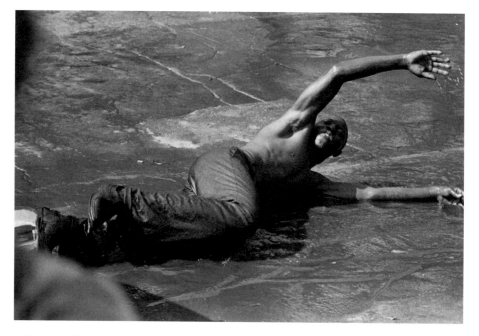

7 Unknown photographer, *Protestor Sprayed with Fire Hose,* Birmingham, Alabama, May 7, 1963. © Bettmann/
CORBIS, Seattle, Washington.

in action, a New Jersey reader explained, "A mob is . . . an engine of destruction. . . . The [Bir-
mingham] police know that and they also know that the best cure is to break it into small
groups. The easiest and most merciful way to do this is with a fire hose." A second *Life* reader
wrote, "It is such a shame that Negroes who could be out earning money and, in some cases,
respect, are participating in such things as the Birmingham violence. . . . All they can think
of is violence."[13]

 Although we might be tempted to dismiss such sentiments as outliers, based on our modern
view that the writers were on the "wrong" side of history, the number of such claims in the
early 1960s counters the notion that the "truth" of the photographic evidence was obvious and
that such truths necessarily prompted racially progressive responses in whites. Given that many
whites saw "restraint" in the images of firemen who pummeled marchers with high-pressure
jets, while others saw only "brutality," we must appreciate that the photographs operated in
more complex ways than are readily apparent today. The meanings ascribed to the photographs,
and the attitudes and actions they promoted, were clearly produced in part by contextual fac-
tors outside the photographic image.

To understand how the photographs moved many millions of moderate and liberal whites in the 1960s, consider the most widely circulated account of the Birmingham conflict—the aforementioned photographic essay in *Life,* which the magazine published on May 17, 1963, under the title "The Spectacle of Racial Turbulence in Birmingham: They Fight a Fire That Won't Go Out" (figure 8).[14] The essay is a key document of the era, because many of its thirteen photographs, taken by the southern white photographer Charles Moore, quickly assumed status as iconic images of the civil rights struggle. Moore's stark photographs of Birmingham became as famous as those of the Little Rock Nine being pursued by mobs outside the previously segregated Little Rock Central High School (see figure 40), dignified lunch counter protestors weathering verbal abuse and physical attacks in Jackson (figure 9), shell-shocked Freedom Riders clustered around their firebombed bus near Aniston (see figure 2), and, in time, those of peaceful marchers absorbing the blows of police batons at the Edmund Pettus Bridge in Selma (see figure 1). With nearly nineteen million paid subscribers at a time when the U.S. population was just over 180 million, *Life* was the largest-circulation news source and among the most influential periodicals of the early 1960s.[15]

Many of Moore's photographs of police dogs, fire hoses, arrests, and demonstrations stand today as visual shorthand for the civil rights movement and are consequently reproduced with little explanatory text. In the first blush of the conflict, when their meanings were still in flux, *Life* reproduced the photographs with copious descriptive copy. On a two-page spread (figure 10) that displays a sequence of three photographs of a well-dressed black man being mauled by a lunging police dog, *Life* explained, "With vicious guard dogs the police attacked the marchers— and thus rewarded them with an extreme outrage that would win support all over the world for Birmingham's Negroes. If the Negroes themselves had written the script, they could hardly have asked for greater help for their cause than . . . Connor freely gave. Ordering his men to let white spectators come near, he said: 'I want 'em to see the dogs work.' " The caption notes that this "brutal" scene "is the attention-getting jack pot of the Negroes' provocation."[16]

This description juxtaposes the portrayals of whites who "fight" and "attack" with those of blacks who require "help" and are "brutalized." The text guides the reader's interpretation by suggesting a contrast between the *activity* of brutal white policemen and the *inactivity* of peaceful black marchers. It suggests that white actions served blacks better than anything the activists themselves might have "scripted." That the article focuses on the subject of white agency is apparent even in its subtitle—"They Fight a Fire That Won't Go Out"—which frames whites as the scene's active players, waging a metaphoric battle against the black "fire" with their water hoses. Echoing the coverage in *Life,* mainstream media outlets routinely cast black Birmingham protestors as the hapless victims of violent whites. They reported on youths hit with firemen's hoses as "flattened," "sent sprawling," "spun . . . head over heels,"

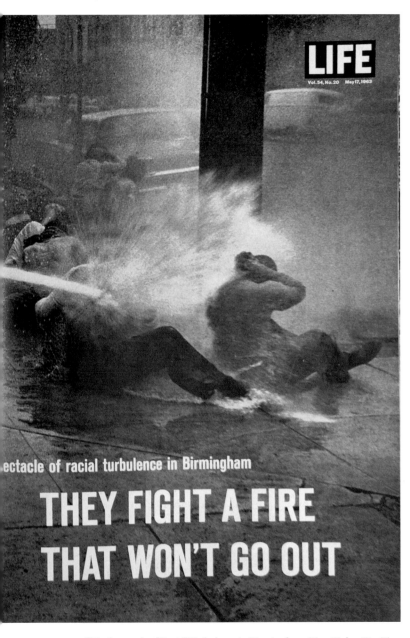

LIFE

Vol. 54, No. 20 May 17, 1963

..ectacle of racial turbulence in Birmingham

THEY FIGHT A FIRE
THAT WON'T GO OUT

8 "The Spectacle of Racial Turbulence in Birmingham: They Fight a Fire That Won't Go Out," *Life*, May 17, 1963. Text © 1963 Life Inc. Reprinted with permission. All rights reserved. Photograph © Charles Moore/Black Star, New York.

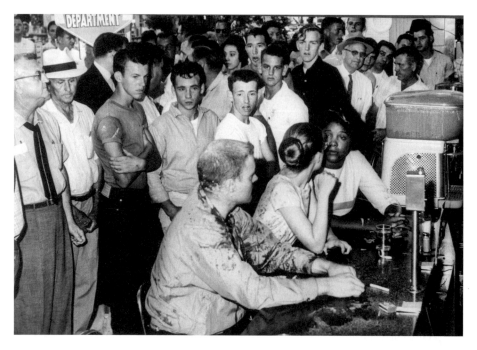

9 Fred Blackwell, *Sit-In at F. W. Woolworth's Lunch Counter, Jackson, Mississippi,* May 28, 1963. © Bettmann/ CORBIS, Seattle, Washington.

"sitting passively," "swept along the gutter by a stream of water," "cut . . . down like tenpins," or "flung . . . into the air like sodden dolls," some with their clothing "ripped off."[17] A white Birmingham native recalled how Connor's fire hoses sent black "arms and legs . . . jerking like those of puppets on a string [and] bodies cartwheeling across the grass like scraps of paper caught in the wind."[18] The consistent ascription of such traits to whites and blacks is the most important frame in white media accounts of civil rights.

Even when white reporters made a conscious effort to communicate the "determination and courage" of Birmingham's black activists, their stories invariably reproduced a picture of black inactivity. *Time*'s May 17 coverage of the Birmingham campaign opened with the following description: "Birmingham's Negroes had always seemed a docile lot. Downtown at night, they slouched in gloomy huddles beneath street lamps, talking softly or not at all. They knew their place: they were 'Niggers' in a Jim Crow town, and they bore their degradation in silence. But last week they smashed that image forever." The article's framing paragraph establishes the docile "before" picture of Birmingham's blacks and sets the stage for the dramatic

[handwritten: White perspective]

"after," which "smashed" the old image forever. In the next paragraph, the reporter explains, "The scenes in Birmingham were unforgettable. There was the Negro youth sprawled on his back and spinning across the pavement, while firemen battered him with streams of water so powerful that they could strip bark off trees. There was the Negro woman pinned to the ground by cops, one of them with his knee dug into her throat." And farther down the page, *Time* noted, "For more than a month, Negro demonstrators in Birmingham had sputtered, bursting occasionally into flames, then flickering out."[19]

So how has the image of black residents changed in the aftermath of the protests? Blacks had emerged from the nighttime shadows into daylight to interact with whites; whereas they had previously stood quietly on streets, they were now sprawled across them. In the eyes of the white media, blacks had merely traded their "docile" victimization in the dark for a new kind of subjugation in the light. Once again, in the language in the article, white firemen "batter" and white police "pin" and "manhandle" blacks, who are sent "sprawling" and "spinning" along the ground and who ultimately "sputter out." Despite *Time*'s promise of a "new" image for blacks, it simply delivered a more dramatic spectacle of their victimization. The white photographers and journalists who descended on Birmingham could have reported the evidence of black agency in the organization and staging of massive protest marches and consumer boycotts and pointed up white agency in the violent efforts to suppress such acts of protest. Yet, with the options of reporting on black actions, white actions, or some combination of the two, they consistently narrated the "story" of Birmingham as the white suppression of blacks.

During the 1960s, keen observers recognized the penchant of the mainstream media to foreground white agency in their coverage of the civil rights struggle. The veteran television and print journalist Paul Good commented on the steady diet of white-on-black violence— "tales of Southern goons brutalizing black men, women, and children"—that white newspapers and television stations fed their audiences in the early 1960s. He noted that popular magazines, "like *Life* or *The Saturday Evening Post* . . . were obtuse in their editorial understanding and superficial in their handling of civil rights stories." Danny Lyon, an early staff photographer for the SNCC who spent years photographing protests from the perspective of activists, was struck by the degree to which the northern press confined its reporting to the actions of whites. He commented that white reporters gravitated toward "the drama of a bus getting bombed or a [white] riot at Ole Miss." That such stories scripted particular roles for blacks and whites is dramatized by the instructions given to one television news cameraman in the early 1960s. As the cameraman recalled, his editor made clear that "the Klan didn't scare him and that I should get a shot of them burning a cross in front of a Negro's house. Says he'd like the Negro on his knees begging and the Klan should have their pillow cases [on] . . . and in color yet."[20]

How far editors were willing to go to acquire the desired shots of a "Negro on his knees"

THE DOGS' ATTACK IS NEGROES' REWARD

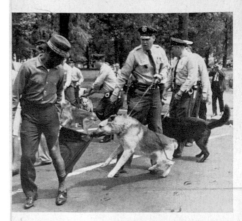

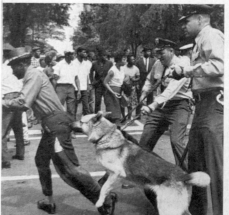

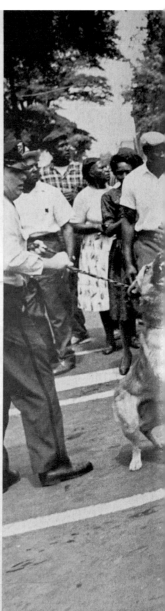

ATTACK DOGS. With vicious guard dogs the police attacked the marchers —and thus rewarded them with an outrage that would win support all over the world for Birmingham's Negroes. If the Negroes themselves had written the script, they could hardly have asked for greater help for their cause than City Police Commissioner Eugene "Bull" Connor freely gave. Ordering his men to let white spectators come near, he said: "I want 'em to see the dogs work. Look at those niggers run." This extraordinary sequence—brutal as it is as a Negro gets his trousers ripped off by Connor's dogs—is the attention-getting jack pot of the Negroes' provocation.

CONTINUED

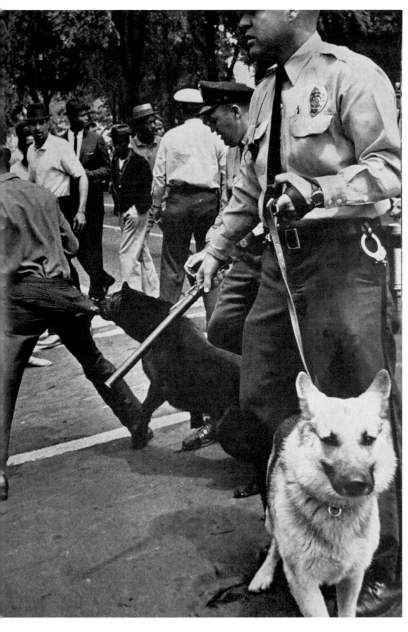

10 "The Dogs' Attack Is Negroes' Reward," *Life,* May 17, 1963. Text © 1963 Life Inc. Reprinted with permission. All rights reserved. Photographs © Charles Moore/Black Star, New York.

11 Joe Chapman, *A Negro Youth Kneels on a Glass-Littered Sidewalk,* Birmingham, Alabama, September 15, 1963. UPI Telephoto. New York World-Telegram and Sun Collection, Library of Congress, Prints and Photographs Division, Washington, D.C.

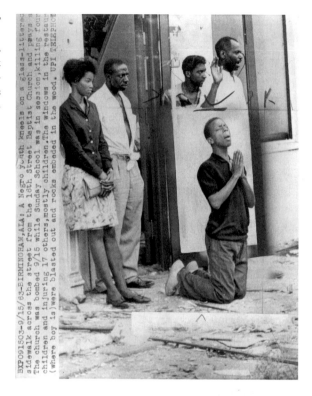

is illustrated by a rare newspaper production photograph from the *New York World-Telegram and Sun* preserved at the Library of Congress (figure 11). A United Press International photograph of black spectators watching the chaotic aftermath of the Ku Klux Klan's bombing of the Sixteenth Street Baptist Church in September 1963 retains an editor's grease-pencil crop marks above the head and below the shin of the boy on his knees. The lower bodies of the two figures directly behind the boy have been airbrushed out and the figures on the left cropped, so that the image of the boy praying in isolation could illustrate an article published in the paper on September 16.[21] In removing the four standing figures—and any ambiguity of meaning conveyed by their facial expressions, gestures, and poses—the manipulated image delivers a resonant message of blacks brought to their knees by the violence inflicted by whites. As we'll see, the white penchant for spectacle, comfort reporting from the perspective of white actors, and even their liberal politics led white reporters and editors to downplay the bravery and accomplishments of blacks as they conjured a fantasy of black passivity in the face of white aggression.

Ironically, the violent whites who appeared in news accounts of Birmingham were ulti-
mately cast as agents of progressive social change, despite their obvious desire to preserve the
racial status quo. In contrast to much nineteenth- and early twentieth-century imagery,
wherein whites were the agents of social changes they *supported,* the photographs and articles
chronicling Birmingham consistently depicted southern whites as forceful actors who inad-
vertently promoted changes they were determined to prevent. This view typified northern
whites' response to the civil rights struggle in the South. In a meeting with civil rights leaders
in the White House Cabinet Room in June 1963, President Kennedy remarked to the assembled
group that Bull Connor "has done more for civil rights than almost anybody else."[22] David
Halberstam, well known for his coverage of and sympathy for the black freedom struggle,
claimed in 1967, "In retrospect it was not so much Martin Luther King who made the move-
ment go, it was Bull Connor; each time a bomb went off, a head smashed open, the contribu-
tions would mount at King's headquarters."[23]

On the flip side, the previously quoted whites who wrote letters to the editor to condemn
black marchers (and praise white officials) consistently highlighted black action in their argu-
ments, characterizing protestors as a "screaming" mob that "charged down ... sidewalks
knocking down anyone who got in [its] way" and as an "engine of destruction," fixated on "vio-
lence." Whites who favored extending greater civil rights to blacks reflexively cast blacks as a
people acted upon, whereas whites who rejected the civil rights project tended to see blacks as
a force exerting power over whites. Even though progressive and reactionary whites, respec-
tively, supported divergent social agendas, each group showed allegiance to a value system that
understood disempowerment as the "normal" role for nonwhites. In trying to depict black
protestors sympathetically, progressive whites described them as inactive, which in the racial
logic of the day equaled normal and safe. On the other side of the political continuum, reac-
tionary whites described the same black protestors as active, knowing that such a description
would signal to other whites the abnormality of assertive blacks.

Even as the photographs of Birmingham in the mainstream press recorded distinctive acts
of protest, most shared a view of white-black relations that contrasted the restraint and disen-
gagement of black protestors with the violent aggression of white attackers. This contrast was
not unique to the coverage of the Birmingham campaign. It served as the gatekeeper in policing
the eligibility of images for inclusion in the canon of civil rights photographs. Although white
press photographers in Birmingham did produce images suggesting alternative roles for whites
and blacks, these images gained little traction with whites in the North.

At the foot of the final page of Moore's essay in *Life* (figure 12), the editors reproduced a
tightly cropped detail of a much larger photograph that shows smiling young marchers seeking
to shame a policeman sitting astride his motorcycle, billy club in hand, to watch the crowd.

QUERY FOR SOUTHERN WHITES—WHAT NOW?

The Negroes of Birmingham know what they want and how they want to get it. The white people of that city, shaken by recent events, are perplexed about what to do, and some are searching for attitudes and policies to solve the searing problem. LIFE Reporter Bill Wise spoke to a cross section of white Birmingham residents to learn their reactions and hear their suggestions for dealing with the new Negro tactic of nonviolent mass demonstrations.

REVEREND WALLACE W. LOVETT, pastor of Woodlawn Methodist Church: "I think the demonstrations are delaying attainment of the ultimate objectives of the colored people of Birmingham. The solution to the problems we face here will not come out of demonstrations of massive force, but out of sensible negotiations by leaders of both groups."

FRANK PLUMMER, president of the Birmingham Trust National Bank: "I was very concerned with their problems but now I've lost sympathy with this thing. If we could keep the outsiders—both white and black—out of here we could solve the problem."

JACK WILSON, salesman: "They are defeating themselves. They are just causing a lot of anger and resentment. Martin Luther King has told them that after another week or two of this the people of Birmingham will be willing to submit to their demands, but that simply isn't true."

TED HUBBARD, engineer: "A few weeks ago I wouldn't have thought a thing about walking down a street in the colored area alone, but I sure as hell wouldn't do it now. They aren't trying to prevent trouble. They are looking for trouble. If you get 4,000 individuals, white or black, and try to lead them down the street, it only takes one hothead to start a riot."

JOE FERGUSON, barber: "They call these people out here demonstrators. They called those white boys down at Ole Miss a 'rioting mob.' "

MARVIN COX, retired Air Force officer: "I served 20 years in the service of my country and was proud of it, but if I had known that this was what I was fighting for I would have been ashamed."

R.L. BURDETTE, scrap iron broker: "When a man takes small children and purposely puts them where they can get hurt, he is far worse than Bull Connor."

MORGAN KNIGHT, car salesman: "If they keep trying to shove this thing down people's throats there is going to be real trouble. They are just making people mad."

DR. FRANK BUCHANAN, Baptist minister: "This thing has to be solved by a process of evolution. A lot of good intelligent Negroes in this understand this, but they can't speak out for moderation because the Kings and other outsiders call them Uncle Toms and accuse them of selling out their race."

JESSE MADARIS, parking lot attendant: "We've got to accept integration. Not that I want to, but it is here. But this situation now is going to lead to small war between the Negroes and the whites. The white people are finally going to get riled up enough so that we will have real bloodshed."

A WHITE HIGH SCHOOL TEACHER: "All this time we've done nothing to prepare these kids for social change. All these years there should have been some effort to prepare them for this. But we've been forbidden to even mention it. They could have been taught about the worldwide aspirations of all peoples for equality, and there should have been social exchange between colored and white children. . . . The demonstrations are worthwhile if they only focus the attention of right-thinking people on this situation so that eventually something may be done about it. To me the solution is very simple: just treat human beings as human beings. But to many of these people Negroes are not human beings. I am ashamed to ask you not to. If you do I will lose my job. The fear that prevents people from saying what they want to say is a terrible thing."

ALICE HUMPHRIES, sales clerk: "I'm not in favor of Bull Connor and his dogs. This is true of a great many people of Birmingham, but a lot of people won't speak their thoughts because they are afraid. I think the demonstrations are ill-timed. If they had waited until the new city government was installed, maybe this wouldn't have been necessary."

EDDIE ENTREKIN, college student: "I think this has been coming for a long time. Birmingham has been a sort of radical bastion of the South. Most people here realize the Negroes haven't had the rights they deserve, but they [the whites] have been unwilling to change. At first I was glad to see the demonstrations, but I have begun to question King's motives lately."

TOMMY ARWOOD, auto body and paint man: "You can't blame the Negro for what he is trying to do. Sooner or later they are going to win, but they aren't going to school with my children."

CARDER HIGGINS, management trainee: "I guess if I were in their shoes I might do the same thing. I think maybe we've handled it wrong. If they want to parade and march along and sing and shout we should let them."

GEORGE SEIBELS, city councilman-elect: "It is most unfortunate that all these unlawful, untimely demonstrations took place just following the election of the new city government. They have done everything to upset what hope we had for making progress."

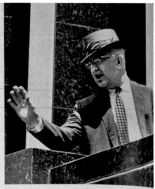

POLICE BOSS. Busily waving a hand, Commissioner "Bull" Connor directs police task force. Many white citizens deplore Connor's ruthless methods but hesitate to say what they think.

JEERING MOB. Waggling their fingers at an officer *(left)*, youthful Negroes taunt police. Provocation like this, to most whites, is a wide-open invitation to full-scale racial warfare.

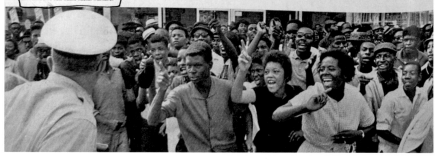

13 From the *Washington Post*, © May 4, 1963. The Washington Post. All rights reserved. Used by permission and protected by the Copyright Laws of the United States. The printing, copying, redistribution, or retransmission of the material without express written permission is prohibited. Page reprint courtesy of PARS International Corporation, New York.

The version reproduced in *Life* tamps down all signs of white control by cropping out the club, thereby making the line of black youths the scene's most threatening figures. In the caption, *Life* described a "jeering mob waggling their fingers [to] taunt police."[24] When the *Washington Post* made its first report on Birmingham after the dramatic use of dogs and fire hoses, it published four photographs of the conflict, two illustrating blacks in classic inactive poses—absorbing the force of a fireman's hose and suffering the bite of a police dog—and two showing blacks in more active roles—goading a leashed police dog by waving a jacket like a matador's cape and lunging to "attack" one of the dogs with a knife (figures 13 and 14).[25] "Active" images

14 Bill Hudson, *Man with Knife Attempting to Stab Police Dog, Birmingham, Alabama,* May 3, 1963. AP/Wide World Photos and Bill Hudson, New York.

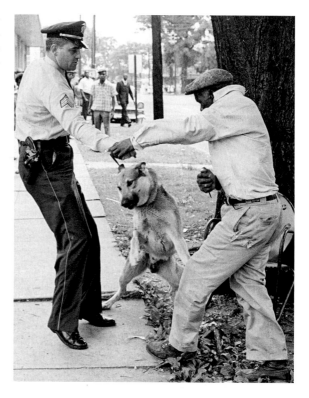

of "jeering" mobs and "attacking" men, although reproduced in a handful of white magazines and newspapers in the days immediately following the events and well known to historians today, quickly dropped from northern white media accounts in the 1960s and have effectively vanished from present-day photographic histories of civil rights.

In the visual representation of Birmingham, even the most radical whites in the early 1960s displayed a racial conservatism drawn directly from the mainstream press. Andy Warhol, in his iconoclastic battle against abstract expressionism, created narrative prints and paintings of Birmingham for his *Race Riot* series, illustrating police dogs on the attack (figure 15). We know from a surviving two-page photographic spread that Warhol ripped from a magazine and annotated with instructions to his studio assistants that his source for the series was Moore's photographs from *Life* (figure 16). Ignoring published images that spoke unequivocally to whites of black agency, Warhol selected the photographs that most succinctly articulated a safe narrative of peaceful, victimized blacks. Given that the artist indiscriminately referred to the dog-attack pictures from Birmingham as both his "Montgomery" and "Selma" pictures, he was apparently more interested in the racial dynamic they displayed than in the specifics of

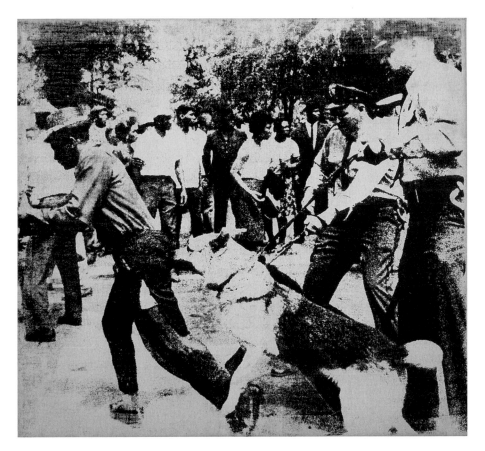

15 Andy Warhol, *Little Race Riot,* 1964. Synthetic polymer paint and silk-screen ink on canvas, 76.2 × 83.8 cm. The Menil Collection, Houston, Texas. Photo by Paul Hester, Houston. © 2009 The Andy Warhol Foundation for the Visual Arts, Inc./Artists Rights Society (ARS), New York.

the campaign. For well-meaning whites—whether reporters, editors, or artists—photographs that too obviously illustrated active blacks and inactive whites held scant allure.[26]

The broader photographic record of the civil rights era neatly reproduces the dynamic evident in the coverage of Birmingham: the iconic images of the struggle, which overwhelmingly depict blacks as the victims of history, coexist with more marginal photographs, which illustrate empowered blacks. Such iconic photographs include the aforementioned confrontations over voting rights and the integration of schools and lunch counters but also well-known photographs of Rosa Parks being fingerprinted in 1956 (figure 17); King being roughed up during his arrest in 1958 (figure 18); scores of limp protestors being dragged from streets, courthouse

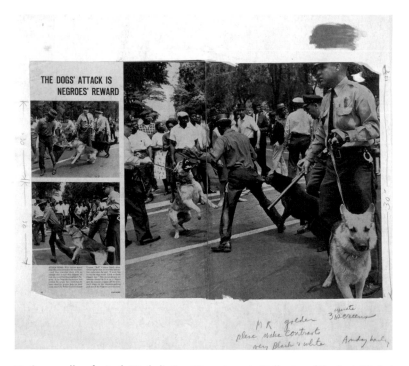

16 Source collage for Andy Warhol's *Race Riot* series, 1963. Collection of The Andy Warhol Museum, Pittsburgh, Pennsylvania. Founding Collection, contribution of the Warhol Foundation for the Visual Arts, Inc. © 2009 The Andy Warhol Foundation for the Visual Arts, Inc./Artists Rights Society (ARS), New York. *Life* magazine text May 17, 1963, © 1963 Life Inc. Reprinted with permission. All rights reserved. Photographs © Charles Moore/ Black Star, New York.

steps, and bus stations; and the Pulitzer Prize–winning photograph of James Meredith after being shot during his 1966 Mississippi March Against Fear (figure 19). Among the circulating photographs that depict strong, active blacks are many dozens of striking images of protest marches (figure 20), Martin Luther King delivering his "I Have a Dream" speech to hundreds of thousands of listeners on the Washington Mall (figure 21), and the sea of dignified sanitation workers in Memphis holding their famous "I AM A MAN" placards (figure 22).

However, even the well-known images of empowerment were frequently circumscribed by racial dynamics seen more readily in photographs featuring white-on-black violence. In Bob Adelman's photograph of King, the civil rights leader strikes a powerful pose as he gestures toward the sky against the colossal columns of the Lincoln Memorial behind him. But the speech immortalized by the photograph was lauded in the 1960s (and is popularly revered today) for its recollection of a "dream." In the snippets of the address most commonly recalled

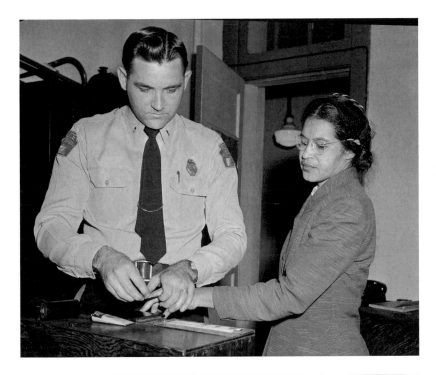

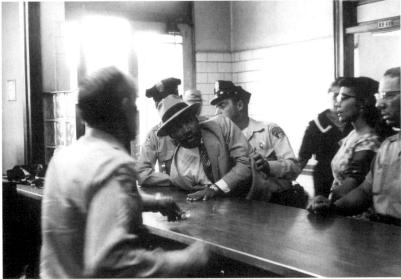

17 (Top) Gene Herrick, *Rosa Parks Being Fingerprinted, Montgomery, Alabama,* February 22, 1956. AP/Wide World Photos and Gene Herrick, New York.
18 (Bottom) Charles Moore, *Martin Luther King, Jr., Arrested on a Loitering Charge, Montgomery, Alabama,* September 3, 1958. © Charles Moore/Black Star, New York.

19 Jack Thornell, *James Meredith Shot and Wounded During His March Against Fear, Hernando, Mississippi,* June 6, 1966. AP/Wide World Photos and Jack Thornell, New York.

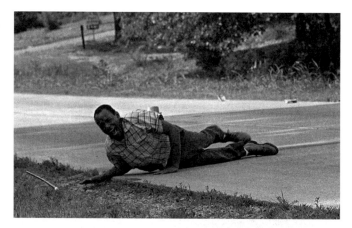

20 James Karales, *The Selma to Montgomery March,* March 21–25, 1965. Rare Book, Manuscript, and Special Collections Library, Duke University, Durham, North Carolina. Used with permission of the Estate of James Karales.

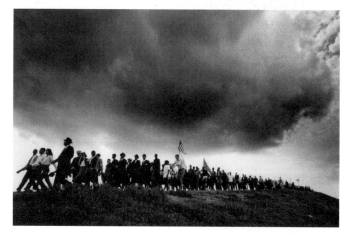

by whites, King does not remake the world but simply dreams of a more perfect order to come. As the historian Drew Hansen has documented, many progressive blacks in the 1960s criticized the speech for its failure to articulate a concrete program for change and for its reliance on stirring rhetoric they deemed empty.

The student activist Anne Moody spoke for many more radical blacks who attended the March on Washington when she lamented having "sat on the grass and listened to the speakers, to discover we had 'dreamers' instead of leaders leading us." Hansen documents the appeal of the speech, in its vagueness and general invocation of hope rather than action, to white politicians who supported civil rights.[27] In contrast to the speech of John Lewis, the chairman of the SNCC, who presented a searing indictment of the structure of American society, King's

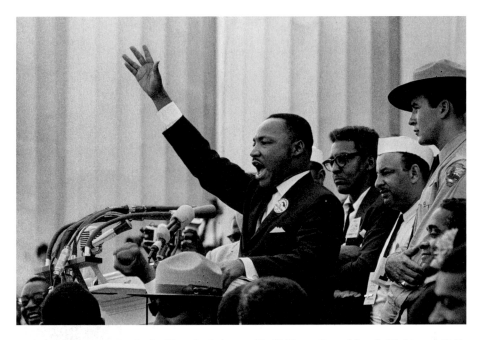

21 Bob Adelman, *Martin Luther King, Jr., Delivering His "I Have a Dream" Speech,* Washington, D.C.,
August 28, 1963. © Bob Adelman/CORBIS, Seattle, Washington.

appeal seemed safe. Few pictures of John Lewis on the podium in Washington circulated in
the white press, because whites had no inclination in 1963 to linger on his call to action: "The
revolution is at hand, and we must free ourselves of the chains of political and economic slav-
ery.... We will not wait for the courts to act, for we have been waiting for hundreds of years.
We will not wait for the President, the Justice Department, nor Congress, but we will take
matters into our own hands and create a source of power, outside of any national structure."[28]
For most whites in the 1960s, Adelman's photograph was appealing because of its depiction
of a patient King who would wait for social changes brought about by well-meaning whites.

Ernest Withers's photograph of the sanitation strike in Memphis is similarly well known
today and equally complex. It records black workers' mass walkout in February 1968 to protest
discriminatory treatment and life-threatening working conditions. The photograph presents
an orderly assembly of men who form a human wall blocking the street. The strikers grip hun-
dreds of identical protest signs that mark a strong horizontal band across the composition. With
their disparate clothing and physiques, the men are united by their black skin and their clear
declaration of shared identity—as men. The poignant assertion of humanity (and manhood)

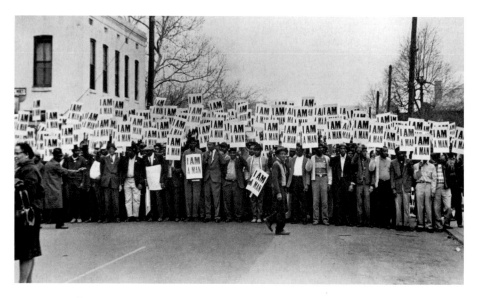

22 Ernest Withers, *Sanitation Workers Assemble in Front of Clayborn Temple for a Solidarity March,* Memphis, Tennessee, March 28, 1968. © Ernest C. Withers Estate, Panopticon Gallery, Boston, Massachusetts.

invokes the inscription on the antislavery medallion designed by Josiah Wedgwood in 1787 (figure 23), which he in turn modeled after the seal of the English Committee for the Abolition of the Slave Trade of that year. Wedgwood's supplicant slave, who asks, on bended knee, "Am I not a man and a brother?" was a ubiquitous emblem of emancipation in the nascent United States that tugged at the emotions of whites. Withers's photograph is affecting, but realization that the strikers' assertion of identity is rooted in eighteenth-century debates on the humanity of nonwhites should give readers pause. The workers' forceful affirmation of our shared humanity is ultimately undercut by their need to make such a claim in the late twentieth century.

The difficulties posed to whites by representations of unambiguously powerful blacks were laid bare by the white reaction to John Dominis's photograph of John Carlos and Tommie Smith's 1968 Olympic protest in Mexico City (see figure 61). Whereas images of abused students and beaten marchers spoke fluently to northern whites of racial injustice, the athletes' Olympic protest did not. After placing first and third, respectively, in the men's 200-meter race, each athlete mounted the medal stand with an Olympic Project for Human Rights button pinned to his track jacket, black socks displayed prominently by shoeless feet and rolled pant legs, and a single black glove. After receiving their medals, the men pivoted toward the rising flags and, as "The Star-Spangled Banner" played, each raised a black-gloved fist in the air and lowered his head. As the

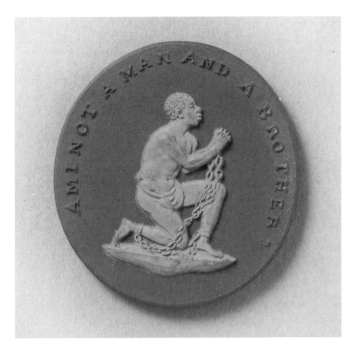

23 William Hackwood, *Am I Not a Man and a Brother?* 1787. Tinted stoneware medallion designed by Josiah Wedgwood. 3.2 × 3.2 cm. Courtesy of the Brooklyn Museum, New York. Gift of Emily Winthrop Miles.

pair stood motionless on the stand, the scene was captured in black-and-white by press photographers and in color by television cameramen and quickly circulated around the world.

At a press conference following the ceremony, and in a television interview the next day with Howard Cosell, Smith patiently explained that the athletes' shoeless feet and black socks called attention to the poverty of black Americans and the raised gloved fists stood for black unity and pride.[29] Like the photographs of the Birmingham and Selma campaigns, this photograph showed blacks engaged in a silent, peaceful demonstration that sought to bring to the attention of national and international audiences the social and economic inequalities suffered by blacks. *Life* magazine, describing Smith and Carlos just after their Olympic protest, acknowledged, "They are not separatists. They do not believe in violence. They are dedicated to . . . gaining dignity and equality for all black people."[30] Yet the photograph ignited furious debate in white America—about the propriety of the athletes' actions rather than the issues they sought to address. The failure of the protest to engage most whites on issues of poverty and racism resulted directly from the athletes' tactics. The Olympians pointed to suffering without exemplifying it and, more scandalously, delivered their message from a position of power. Even today, the image is most frequently reproduced under the heading of "Black Power" rather than "Civil Rights,"

as if power and rights are somehow opposed (see chapter 4 for more on this photograph). In the 1960s, photographs that made the agency of blacks all too obvious diminished the odds of reaching otherwise sympathetic whites.

The degree of distress that Smith and Carlos's peaceful and lawful protest stirred up in whites suggests the challenges blacks faced in crafting demonstrations to make visible long-ignored problems and prompt sympathy in whites. Blacks who hoped to reach whites through protest had to navigate a narrow range of "acceptable" actions, as is evident in the distinctive white responses to the civil rights protests of Birmingham and Selma, Alabama. The Selma campaign sought to highlight the high percentage of qualified blacks systematically disenfranchised in Dallas County, register willing voters, and push the federal government to become more involved in voting rights issues. As in Birmingham, it began quietly, with protest marchers and pray-ins that garnered limited media attention; it became headline news only after the spectacle of "Bloody Sunday" in the spring of 1965.

The historian David J. Garrow provides a detailed comparison of the white reaction to the two campaigns. He notes that the Selma protests produced vastly more sympathy for blacks among whites and led to significantly greater legislative action in Congress. Not only did Selma receive greater media coverage, but news outlets focused more on the peacefulness of the protestors and on the justness of their cause. The press coverage of the Birmingham campaign was generally sympathetic but gave little attention to King's demands, showing more interest in the spectacle of violence than in the roots of the conflict. Garrow attributes the more favorable response of the white public and Congress to the Selma protest to three main factors: Selma had just one, clearly articulated aim, voter registration, in contrast to the six goals of the Birmingham campaign; to many whites, voter registration seemed a more basic, less threatening, and more inalienable right than desegregated lunch counters or better job opportunities; and most important, while press reports of Birmingham often mentioned that some of the city's blacks engaged in violence (such as the knife-wielding man in figure 14), those from Selma rarely did.

Garrow concludes that "while the [white] outrage at law-enforcement tactics at Selma was magnified further by the blacks' own commendable conduct, at Birmingham the perceived conduct of the blacks served to *reduce* the quantity and intensity of the outrage generated by the use of dogs and hoses." He explains white reaction as largely a function of an American political culture that condemns violence, specifically that against peaceful victims.[31] Garrow's thoughtful analysis of the two campaigns provides a guide to the "perfect" black protest but also hints at the severe limitations black activists faced. Given the depictions of inactive versus active roles in the photographic record, the fact that whites were more sympathetic, and more willing to act legislatively, after Selma seems unremarkable, in light of the marchers' even-greater display of "appropriately" passive roles than their compatriots in Birmingham. But

considering that Garrow ultimately sees only slight differences between the black performances at Birmingham and Selma, the two campaigns seen in tandem point at once to the power and the limitations of black protest. While pictures of black passivity were key to generating sympathy among whites and, consequently, to pushing through legislative reform, they also limited the types of protests blacks could stage and the reforms they could demand if they wished to maintain white support. Birmingham and Selma each gave a victory to the civil rights movement because each campaign adhered to a script written for blacks by whites. To deviate from that script in 1960s America was a sure way for blacks to lose white support.

I posited at the start of this chapter that photographs of the civil rights struggle contain no agreed-upon "truths." They offer a record of specific people interacting at particular times and places; in this sense, they contain facts about the material world. But they say little about social realities, about which we care much more. The comments and reactions that the photographs elicited from viewers in the 1960s reveal that Americans looked to civil rights photographs to see who was the victim and who was the aggressor and to determine whose cause was just. On these issues, the photographs provide no ready answers, notwithstanding what viewers imagined.

The narratives Americans read in photographs were produced by external cues such as captions, text, and photographic juxtapositions but also by internal factors such as the racial values that individuals brought with them to the images. The specific events captured on film surely played a role in guiding viewer responses, but they, perhaps surprisingly, were of secondary importance to these other frames in establishing the social significance of photographs. We can see this phenomenon at work in the many misreadings of photographs, whose subject matter and media framing combined with viewers' political predispositions to overpower the visible evidence of the images. Scenes of Birmingham's nonviolent protestors could appear to be more violent, as a group, because of narratives circulating in society about the violence of the city's blacks, but particular images of physically assertive blacks could be made to seem less so in the right contexts. Although whites were predisposed to see violence in all scenes of black protest (since protest was outside acceptable black roles and thus carried a hint of aggressive self-determination that defied the norm of black disempowerment), even protestors who resisted police authorities could be read as nonviolent with the appropriate framing.

Bill Hudson worked alongside Moore, and a handful of other white photographers, to capture the demonstrations on May 3 in Birmingham. He snapped the famous image of Officer Dick Middleton grabbing the shirt and sweater of a neatly dressed black man as a police dog lunges, straining its leash (figure 24). After his day of shooting, Hudson handed off his film for processing to Jim Laxon, the supervising editor of the Associated Press's Atlanta bureau. In an interview with the journalist Diane McWhorter, Laxon recalled his strong reaction to the Hudson photograph in 1963, explaining that "the saintly calm of the young [man] in the

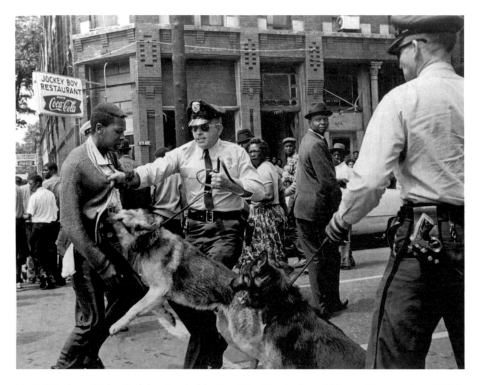

24 Bill Hudson, *Walter Gadsden Attacked by K-9 Units, Birmingham,* Alabama, May 3, 1963. AP/Wide World Photos and Bill Hudson, New York.

snarling jaws of the German shepherd" gave him the same feeling he had experienced nearly two decades before when processing his first Pulitzer Prize–winning photograph (of a woman leaping from a burning high-rise hotel in Atlanta in 1946).[32] The Hudson photograph, published the next day on the front pages of dozens of northern papers, was framed by reporters and editors in ways that echoed Laxon's reading of the youth's innocence and composure in the face of unwarranted violence.[33] The Communist *Daily Worker,* a newspaper highly sympathetic to the black freedom struggle, described Hudson's image as "a grinning cop setting his savage dog at the throat of a frail Negro."[34] An editorial in the *Washington Post* mourned for "the maltreated Negro youth . . . and for [the Negroes'] misguided oppressors."[35] In a memoir of his youth in Birmingham, a white former resident wrote that Hudson's photograph created "an image that would burn forever." He recalled "the thin well-dressed boy seeming to be leaning into the dog, his arms limp at his side, calmly staring straight ahead as though to say, 'Take me, here I am.'"[36]

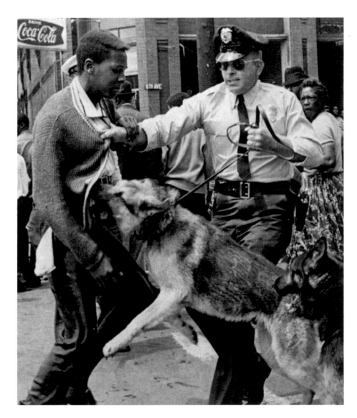

25 Bill Hudson, detail of *Walter Gadsden Attacked by K-9 Units, Birmingham,* Alabama, May 3, 1963. AP/ Wide World Photos and Bill Hudson, New York.

Influential black newspaper and magazine reports in the 1960s presented a decidedly different interpretation of the photograph to their readers. Unlike white publications, which were reticent about interviewing black protestors or even identifying them by name, black media outlets routinely publicized the feelings, motivations, and identities of blacks pictured in civil rights imagery. The black press identified the unnamed civilian in Hudson's photograph as fifteen-year-old Walter Gadsden. We know from a lengthy article in the national black periodical *Jet,* in 1963, that Gadsden was not a student demonstrator that day in May but a curious bystander who went downtown to check up on his protesting schoolmates. He was born into a prominent southern newspaper family that had little sympathy for King or the protest struggle.[37] In the *Jet* article, Gadsden recalled, "When the policeman grabbed me I didn't see the dog at first because it was behind me. When he whirled me around, jerking me toward the dog, I automatically threw my knee up in front of the dog's head" (figure 25).

The reporter explained that Gadsden had grown up with dogs in his household and that

his father had taught him to protect himself from aggressive animals. His raised left knee was his effort to ward off the dog's bite; the height at which he holds his knee suggests that he is not simply walking into the waiting jaws. More significant than the visual evidence of his knee and Gadsden's recorded account, however, are a number of present-day historians' observations about his left hand, which grasps the right wrist of Middleton's outstretched arm. Birmingham protest volunteers attended workshops in the philosophy and practice of nonviolent direct action, where they participated in role-playing sessions to desensitize them to the brutality of the police.[38] Protestors who had received this training in King's nonviolence knew to avoid the type of active resistance that Gadsden displayed. Gadsden's grip on Middleton, had white viewers noted it, would have undercut the attributes "saintly," "maltreated," and "passive" that they ascribed to the youth; these viewers likely failed to see the gripping hand because their attention was focused on other visual and textual cues: the Jockey Boy restaurant sign at the upper left, which conjures a white fantasy of docile black antebellum grooms; Gadsden's respectable dress, slumped shoulders, slack right arm, and downward gaze; and photographic captions that highlighted the "attacking" or "lunging" dog.

Another possibility is that the signs of Gadsden's self-defense were simply less legible to white audiences in the 1960s. The historian Christopher Strain recently documented the integral, albeit largely unacknowledged, role played by black self-defense in the American civil rights struggle from its onset. He traces the importance of self-defense before the rise of the Nation of Islam and the rhetoric of black power and also suggests that journalists, historians, and even some activists were blind to it because of their eagerness to categorize all acts of black protest as either "violent" or "nonviolent."[39] Americans at the time may simply have failed to register that Gadsden was acting in self-defense in the face of obvious aggression, for they had been conditioned to read black protest in either/or terms. Confronted with an ambiguous image, many viewers simply edited out the visual evidence that contradicted their preferred reading of black protest. *Jet*'s reporter seemed amused that a photograph of an untrained bystander caught actively defending himself produced "a perfect picture of non-violence in action: a tight-lipped, grimacing youth passively submitting to the vicious brutality of a Dixie policeman and his dog."[40]

While the white misreading of the Hudson photograph was one that inadvertently aided the civil rights cause, we know that protest leaders took advantage of the propensity of whites to project meanings onto the actions and motivations of blacks. Wyatt Walker, one of King's chief aides in Birmingham, noticed that the white press was unable to distinguish between curious black bystanders, unconnected to the movement, and trained protestors dedicated to the cause. To make up for the modest number of protestors willing to march at the start of the campaign in early April, Walker determined to send marchers out only when black crowds were present. As he recalled of the white press, "All they know is Negroes, and most of the

spectacular pictures printed in *Life* and in television clips had the commentary 'Negro demonstrators' when they weren't that at all."[41] Despite our tendency to assume that visual evidence was important in molding viewers' understandings of the photograph—and events in the street—white perceptions of Birmingham came into focus through a race-based lens that was only loosely tied to visual evidence.[42]

The photograph contained sufficient signs of black inactivity and white activity to allow whites to read a reassuring narrative of race. Once the photograph was pigeonholed, audiences had little interest in what it actually depicted. The story line was set. Although we can certainly learn something about the era from what the photograph's audiences failed to see, we can glean little social significance from close readings of the documentary details captured in a photographic frame. Historians have long known, for instance, that American photographers of the Civil War dragged corpses across battlefields and arranged them for effect, posing them with rifles and canteens to create more picturesque and morally resonant images for their Gilded Age audiences. Thus, the iconic photographs of the Civil War "lied" about the details of particular battles to communicate larger narratives about war and death that reflected the values prized at the time. Hudson's photograph of Gadsden was not staged, but its framing in the press and the ease with which it allowed viewers to reduce the complex social dynamics of the Birmingham campaign to a stark narrative of good versus evil ensured that it was as removed from the social complexities on the street as were the battlefield photographs of the previous century. As reporters of both the Civil War and the civil rights movement readily grasped, iconic photographs eschew the complexity of real-world social dynamics in favor of unambiguous messages that audiences can easily digest. Simplistic and resonant narratives of life and death, good and evil, peace and violence, inaction and action, North and South, and black and white are at the heart of all iconic scenes.[43]

Even if one acknowledges that whites consistently saw inactive blacks and active whites in civil rights photographs, the temptation exists to attribute this perception to the tactics embraced by the leaders of the civil rights struggle. Perhaps the evident passivity of black protestors should be seen as a consciously adopted tactic of the activists. After all, black protestors were famous for "passive resistance," which was introduced to the movement by James Farmer, James Lawson, Glenn Smiley, and Bayard Rustin and popularized by Martin Luther King Jr. But whites' investment in black passivity should not be confused with the historical realities of the struggle. Consider that passive resistance is not the same as inactivity, nor does it represent a lack of agency; depicting blacks as passive was routine long before the development of twentieth-century civil rights strategies; and white journalists (and later historians) presented black civil rights protestors as passive because that narrative most effectively engaged whites and met their psychological needs.[44]

In *Life*'s eulogy for Mahatma Gandhi after his assassination in 1948, the editors spoke admiringly of how Gandhi "took his own religious belief in nonviolence and from it fashioned the weapon of . . . organized pacifism." Rather than contrasting Asian inactivity with the activity of Europeans or imagining Indian independence as a by-product of the well-meaning British, the editors celebrated the tremendous power of nonviolent civil disobedience. So inspired were these editors with Gandhi's achievements that they asked readers to consider whether his "weapon" might "turn out to be the answer to the atomic bomb." Echoing such assessments, the eulogy in the *Los Angeles Times* deemed him a "meek" man who nonetheless "wielded tremendous power," and the remembrance in the *Washington Post* noted that he turned the simple act of fasting into a "potent weapon."[45] A *Life* article on American civil rights that appeared a week after the publication of the Birmingham photographs extended this military metaphor, noting that Gandhi "forged passive resistance into a weapon."[46]

That the editors of *Life* could cast Gandhi and his supporters as powerful actors and King and his black followers as hapless victims is intriguing, given the influence of Gandhi's philosophy on the civil rights movement. Civil rights organizers counted on the brutality of police chiefs and the hostility of governors to create newsworthy spectacles (much as Gandhi counted on the overwrought reactions of South African and colonial British officials), but the protests, and the political advances that came in their wake, were nonetheless the product of black action. Nonviolent activists need great self-control and power of will to weather verbal and physical abuse while sitting calmly at a lunch counter or standing stoically before a lunging police dog during an orderly protest in the street. A white reporter whose childhood training taught him to equate bravery with physical violence recalled how the activists changed his thinking after years of covering their protests: "[What] King and his followers and all of the SNCC and CORE kids do, that is, keep nonviolently moving forward in the face of threats and beatings, and even death . . . took a lot more courage than fighting."[47]

Black practitioners of nonviolent civil disobedience, to counter perceptions that their tactics were passive, linked the practice rhetorically to war. James Farmer, cofounder of the Committee of Racial Equality (CORE, later the Congress of Racial Equality) and a pioneering figure in the modern civil rights movement, called the struggle a "war without violence," explaining that civil disobedience was "not acquiescence, as most people at that time, when they heard of nonviolence, assumed it was."[48] King too, throughout his career, emphasized that nonviolent protest was active. Shunning the term *passive resistance,* which appeared frequently in white press coverage of civil rights, King referred to his approach as "nonviolent direct action."[49] To his followers, he explained, "Our weapons are protest and love," and "we are going to fight until we tear the heart out of Dixie." In another speech, he told his black audience, "We have a power, power that can't be found in Molotov cocktails, but we do have a power. Power that

26 Margaret Bourke-White, *Liberated Prisoners at Buchenwald, Germany,* April 4, 1945. Time & Life Pictures/Getty Images, New York.

cannot be found in bullets and in guns, but we have a power. It is a power as old as the insights of Jesus of Nazareth and as modern as the techniques of Mahatma Gandhi." Speaking of the protest marches in Birmingham, King noted to a *Newsweek* reporter, "Non-violence has become a military tactical approach." Surely appreciating the white penchant for downplaying the agency of blacks, advocates of direct action used metaphors of armed conflict to describe their nonviolent approach and so remove the taint of passivity from black resistance.[50]

While the example of Indian empowerment necessitated no shift in *Life*'s depiction—the magazine rarely covered the activities of Indians—the same cannot be said of the magazine's portrayals of Jews. Throughout the 1930s, and into the 1940s, particularly after the liberation of Nazi death camps in the waning months of World War II, the U.S. press routinely depicted Jews as victims whose bodies were acted on by others (figure 26). Toward the middle of the twentieth century, images of victimized, weak, emaciated, or dead Jewish bodies were widely disseminated in the media. Within a few years of the end of the war in Europe, however, such depictions were counterbalanced by photographs and articles celebrating the heroic exploits

27 David Rubinger, *Haganah Fighters in Action behind Barricade of Crumbled Old City Walls,* Jerusalem, British Mandate of Palestine, January 1, 1948. Time & Life Pictures/Getty Images, New York.

of rugged Jews battling numerically superior Arab forces in the Near East (figure 27). Just three years after the conclusion of the war in Europe, the editors of *Life* praised the Jews of Palestine for battling "powerfully" against encircling Arab armies. Other media accounts described Jewish fighters as "crack troops," "tough commandos." and "warriors."[51] While the mainstream press quickly transformed Jews from victims of violence to calculating actors in control of their own destiny, blacks' activism in the streets failed to gain them a corresponding shift in popular perception. Art and photographic historians may be more attuned today to the social damage done by images of blacks as violent aggressors, but the effects of iconic civil rights scenes were no less pronounced.

One could argue more easily that scenes of black passivity in the white media of the 1960s reflected the choices of blacks if these images did not hew so closely to nineteenth-century formulas. Exactly one hundred years before Moore and Hudson snapped their famous images, a white photographer produced a daguerreotype widely known as *The Scourged Back* (1863). It shows a black man, viewed from behind, with dramatic whipping scars crisscrossing his back.

28 McAllister & Brothers, *The Scourged Back,* 1863. Albumen silver carte de visite, 10 × 7 cm. Courtesy of the Library Company of Philadelphia, Pennsylvania.

The sitter was a freedman we know today only as Gordon, who escaped from the Mississippi plantation on which he was enslaved and met advancing Union troops at Baton Rouge in March 1862 during the U.S. Civil War. The original image, taken by the New Orleans photographic team of McPherson and Oliver, was turned into a popular abolitionist carte de visite by the Philadelphia firm of McAllister & Brothers (figure 28) and ultimately reproduced in a woodblock engraving for the Independence Day issue of *Harper's Weekly* in 1863 (figure 29).

Had the photograph been conceived as a portrait, photographers and abolitionists might have narrated any one of several powerful stories with it: Gordon's harrowing escape from slavery, his resourcefulness in rubbing onions against his body to throw off pursuing bloodhounds, his

29 *Harper's Weekly, Gordon under Medical Inspection,* woodblock print, July 4, 1863. Courtesy of the Library Company of Philadelphia, Pennsylvania.

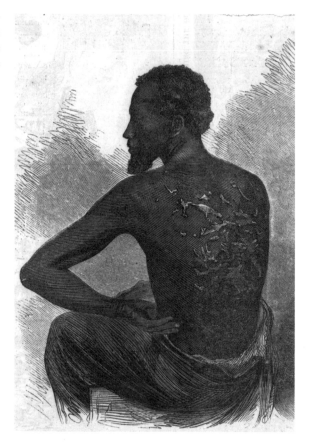

brave exploits as a scout for Union troops, or his determination to serve in the Union army.[52] But, contravening the conventions of portraiture, Gordon is stripped to the waist, appears without identifying background or props, and shows only his shaded profile to viewers. With Gordon's scars foregrounded and the abolitionist carte de visite titled *The Scourged Back* and the *Harper's Weekly* article on him called "A Typical Negro," viewers were encouraged to equate the sitter's identity with his victimization. The three versions of this powerful image worked in conjunction with President Lincoln's Gettysburg Address to shift views of the Civil War in the North from that of a conflict fought to preserve the Union to one that would ensure what the president famously called "a new birth of freedom."[53] *The Scourged Back,* a prototype of the photographs taken by northern periodicals in Birmingham, shows a black body damaged by brutal southern whites, in an effort to galvanize the sentiments of northern liberals.

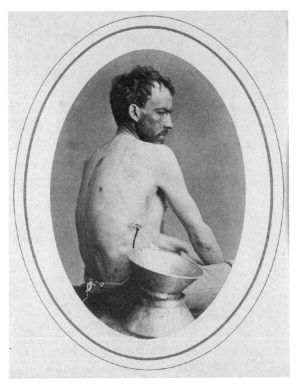

30 Reed B. Bontecou, *Israel Spotts,* c. 1865. Albumen silver print, 18.9 × 13.1 cm (29.8 × 24.3 cm with mount). The Metropolitan Museum of Art, New York, Gift of Stanley B. Burns, M.D., and The Burns Archive, 1992 (1992.5136). Image © The Metropolitan Museum of Art.

 The formula for depicting black civil rights protestors and former slaves was, on rare occasions, applied to whites. But viewers understood that whites displayed in settings and poses typically reserved for blacks transcended the violence they suffered. Two years after the production of the carte de visite of Gordon, the surgeon Reed B. Bontecou made an albumen silver print of Israel Spotts, a patient under his care (c. 1865; figure 30). The image shows a gravely wounded Civil War soldier striking the mirror image of Gordon's then-famous pose as pus drains into a bowl from his infected right lung. Despite the formal similarities of the photographs, Spotts has an identity beyond the details of his battle-scarred back or the medical procedures he endures. First, the photographic print is labeled with the sitter's full name, suggesting that Spotts had an existence beyond the photographic frame. Second, Bontecou gathered his medical photographs in a published volume that reported on his treatment of individual patients and their response to his care.[54] Whereas abolitionists circulated their carte de visite of Gordon with no contextual information, knowing that the prominent scars would convey all the information northerners needed, the surgeon's photographs and medical notes

gave the histories of named men who responded to treatment in personalized ways. Third, because white viewers were conditioned to read nonwhites as representative of their race, victimized black bodies said less about the individuals depicted than about the plight of all blacks. *The Scourged Back* necessarily spoke to whites about the black condition, whereas *Israel Spotts* described the experience of a single (white) man.

The dearth of identifying information accompanying the freedman's photograph and the plethora of details accompanying the image of the patient have a lot to do with the nature of abolitionist and medical photography, respectively. But we should not deem the different conventions governing these photographic genres to be a race-neutral explanation of the men's disparate depictions. In the third quarter of the nineteenth century, white middle-class men appeared topless almost exclusively in photographic genres that offered a socially respectable explanation for their state of undress and preserved their individuality. Black men, in contrast, had their inferior social position marked through depictions (be they abolitionist or anthropological) that ignored the men's individuality in the promotion of a "type." If one views these photographs in isolation, maintaining anonymity for the bodies in abolitionist photographs and naming the bodies in medical photographs appear to make perfect sense, but the selection of an appropriate photographic genre for the depiction of either blacks or whites was driven by racial considerations. Throughout the nineteenth century (and for much of the twentieth), blacks were overwhelmingly relegated to photographic genres in which their anonymity and their role as symbols "made sense."

From Civil War to civil rights, the visual codes in iconic images of blacks changed little. To judge by the photographs only, the depiction of blacks as victims has been a historical constant, without regard to the social conditions of the time and place. The transhistorical picture of black suffering owes much to the consistency of these codes, but it has been advanced by the photographic medium itself. In *On Photography* (1977), Susan Sontag points out that Western first-world nations generally shield their citizens from normal human suffering—privation, misery, pain, disease, and especially death. She contends that Westerners consequently are curious to experience vicariously what they secretly dread: "The feeling of being exempt from calamity stimulates interest in looking at painful . . . [photographs], and looking at them suggests and strengthens the feeling that one is exempt. Partly it is because one is 'here,' not 'there,' and partly it is the character of inevitability that all events acquire when they are transmuted into images. In the real world, something *is* happening and no one knows what is *going* to happen. In the image-world, it *has* happened, and it *will* forever happen in that way."[55] In light of Sontag's insights, one can see how the photographs of injured black bodies reinforced a racial divide between those who suffer and those who observe, naturalized a century of photographic depictions of victimized blacks, and so managed to "explain" such imagery without recourse to the economic, social, and political conditions of black life.

In the 1960s, the appeal of civil rights photographs to whites rested largely on their ability to focus white attention on acts of violence and away from historically rooted inequities in public accommodation, voting rights, housing policies, and labor practices. Because viewers imagined that the meaning of the photographs resided in the captured scenes, photographs of policemen loosing attack dogs or of firemen plying their hoses scripted the "problem" of race as violence. This narrative let whites who condemned or simply avoided racial violence off the hook. In isolation, photographs presented racism as an interpersonal problem—evil white officials and mobs inflicting injury on innocent blacks—thereby obscuring the structural inequalities that benefited whites in the South and the North. And in picturing "racists" as the most violent southern thugs, the photographs let northern whites imagine their own politics as progressive, or at least humane, and did not challenge them to examine their systems of belief. The absence of any meaningful social or historical context allowed whites to "feel" for blacks, untroubled by their own stake in a racially oppressive system. The images could then generate sympathetic reactions and incremental reforms for blacks without disturbing the underlying racial values that allowed social inequalities and even violence to continue.

Northern whites' need to decontextualize racial struggles to empathize with the plight of nonwhites is apparent in their reaction to civil rights protests in the North. A number of historians have documented how King was unable to duplicate the dramatic victories he had enjoyed in the South when he made his first forays into northern cities. In January 1966, two and a half years after Birmingham, King moved into an overpriced, dilapidated apartment in Chicago's west-side slums to publicize a new initiative to win housing and economic reforms for the city's black residents. Working with the Coordinating Council of Community Organizations, the SCLC organized a series of multiracial marches against the Chicago Real Estate Board, specific real estate agencies, and Mayor Richard J. Daley.[56]

In virtually every white neighborhood through which the protestors marched, they encountered large, angry crowds of residents wielding rocks and bottles and shouting obscenities (figure 31). Andrew Young echoed the amazement of other civil rights marchers that summer at the unexpected fierceness of the counterprotests in Chicago. To a reporter, he recalled a march through the south-side Chicago neighborhood of Marquette Park: "The violence in the South always came from a rabble element. But these were women and children and husbands and wives coming out of their homes [and] becoming a mob. . . . It was far more frightening." In discussing the same march, King recalled that he had "never seen as much hatred and hostility on the part of so many people."[57] While Chicago's white newspapers tended to interpret the violence of southern marches as an unacceptable consequence of white prejudice, they deemed similar disturbances in the North to be the result of black incitement.

Any comparison of white reactions to the Birmingham and Chicago protests must account for significant changes that took place in the racial context between 1963 and 1966. The rise

31 Benedict J. Fernandez, *Anti-Integration Protestors, Chicago Suburb,* Illinois, September 1966. © Benedict J. Fernandez. Courtesy of Almanac Gallery, Hoboken, New Jersey.

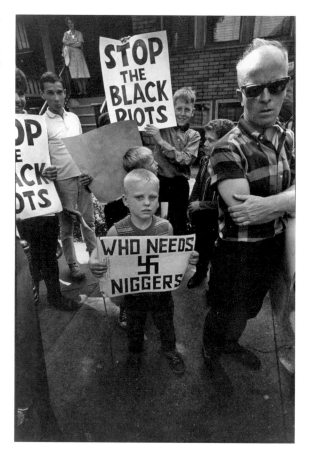

of the "black power" movement, the media's increasing attention to the Nation of Islam, the separatist and militant turn of the SNCC after Stokely Carmichael replaced John Lewis as chairman in 1966, and well-publicized racial disturbances in Rochester, Harlem, Bedford-Stuyvesant, and Philadelphia in 1964 and Watts in 1965 left many whites feeling more apprehensive about acts of black protest. But even the marked social change of these years cannot explain why northern liberal whites withdrew their support for King's agenda once he began protests in midwestern and northeastern cities. To note the antipathy of many northern working-class whites to civil rights reform is one thing, but to see the number of progressive whites who lauded and encouraged the northern campaign at the start turn against it once black demonstrators took to the streets is another.

The liberal Catholic archbishop of Chicago, John Cody, had a letter read at the Soldier

Field rally that kicked off the summer phase of King's Chicago campaign in July, pledging that "your struggles and your sufferings will be mine until the last vestige of discrimination and injustice is blotted out here in Chicago and throughout America." Just one month later, however, Cody was sufficiently concerned about the peaceful marches and violent counterprotests that "with a heavy heart," he declared that the civil rights marchers had a "serious moral obligation" to halt. Robert Johnson, a member of the International Executive Board of the United Auto Workers, who five months earlier had declared the UAW to be "in this thing all the way," also asked King to reverse course as the turmoil in Chicago grew.[58] When white-on-black violence came north, liberals felt more anger and fear than sympathy. As long as the protests took place at a physical and psychological remove, northern media outlets could select photographs of protesting blacks that reinforced a "safe" dynamic of black-white relations. Once protests moved north, this tactic proved impractical because northern whites were then exposed to unmediated scenes of black agency in the streets. In Chicago, the up-close experience of black activism effectively prevented the emergence of northern white solidarity with blacks.

To a remarkable degree, liberal whites in the North and the South responded similarly to black agency in their own regions. At the conclusion of Moore's photographic essay in *Life*, the editors printed interviews on race relations with a cross section of whites from Birmingham (see figure 12). Respondents with liberal and conservative views expressed conflicting prognoses for the South's racial tensions yet were virtually unanimous in their view that recent black actions had exacerbated the problems. Birmingham's Reverend Wallace Lovett expressed the sentiments of many of the region's more open-minded whites: "The solution to the problems we face here will not come out of demonstrations of massive force, but out of sensible negotiations." In April 1963, a month before *Life* published its interviews, eight of Birmingham's most liberal white clergymen criticized King directly for leading the protests in their city. In their "Public Statement of Eight Alabama Clergymen," which first appeared in the *Birmingham News,* the religious leaders claimed that protest actions that "incite . . . hatred and violence, however technically peaceful those actions may be, have not contributed to the resolution of our local problems." And they urged the "Negro community to withdraw support from these demonstrations. . . . When rights are consistently denied, a cause should be pressed in the courts and in negotiations among local leaders, not in the street."[59] As if reading from the same script, liberals in the North and the South criticized peaceful demonstrators for the outbreak of violence as they counseled blacks to pursue quiet talk rather than action.

The shared language of liberal whites in the North and the South is noteworthy but hardly astonishing. Present-day observers are likely to see the failure of so-called progressive whites to act on their professed beliefs as a normal if unfortunate response to the real-life complexities of their era. After all, it is easier to "know" intellectually which course of action is consistent

with one's beliefs when events are safely distanced by geography or time; when a conflict is at one's front door —and the stakes are more personal—emotion trumps belief. For many of us, knowing that liberal whites in the North espoused a rhetoric of equal opportunity mitigates our disappointment with their reaction to black activism. If most whites in the 1960s could not act on their beliefs, they deserve credit for valuing a rhetoric that anticipated a more just American society.

The impulse to distinguish between progressive and reactionary whites is deeply engrained in the narratives of the civil rights struggle. During the 1960s, conservative whites saw a political gulf between those who supported states' rights and regional customs and those who advocated federal intervention; progressive blacks found in such divisions reassuring proof that the conflict was not between blacks and whites but between those who believed in ideals of freedom and equality and those who did not; and, as I've suggested, both moderate and liberal whites took the rift as a marker of their moral distance from whites who advocated or accepted violence. Given the many groups eager to highlight ideological differences between whites, period observers and historians have exaggerated the divisions and given insufficient consideration to the social repercussions of the race-based values whites continued to share. Although whites in the 1960s certainly held a range of attitudes toward race, the emphasis on the ideological divisions separating whites has dramatically flattened interpretations of the era's visual culture. As an interpretive counterbalance, we need to consider how the beliefs shared by so-called progressive and reactionary whites helped define the significance of civil rights images, rather than articulate again how the photographs mark the divide between "good" and "bad" whites.

The manner in which liberal and conservative whites used photographs of violence against inactive black victims (and the violence itself) revealed a shared understanding of blackness in the North and the South. Sympathetic and hostile whites may have used such "violence" with the intent to liberate or repress blacks, but in each case, the desired social end relied on a sense of the immutable relation between black and white. We know from the photographic record and Moore's own accounts that he threw himself into the center of the conflict in Birmingham. In a photograph taken by a staff photographer for the *Birmingham News* (figure 32), we see the tumult of the streets and, in the center of the photograph toward the back of the scene, Charles Moore, aiming his camera while framed between a disheveled Gadsden, on the left, and a white policeman, on the right. Years after his work in Birmingham, Moore told an interviewer about his mind-set as he documented the confrontations: "I didn't want to stand back and shoot [the events] with a long lens. I didn't have much equipment at the time, no lens longer than a 105 mm, but even a 105 would have kept me out of the action. No, I wanted to shoot it with a 35 mm or a 28 mm lens, to be where I could feel it, so I could sense it all around me. . . . I wanted to get a feeling of what it was like to be involved." Moore's interest in getting

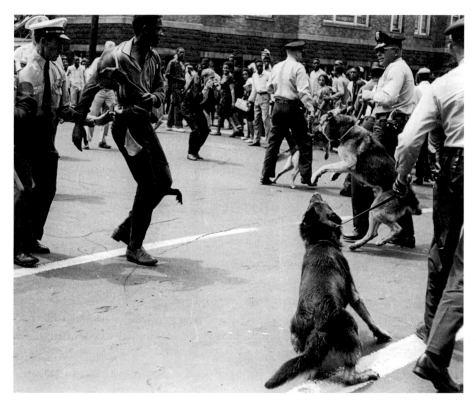

32 Ed Jones, *Demonstrator Attacked by Police Dogs,* Birmingham, Alabama, May 3, 1963. © *The Birmingham News,* Birmingham, Alabama. All rights reserved.

his camera into "the action" to capture close-ups for his national white audience dovetails with "Bull" Connor's expressed desire to bring white spectators into the fray to "see the dogs work," as he famously said. Driven by different agendas, the journalist and the commissioner sought to draw whites into scenes of brutalized, inactive blacks. The political distance between the two men should not obscure their shared desire to make a particular kind of black body visible for the edification of whites.[60]

Some readers will understandably feel ill at ease with my linking a progressive journalist to a reactionary politician. However, the point is not that whites in 1960s America had a common vision for society but that they built their distinctive visions on shared racial bedrock that few whites questioned. Taking society as they found it, photographers and editors of the northern white press used long-standing norms of racial identity to move their white audiences

in productive ways. Instead of complicating or disrupting whites' standard picture of blacks, or the civil rights struggle, the white press relied on these legible and comfortable formulations to make the case for reform. As a consequence, the limits of reform were embedded into the project's grammar because the changes encouraged by civil rights photographs could not alter the "passive" role for blacks that generated white sympathy in the first place. In an odd way, the iconic photographs accepted and perpetuated the same destructive dynamic of white power enacted in the streets by southern white mobs and law enforcement officials.

We often consider images of violence to serve one or another opposing function: they endorse ("this is what happens when people forget their place"), or they condemn ("this is what happens when people lose their humanity"). But in practice they serve both. America has a long and troubling history of lynchings in which mobs worked with the tacit approval, even support, of authorities to torture and kill a victim outside of the legal system. Up through the early decades of the twentieth century, gruesome photographs of lynching victims circulated freely in American society—even on postcards sent to friends and family through the U.S. mail—as racist endorsements of white power. But black antilynching crusaders, such as Ida B. Wells, displayed the same images to condemn white brutality.[61] The photographs were identical, so some of those who viewed lynching postcards or antilynching tracts surely had emotional responses opposite to those the presenters intended. It is difficult to see any photographs depicting the abuse of black Americans as wholly benign.[62]

Intellectual and practical dangers exist in the circulation of any violent imagery, but when the group depicted is disproportionately the victim of real-world violence, the stakes are even higher. Depictions of violence are not the same as the violence itself, and even violent scenes can catalyze productive change. However, when representations of black passivity and victimhood are the norm, images that adhere to this norm help maintain racial systems of domination. Without taking anything away from the liberal whites who empathized with the blacks depicted in scenes of violence, neither a sympathetic engagement with black protestors nor disgust with segregationist tactics exempts one from complicity in a nineteenth-century dynamic of black-white relations that has consistently limited the opportunities of blacks. Although scenes of violence against blacks made liberal whites uncomfortable, they also offered a socially acceptable way of illustrating racism. For white audiences, such images are perversely safe to look at, because they create distance between the perpetrators of violence and those who witness it. White discomfort with such scenes in the 1960s was a visceral reaction to the violence performed by "bad" white actors on "innocent" black victims. If the photographs had illustrated the discriminatory practices that oppressed blacks across the United States, and that were tacitly supported by millions of whites in the North, public discomfort with the photographs would have had a more threatening, personal root.

Moore's progressive credentials are not in doubt. He not only documented many key events

of the civil rights struggle but spent many years lecturing to student groups on the lessons of the 1960s. In a recent interview, he noted, "Some people's attitudes will never change, but I hope and believe that the civil rights movement has helped a younger generation understand the need for equality and justice for all peoples."[63] The photographer and his editors at *Life* were well-intentioned liberals who worked hard to effect change with the visual and rhetorical tools they had readily at hand. They sought to prod American society into prompt and meaningful change.

Notwithstanding the good intentions of journalists and the positive outcomes of publishing the iconic photographs of Birmingham, more empowered models of black identity were available in 1963. Leigh Raiford, a scholar of American studies, has called attention to photographs and posters created by SNCC that contained alternative discourses for picturing the agency of blacks in the early 1960s. She notes how infrequently SNCC's civil rights posters used violent imagery, instead highlighting blacks as the engine of civil rights reform. A 1963 SNCC poster created from a Danny Lyon photograph of participants at the March on Washington bears little affinity to scenes of activists hit by water jets and menaced by dogs (figure 33). As is evident in the original Lyon photograph (figure 34), the man with his right arm extended snaps his fingers. In the poster, however, that gesture, seen against the sky and obscured by the large *N* of "NOW," has encouraged viewers to mistake his raised hand for a fist.[64] The poster illustrates an alternative model for depicting civil rights protests, in which racist whites are banished and blacks are forceful actors. In Raiford's words, the poster illustrates "that freedom is not to be found in heavenly hereafter but grasped [by blacks] this instant." Her study reminds us of the influence of SNCC's imagery in advancing the civil rights agenda and suggests both the availability of such alternative imagery to white editors and reporters and the barriers to its wide dissemination.[65]

If the white photographers of civil rights had produced images foregrounding the agency of black protestors, popular white periodicals would probably not have published them. Had the white media published images that directly communicated the active role of blacks in tearing down segregation, they would probably not have generated sympathy for blacks among many northern whites, nor would they have aided the passage of civil rights legislation. Had such progressive images appeared in popular venues with appropriate captions, they would surely have proved counterproductive in the short term—unnerving northern whites, leading them to feel greater sympathy for southern whites, and possibly smoothing the way for Alabama's Governor George C. Wallace to deploy National Guard troops to crush Birmingham's civil rights protests. While whites could have made and published photographs representing the "activeness" of blacks in the struggle, such images would not have worked as quickly to improve the day-to-day lives of blacks. Although King was quick to chastise liberal whites when they failed to commend "the Negro sit-inners and demonstrators of Birmingham for their sublime courage, their willingness to suffer and their amazing discipline in the midst of

33 Student Nonviolent Coordinating Committee, *Now*, 1963. Offset print on paper, 55.9 × 35.6 cm. Tamiment Library, New York University, New York.

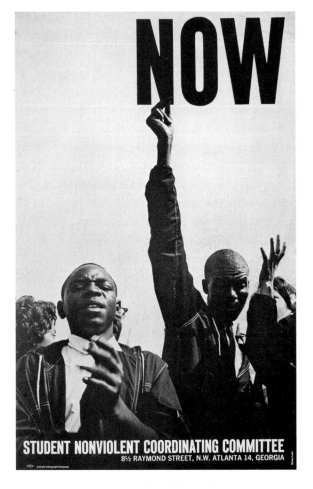

the most inhuman provocation," he also needed and appreciated the images Moore and Hudson created. In the climate of 1963, few could imagine circulating photographs in the white press that would both articulate the power of direct action *and* generate the sympathy among liberal whites that the movement desperately sought. Understanding that black frustration with segregation was high and support for nonviolent direct action limited, King repeatedly explained to white audiences that reform could not wait.[66]

Yet I have no doubt that images forcefully depicting black agency in the mainstream press could have chipped away at the long-standing orthodoxy that confined people of color to marginal roles in the American drama and ensured that their voices went unheard when they

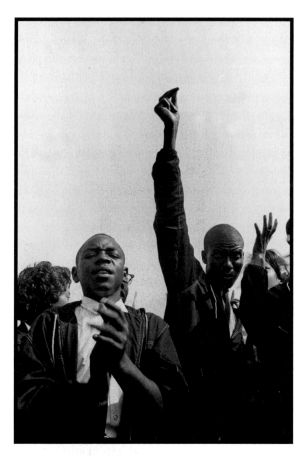

34 Danny Lyon, *Members of the Student Nonviolent Coordinating Committee (SNCC) Sing Freedom Songs during the March on Washington,* August 28, 1963. Courtesy of Danny Lyon and Magnum Photos, New York.

sought to reject their assigned parts. As we have seen, photographs in the white mainstream press observed this orthodoxy—counting on its existence to generate white goodwill and, ultimately, unthreatening reforms. Images of empowered blacks in *Life, Time, Newsweek, Look,* and the *Saturday Evening Post* would have paid off only in the long term. They would not have spurred immediate legislative action but could have helped eliminate the ideological foundations that made both prejudiced beliefs and unjust laws appear natural and right. In other words, such imagery might have attacked the source of racial inequality rather than right superficial wrongs that were merely symptoms of the disease.

We cannot easily imagine how history could have turned out differently, never mind accept the notion that media depictions of black agency could have supported far-reaching reform.

But history suggests that the major social and legislative reforms of the early 1960s—including the Civil Rights Act of 1964 and the Voting Rights Act of 1965—were not the greatest changes possible amid the social and political realities of 1960s America. In his monumental study of municipal politics and civil rights, *Dividing Lines* (2002), the historian J. Mills Thornton III notes that period observers and historians have consistently simplified the complexities of the civil rights struggle. For many years, reductive assumptions prevailed: that southern whites were unified in their support of white supremacy and segregation, that black fervor for civil rights was identical to support for integration, and that elimination of segregation meant the eradication of racial injustice. In an effort to restore the local character and historically uneven development of the civil rights movement, Thornton's *Dividing Lines* takes aim at the enduring belief that the civil rights struggle was a coherent southern protest movement propelled by national leadership. Building on the insight of the historian C. Vann Woodward that local politics played an important role in creating segregation in the 1890s, Thornton shows that political maneuvering in Montgomery, Birmingham, and Selma provided the tools for destroying segregation in the 1960s. Rather than interpreting the movement as a wave of activism beginning in Montgomery, picking up speed in Birmingham, and growing into a tsunami in Selma, Thornton makes a plausible case for each campaign's eruption from local conditions. Although blacks in Birmingham certainly paid keen attention to events in Montgomery, Thornton reminds us that so did blacks in the North and in cities across the South in which no comparable civil rights campaigns emerged.[67]

In digging deeply into the unique conditions in each of his selected cities, Thornton reveals that local reforms were both limited and enabled by the political conditions of their communities. He unearths a wealth of evidence that changing political conditions made once-"unrealistic" reforms possible. Assumptions about what was and was not possible "were in fact subject to evolution; as changes came to the community, the frontiers of what appeared achievable in the future were gradually moved."[68] Blacks were much more likely to bury their internal political differences and unite against the white power structure when they perceived a realistic possibility of change; and the resulting unity and willingness to set their sights on a common goal made the attainment of reform more likely. In a kind of feedback loop, perceptions of change opened the door to the ever-expanding possibilities of real-world change. Given the tendency of Americans in the 1960s to interpret the discrete protest actions in southern cities as a coordinated movement, initially modest efforts to alter the patterns of segregated seating on Montgomery buses or desegregate the lunch counters at a handful of downtown Birmingham department stores played an outsized role in shifting national horizons of political possibility. Once we appreciate that the opportunities for reform were always uneven—that the changes in Birmingham, for example, were impossible in Mobile, or even in Birmingham, before black

(and white) residents imagined otherwise—we cannot speak authoritatively of "the limits of reform in 1960s America." As the next chapters build their case for the role that photographs played and *might have played* in the 1960s, I ask readers to bear in mind the uneven and malleable border of what was achievable and to entertain the possibility of alternative histories of civil rights.

2 WHITE SHAME, WHITE EMPATHY

It will take more than an appeal to the American conscience . . . to solve "the Negro problem," though such an appeal is long overdue. Nothing less than a radical reconstruction of American society is required if the Negro is to be able to take his rightful place in American life. And the reconstruction must begin not just in Oxford, Mississippi, or Birmingham, Alabama, but in New York, Philadelphia, Chicago, and other great cities of the North as well.

CHARLES E. SILBERMAN, *CRISIS IN BLACK AND WHITE* (1964)

On Saturday, May 4, 1963, the day Hudson's dramatic photograph of fifteen-year-old Walter Gadsden appeared in papers across the country, President Kennedy held a previously scheduled meeting with the liberal lobby group Americans for Democratic Action (ADA). The clash in Birmingham dominated the meeting. It placed the president on the defensive as he endeavored to defend his record on civil rights and explain the constitutional limitations on his authority to intervene in Birmingham. Widely circulated reports of the meeting in the press, and in Arthur Schlesinger's best-selling account of the Kennedy presidency, *A Thousand Days* (1965), recount the president's heartfelt reaction to Hudson's photograph. Newspaper articles describe Kennedy as "dismayed" and "horrified" by the photograph, while Schlesinger's memoir reports that the image made the president "sick." Kennedy's emotional response is cited in virtually every scholarly account of the Birmingham conflict.[1]

Not until 2006, when the historian and journalist Nick Bryant accessed tape recordings of Kennedy's White House meetings, did a more complex picture emerge. From Bryant's work, we now know that Hudson's photograph was a major topic at the meeting with the ADA but that Kennedy's concern was with its political effects, not its personal toll. Kennedy never claimed that the photograph made him "sick." Instead, he speculated about its social and political role in aiding communist expansion abroad and segregationist politics at home. Commenting on the propaganda value of the photograph to the Soviet Union, Kennedy asserted, "What a disaster that picture is. That picture is not only in America but all around the world."

Later in the meeting, he returned to the damage inflicted by the photograph: "I think it's a terrible picture in the paper. The fact of the matter: that's just what Connor wants."[2]

Bryant's research returns complexity to Kennedy's reaction in the first hours after the photograph appeared. The president's early assessment that the picture was a better aid to Connor than to King shows clearly that violent scenes were often a double-edged sword; for Kennedy, the photograph was not an obvious catalyst of progressive change. Even more interesting is the distance between the president's reaction and its characterization in the press. None of the twenty members of the ADA delegation publicly countered press accounts of Kennedy's emotional reaction, nor did anyone in the administration seek to set the record straight. Meeting participants probably thought that "dismayed," "horrified," and "sick" were appropriate—even politically useful—responses. ADA members and White House staffers likely let the press reports stand because in the early 1960s, Americans readily assumed that feeling for the victims of injustice was a meaningful sign of solidarity and a stepping-stone to social change. For the president, who then felt unable to introduce civil rights legislation, send in troops to aid black protestors, or even voice public support for King in the Birmingham campaign, reports of his emotional distress stood in for a lack of concrete action. While public expression of Kennedy's belief that the photograph advanced the segregationist cause would only have alienated the president's black supporters, widespread reports of his feeling for Birmingham's activists signaled concern for blacks without obliging him to embrace policy changes sure to alienate white voters in the South.

Kennedy's apocryphal "sick" feeling is a constructive entry point for analyzing the reactions of whites to the photographs of Birmingham. As with the president, the emotions claimed publicly by white reporters, politicians, intellectuals, and ordinary citizens invariably masked more ambivalent responses to the scenes of fire hoses and attack dogs. In this chapter, taking my cue from Kennedy's complex reaction to Hudson's photograph, I examine the range of emotions that pictures of Birmingham catalyzed in northern whites, and I seek to disentangle the white expression of feeling for blacks from whites' underlying concerns and to clarify the degree to which emotion built empathy for nonwhites and ultimately drove racial reforms.

Publication of the Birmingham photographs prompted many northern whites to trumpet how the images made them feel. In a letter to the editor of *Time,* for example, a reader from Binghamton, New York, contrasted his response to the magazine's illustrated articles on Birmingham with his reaction to a profile of the black writer James Baldwin. He complimented *Time* for offering "a forceful, factual account of the Birmingham brutality—appealing to the readers' hearts. You followed this with a philosophical article on James Baldwin—appealing to the readers' minds."[3] While the essays on Birmingham and Baldwin each strove to offer accurate pictures of the desperate conditions experienced by American blacks, the letter writer

understood the effect of the former to be primarily emotional. In turn, in a letter to the *Chicago Daily Defender,* a black clergyman from Chicago analyzed the emotional tug of the nonviolent demonstrations in Birmingham on whites: "The Negro has discovered a weapon that renders [traditional] weapons impotent while at the same time working on the heart and conscience of both the hearty and the heartless."[4]

Reporters and editorial boards were similarly fixated on the power of news reports and imagery to arouse passions. On May 5, the editors of the *New York Times* penned a blistering condemnation of the events in Birmingham. The editorial, "Outrage in Alabama," opened, "No American schooled in respect for human dignity can read without shame of the barbarities committed by Alabama police authorities against Negro and white demonstrators for civil rights. The use of police dogs and high-pressure fire hoses to subdue schoolchildren in Birmingham is a national disgrace."[5] The *Washington Post*'s editorial that day was equally vigorous: "Men of goodwill and human compassion everywhere must mourn at this anguishing and squalid disorder in the family of man. And they must mourn in equal measure for the maltreated Negro youth." The *Philadelphia Inquirer* asserted in an editorial headline, "Alabama Shames the Nation."[6]

In the days following the publication of the photographs, senators and representatives took to the floor of Congress to denounce the violence in affecting terms. Senator Wayne Morse, a Democrat from Oregon, claimed, "[The] conflict between peaceful Negro demonstrators and police in the cities of America brings to mind nothing so much as the assaults of the Nazi party storm troopers against the Jews." It offered "a shameful commentary on American democracy."[7] Republican senator John Sherman Cooper of Kentucky reacted with equal force: "The unhappy events of the last few days in Birmingham should shake the conscience and sense of justice of the American people." Republican senator Jacob K. Javits of New York stated that the "conscience of America must be deeply troubled" and announced, "We're ashamed of these actions." Augustus Hawkins, a Louisiana-born state representative from California, lamented, "This evening's newspaper will add additional stories; more of us will become emotional, some sadder, and a few will calmly question their civil responsibilities and moral duties."[8]

Some of the most forceful and pained reactions to the Birmingham violence came from white liberal intellectuals in the North. Kennedy's advisor and speechwriter Arthur Schlesinger Jr. singled out Hudson's "shocking photograph" and claimed, "Birmingham abruptly transformed the mood of the nation. Churchmen, whose piety had studiously overlooked what John Quincy Adams had called the foul stain on the American conscience, idealistic students, recently preoccupied with disarming the United States and leaving the Soviet Union the great nuclear power in the world, ordinary citizens, complacent in their assumptions of virtue, were for a season jerked into guilt and responsibility. Bull Connor's police dogs accused the con-

science of white America in terms which could no longer be ignored."[9] The journalist and *Forbes* editor Charles Silberman wrote, "For a brief period following the demonstrations in Birmingham in the spring of 1963 . . . it appeared that the American conscience had been touched; a wave of sympathy for the Negro and of revulsion over white brutality seemed to course through the nation."[10] The liberal presiding bishop of the Episcopal Church, Arthur Lichtenberger, warned his congregants in the wake of the Birmingham protests that constitutionally protected rights "are not rights to be litigated or negotiated. It is our shame that demonstrations must be carried out to win them."[11]

This small sampling—drawn from the scores of recorded reactions of members of the public, newspaper editorial boards, elected officials, and intellectuals—is representative of the outpouring of emotion that reports of the Birmingham violence elicited from moderate and liberal whites in the North. Given the diversity of the groups that spoke out on the issue, the consistent appearance of a few key themes is striking. Most of the writers note the emotional toll imposed by the events in Birmingham (almost always mediated through the photographs) and point to either the hope of future change or evidence of its start. In the estimation of white observers, the events of Birmingham were "appealing to the reader's hearts," making whites "question their civil responsibilities and moral duties," and "jerked" whites into "guilt and responsibility." In describing the emotional tug of the photographs, commentators consistently credited the photographs with producing a troubled "conscience" and "shame." We are told that the images awakened the consciences of liberal whites, forcing them to make moral judgments about the justness of the scenes, with shame being the most common emotional result.

Shame, as clinical psychologists explain, is a response to negative social stimuli and affects both individuals and groups. It results from a devaluation of the self when positive feelings of identity diminish in the face of external judgments. People feel shame when they believe that others hold negative views of them, when such views stem from behaviors or personal attributes that are parts of their identity but that they do not value. Shame is simply a reaction to being judged ill by others for actions or characteristics that one deems undesirable.[12] But the expression of white liberal shame in the North took place in a unique social environment that allowed it to flourish in the aftermath of Birmingham. To experience shame, whites needed to believe that the photographs exposed a personal or group failing, but they also had to be without psychological defenses that would allow them to hold emotion at bay. Northern shame owed much to whites' physical remove from blacks.

Whites in the North had the luxury of holding more progressive attitudes on race than did whites in the South, because they were born into a society that erected fewer visible barriers to nonwhite advancement and because they had few opportunities to observe the material conditions of black life. The rigid segregation of northern cities in the early 1960s was enforced

primarily through economic inequality. It allowed whites to espouse more racially tolerant values without confronting the distance between their professed beliefs and the lived reality of black life. Once the inequity was made undeniable, however, whites had to consider the distance between their beliefs and the treatment of blacks and what it revealed about them, their nation, and their race. The obvious disjuncture produced shame. White liberals in the North were not the only ones with feelings for blacks, but white southerners had always lived in closer proximity to blacks and in a more obviously stratified society, which encouraged them to erect "protective" social and mental structures that partially insulated them from feeling. As the white southern novelist Carson McCullers wrote, southerners' complicity in racial inequality was "not fully knowable, or communicable [because] southerners . . . lived so long in an artificial social system that we insisted was natural and right and just."[13] King's relative success in stirring the emotions of whites in the North did not stem from their greater thirst for racial equality alone or from a corresponding willingness to dismantle white privilege. Rather, northern whites' intellectual investment in more progressive racial beliefs combined with their relative lack of defensive psychological structures to leave them more vulnerable to seeing racial inequalities in the photographs.

But what can we learn from the fact that white senators from New York and Oregon, along with white editorial boards from New York and Washington, D.C., experienced shame about the actions of racist southern police? How were whites diminished and their failings exposed by the photographic scenes? One explanation is that their shame grew as the photographs diminished their positive feelings of national identity. In this reading, the violent acts of whites in the South did not so much reveal the personal failings of liberals in the North as draw attention to the distance between American political ideals and the reality of life for blacks. Shame grew out of the knowledge that Americans would be judged abroad for having failed, as the president of the AFL-CIO, George Meany, suggested, to deliver to Birmingham's blacks on the national promise of "true equality of citizenship and true equality of opportunity."[14] That northern whites were troubled by such judgments is borne out by their expressions of concern about the international reaction. Politicians were convinced that the pictures of Birmingham would, in the words of U.S. Secretary of State Dean Rusk, "embarrass our friends abroad and make our enemies joyful." As the *New York Times* advised its readers, "On the international scene these outrages will be immeasurably costly to the United States. In all the emerging countries, our pretensions to stand for democracy and individual worth are undermined by what is happening in Alabama." Five days later, a *New York Times* editorial noted, "What was purely a domestic American issue has become a phase in a worldwide struggle [with] cold war implications."[15] To the chagrin of those invested in American ideals of democracy and equality, foreign outrage at the violence in Birmingham drew attention to flaws in

the American system. Forced to confront how their nation failed to live up to its values, many whites were shamed.

Northern white shame was likely generated also by awareness of more personal failings. After all, the violence exposed white northern complicity in the crime of segregation and in the economic and physical force needed for its maintenance. Norman Podhoretz, best known today as a neoconservative writer and critic, wrote a perceptive 1963 article on American race relations from the perspective of a self-described white liberal. "My Negro Problem—and Ours," an essay that unsettled readers across the political spectrum in the 1960s, contrasts his youthful belief in his economic and social powerlessness with his understanding in his adult-hood of the racial advantages enjoyed by even the most economically impoverished whites: "I know now, as I did not know when I was a child, that power is on my side, that the police are working for me and not for [blacks]. And knowing this I feel ashamed and guilty, like the good liberal that I have grown up to be." He continues, "This, then, is where I am; it is not exactly where I think all other white liberals are, but it cannot be so very far away either."[16] Certainly some whites in the North looked at the images produced by Moore and Hudson and felt shame that their nation had failed to act on its values. The photographs forced countless whites to grapple with how their reticence to promote civil rights had relegated blacks in the South to violent and segregated lives. But an equally plausible view is that many liberal intellectuals who were gripped by shame shared Podhoretz's sentiments and knew that the police officers in Birmingham—and across the United States—wielded their authority on behalf of all whites, to serve and protect their social and economic power.

Whether white viewers of the photographs felt shame at the exposure of national failings or personal ones, the response was predicated on their identification as white. In other words, their emotional responses stemmed from their tacit identification with brutal white policemen, racist politicians, and complacent southern whites. Given the vehemence with which liberal whites rejected the actions of "racist" southerners, this idea may sound contradictory, though an investment in racial whiteness had everything to do with the generation of white emotion. Whereas whites see evidence of violent ethnic or racial conflicts taking place halfway around the world as "a shame," such conflicts are unlikely to "shame" them.

A *Los Angeles Times* reader wrote to the editors in May 1963 to explain the very different emotions generated by reports of violence in other parts of the world and by coverage of the Birmingham struggle: "Over the years I have seen pictures and read accounts in *The Times* of atrocities committed in other countries and have had feelings of horror, disgust and pity. But mixed with these emotions there has always been a feeling of pride. In spite of Little Rock, Oxford and other incidents I have always felt secure that [the United States] is a nation of laws and not of beasts and that the rule of law would prevail. But after seeing the pictures on the

front page of *The Times* and reading the account of the incidents in Birmingham two other emotions have been added, shame and fear. Shame that in the greatest country in the world people who have sworn to uphold the law are acting like wild beasts."[17] If one does not identify with the perpetrators—or at least with their race—shame is unlikely to animate one's reaction, regardless of how much emotion an event generates. Unsurprisingly, then, I have found no references to shame in either the Canadian or the British press coverage of Birmingham. For whites tenuously linked to the perpetrators of violence, shame was not in play. And although the temptation exists to see this difference as proof that white Americans felt shame primarily as members of a nation, rather than as members of the white race, the black reaction to Birmingham precludes such an interpretation.

Events in Birmingham may have filled blacks with fear and pride but not with shame. Blacks' responses show that they interpreted events as a racial tragedy, not a national one. The editors of the conservative black periodical *Birmingham World* were often-severe critics of King and the SCLC, but when they looked at the photographs of attack dogs, they saw "the picture of [the white] race which this gives to the world."[18] Even white observers noted that the emotional tug of the photographs was racially specific. President Kennedy's assistant attorney general and chief of the Civil Rights Division, Burke Marshall, recalled, "The pictures of the police dogs and fire hoses going throughout the country stirred the feelings of every Negro . . . [and] most whites."[19] If whites expressed a range of reactions to the Birmingham violence, blacks did not. The events were of sufficient symbolic power for blacks across the country that their political differences melted away in the face of photographic evidence of state-sanctioned violence. As the editors of *Ebony,* who famously shied away from political commentary in their magazine, wrote in the fall of 1963, "It remained for Birmingham, Alabama, its police commissioner Bull Connor, the use of police dogs, the arrest of children, the brutal employment of high-pressure fire hoses, and statements callous and coarse, to provide the catalyst, the quickening of will, the resolution to act from the grass roots of the Delta's rich soil and the ghettos of cities and towns, large and small."[20] Linking the current mood of black America directly to Birmingham, Bayard Rustin wrote in 1963, "The Negro masses are no longer prepared to wait for anybody; not for elections, not to count votes, not to wait on the Kennedys or for legislation, nor, in fact, for the Negro leaders themselves. They are going to move. Nothing can stop them from moving."[21] And referring to Hudson's photograph of Gadsden, one period author and activist wrote, "If there was any single event or moment at which the 1960s generation of 'new Negroes' can be said to have turned into a major social force, the appearance of that photograph was it."[22]

Within Birmingham's black community, political dissent virtually dissolved in the aftermath of Connor's violence. The reaction of A. G. Gaston, the wealthiest black businessman in

Birmingham in the 1960s, to the use of dogs and fire hoses is emblematic of the change of heart that swept over Birmingham's more conservative blacks and swelled attendance at King's church rallies in the early days of May. Gaston was cautious by nature, generally deferential to the white power structure, and suspicious of the SCLC and King. An often-recounted anecdote describes his telephone call with David Vann, a white Birmingham lawyer, on the morning of May 3. In the midst of expressing his desire for the SCLC to halt the protests, leave town, and allow emotions to cool, Gaston watched from his office window as a young black girl tumbled down the street under the force of a fireman's hose. Ending the call abruptly, Gaston exclaimed to Vann, "I can't talk to you now or ever. My people are out there fighting for their lives and my freedom. I have to go help them."[23] Gaston's reaction to the scene was distinct from those of whites with comparable wealth and political influence. He felt anger at white Americans and solidarity with his "people," despite his firm disagreement with the tactics of the SCLC. While the events of Birmingham made preexisting white political cleavages more visible, and may have prodded some apathetic whites into more sympathetic positions, little evidence exists that the scenes of water hoses and dogs caused significant numbers of whites to undergo a political about-face like Gaston's. His reaction makes sense only in light of his identification as black.

The historian Adam Fairclough explains the historical context that ensured that the use of police dogs in Birmingham would trigger in blacks both strong emotions and a unified response. While sympathetic whites saw merely brutality, blacks saw historical reminders of life under slavery and the brutal post-Reconstruction era. For centuries, whites used dogs to control and punish American blacks.[24] In nineteenth-century visual culture (including antislavery woodcuts, lithographs, and almanacs) and in print culture (including biographies, political speeches, and fiction), there are few vignettes more chilling than the use of tracking dogs to hunt down escaped slaves and return them to a life of servitude. Such dogs famously appear in Harriet Beecher Stowe's *Uncle Tom's Cabin* (1852), the New York Anti-Slavery Society's *Legion of Liberty!* (1857; figure 35), Frederick Douglass's *Life and Times of Frederick Douglass* (1881), Mark Twain's *Adventures of Huckleberry Finn* (1884), Charles W. Chesnutt's *The Conjure Woman* (1899), and in countless slave narratives and interviews with freedmen and freedwomen. Frederick Douglass, in his famous Independence Day speech in Rochester, New York, in 1852, conjured for his audience the essence of American slavery with a handful of searing visual images—of burnt and flayed flesh, manacled limbs, sundered families, and human beings hunted by dogs. The sight of attack dogs in the streets during the modern civil rights struggle only heightened such associations. Responding to the use of police dogs on peaceful civil rights protestors in Jackson, Mississippi, in the spring of 1961, Roy Wilkins, executive secretary of the National Association for the Advancement of Colored People, telegraphed the governor of the state to demand that he "call off the dogs, [since] slavery is over."[25]

Letting the oppressed go free.

35 Unknown artist, "Letting the Oppressed Go Free," April 1857. Wood engraving from *The Legion of Liberty,* courtesy of the American Antiquarian Society, Worcester, Massachusetts.

 Elizabeth Alexander, the literary scholar and poet, argues that the legacy of slavery and race-based violence in the United States has left different marks on black and white audiences. She argues that blacks have an intuitive response to violated bodies. While white males are the primary producers of scenes of white-on-black violence, "black people also have been looking, forging a traumatized collective historical memory which is reinvoked at contemporary sites of conflict."[26] Although the images of attack dogs in Birmingham may have filled whites with anger, disgust, embarrassment, and shame, whites lacked the communal memories needed to experience the terror and pain that gripped virtually all black viewers. No one better described the immediacy of the Birmingham photographs for blacks than Jesse Jackson, the twenty-one-year-old student body president of North Carolina Agricultural and Technical College in Greensboro. Explaining why events in Alabama sparked protests across North Carolina in 1963, Jackson declared, "When a police dog bites us in Birmingham, people of color bleed all over America."[27]

 White American viewers of the photographs did not "bleed" for the Birmingham protestors, notwithstanding the claims of many progressive whites. After Hudson's photograph of Gadsden appeared on the front page of the *Washington Post,* the Maryland resident Ruth Hemphill wrote to the editors to credit the image with awakening "a feeling of shame in all

who have seen that picture, who have any notion of human dignity." A few sentences down, Hemphill asserted that if the man in the photograph "can have a beast deliberately urged to lunge at him, then so can any man, woman or child in the United States. I don't wish to have beasts deliberately urged to lunge at me or my children and therefore I don't wish to have beasts lunging at the citizens of Birmingham or any other place." Hemphill's letter is unusual for its refusal to describe the dog attacks in racial terms. By leaving out all racial descriptors, she attempts to empathetically project Gadsden's fate onto "any man, woman or child" in America.[28] While the letter is admirable for its effort to take universal lessons from the depiction of a black victim, I doubt that it offered an effective rhetorical strategy for prodding Americans into questioning the depicted violence. First, few whites or blacks in 1960s America would have deemed plausible the threat of police dogs unleashed on white children. The editors of the black newspaper the *Pittsburgh Courier* noted that even against Klansmen, "dogs would never be turned." And they remarked on the general understanding that attack dogs "are reserved for the lowest and weakest minorities."[29] Second, the vast majority of Americans did not then have the capacity to read a black man or woman as a stand-in for an (unraced) citizen. The disgust and shame that many moderate and liberal whites felt over the events in Birmingham were rooted in their knowledge that the treatment of nonwhite protestors had everything to do with the activists' race.

The federal government, in its calculated use of documentary photography during the twentieth century, counted on this inability of whites to read nonwhite bodies as universal signs. Between 1933 and 1945, the Farm Security Administration (FSA) oversaw an extensive effort to document and publicize the economic and social distress caused by the Great Depression. The initiative was part of wide-ranging government efforts to promote sympathy for the poor among middle-class Americans and, consequently, to gain support for the taxation and spending required to establish the modern social safety net. But as the photographic historian Nicholas Natanson has noted, Roy Stryker, head of the Information Division at the FSA, worked to minimize the percentage of photographs that depicted poor black citizens. Stryker knew that circulating images of blacks could imperil the agency's goal of fostering whites' support for government programs, given the inability of most whites to read black poverty as a sign of national distress (figure 36). Writing in 1937 to Dorothea Lange, one of his best-known photographers, Stryker advised her to take photographs of both "black and white [tenant farmers], but place the emphasis on the white tenants, since we know that these will receive wider use."[30]

During the next decade, the federal government published a host of photographs of Japanese American citizens and residents who had been deported from their homes and imprisoned in isolated camps across the western United States without charges or trials during World War II.

36 Dorothea Lange, *Destitute Peapickers in California: A 32-Year-Old Mother of Seven Children (Migrant Mother),* February 1936. Library of Congress, Washington, D.C., Prints and Photographs Division, FSA/OWI Collection.

Created to illustrate the federal government's humane treatment of these "prisoners" (figure 37), the photographs circulated without concern about raising fear among whites that their habeas corpus rights would be stripped. While a small minority of whites objected to the special treatment of U.S. citizens who were of Japanese descent, virtually no whites expressed fear that the treatment of Japanese Americans portended similar treatment of whites. In the white imagination, lessons of universal suffering (read from white bodies) were not to be confused with racialized narratives of suffering (read from the bodies of nonwhites).[31]

Whites saw the white-on-black violence in civil rights photographs as an unfortunate reaction to biological difference. American audiences knew that black civil rights activists were physically abused for the color of their skin and that white protestors who marched in support of black rights were beaten for their ideological beliefs and actions. A reporter in Birmingham observed that firemen's "hoses were directed at everyone with a black skin, demonstrators and non-demonstrators" alike, and we should remember that Gadsden was attacked despite being uninvolved in the protest and apathetic toward its aims. At the same time, the police consis-

37 Dorothea Lange, *Just About to Step into the Bus for the Assembly Center,* San Francisco, California, April 6, 1942. United States National Archives, College Park, Maryland.

tently permitted whites of all political persuasions to observe the daily protests unmolested.[32] Blacks were subject to violent treatment regardless of their individual beliefs, merely because of their presence; whites were protected from violence until they signaled to police their sympathy with the civil rights struggle. Because whites knew that blacks were targeted on the basis of race, they read violated black bodies as a reflection of black life. Since the organizing narrative that whites relied on to make sense of the civil rights struggle rested on the blackness of the victims, the photographs were unable to transcend race. By reducing the meanings of the photographs to a few basic plot lines removed from social context, white viewers lost the opportunity to understand the aims of black protestors. In the white imagination, blacks' beliefs and actions became incidental to their victimization.

Southern whites were also eager to downplay the ideological motivations of the black civil rights protestors, but they went a step further, seeking to obscure the political motivations of liberal whites with equal vigor. Once white protestors or intellectuals aligned themselves with the interests of blacks, conservative southern whites reframed the motivations of such "deviants" in ways that obfuscated their beliefs. To be a white civil rights protestor in the South in the first half of the 1960s was often to be labeled and dismissed as a "communist," but also a

38 Unknown photographer, *James A. Peck Beaten by White Mob,* Birmingham, Alabama, May 14, 1961. © Bettmann/CORBIS, Seattle, Washington.

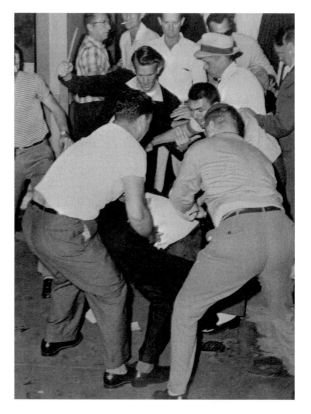

"homosexual," a "race mixer," a "white Nigger," or, most pointedly, a "Nigger lover." This last epithet has been hurled at racially progressive whites since the era of abolition. Southern whites used it freely throughout the civil rights era against the white Freedom Riders who protested segregated public facilities in Birmingham in 1961 (figure 38), William Moore during his solo protest trek from Tennessee to Mississippi to advocate racial coexistence in 1963, the Freedom Summer voter-registration workers Andrew Goodman and Michael Schwerner (figure 39) just before their murders by the Ku Klux Klan in 1964, and many thousands of lesser-known whites who dared to reject the racial status quo.[33] "Nigger lover" was an emotion-laden label that raised the much-feared specter of miscegenation among whites. It so inflamed white suprema-cists that its mere invocation diminished their capacity for calm thought; but even for those less invested in preserving white power, the epithet undermined the legitimacy of progressive beliefs by interpreting them as the product of sexual desire.

The defenders of white privilege smoothed the way for subjecting progressive whites to the

violent treatment traditionally dealt to nonconforming blacks by imagining the political actions of progressives as tawdry expressions of interracial longing. Pamela E. Barnett, a literary and cultural historian, explored the potent symbolic threat that white civil rights advocates, by crossing racial boundaries, posed to those wedded to the racial status quo. She points out that in the culture of 1960s America, civil rights supporters and detractors alike imagined "freedom" through transgressive sexualities (interracial and homosexual) and through in-between identities (interracial and androgynous). Because racism, sexism, and homophobia draw from an investment in binary identities—black-white, masculine-feminine, and gay-straight—both those who seek to preserve conventional social relations and identities and those who seek to tear them down see the crossing or effacing of clear-cut identities as a break-

down of older orders and a rejection of the status quo. The emergence of new social relations is either a cherished aim or a dreaded outcome depending on one's politics. Barnett notes that popular opposition to events as disparate as the 1957 integration of Little Rock Central High School in Arkansas and the 1964 SNCC-organized voter-registration drive in Mississippi consistently centered on white concerns about interracial sex and marriage. Despite protestors' articulation of measured, chaste goals—such as integration of public schools or equal access to the ballot—whites opposed to civil rights action perceived the protests as attacks on the integrity of their racial identity.[34]

Given the importance of whiteness to European Americans in understanding who they were, threats to its coherence caused many to project onto the attack the most extreme peril to racial identity they could imagine—miscegenation. This observation helps explain why many of the lynchings of black men who had attained economic or political success were carried out under spurious claims that they had raped white women. While contemporary Americans will see such accusations as transparent lies raised to dispose of a threatening figure, many white Americans up through the first two-thirds of the twentieth century saw black "violation" of social and economic norms and the defilement of white women as markers on a continuum of threats. After all, for conservative whites, economic competition with blacks represented a breakdown of racial boundaries, the logical conclusion of which was biological corruption of the white race through interracial sex. In fantasizing that whites who were sympathetic to blacks had this "unthinkable" act in mind, conservatives both obscured the political arguments for ensuring blacks' civil rights and provided a rationalization for white-on-white violence. Even Charles Moore's politics and professionalism were questioned because of his attention to civil rights stories. When Moore worked for the *Montgomery Advertiser,* before starting his freelance work for *Life,* the governor of Alabama, John Paterson, dismissed the photographer's interest in civil rights stories as a crude reflection of Moore's desire to have sex with "Nigger gals."[35] Reactionary whites consistently reduced the political to the personal when characterizing the motivations of liberals who embraced the ideology of civil rights.

As we have seen, both northern and southern whites decontextualized the civil rights struggle. Northern whites interpreted visual evidence through their racial values, diminished the agency of blacks, and focused on sensationalistic and reductive narratives at the expense of social context. At times they did so for the altruistic and practical aim of galvanizing white support for civil rights; at other moments, they acted on a more selfish desire to protect a threatened sense of self. The resulting picture of northern feeling and action appears at odds with itself, given everything the photographs are credited with achieving. The often-remarked-upon affective "appeal" of the photographs to the hearts and consciences of whites and the claims for their role in catalyzing constructive change are difficult to reconcile with the images'

disconnect from the social, political, and racial realities of black Americans. After all, images working in a social vacuum produce progressive social change only by chance.

While the conventional view is that the emotions the photographs engendered in whites were a force for productive social change, the images did as much to hinder black rights as to advance them. Since whites supplied a context for the works that had little to do with the lives of blacks, the emotions they felt, and their subsequent actions, did more to fulfill their own psychological needs than to ensure the civil rights of blacks. The lack of an accurate context, as well as the nature of the emotion produced by the photographs, compromised the social efficacy of the emotion. I do not claim that emotion per se is incapable of catalyzing meaningful change in viewing civil rights photographs, but that the specific emotions whites experienced stunted reform.

For decades scholars within literary studies and, to a lesser degree, photographic history have vigorously debated the role of "emotional" texts in catalyzing progressive social change. Studies have considered whether or not white middle-class Americans were moved by nineteenth- and twentieth-century fiction and documentary photography to empathize with the pain and emotion of disempowered peoples and consequently support legislation and social arrangements that aided less-advantaged groups.[36] Not wishing to wade into the larger political debate, I take my lead from the literary scholars Lora Romero and June Howard, each of whom has suggested that we sidestep judgments about whether specific media or categories of artistic production produce "good" or "bad" political effects and instead focus on the cultural work they have performed in localized settings.[37] In their view, "emotional" texts are not better or worse than "rational" texts in general; each must be judged in context.

I suggest that the "shame" that the Birmingham photographs consistently elicited from white Americans hindered the images' political work. The psychologists June Price Tangney and Ronda L. Dearing have performed empirical research on the psychological mechanisms of shame and its ability to generate empathy and social change. To augment their study of subjects in the lab and produce a revealing picture of shame in practice, they also conducted a survey of recent work by colleagues in clinical, social, personality, and developmental psychology. In reporting their results, they illuminate the significant distinctions between guilt and shame. While both may be produced by similar stimuli, they are experienced in distinctive ways that have far-reaching psychological and social implications. Tangney and Dearing quote Helen Block Lewis, a pioneering researcher on shame and guilt whose theories were confirmed by their work: "The experience of shame is directly about the *self*, which is the focus of evaluation. In guilt, the self is not the central object of negative evaluation, but rather the *thing* done or undone is the focus. In guilt, the self is negatively evaluated in connection with something but is not itself the focus on experience."[38]

Tangney and Dearing show that people who are shamed focus on the fact that they did something bad, while guilty people focus on the disturbing things they have done. This seemingly subtle distinction allows guilty individuals to place distance between themselves and the source of their distress, through their emphasis on the act over the actor. Scrutiny of the act, and the distance that such attention permits, encourages guilty individuals to consider how things could have turned out differently; in Tangney and Dearing's lab, subjects who experienced guilt expended a great deal of time and energy wondering what they could have done differently. Those who experienced shame, in contrast, were so focused on the act as a reflection of their self-worth that they were unable to consider how they might have behaved differently. Shameful subjects showed more concern about their own pain than about the need to remedy the pain or discomfort of others.

Tangney and Dearing explain that whereas guilt can help generate empathy, shame prevents individuals from forging empathetic connections to others. Consumed by their pain, people experiencing shame turn inward to escape from engagement with the social world and to tend to their psychological wounds. A fundamental difficulty for researchers in imagining how shamed people might rectify the interpersonal or social problem that gave rise to their emotion is that those feeling shame define the larger "problem" as their wounded sense of self. Since efforts to alter behavior, compensate victims, or even apologize for one's actions do not address the ego-threatened state of the shamed individual, such external-looking actions hold little allure for those experiencing shame. Tangney and Dearing show that those who feel shame consistently opt for "solutions" like withdrawal, anger, and the shifting of blame onto others. As the authors note, the tactic of blame shifting is a particularly powerful means of protecting the self, which further distances the individual from both the social world and internal knowledge of self.[39]

Tangney and Dearing's work helps explain an apparent anomaly: a sizable minority of the northern liberal whites who supported black protests in theory condemned them in practice. That many conservative whites in the North questioned the need for black protests in the first place is unremarkable: a significant percentage held blacks responsible for the ensuing violence, despite the protestors' overwhelming adherence to nonviolent tactics. More noteworthy is the minority of reliably liberal whites in the North who at moments of intense emotion echoed the tone and substance of conservative white attacks on blacks. As I detail in chapter 3, many liberals blamed blacks for unleashing the violence through their protests. They considered protest leaders' decision to encourage the participation of minors to be "perilous" and "dangerous" and, ultimately, blamed the injury of children on black adults. We can see such condemnations as inconsistent with liberal values or appreciate instead their consistency with the operation of shame. Liberals who sounded like their conservative peers managed their shame

and protected their threatened sense of self by shifting blame onto the victims of violence. Although liberal critics of the protests shared the rhetoric of conservative whites, this rhetoric served psychologically distinct needs in the two groups.

Both moderate and liberal viewers in the North were more likely to shift the blame for racial injustice onto southern whites in an effort to manage their shame. On its surface, this perspective hardly seems like a *shifting* of blame, for who was more deserving of criticism than the southern officials and mobs who consistently reacted with violence to the peaceful demonstrations of black adults, youths, and children seeking their constitutional rights? But recall that the shame generated in northern whites was personal. Whites were shamed because they felt complicit. Since the vast majority of liberals who blamed southern whites did not articulate their own stake in the matter, their heated rhetoric served as a defensive gesture and allowed them to retreat from the kind of self-examination needed to build empathy and create a coalition of advocates for meaningful social change. Although apologists for the Birmingham authorities routinely underestimated the extent of black injuries—as one wrote, "the only injury of any consequence . . . was sustained by a policeman"—only a handful of protestors required medical attention and none were gravely injured.[40] In light of the casualty record, one might well wonder if the liberal white recourse to heated adjectives—"brutal," "barbarous," "disgraceful," "shameful," "vicious"—might say more about whites' need to fortify their defenses against complicity than about the events in Birmingham in early May. Without in any way condoning the use of dogs or fire hoses against human beings, we can note the silence with which whites met scenes of black poverty in the North, which took a much greater toll on black bodies each day.

Tangney and Dearing note that certain individuals show a propensity for experiencing shame.[41] Thus, perhaps the many pained commentators who expressed their shame and condemnation in congressional speeches, pastoral letters, newspaper and magazine articles and editorials, and letters to the editor would have experienced shame even if they had held more productive racial outlooks. But if we bracket the reactions of those shame-filled observers whose words dominate the debates about Birmingham, we still must ask why other individuals—those less wired for shame—failed to express their concern and guilt about the acts of police and fire officials.

Given that the people who expressed shame were also the ones issuing the hottest expressions of outrage, and in light of Tangney and Dearing's observations that anger is a common means by which shamed individuals redirect their psychological energies away from themselves to avoid any taint of complicity, historians may have inadvertently exaggerated the degree of white concern about events in Birmingham. If a significant percentage of white expressions of emotion came from individuals whose primary motivation was self-protection rather than

straightforward concern about the treatment of blacks, then the pool of whites interested in agitating for reform was surely modest. This observation might further support the historian David Garrow's claim that the Birmingham struggle produced few material benefits for American blacks. While the symbolic victory was real enough, the claims of many blacks and whites that the conflict produced sweeping changes are not borne out by the legislative or social records. Liberal whites, conservative whites, and virtually all blacks had interests in crediting the events in Birmingham for bringing about change, but as Garrow's analysis illuminates, few transformations were apparent in the immediate aftermath of the conflict. The modest gains in Birmingham itself—clerkships promised to a handful of blacks in downtown stores, the desegregation of department store changing rooms and lunch counters, and the establishment of a biracial committee to work on desegregation issues—were not even matched by nearby cities in the state.[42]

Of course, liberal whites in 1963 did not see shame as a barrier to racial progress; many considered it the route to meaningful change. Harry Golden certainly saw it this way. Golden was born into a Jewish Ukrainian family that immigrated to the United States at the turn of the twentieth century. He lived briefly in New York's lower east side before his family relocated to Atlanta. He gained fame as a progressive reporter for the *Charlotte Observer* and, later, as publisher of the *Carolina Israelite,* which printed liberal-leaning articles on race and segregation. As a religious outsider and keen observer of American life who witnessed the conditions of black life in both the North and the South, Golden spoke with an authority enjoyed by few of his white contemporaries. Writing in 1964, he acknowledged that a lack of housing, employment, and educational opportunities had created a desperate situation for blacks in such northern cities as New York, Chicago, Philadelphia, and Detroit and that de facto segregation was a feature of life in the North. But he still maintained that northern cities were crucially different from their counterparts in the South: "There is this difference: every elected official of the North, every community leader declares himself against racial segregation and discrimination of every kind. And this declaration and impulse shames the majority and often makes them change their discriminatory policies. . . . To be ashamed is to start on the way to respectability and honor."[43]

In Golden's analysis, black life in the North and the South was miserable, separated only by degrees, with progressive white attitudes and feelings in the North standing as the key regional difference. Implicit in his account is the notion that northern blacks had a stake in the emotion of liberal whites. Such a view is remarkably consonant with the previously cited views of white observers from the North who linked white emotion to either the promise or stirrings of social change. In a common move for liberal whites, Golden wrote that the southern segregationist had "sacrificed his humanity" while failing to turn his analytic lens on the North. In

a 1963 essay on segregation in the *New Republic,* a perceptive northern white psychiatrist made explicit the bargain struck between northern and southern whites. He noted the willingness of northern whites to drag their feet on civil rights provided that they could blame their fellow whites in the South: "When the harvest of segregation becomes embarrassing, when the shame of riots becomes brimful and the scandal in the world's richest democracy of its entwined poverty and violence emerges beyond disguise, he, the Southern race-baiter, stands prepared for our collective need. Upon him fall our faults and compromises, evasions and duplicities. Glaring at him we dismiss the . . . Northern Negro slums, or the cynical sectional barters which ignore human rights, or our many niggardly responses to needy fellow citizens, hungry, persecuted, or merely in pursuit of a nearby home or school. Off this strange scapegoat goes, comfortably away from all of us."[44] The projection of responsibility onto the southern segregationist blunted the discomfort of northern shame as it diminished the likelihood of whites experiencing the introspection needed to initiate reform in the North.

Whatever emotions were key to the white response, recent clinical research suggests that the white experience of emotion in viewing *representations* of white-on-black racism does not correlate with progressive racial views. In 2009, Canadian and American psychologists published the results of a study in which they asked nonblack subjects to rate their level of distress after being exposed to incidents of white-on-black racism. Study participants who either read about or watched a video of overt racial prejudice practiced against blacks deemed the incident significantly more distressing than did those who observed the incident in person. The researchers hypothesized that when removed from actual events, subjects consciously adopted a mindset that allowed them to draw on egalitarian values in imagining their responses. And they concluded that subjects who witnessed the racist incident in person responded more spontaneously to reveal their latent biases against blacks.

When those who read about or watched a video of the incident were asked to predict if they would choose to pair up in a subsequent exercise with the black man subjected to the racist slur or the white man who made it, 75 percent of subjects who read about the incident and 83 percent of those who watched it indicated a preference to partner with the black. These white predictions of behavior clash with the clinical observation that 71 percent of those who witnessed the incident live actually chose to partner with the "racist" white rather than the "victimized" black. This clinical study demonstrates the propensity of Americans to experience heightened emotional distress when confronted with representations of racism and their relative indifference to racism in daily life. But it also suggests how representations mask the core beliefs on which people act. In the study, textual and visual representations facilitated strong emotional reactions because of the distance they created between viewers and the racist acts. They did not, as photographic historians frequently assume, make the incidents more immediate.[45]

With great consistency, liberal whites in the North mistook their emotion for an investment in racially progressive politics, confused the fervor of their reactions with the start of real-world reform, and conflated the sincere concern they felt with a commitment to make meaningful change. Their experience of shame and exposure to representations of violence threw up impediments to creating the more just society that they valued in theory. If the white liberal reaction to the civil rights movement documented here was the most progressive one then possible, my book primarily serves to recover the historical complexity of American reactions to images of civil rights. But given evidence suggesting that the liberal white response was merely the dominant one, and that other viable options then existed, the book also documents the degree to which even progressive whites made choices in defense of the racial status quo. To clarify the range of actions then possible for whites, and to ensure that we Americans do not cement into our collective imagination the notion that only one course was feasible at the time, I offer an alternative history.

I start this analysis by considering the choices made by Sue Thrasher, who grew up in a white working-class household on a farm in West Tennessee in the 1950s. Thrasher joined the SNCC while a college student in Nashville in the early 1960s and later helped found, under Sam Shirah, the Southern Students Organizing Committee, a group dedicated to bringing together white college students to support black civil rights. In the spring of 1963, she volunteered in Nashville civil rights protests with John Lewis, then the head of the local SNCC chapter. The twenty-three-year-old Lewis was already well known in the movement for his dogged work on civil rights and his unwavering commitment to nonviolence in the face of brutal aggression. Having gained fame in the movement during the Freedom Rides in 1961, Lewis was elected national chairman of the SNCC in 1963, gave a stirring address at the March on Washington the same year, helped organize the Mississippi Freedom Summer in 1964, and led the protestors at the Edmund Pettus Bridge in 1965. Thrasher vividly recalls an occasion when she, Lewis, and some fellow protestors returned to the church one afternoon after a downtown demonstration. As they sat talking quietly at the front of the church, three young white men "looking for trouble" entered from the back, apparently not having found sufficient confrontation on the street. Lewis walked back to speak with the men, and after a few minutes, they left without causing any damage or harm. As Thrasher remembered years later, "More than anything else in the world, I wanted to separate myself from these white southerners, to make clear that I was not like them. I said something to the effect of 'How dare those hoods come into this church.' John [Lewis] looked me dead in the eye and said, 'Don't call them hoods; they are human beings, just like you and me.' . . . I was chastened."[46]

Thrasher's expressed need to "separate" herself from the "white southerners" who invaded the church makes sense only if she identified with them, or if she suspected that Lewis and the

other black activists perceived a link between all whites. Either she identified with the youths as a fellow "white southerner," or she feared that the blacks with whom she heroically worked for black civil rights lumped together progressive and reactionary whites because of the color of their skin. Whatever the case, Thrasher's need to distance herself from the youths suggests a fear that racial identification was more significant than ideological belief and action for categorizing people in American society. Despite all that she had done for the civil rights movement, Thrasher responded as if her whiteness said more about her (to herself or to the black activists) than her deeds. The lessons Thrasher learned that day from Lewis, in her words, about "whiteness and . . . class" were multiple.

While the majority of American whites in the early 1960s were unwilling to judge Lewis on anything *but* the color of his skin, he was nonetheless able to transcend this identity model, appreciating Thrasher for what she believed and seeing beyond how she looked. Even more, Lewis had taken a huge conceptual leap in identifying himself with the white youths. In the face of their animosity toward him and the civil rights project, Lewis demonstrated his ability to make an empathetic connection with the youths as fellow human beings and so embrace a metacategory of identity beyond his more narrowly defined racial identification. "They are human beings, just like you and me," he pointed out to Thrasher. We are no different than they. As Thrasher gratefully recalled, "I don't suspect that John ever fully knew how much, in that moment, he made me begin thinking."[47]

Thrasher's opportunity to "begin thinking" was due foremost to her unusual decision to work cooperatively with blacks in the South. The SNCC of the early 1960s offered a rare space in American society in which whites and blacks could interact on a relatively level playing field. As a significant body of social psychological research has demonstrated, contact between members of different groups does not significantly reduce bias and conflict unless four specific conditions are met: the groups must have equal status in the interaction, they must have common goals, the contact must provide opportunities for personal dealings, and the interaction must be fostered by institutional support.[48] So, in contrast to the many liberal whites in the North whose interactions with blacks were limited to employer-employee exchanges, fleeting social gatherings or hierarchically defined work providing social services to the disadvantaged, Thrasher immersed herself in an egalitarian environment that fostered intergroup empathy. If the SNCC environment was hospitable to interracial growth, it remained for Lewis to present Thrasher with a radically new concept of identity.

In linking Thrasher, himself, and the white youths together in one identity position, Lewis invested in what psychologists call the "in-group identity model." Rather than working to attain a racially just society by dissolving all group identities, which proves difficult to achieve outside of short-term experiments in a lab, the in-group identity model works to reshape existing

boundaries to be more inclusive. Accepting the importance to human beings of demarcating
"us" from "them," and the reality that all of us possess multiple social identities, the model sug-
gests how to expand the pool of those deemed "us." As one psychological researcher explains,
"Inter-group bias and conflict can be reduced by factors that transform participants' representa-
tions of memberships from two groups to one, more inclusive group. With a common in-group
identity, the cognitive and motivational processes that initially produced in-group favoritism
are redirected to benefit the former out-group members."[49] The expectation is not that people
will forsake previously held identifications such as "black" or "white," for instance, but that they
will allow those formerly outside of their group to join them in other groups with higher levels
of inclusiveness, such as those of "southerners," "Americans," or, in Lewis's case, "human beings."
Research has shown that whites and blacks who share common identities experience reduced
racial threats. In other words, when blacks and whites see themselves joined into a larger identity,
they engage in less interracial competition for resources and power, perpetrate fewer overt acts
of violence against one another, and experience less anxiety about differing values and beliefs,
because their new shared identity stresses similarity over difference.[50]

Lewis's humanistic understanding of identity resonated with Thrasher because it held out
a viable option for progressive whites. Profound social changes could have resulted if a signifi-
cant minority of whites had embraced Lewis's identity model through egalitarian work in
partnership with blacks. Reliance on an in-group model would have eliminated the need for
liberals to engage in the psychologically difficult zero-sum game of "helping" an alien group,
allowing them to focus instead on the satisfying work of ensuring that the members of their
group (here black and white) enjoyed equal advantages. Embrace of the model would have
lessened the appeal to whites of the reactive approach to civil rights that Congress and President
Kennedy practiced in the early 1960s. Rather than accepting a piecemeal approach, with each
black protest eliciting a measured white response, based on the calculation of how little the
majority had to give up to pacify the minority, large swaths of white citizenry would have
shared a stake in bringing justice to "its" members. This model would also have gone a long
way toward defusing the unproductive generation of emotion over the photographs, which
gave the illusion of concern but ultimately served to redirect blame to mitigate whites' shame.
And finally, the model would have allowed white America—despite any tactical and philo-
sophical differences with black civil rights protestors—to see the suffering and appreciate the
plight of *their own* people, much as Gaston did when he saw the young girl tumble down the
street. We can only imagine the unfolding civil rights history of the 1960s had white Americans
seen not the children of blacks but *their* (black) children buffeted by hoses and mauled by dogs.

The historical record shows that a few liberal whites did write and speak of their belief that
blacks and whites were joined into the larger communities of "Americans" or "human beings."

Such expressions, however, were almost always well-intentioned gestures that had little ground-ing in the white experience of identity. Even those who voiced a theoretical appreciation for blacks as an indelible part of the American family failed to experience the photographs of vio-lence as if they spoke to the lived reality of their group. Because whites failed to feel the violence as *their* pain and failed to appreciate that the blacks in the photographs were their "people . . . fighting for their lives and [our] freedom," the rhetoric of a shared identity was unsupported by their psychological identifications. After all, only a tiny percentage of blacks who viewed the photographs had personally felt the sting of water hoses and the bite of police dogs. Their pain sprang instead from a shared sense of identity, history, and destiny, then alien to even liberal whites.[51]

3 PERFECT VICTIMS AND IMPERFECT TACTICS

If we run away, we'll fool ourselves; you can't run away from being a colored man. It don't make any difference where you go—you has the same problem, one way or another.

UNNAMED BLACK WOMAN EXPRESSING SUPPORT FOR CHILDREN'S PARTICIPATION IN CIVIL RIGHTS (1960)

In the weeks before Bull Connor resorted to dogs and fire hoses, King knew that the Birmingham campaign was faltering. Hundreds of black protestors were incarcerated, funds for bailing out jailed marchers were rapidly dwindling, liberal white clergy were criticizing King's tactics and calling on him to halt the protests, and the opposition to desegregation by public safety officials, downtown business owners, and members of the white public appeared just as strong as when the protests had begun.

If the white establishment presented an outwardly unified front, the same could not be said of the black community, in which fissures were growing more public and pronounced.[1] Not only had the city's conservative black newspaper, the *Birmingham World,* deemed King's "direct action . . . both wasteful and worthless," but the city's black citizens were less willing to volunteer for marches. Blacks were discouraged by the lack of progress, the powerful stigma of going to jail, and the ever-present threat of being fired by their white employers if they were seen protesting segregation.[2] In an ominous sign of flagging support, a Saturday evening protest rally on April 27 drew just a fraction of the crowd that had turned out at the start of the month.[3] What concerned King most, however, was the dwindling national press coverage of the Birmingham movement. Reporters had grown tired of a story that lacked drama—in which small groups of marchers were arrested quietly each day with little show of force. When the late-April murder of the white civil rights marcher William Moore near Attalla, Alabama, inspired two groups of activists to take up his quixotic trek to the governor's mansion in Jackson, Missis-

sippi, the national news media departed Birmingham for Jackson in the hope for more news-worthy spectacles. Without a national audience, neither the bravery of Birmingham's black citizens nor the brutality of the city's segregationist policies had a chance of catalyzing political or social change. As King pointedly acknowledged in *Where Do We Go from Here* (1967), "While Negro initiative, courage and imagination precipitated the Birmingham and Selma confrontations and revealed the harrowing injustice of segregated life, the organized strength of Negroes alone would have been insufficient to move Congress and the administration without the weight of the aroused conscience of white America."[4]

As we have seen, everything changed on May 2 with the start of the Children's Crusade. The inclusion of teenagers and children in protest marches achieved King's goal of filling the jails and limiting the options of public safety officials, led Connor to abandon his nonviolent handling of protestors, reestablished the black community's commitment to the campaign, engaged the national media, and secured the attention of white Americans across the country. Despite general acknowledgment by scholars today that "mobilizing the children saved the movement from collapse," King anguished over the decision.[5] James Bevel's proposal to recruit youth into protest marches was vigorously resisted by many black adults. They had well-founded fears of police beatings and rapes that would physically and psychologically scar a generation of young blacks and were concerned that criminal convictions would prevent the young people from securing educations or jobs.[6] King understood the risks of participating in such a protest, knowing that Birmingham society was inherently violent and unjust and that protest would be a means of "*surfacing*... tensions already present."[7] His ultimate decision to expand the ranks of protestors was driven by his practical need for a spectacle that would save the campaign from irrelevance and by the careful groundwork laid by Bevel and his partner, Diane Nash, in the local black schools over the preceding weeks. Long before they received permission to engage the city's youths, Bevel and Nash conducted extensive recruitment and educational efforts aimed at drawing young people into the movement. At a moment when King could conceive of no other routes to success, the student organizers presented the SCLC leaders with thousands of enthusiastic young recruits. One historian termed this decision the most "drastic" one of King's career.[8]

The initial agreement was to restrict participation to those of high school age and older, but as the Sixteenth Street Baptist Church swelled with eager students from middle and elementary schools, organizers effectively abandoned the age limit. Newspaper reporters documented the participation of black children as young as six marching, braving fire hoses and dogs and willingly heading off to jail.[9] Whatever else the participation of children did for the campaign, it engendered considerable debate. Blacks were ambivalent. Some observers interpreted the participation of children in unequivocal terms: Malcolm X railed against their

presence in the streets, charging that "real men don't put children on the firing line," while a Birmingham father expressed steadfast support for his jailed twelve-year-old son's activism, noting in the third person, "His father's been a slave all his life."[10]

More characteristic of black community reaction was the response of James Forman, who witnessed the first use of police dogs in Birmingham just before the launch of the Children's Crusade. When two King aides expressed joy about a dog attack, exclaiming, "We've got a movement. We've got a movement. We had some police brutality," Forman lamented, "It seemed very cold, cruel, and calculating to be happy about police brutality coming down on innocent people . . . no matter what purpose it served." Understanding the value of such spectacles for galvanizing support for civil rights, Forman never lost sight of the human costs of placing idealistic people in harm's way. Similarly complex emotions haunted Glenn Smiley, a southern minister and national field secretary of the Fellowship of Reconciliation who had worked closely with King since the Montgomery Bus Boycott to build understanding of Gandhian nonviolence within the movement. As Smiley sat on the steps of the Sixteenth Street Baptist Church watching the police turn water hoses and dogs on children, he noted that the scene was simultaneously horrifying and predictable, the logical end point of his work in nonviolent protest.[11] Mindful that Birmingham's black citizenry did not see the May 3 violence toward their children as a media victory, King gave a subdued speech that evening at the church. Acknowledging the pain and anguish of the congregants upon witnessing the day's events, he granted, "Today was a dark day in Birmingham," but told his congregants that they had "gone too far to turn back."[12]

White reaction to the participation of children in Birmingham was overwhelmingly negative. Although a few white observers on the far left of the political spectrum were sympathetic to the role played by young protestors, the vast majority of whites were united in their opposition and, frequently, in their disgust. The many whites hostile to the campaign's aims used the presence of children as an excuse to rail against the SCLC leadership and as a means of deflecting attention away from the concerns and objectives of protestors. Representative Huddleston of Alabama asserted on the floor of the House of Representatives that use of children constituted "the most shameful aspect of [SCLC's] actions." He claimed that protest leaders "took little children from their schools and their homes and, after subjecting them to the same professional propaganda that had beguiled some of their parents, sent them out to demonstrate, sent them out as a shield for the lawbreaking adults, used them, in short, as pawns in an explosive situation. . . . It is intolerable."[13] Albert Boutwell, the mayor-elect of Birmingham, claimed that "irresponsible and unthinking agitators" were using children as their "tools": "Whatever our sympathies and loyalties have been in the past . . . I cannot condone and you cannot condone the use of children to these ends. I do not need to emphasize the difference

between demonstrations by adults and the terrible danger of involving immature teen-agers and younger children."[14] In most every attack, the defenders of segregation criticized blacks for manipulating children into participating in a struggle that the youngsters could not possibly understand or be ethically encouraged to undertake.

White moderates and liberals typically expressed sympathy for the plight of American blacks in the South before tempering their support with vigorous criticisms of tactics. Northern media outlets displayed scant interest in the Birmingham campaign during much of April; by the start of May, they were devoting significant front-page coverage to the events in Birmingham, expressing shock, of course, at the use of dogs and fire hoses on human beings but also alarm at the organizers' use of young marchers. After offering the standard sympathy to marchers typical of the liberal press, a *New York Times* editorial on May 11 stated that efforts "to spread more marches through Alabama at this juncture, as some Negroes have suggested, could only renew the danger of heavy casualties and irrepressible violence. The presence of hundreds of children among the marchers made all these marches especially perilous ventures in brinkmanship."[15] *Time* declared of Birmingham, "There had been no winners in a war that had no heroes. Bull Connor was by no means Birmingham's only shame; the city's newspapers, for example, put the story of the midweek riot on an inside page. Yet at the same time, Negro Leader King could be criticized for using children as shock troops and for inciting protests." Expressing similar sentiments, *Newsweek* noted, "Even some friendly voices raised the prickly questions: if it was wrong for the police to put the children in jail, was it right for the integrationists to start them on the way?"[16] Charles Moore's response to the scenes epitomized that of the majority in the liberal white media. While calling the use of attack dogs on people "revolting," he expressed dismay to Andrew Young that black adults would subject young children to such dangers.[17]

White public officials sympathetic to civil rights toed a similar line. Father Albert Sidney Foley, the chairman of the Alabama Advisory Committee of the United States Commission on Civil Rights, worried that the use of children in Birmingham would "send down the drain three years of hard work on the part of many [progressive] people."[18] Attorney General Robert F. Kennedy issued a statement on May 3, calling the Birmingham protests "the understandable expressions of resentment and hurt by people who have been the victims of abuse and deprivation of their most basic rights for many years," but he also offered a warning: "School children participating in street demonstrations is a dangerous business. An injured, maimed or dead child is a price that none of us can afford to pay."[19] President Kennedy was less direct, though he too made clear his objections to the participation of children in protest actions. In a private meeting in June to discuss civil rights progress with many of the country's most prominent black leaders, the president argued for calling off the planned March on Washington. Kennedy

noted with concern that the approval rating of his administration had fallen to 47 percent from a high of 60 percent, attributing the drop to his commitment to civil rights and to the country's unease with black protests that were now a feature of American urban life. The president worked to impress upon the assembled leaders that "the wrong kind of demonstration at the wrong time" complicated efforts to promote legislative reform. When King pointed out, to the satisfaction of the black attendees, that black protest was virtually always deemed "ill timed" by whites, Kennedy shifted gears, enjoining the leaders to monitor who participated in future demonstrations. Framing his comments as concern for the welfare of children, Kennedy said, "What seems to me terribly important is to get, and keep, as many Negro children as possible in schools this fall. It is too late to get equality for their parents, but we still can get it for the children—*if* they can go to school and take advantage of what educational opportunity is open to them. I urge you to get every Negro family to do this at whatever sacrifice."[20] Unable to convince his skeptical audience of the need to curtail political demonstrations, Kennedy pinned his hopes on keeping the movement's most potent and controversial weapons out of the fray of the streets and the press.

The fact that many moderate and liberal whites supported the goal of desegregating Birmingham is heartening, even if they quibbled over movement tactics. The white response suggests that decades of black activism had sufficiently pricked the conscience of white America to compel a shift—from focusing on the legitimacy of the underlying claims to tacitly accepting the claims and debating the efficacy of approach. Yet criticism of nonwhite tactics has been a standard move of moderate and liberal whites since the nineteenth century. With great frequency, whites have expressed sympathy for the aims of racial reformers, before voicing concern about the reformers' "counterproductive" approach to change.

The nineteenth-century civil rights leader Frederick Douglass, for example, was criticized during his lifetime for the "violence and exaggeration of expression" of his autobiography, *Narrative of the Life of Frederick Douglass, an American Slave* (1845). Douglass's white supporters expressed concern that the autobiography would "diminish" the success of the abolition movement. Decades later, the liberal press attacked the antilynching crusader Ida B. Wells for pressing her case for southern reform in speeches to the British public. The *New York Times* deemed lynching "the acts of savages" that "could not take place in a civilized community" yet cautioned that the British parliamentary committee that Wells encouraged to look into American lynching "would scarcely deter those wild and free South-Westerners from working their will. It might even stimulate them to fresh excesses in the way of torturing negroes . . . [especially] if it were generally understood that the British committee was moved to action upon the *ex parte* statements of a mulatto."[21] If the white conscience had truly been pricked by the horrors of slavery, lynching, or Jim Crow society, whites would have no need to shift to

attacking tactics—they would have no need for an attack at all. Concerned whites would simply acknowledge the justness of the issues raised and begin work on the underlying causes of violence and inequality.

Liberal whites who take note of racial inequalities but choose to direct their energies toward chastising blacks for their tactics have more in common with those who deny the existence of racism in U.S. society than they may care to concede. The acknowledgment of racial problems can be the first step on the road to reform, but it can also provide political cover for issues left unaddressed. When "acknowledgment" goes hand in hand with efforts to cast doubt on the morality of a protest action or the motivations of the activists, it is a significant impediment to reform. As one Alabama congressman who condemned the use of children in the Birmingham struggle unself-consciously observed, "To question the timing of these unfortunate incidents is to question the motive of them."[22] During an era in which blacks drew media attention to a host of injustices they faced, many whites simply nodded to the existence of racism and based their reticence to change on their ultimately trivial attack on tactics. The response allowed whites to admit racial realities that were increasingly difficult to ignore without engaging in the difficult work of altering attitudes, actions, or structures.

Even the tiny minority of whites who both approved of the civil rights struggle and supported the involvement of children managed to diminish the movement through their praise. In celebrating the role of children, many radical whites lessened the agency of adults and downplayed the thoughtful strategies of movement participants by designating the "innocent" children as movement leaders who showed elders the way.[23] One white SNCC worker, after noting that the legacy of white-on-black violence terrified and paralyzed many black adults, wrote, "Much of the movement's strength lies in its innocence; in short, its children." A sympathetic white liberal editor noted that nonmovement black adults in Birmingham had "their courage built up" by the sight of "shiny-faced school children marching off to jail." And an editorial in the liberal periodical the *New Republic* commented that Connor and King seemed equally "surprised" by the surge of "laughing school children" who took to the streets. In an editorial full of praise for King and his nonviolent "army," the periodical nonetheless depicted children in the lead, thereby implicitly contrasting the strength of black children with the weakness of their parents. Describing one of King's mass rallies in Birmingham in which child protestors were asked to come forward and give testimony, the editors wrote, "Each child [activist] of parents so long timid and respectable told how proud he or she was to have been in jail, how easy it had been."[24] In an eerily familiar move, whites supportive of children's participation tended to dehistoricize the black civil rights struggle by rooting the power of children in their lack of historical perspective. "Innocent" of history, the children accomplished what their knowing and fearful parents could not.

40 Pete Harris, *Elizabeth Eckford, One of the Little Rock Nine, Pursued by the Mob Outside Little Rock Central High School,* Little Rock, Arkansas, September 4, 1957. © Bettmann/CORBIS, Seattle, Washington.

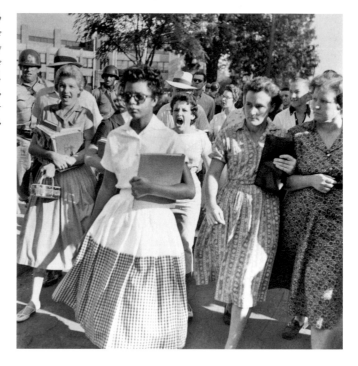

The white expression of concern about the role of children in Birmingham was the latest iteration of a debate that had raged since the advent of the modern civil rights movement. In response to the published photographs of Elizabeth Eckford walking purposefully away from a crowd of agitated schoolchildren who surround and menace her (figure 40), no less a political theorist than Hannah Arendt weighed in on the appropriate place of children in social struggles. Writing in the radical periodical *Dissent* in 1959, Arendt modeled the "even-handed" criticism of both black and white actors that would come to typify the liberal response to the use of children in the Birmingham campaign. Arendt made clear that she held the white mob in contempt but reserved her harshest criticism for those liberal blacks and whites from whom she expected more. After blaming Arkansas's two progressive senators for their "eloquent silence," Arendt proclaimed, "The sorry fact was that the town's law-abiding citizens left the streets to the mob, that neither white nor black citizens felt it their duty to see the Negro children safely to school." For this ardent supporter of civil disobedience in theory, the most chilling feature of school integration efforts was that it "burden[ed] children, black and white, with working out a problem which adults for generations have confessed themselves unable to solve." "Have we come to the point," she plaintively asked, "where it is the children who are . . . asked to change or improve the world?"[25]

Whites critical of children's participation in civil rights were largely sincere and felt real concern for the dangers kids faced when they participated in protests. But a comparison with the less judgmental ways in which black parents and observers managed to express their equally sincere concern prompts us to consider both the social context in which white dismay was produced and the political implications of such anguish. White unease consistently centered on the beliefs that adults were manipulating children too young to understand the consequences of their actions (the youthful protestors were "pawns" or "tools" who were "taken" and "used") and that the children were being exposed to inordinate harm (as "shock troops" in "perilous ventures" subject to "terrible dangers") and would ultimately pay "a price that none of us can afford to pay."

Hanging over these white criticisms was the specter of black opportunism—the suggestion that parents and civil rights leaders used naïve children to advance a cause, at best, and careers, at worst. Many of the least sympathetic observers made this link explicit, imagining that the entire Birmingham campaign was simply King's latest effort to wring money and fame from a crisis he manufactured. The *Birmingham Post-Herald* explained to its readers that King and his associates "thrive on trouble and the publicity it brings them. They give no thought to nor do they care what permanent damage they leave behind when the last possible dollar has been wrung from the Birmingham commotion."[26] King understood that this attack could harm the movement, and he expended considerable energy explaining the morality undergirding the participation of black children.

In *Why We Can't Wait* (1964), King offered a careful refutation of the charges leveled by his white critics. After describing the vital role children had played in the Birmingham campaign, he acknowledged the rhetoric of detractors, noting, "Many deplored our 'using' our children in this fashion." Zeroing in on the hypocrisy of the critics, King asked rhetorically, "Where had these writers been, we wondered, during the centuries when our segregated social system had been misusing and abusing Negro children? Where had they been with their protective words when, down through the years, Negro infants were born in ghettos, taking their first breath of life in a social atmosphere where the fresh air of freedom was crowded out by the stench of discrimination?"[27]

King understood that white criticism rested on an unspoken belief that blacks should take American social relations as they found them. If whites lashed out against children placed in their path, blacks were deemed responsible, despite the peaceful aims of the protests. Accusations of black "incitement" consistently assumed that the victims (or in this case, their parents) clearly understood what made white policemen and mobs react violently and that such knowledge constituted an obligation to refrain from actions known to catalyze violence. White critics called blacks to task for provoking those with power much as people then judged the victims of domestic violence. King reasonably countered that whites must assume responsibility

for maintaining systems of domination that leave blacks consistently disadvantaged.[28] He blamed the perpetrators of violence, of course, but also the many millions of complacent whites who were more concerned about the handful of well-publicized incidents of violence "incited" by blacks than with the day-to-day violence in American society. Recall that for King, the brutality the protests "surfaced" was a characteristic of the society, not an aberration.

In addition to illustrating white responsibility for America's racial system, *Why We Can't Wait* paid significant attention to black agency. King forcefully argued, in a pointed refutation of the most frequent and resonant complaint of white critics, "Children understand the stakes they [are] fighting for." To make this case to whites, he opened his book with two extended and disturbing vignettes of black childhood—of a young girl in Birmingham and a boy in Harlem. In each, we see children hobbled by inferior schools, crushing poverty, menial jobs, appalling health care, overt racism, and the near absence of hope. He encourages his white readers, through their vicarious experience of the hardships faced by black children, to see the limitations of judging the morality of black tactics against the norms of white middle-class life. King links the deprivations of black childhood to his protagonists' clear-eyed understanding of social relations and hunger for change. The child protestors were not "taken from their schools and homes," as his critics claimed, but played an active role, embracing the opportunity to remake their flawed society. As King described it, in the summer of 1963 "the boy in Harlem stood up. The girl in Birmingham arose. Separated by stretching miles, both of them squared their shoulders and lifted their eyes toward heaven. Across the miles they joined hands, and took a firm, forward step. It was a step that rocked the richest, most powerful nation to its foundations." In King's estimation, the social and economic conditions afflicting blacks ensured that black children could understand the stakes. When the youths "stepped forward" to take on the challenges, they did so from a position of knowledge.[29]

King's imagery is evocative and his rhetoric stirring, but readers may remain skeptical of the capacity of children to apprehend the stakes of their school desegregation efforts in Little Rock, sit-ins in Nashville, pray-ins in Birmingham, or marches in Selma. After all, the undeniable suffering they had experienced did not necessarily translate into a thoughtful understanding of social relations or an ability to weigh the consequences of their actions. Yet, although the assessments of both King and his critics were surely colored by their respective agendas, King had the advantage of hearing directly from the young protestors whom most whites knew only as unnamed figures represented in newspapers and magazines. For example, the editors of *Life* described the unidentified Birmingham activist in figure 41, whose views they did not quote, as "glaring sullenly at firemen who just soaked him with [a] hose jet" and told their readers that he "expresses Birmingham's long-standing racial bitterness."[30] Because white reporters, editors, and publishers in the 1960s were disinclined to interview black protestors,

THE HATREDS GROW AS INDIGNITIES MOUNT

FACE OF HATRED. Glaring sullenly at firemen who just soaked him with hose jet, Negro expresses Birmingham's long-standing racial bitterness.

PASSIVE RESISTANCE. Refusing to walk, arrested demonstrators make police officers drag them bodily to wagons for transportation to jail.

32

41 Charles Moore, *Face of Hatred,* Birmingham, Alabama, May 3, 1963. Text © 1963 Life Inc. Reprinted with permission. All rights reserved. Photograph © Charles Moore/Black Star, New York.

white northern critics of King could only speculate on black youths' motivation and comprehension of the issues. Because they so rarely heard from blacks, whites hoping to make sense of the struggle had to extrapolate from what they knew of white middle-class kids or to rely on media reports of southern whites' assessments of the situation.[31] Notwithstanding the considerable stakes for King in convincing white America of the children's agency, the testimony of children—preserved largely in the black press and in a host of interviews by academics and biographers—bears out his claims.

In 1964, the white psychiatrist Robert Coles published the first volume of his groundbreaking series *Children of Crisis: A Study in Courage and Fear*. This remarkable study, whose second and third volumes earned Coles a Pulitzer Prize in 1973, presents findings from his near decade of work with black and white children in the South who lived amid the social and psychological turmoil of a segregated, though slowly desegregating, society. The lives he depicts are complex and vivid. We come to understand each child through his or her own words, carefully preserved by the psychiatrist from the hundreds of interviews he conducted with each of his informants over the course of years. In Coles's chapter on civil rights activists, he introduces us to Fred, a bright and hardworking student from a working-class home who was arrested eight times by the age of seventeen for his participation in the student protest movement. Three years before, he had been an early volunteer when Atlanta took its first tentative steps to comply with the Supreme Court's 1954 *Brown v. Board of Education of Topeka* decision outlawing segregation of the races in public education. Out of hundreds of applicants, Fred was one of three black students selected by the school board to attend a rich suburban high school, over the strenuous objections of his father, who feared for the safety of his son and the security of his own job.

During Fred's freshman year of high school, he provided Coles with a sophisticated and penetrating analysis of the condition of American blacks and of his personal motivations: "Success, that's what my dad has been talking about all my life. The poor guy, he doesn't see how ridiculous his talk is. He thinks I can be 'successful,' when actually I'll be lucky if I can vote, and be treated better than a dog every time I go register my car, or try for a driving license, or buy something in a store. They say I'm lucky; I'm going to the best high school in Georgia. Well that's about what success is for a Negro: being alone; being the exception; and knowing every second that the top for you isn't even enough to make you feel safe on the street, because it's the bottom for everyone else."

During one interview in which Fred interpreted Coles's questions as a defense of his father's conservative position, he explained to the psychiatrist, "Your children may not always go along with you, just as I'm not following all my father's advice; but there's a difference, too. You are white and I'm a Negro. If I don't join the movement and try to change things here, *my* children might just as well not be born. It's that bad." After one of his stints in jail, Fred tried to explain

to Coles why he was willing to place his education and future career at risk by participating in the civil rights struggle. He needed to take risks, he said, "because I don't think a few like myself should go into the white world, leaving twenty million Negro people standing outside, scared and hungry as they always have been."[32]

Fred's social analysis may be unusually insightful, but its basic points appear in the testimonies of a broad range of child and adolescent activists across the South in the early 1960s. Despite their lack of experience, many children focused on their obligation to act for other generations—on the need to improve the future for their children and grandchildren and even for their parents. Fifteen-year-old John Washington argued with his parents in 1961 over his desire to be one of a handful of the first blacks admitted to a previously all-white public school in Atlanta. Trying to dissuade him from provoking a white attack, his parents suggested that perhaps by his children's generation, integration might be safely attempted. Washington shot back that he would start desegregation, "so that my children will be the first really free Negroes." As he recounted, "[my parents] always told me that they would try to spare me what they went through; so I told them I wanted to spare my children going through any mobs. If there were mobs for us to face, we should do it right now."[33]

Sheyann (Shey) Webb and Rachel West Nelson were eight and nine years old, respectively, in 1965 when they participated in the first Selma-to-Montgomery March. Speaking to a biographer a decade after the event, Nelson recalled what motivated the girls to skip school, defy their parents, and face arrest, tear gas, billy clubs, whips, and charging horses: "When me and Shey were kids, we had talked about . . . having babies and all. We knew what we were doing in 1965 wasn't just for us, but for the children still to be born. We wanted them born free."[34] Mary Gadson was a teenager who participated actively in the Children's Crusade in Birmingham. She was hit with jets from fire hoses and threatened with dogs, all the while hiding her involvement from her parents, who lived in fear. Gadson recalls being motivated "by a sense of doing right. I thought one day that I want to have kids, and I don't want them to go through what I did."[35] In *Why We Can't Wait,* King recorded the declarations of an unnamed boy who struggled to gain his terrified parents' acceptance of his civil rights work. "I'm not doing this only because I want to be free," explained the child. "I'm doing it also because I want freedom for you and mama, and I want it to come before you die."[36]

The testimony of children active in the civil rights movement suggests that they not only understood the goals of the movement but that they were motivated in part by empathetic connections with past and future generations. The children were not driven by a self-serving (though inarguably legitimate) desire for personal freedom alone but also by an altruistic wish to improve the lives of others. In recognizing that the full benefits of their struggle might not be secured until the next generation, they exhibited a maturity far beyond what whites credited

them with. The understanding that King saw in black children, which he attributed to their experiences of racism and deprivation, was largely borne out in Coles's clinical research. The psychiatrist concluded that the white press's frequent criticism of the movement's "cynical use of children" failed to take into account the historical and psychological conditions of black southern life: "At the turn of the [twentieth] century the labor movement asked for 'a childhood for every child.' Many of these Negro 'children' still lack that 'right.' Is a sixteen-year-old boy who has lived in stark, unremitting poverty, worked since eight, earned a living since fourteen, married at fifteen, and is soon to be a father, a 'child'?"[37]

Children's testimony also makes clear that young activists were much more likely to join the struggle against the wishes of adults in their lives than at their urging. Many children participated without their parents' knowledge, over their parents' strong objections, or after convincing resistant parents of their commitment to the cause. Fred joined the struggle against his father's wishes but with his mother's support; Washington did so after his arguments and pleading brought his parents reluctantly around; Webb and Nelson each confronted parents and teachers whose strong objections diminished over time as the depth of the girls' feelings became clear; Gadson knew that her parents would be unsupportive and chose to hide her activities from them. Fairly typical is the story of Freeman Hrabowski, a black twelve-year-old who headed up a line of child marchers in Birmingham during the Children's Crusade. Hrabowski led his column of children all the way downtown to City Hall, where he confronted a surly Bull Connor. To Connor's question, "What do you want, little Nigger?" the child replied, "We want our freedom." Angered by what he took as the insolence of the boy, Connor grabbed Hrabowski and spat in his face.

Hrabowski's parents had long approved of the civil rights struggle and had taken their son to the SCLC's mass meetings in Birmingham to learn about the movement. On the night that their son came to them explaining his desire to join the demonstrations, they worked to convince him that he was simply too young to make such a decision. Freeman called his parents "hypocrites" for thwarting his decision to act on his beliefs and stormed off to bed. Unsettled by his charge and concerned to balance their son's safety with their commitment to social change, the boy's parents stayed up all night debating the issue. In the early morning, they went to their son's room and announced their willingness to let him go.[38] Birmingham's Reverend Calvin Woods was even more active in the movement than the Hrabowskis, having spent time in jail for his protest activities, yet even he sought to keep his youngest children from joining the marches and facing arrest. "They're worrying me to death about going to jail," he reported. But as time went on and the arguments of his children persisted, Woods admitted that he'd "become convinced they are serious and want to bear witness to their demand for freedom, and I'm going to have to let them go."[39] Similar trepidation filled many other black

households in Birmingham, and throughout the South, when children expressed a desire to enter the protest movement.

Bevel and Nash doubtlessly encouraged the participation of children. In their relentless efforts to expand the ranks of the Birmingham protest movement, they targeted student leaders and athletes for recruitment, knowing that such trendsetters would increase the cachet of the movement for other young people. They also enlisted the aid of sympathetic disc jockeys who reached virtually all of the city's youth each day to promote upcoming marches, arranged for screenings of the inspirational NBC documentary *The Nashville Sit-In Story* (1960), circulated countless flyers, and organized mass meetings and workshops for youth. But as David Halberstam explains, Bevel focused his attention on children because he believed them to be less constrained by the economic and social forces shackling their parents and not because they were more malleable recruits. Children were unhampered by the financial considerations or social stigmas that kept many parents from taking to the streets and risking arrest and loss of their jobs for their beliefs. As Halberstam notes, Bevel did not persuade the youths to take stands that were alien to them; he gave them the tools to act on their beliefs, to take ownership of their lives and of the struggle for black rights.[40] In charismatic and fiery speeches, he explained how children could make a difference to their community and their nation, which was a message that the younger generation of blacks eagerly embraced. Bevel did not promise his young recruits glory or even freedom and certainly not adventure, but he offered them the ability to "make witness against the system . . . exposing themselves to danger" and so to save the country through their suffering.[41]

The most compelling evidence that children understood the consequences of their actions is their eagerness to return to sites of conflict—white schools, lunch counters, city buses, and courthouse steps—*after* experiencing the brutality of public safety officials and mobs. Even if one argues that the children could not have fully comprehended the risks of their actions beforehand, their ongoing commitment to the struggle after having suffered both mental anguish and physical injury during the confrontations indicates that their choices were informed. Jennifer Denise Fancher was seven when she participated in the Children's Crusade. In May 1963, she was featured in a lengthy article in *Jet* in which a reporter acknowledged that the girl "doesn't yet know the dictionary definition of the word *segregation*" but assured his readers that she nonetheless had a keen sense of the race-based injustices of her life: "She's tired, dead tired . . . of using second-hand books passed on to her after they've been battered from years of use at all-white schools. She's tired of being scarred and scratched falling on rough gravel streets, simply because there are no parks or playgrounds for 'special' little girls like her. She knows she wants to swim, but is not allowed to because racist Birmingham ruled that the black of her skin didn't match the green, chlorinated waters of the fine pools where whites are

allowed to frolic." Fancher was undaunted by a bite from one of Connor's police dogs during a protest march in early May: "I wasn't afraid when the dog attacked me. I got off the ground and ran to meet mother. She took me to get a [tetanus] shot . . . and took me home. I want to go and sign up again. I want to go back downtown." The day after being mauled, Fancher, the reporter notes, returned to the Sixteenth Street Baptist Church and signed up for another protest march.[42]

A reporter for the *Chicago Daily News* visited Birmingham on Monday, May 6, to observe how the city was coping with the arrests of eight hundred black protestors that day—a figure that then exceeded the single-day record for civil rights arrests in the United States. Because of severe overcrowding, juvenile marchers were processed at the city jail and then bused to barracks at the state fairgrounds. (In an irony noted by at least one child protestor, the fairgrounds and its amusement park had previously been off-limits to blacks.)[43] Even there, space was limited, so many of the hundreds of children had to stand in an uncovered courtyard in the rain. A young protestor told the reporter that hours after their arrests, he and his fellow marchers had not yet been given food or drink, adding, "but we still want our freedom. When I get out I'll start demonstrating all over again."[44] Other children jailed during the Children's Crusade told reporters, "If they let us out we're going right back to the fight and we'll end up here again"; "If my bond is posted for me, I'll refuse to leave. If they make me leave, I'll join the marchers tomorrow"; "They threw me in jail naked; the water tore my clothes off. I'll do it again if I have to."[45] The children now knew precisely what they faced and still chose to continue.

Even if the children held a perfect understanding of the aims and risks of their participation in the movement, most readers will agree that responsibility for their safety rested ultimately with adults (both white and black). Many observers at the time believed that adults had an obligation to protect children and that some decisions were simply too consequential to leave to the young, no matter how nuanced children's understanding of race and the stakes of their activism might have been. The editors of *Newsweek* clearly thought so, suggesting that adults on both sides of the protest erred in their treatment of black children: "If it was wrong for the police to put the children in jail, was it right for the integrationists to start them on their way?" In a similar vein, Robert Kennedy's poignant comment that "an injured, maimed or dead child is a price that none of us can afford to pay" was an apparently evenhanded effort to remind Americans that regardless of where they stood on the political debates of the day, they should remain united in their concern for society's most vulnerable members. While it is legitimate to ask if individual parents and civil rights leaders acted in the best interests of protesting children, I am more concerned in this study to illuminate the consequences of the decisions and actions of those in power.

Readers should not be surprised that white parents were less frequently called to task for

placing *their* children in harm's way during desegregation struggles. Coles spoke with white parents who sent their children to school in the face of angry mobs that sought to shut down or resegregate newly integrated public schools. While these mobs often singled out these white students for particular harassment, rare was the northern liberal critic who faulted the children's parents. As Coles has pointed out, some whites sent their children to integrate schools on philosophical grounds—acting on their religious convictions of equality, commitment to public education, distaste for segregation, or support of integration—but many others left their children in these schools for more mundane reasons—apathy, absence of alternative schools, or a lack of funds for private education. Other parents took things a step further, either through encouragement or acquiescence allowing their children to become part of the threatening mob. As photographs of the pro-segregation demonstrations in Little Rock (see figure 40) and Chicago (see figure 31) famously illustrate, children and youths were dominant players on both sides of racial protest.[46]

If white parents made choices that harmed individual children, elected officials were to blame for damage inflicted on virtually every school-aged child—through their efforts to make political points on segregation, of course, but also through the decisions they made about public education, taxation, and the appropriate roles of the state and federal governments. Harm was done to black and white children by legislators who kept southern public schools chronically underfunded; mayors and city councils who were quick to close public parks, swimming pools, golf courses, and even schools in reaction to court-ordered integration; and the police and courts who, by enforcing Jim Crow laws, prevented millions of Americans from having meaningful social and romantic relationships with members of another race.[47] White parents and public education officials who endangered their children to make political points never faced the degree of criticism that liberal whites leveled at black parents who simply acceded to their children's wishes to obtain a decent education or basic civil rights. When we consider that the assignment of blame is possible only when alternatives exist, we can see the irony of holding responsible the group with the fewest options for placing children at risk.

In chapter 2, we saw that the lack of meaningful contact between whites and blacks severely reduced the possibility for whites to develop intergroup empathy. Without significant egalitarian interactions between the races, even the "progressive" ideological positions held by whites had limited utility to foster meaningful change, since they rested on imaginary foundations. While such progressive positions hold great theoretical appeal, they are based on social relations and beliefs that exist only in the mind of the "progressive" and are thus unlikely to produce change in the real world. In bringing together the testimony of activist children in this chapter, I seek not only to give voice to some of the youths whom John Lewis described as the nameless "faces . . . in photographs in history books" but also to show that such voices were largely absent

from the conversations of liberal whites.[48] Whites could not have concluded that black children were naive and susceptible to manipulation if they had listened to the testimony of blacks; in suppressing black voices in the media, reporters and editors stood in the way of change. The photographs of child protestors that circulated in the white world took on meaning that had little to do with the lives and beliefs of the anonymous children in them. The narratives that animated the images and the solutions they suggested—to the extent that solutions existed—were created in a racial vacuum maintained by whites.

The omission of children's voices per se is unremarkable, given that the reporting practices of even the liberal media served to decontextualize the civil rights struggle. But the absence assumes greater significance when we consider that children—and their photographic representations—stood at the heart of white American conceptions of civil rights.[49] When white Americans in the 1960s conjured up the key moments of the black civil rights movement, they thought of Rosa Parks on a Montgomery bus and the Selma marchers at the Pettus Bridge, but also, significantly, of the *Brown v. Board of Education of Topeka* Supreme Court decision named for the father of seven-year-old Linda Brown in 1954, the lynching of young Emmett Till in Money, Mississippi, in 1955, the integration of Little Rock High School by six girls and three boys in 1957, the sit-ins by four college freshmen in Greensboro in 1960, the murder of four children in the bombing of the Sixteenth Street Baptist Church in Birmingham in 1963, and, of course, the Children's Crusade. Children played key roles in virtually every major event of the modern civil rights movement.

Children were integral to the story of civil rights because of the unique emotional force they exerted on whites. Kids occupy a central place in civil rights history not simply because they joined events that were decisive to the struggle but because they catalyzed otherwise unremarkable protests into emotional and seemingly transformative events. Child protestors could exert this power in society because of the predispositions of whites to see them as innocent and lacking in agency. Such associations established children as the perfect victims, because they fit into the dominant racial dynamic that deemed blameless and submissive nonwhite victims to be most worthy of white concern. Of course, some civil rights protests that featured children garnered little white attention, and others made national news without the presence of kids. Because children were linked in the white imagination to traits valued in black protestors, their presence simply increased the odds of capturing the attention and sympathy of whites. And because child activists appealed to whites for their qualities as children—not for who they were or what they thought—whites found nothing odd in media reports that failed to solicit the testimonies of kids.

The white fixation on the qualities of children provides clues for understanding the handful of important civil rights events that were not explicitly linked to the young. In Montgomery and

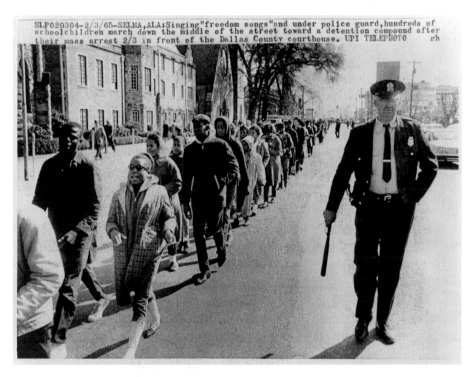

42 Unknown photographer, *Singing "Freedom Songs" and under Police Guard,* Selma, Alabama, February 3, 1965. © Bettmann/CORBIS, Seattle, Washington.

Selma, for example, a perfect storm of conditions aligned to invest black women, and less frequently, black men, with the nonthreatening and sympathetic traits more commonly associated with children. Black children certainly suffered during the Montgomery Bus Boycott, though the white media represented the struggle by photographs of a petite, respectably dressed middle-class woman in glasses (see figure 17) and later, by images of middle-aged and elderly women boycotting city buses and trudging long distances to their jobs in the rain. As I explain in chapter 4, in adhering to patriarchal models of gender as they stoically suffered, the black women of Montgomery exemplified many of the secondary traits whites viewed as admirable in kids.

In Selma, black children did feature in white media accounts of voting rights demonstrations during much of January and February of 1965. Photographs and articles generated white sympathy for blacks seeking franchise by chronicling the mass arrest of thousands of peaceful black schoolchildren (figure 42), many of whom were subject to electric cattle prods, clubs,

forced marches, and deplorable jail conditions at the hands of county sheriffs.[50] But in Selma, as in Montgomery, the climactic moments of the struggle drew more from representations of women than from images of kids. Front-page newspaper coverage of Bloody Sunday showed scores of female protestors, in their distinctive plastic rain hats, felled by clubs and run over by horses. Visible in the much-reproduced United Press International photograph of John Lewis (see figure 1) is a female marcher at left, brought to her knees by the rush of troopers or a blow from a club. The *Washington Post* caption for the photograph says nothing about Lewis's beating, instead focusing reader attention on the woman at the left: "A woman demonstrator has fallen to her knees and a state trooper tugs at another felled marcher as the troopers break up yesterday's Selma rights march."[51]

Many mainstream media accounts of Bloody Sunday noted the injuries of Amelia Boynton, the most important and dogged civil rights activist in Selma and the marcher most frequently named in photographic captions of the melee. The white press showed Boynton in a range of poses that emphasized her role as victim. Such photographs showed her crumpled on the highway median after the first wave of troopers passed, lifted by fellow protestors off the roadway (figure 43), or cradled tenderly in the arms of a sympathetic marcher. In its coverage of the clash, the *New York Times* devoted two paragraphs to Boynton's handling by troopers under the subheading "The Negroes Flee." We learn that in the wake of the troopers' charge, Boynton lay on the highway median, "where the troopers had knocked [her] down." Dazed from blows and tear gas, Boynton failed to leave the highway when ordered to do so by a deputy sheriff. To hasten her retreat, an officer dropped an open canister of tear gas at close range. The *Times* article reports that Boynton and the fallen women around her then "struggled to their feet, blinded and gasping, and limped across the road," before being evacuated to a local hospital. The *San Francisco Chronicle* described its front-page picture of a collapsed Boynton "felled by tear gas" and "comforted by a fellow marcher," while the *Baltimore Sun*'s front-page photograph showed her limp body as she was "aided by two friends after she was injured during the abortive demonstration march."[52]

If whites took black children as the most innocent and inactive members of their race, they understood black women to occupy a middle ground between children and men. As the next most submissive group, women were the next best group for holding the interest of whites. Given this hierarchy, it is unsurprising that whites viewed civil rights events involving children more sympathetically than those involving women and viewed those involving women more sympathetically than those involving men. But the emphasis whites placed on appropriate traits over individual identity theoretically opened the door for any group of blacks to catalyze white attention. To be sure, adult activists had more difficulty stimulating the interest of whites. Because the traits whites ascribed to black children were not deemed innate in adults,

43 Unknown photographer, *A State Trooper Watches Friends Aiding an Unconscious Woman,* Selma, Alabama, March 7, 1965. © Bettmann/CORBIS, Seattle, Washington.

black men and women who wanted to attract white sympathy needed to place themselves in social contexts that highlighted their "childlike" traits.

As we have seen, nonviolent direct action improved the odds that whites would view powerful blacks as inactive martyrs. By encouraging black activists to remain unreactive to white provocations, nonviolent direct action highlighted whites' physical and verbal assaults against blacks. The picture of black inaction and white violence in news accounts and photographs made it safe for northern whites to show interest in the plight of blacks in the South. Most of us can understand how whites' projection of passivity onto nonviolent activists hindered the reach of reform, but a more surprising discovery is that the movement was also limited, and the racial

transformation of U.S. society delayed, by the form of direct action practiced by those in the mainstream of the civil rights movement.

Nonviolent direct action is not a single, monolithic approach to social change. It has a number of distinctive strands. It may work by means of accommodation, producing social conditions that are sufficiently uncomfortable for those in power that they alter policies to accommodate protestors without necessarily being won over to their perspective. It may operate by coercion, implementing such massive and socially paralyzing noncooperation that those in power realize they are losing control and have to alter course. Or it may seek to convert the oppressors to the view of the oppressed, bringing change through the willing cooperation of those in power.[53] King's SCLC overwhelmingly embraced this third approach, seeking to convert white Americans through the middle of the 1960s.

King's aim was to affect the consciences of those with power, for he recognized that no amount of suffering by a numerically inferior group will make a society more just if the group wielding power cannot be moved. Either the powerful must be stirred themselves or a sufficient number of average citizens must be moved that the leaders have to alter course to maintain their popular support. For such protests to be effective, the suffering must gain sufficient publicity to reach a mass audience, and it must cross a threshold in the conscience of the oppressors that convinces them of the need for change. Since those who are oppressed in a society suffer by definition, nonviolent direct action need not create more suffering; it need only make suffering visible and resonant for those in power.[54]

Long before the civil rights movement entered the national white consciousness with the Montgomery Bus Boycott, little-remembered black activists and their white allies used techniques of nonviolent direct action in an effort to change American society. Bayard Rustin, a pivotal figure in American civil rights history, practiced nonviolent protest in the early 1940s, a decade before it gained currency in the mainstream civil rights movement. During a bus trip from Louisville to Nashville in 1942, Rustin bravely selected a seat at the front of the bus in defiance of legal and social restrictions that confined blacks to seats at the rear. When confronted by an angry white bus driver, Rustin explained that any law stipulating that blacks must sit at the back of the bus was unjust and that if he moved, he would be condoning injustice. At one scheduled stop, the frustrated driver called ahead to the police, who eventually stopped the bus on the highway outside of Nashville and ordered Rustin to move.

Rustin gestured to a white child sitting near him and calmly explained to the officers that moving to the back would deprive the boy "of the knowledge that there is injustice here, which I believe it is his right to know." The police responded by clubbing Rustin about the head and shoulders, dragging him off the bus, and continuing to kick and strike him as he lay on the ground. As the assaults ebbed, Rustin stood up, stretched out his arms at his sides, parallel to

the ground in a nonthreatening gesture, and stated in an even voice, "There is no need to beat me. I am not resisting you." At this point, three white southerners got off the bus to defend Rustin and argue with the police. As a policeman raised his club to strike Rustin once more, one of the three whites grabbed the club and shouted, "Don't do that!" The cops eventually bundled Rustin into a car and took him to Nashville for questioning (and more beatings), but not before one of the concerned whites promised to meet Rustin at the station to ensure that he would "get justice." True to his word, the white bus passenger tracked Rustin down just as the prisoner was brought before the assistant district attorney for questioning. Several hours later, Rustin left the courthouse free, "believing more strongly in the nonviolent approach," convinced that "those three men . . . interested [themselves] in my predicament because I had, without fear, faced the four policemen and said, 'There is no need to beat me. I offer you no resistance.'"[55]

Rustin's story—like his life—is inspiring. Remaining true to his belief in nonviolence, he placed himself at grave physical risk to make a point about the injustices of segregation. Yet the obvious effects of his actions were comparatively limited. Only a few dozen people heard Rustin's words and observed his actions; his stand catalyzed no changes in policy or legislation. His "victory" rested in his moral authority and in his ability to arouse the consciences of several whites, who acted in ways that were almost unthinkable in Tennessee in the early 1940s. By "surfacing" the built-in brutality of segregationist structures and by remaining respectful, calm, and nonviolent, Rustin fleetingly created an environment in which average whites felt compelled to act and, perhaps, in which others began to examine their racial beliefs.

Later that year, Rustin joined forces with James Farmer and others to found the Congress of Racial Equality in Chicago. The organization committed itself to ending segregation through Gandhian nonviolent tactics laid out in Krishnalal Shridharani's *War without Violence* (1939). CORE members' collective efforts in direct action in the 1940s and early 1950s achieved a number of targeted victories—breaking housing covenants that excluded blacks from particular houses and neighborhoods, desegregating local restaurants, and drawing attention to segregation in interstate travel.[56] But because their protest actions received modest coverage in the national white press, and so had little chance of resonating beyond the communities in which they took place, the group's successes tended to be local and often only symbolic.[57]

Even in the altered racial context of the early 1960s—with a mainstream media more attuned to racial stories, a vastly greater number of willing marchers, and a white public more sensitized to racial inequities—nonviolent direct action had significant limitations. This became clear to civil rights activists during their lengthy protest struggle in Albany, Georgia. The campaign in Albany was spurred by the organizing efforts of two SNCC activists who arrived in the city in the fall of 1961 intent on politicizing the city's youths, conducting voter

registration workshops, and testing whether local public transportation officials would abide by the Interstate Commerce Commission's recent order desegregating bus and rail facilities. Later that fall, seven black Albany civil rights and social organizations joined with the SNCC workers to form the Albany Movement, an umbrella organization founded to coordinate joint protest activities in the city. Over the next nine months, the Albany Movement and, for a time, King and the leadership of the SCLC staged hundreds of nonviolent direct actions—including marches, sit-ins, freedom rides, pray-ins, and integration efforts in bus and train waiting rooms, libraries, and recreational facilities. The Albany coalition also organized targeted boycotts of local businesses and voter registration workshops. But after months of protests, the city's blacks had attained virtually no concessions from either business leaders or city government. Despite the arrest of hundreds of peaceful protestors and the presence of a large press contingent, white Americans were largely unmoved by the protest actions.

Movement participants and historians attribute the difficulties in Albany to a number of factors, chief among them the political acumen of Laurie Pritchett, the city's chief of police.[58] Pritchett studied *Stride toward Freedom: The Montgomery Story* (1958), King's account of the successful Montgomery Bus Boycott, and used it to counter the impact of nonviolent direct action in Albany. The chief made rental agreements with the sheriffs in adjacent counties to accept Albany prisoners, making it impossible for King to attain his goal of filling city jails, which would have significantly weakened the city's bargaining position. He also assiduously courted the white press, made targeted arrests of protest leaders, practiced discretion in deciding when to make arrests, ensured that his men did not publicly mistreat marchers or prisoners, and, significantly, secured agreement from Burke Marshall, President Kennedy's assistant attorney general, that if he made peaceful arrests, federal authorities would remain on the sidelines. Knowing that arrests for breaking local segregationist ordinances were the least legally defensible, and the most likely to raise the sympathy of northern whites, Pritchett instructed his men to arrest civil rights protestors for loitering, disturbing the peace, parading without a permit, and failing to heed police orders. Pritchett also worked to undermine the campaign from within. When King's arrest at the head of a protest march threatened to bring a flood of new protestors to the city, Pritchett embarrassed King by bailing him out of jail—under the pretense that his bond was posted by an anonymous well-dressed black man who walked in off the street—at a time when the civil rights leader had made a point of choosing "jail, not bail."[59]

Though the Albany Movement had organized a grassroots contingent of hundreds of committed nonviolent marchers who practiced direct action and who suffered physically and materially for their cause, participants accomplished less than they hoped for. Over the course of months, the protestors repeatedly placed themselves in front of the national media, dem-

onstrating the illegality of local public transportation ordinances and voting restrictions as well as the injustices of segregationist laws in restaurants, corporate hiring, and recreational facilities. The common view is that the protests failed to touch the consciences of whites because of Pritchett's refusal to provide the newsworthy spectacles of violence that he and movement leaders believed were key to the success of the struggle. In the simplest terms, one might say that the Albany Movement failed to adequately "surface" for news photographers the racial tensions of black life in the city. As one historian wrote, "In Albany . . . there had been no photos of burning buses or beaten protestors" to sway public opinion.[60] This line of reasoning credits Pritchett with shielding northern audiences from the conditions faced by southern blacks and assumes that documentation of such injustices was the key to engaging whites. But the reality is considerably more nuanced.

Certainly, the conditions of black life were no secret to liberal whites by the early 1960s. U.S. society was awash in historical, literary, and biographical evidence of the violence, racism, and structural impediments that blacks faced. I have cited the clinical work of Robert Coles, *Children of Crisis,* but even more important was the study by the Swedish economist Gunnar Myrdal, *An American Dilemma: The Negro Problem and Modern Democracy* (1944). Myrdal's influential book detailed the myriad social obstacles faced by American blacks, was cited in the Supreme Court's *Brown v. Board of Education of Topeka* decision, and had sold more than a hundred thousand copies by 1965. Other important and widely circulated texts included the federal report that John Hope Franklin authored for the Civil Rights Commission, *Freedom to the Free: A Century of Emancipation* (1963); C. Vann Woodward, *The Strange Career of Jim Crow* (1955); Michael Harrington, *The Other America: Poverty in the United States* (1962); James Silver, *Mississippi: The Closed Society* (1964); John Howard Griffin, *Black Like Me* (1961); Richard Wright, *Black Boy* (1945); Richard Wright and Edwin Rosskam, *Twelve Million Black Voices* (1941); Ralph Ellison, *Invisible Man* (1952); Lorraine Hansberry, *A Raisin in the Sun* (1959); Gwendolyn Brooks, *A Street in Bronzeville* (1945) and her Pulitzer Prize–winning *Annie Allen* (1949); James Baldwin, *The Fire Next Time* (1963); as well as two of King's own books, *Stride toward Freedom: The Montgomery Story* (1958) and *Why We Can't Wait* (1964).

Even network television broadcasts, which were famously resistant to reporting on racially sensitive topics, aired a series of important news programs about violent white reactions to the black freedom struggle and the economic and social realities of black life at the turn of the 1960s. Significant programs included "Clinton and the Law: A Study of Desegregation" (1957) on *See it Now,* "The Nashville Sit-In Story" (1960) on *NBC White Paper,* "Cast the First Stone" (1960) and "Walk in My Shoes" (1961) on *Closeup,* "Harvest of Shame" (1960) on *CBS Reports;* and the CBS documentary *Who Speaks for Birmingham?* (1961). The era's most substantive televised reports on race were two prime-time, multipart documentaries: ABC's *Crucial Sum-*

44 NBC Television Network, *The American Revolution of '63,* September 2, 1963. Publicity still. Library of Congress, Washington, D.C., Prints and Photographs Division, New York World-Telegram and Sun Collection.

mer (1963), which considered racism in the American North and South, and NBC's *The American Revolution of '63* (1963; figure 44), which dealt with black housing, employment, public accommodations, voting rights, education, stereotyping in Hollywood, and the applicability of Henry David Thoreau's philosophy of civil disobedience to contemporary society and along the way showed graphic scenes of white-on-black violence.[61]

Although such sources show that the violence and racism faced by blacks were known to whites in the 1960s, it is important to note that the circulation of photographic, literary, and cinematic depictions of physical and economic violence against nonwhites was not the only means of promoting change. Because thresholds of guilt are socially contingent, members of empowered groups react differently to depictions of violence and inequality over time. For example, photographs of lynchings—even when they depicted compliant victims innocent of any offense— frequently failed to move whites toward guilt and a sense of responsibility. And we know that

the photographs of Elizabeth Eckford (see figure 40)—which are free of physical violence—moved many whites. King often explained that violence was a particularly cogent means of surfacing the injustices of a society, but he was also aware of other ways of achieving this goal.

In *Stride toward Freedom,* King wrote that change would come to America once the oppressor, faced with nonviolent protestors who refuse to submit to unjust laws and practices, became "glutted with his own barbarity" and had his conscience finally awakened. But, he pointed out, this "barbarity" need not be overtly violent to bring the desired change: "Every time one Negro school teacher is fired for believing in integration, a thousand others should be ready to take the same stand. If the oppressors bomb the home of one Negro for his protest, they must be made to realize that to press back a rising tide of the Negro's courage they will have to bomb hundreds more."[62] While white America could see a handful of unjust dismissals or bombings as unfortunate social aberrations that need not arouse great concern, the willingness of protestors to suffer "thousands" of dismissals and "hundreds" of bombings promised to leave whites overwhelmed. Violence remained a particularly potent trigger, but it was not the only "barbarity" capable of initiating change, in King's view.

Members of the public and scholars have placed undue emphasis on violence as the key to the Albany struggle, given the availability of visual and literary texts documenting the injustices of black life in the early 1960s, the range of narratives capable of engaging oppressors, and the episodic success of violent scenes in promoting guilt. In a chilling reproduction of the logic put forth by the most reactionary whites of the 1960s, well-meaning historians have tended to see "violence" as the primary means of solving American problems of race. Even as they condemn the violence itself, progressive academics frequently fetishize its transformative potential. For historical and ethical reasons, the "failure" of the Albany Movement is more revealingly located in the inability of whites to respond to the overwhelming evidence of racial injustice around them than to the absence of photographic scenes of carnage in the streets. King made tactical decisions in Birmingham to promote guilt, not violence per se.

When King acquiesced to Bevel's plan for child marchers, he did so knowing that the "barbarities" his activists had brought to the fore—the jailing of many hundreds of peaceful protestors for demanding constitutional rights, the existence of discriminatory local ordinances that banned blacks from public facilities and businesses and restricted their ability to register to vote, and even the use of police dogs on adult protestors in early April—had failed to dent the consciences of a critical mass of whites.[63] For thirty days, many hundreds of black Birmingham adults engaged in a range of protests and boycotts that the southern press ignored and the northern press buried in stories deep in their papers. Appreciating that the efficacy of nonviolent direct action hinged as much on the reactions of those with power as on the bravery of his activists, King gauged where white America stood and came to meet it there. What those

who lamented the participation of children in Little Rock or Birmingham failed to note was that black children were invariably protestors of last resort. Because whites were unfazed by the obvious injustices of American society and the maltreatment of Birmingham's nonviolent adult blacks, the movement gave them child marchers to make the cruelties of the Jim Crow South more vivid. Whereas the protests by Rustin and CORE moved whites to act locally but rarely garnered the national press required for widespread change, and the Albany Movement secured national coverage but failed to push whites over the threshold of guilt, Birmingham provided both ample coverage and emotion, thanks to the addition of kids.

Reporters who had been disinclined to report on civil rights stories in general, and who were particularly loath to report on events they could not easily plug into their preexisting narratives of black-white conflict, flocked to the scene once children were engaged. Karl Fleming, the veteran *Newsweek* reporter who covered many civil rights events, noted how differently the press reported on civil rights stories in Birmingham from those in Los Angeles. Pointing to the caricatured nature of police brutality in Birmingham, Fleming observed, "You're in Birmingham and here is Martin Luther King on one side and over there was the big, fat, sloppy sheriff with his cigar, dogs, and cow prods. And we wrote our stories like western movie scenarios." Kids versus cops offered just the kind of "good versus evil" drama that the media adored.[64]

While formulaic scenes of youngsters being abused by police and firemen captured the interest of whites, they did not throw light on the historical conditions of black life in Birmingham. They simply tapped into a long-standing white convention for "feeling" black pain. Recall that the captions and articles accompanying the mainstream media's photographs of the melee in May never named the protestors and rarely quoted their opinions. To the extent that civil rights articles in the mainstream press dealt with the activists' grievances, they reduced them to general themes and only infrequently enumerated the protestors' demands. And, of course, the violence in photographs of Anniston, Birmingham, and Selma was virtually interchangeable in its formulaic presentation of victims and perpetrators. For whites, the photographs were generic signs of a type of black suffering that had remained constant throughout much of the nineteenth and twentieth centuries. The addition of children simply upped the ante, tapping into a discourse of sympathy long used by activists with reform agendas—from Abolitionists and Progressives and New Dealers to those opposing the Vietnam War.[65]

Harriet Beecher Stowe famously made the plight of children the heart of her abolitionist novel, *Uncle Tom's Cabin* (1852). The novel presents the poignant drama of children violently taken from their parents, or its threat. Tom is sold away from his wife and kids; Little Eva dies, leaving behind her mother, father, and Tom; Eliza fears her child will be sold away from her; and Cassy kills her third child, unable to bear the thought of losing another to the slave auction. In example after example, Stowe invokes the innocence and helplessness of black children, and the plight of parents unable to protect their offspring, to engender in white readers sym-

pathy for the lot of blacks. In the photographs of Moore, Hudson, and Harris, as in the novel of Stowe, we glimpse little of the black children's thoughts and desires; children are simply the vehicles through which adults play out their emotional dramas and navigate their moral responsibilities.[66] Black children inhabit the novels and photographs of whites to make stark the social relations of the adult world.

King did not deal in fictional characters. The children he led in Birmingham were human beings, but his strategy, like Stowe's, capitalized on the disarming associations and sympathetic appeal of black children to whites. Whites who feared black agency and defined any group of blacks working in concert as a "mob" had difficulty raising alarm over the marches of smiling and laughing children. By the same token, the charge of "black provocation" typically used to disparage black agency and explain white violence failed to resonate with a critical mass of whites in light of the young age of the Birmingham protestors. The criticisms that defenders of segregation and supporters of integration both leveled at Birmingham's black adults for their use of children actually heightened the efficacy of children's participation. In charging that the children were "pawns" and "tools" and that they were "taken" and "used," whites consistently cast the young activists as malleable players manipulated by adults. Since whites found the inactive-active frame to be the most compelling one in civil rights photographs, the more pointed the criticism of black leaders for manipulating children, the more sympathetic the children appeared.

Northern whites reacted in varied ways to the drama of violence against children. As we saw in chapter 2, a significant and vocal percentage inadvertently identified with the southern perpetrators and experienced socially unproductive feelings of shame. But for many of the most liberal whites, who tended to focus on the mistreatment of Birmingham's children, the images placed distance between themselves and the drama's major actors—both white and black. Liberals who criticized both the police who "jailed" the children and the protest leaders who "started them on their way" practiced a moral equivalency in which the violence of whites was as unsettling as the political opportunism of blacks. Through their "evenhanded" disapproval of both sides, these liberal whites held themselves above the fray.

Liberals who failed to identify with either violent whites or politically expedient blacks both aided and hindered the advancement of civil rights. Since they considered themselves neutral observers of the conflict (without the racial investment of shamed whites or radicalized blacks), they had a less personal stake in the outcome of civil rights activism. Whites removed from the racial drama were less threatened by legislative solutions and were confident that problems unrelated to their sense of self might be fixed without impinging on their identity or prerogatives. For whites without shame, the specter of reform did not fuel their racial fears. But just as their distance from violent whites opened them to reform, their detachment from black activists diminished their investment in change. Lacking the political commitments

that come with identification with the cause (for both better and worse), some of the most progressive whites were more complacent than engaged.

The overt aim of the protest movement in Birmingham was to strike at segregationist practices (in custom and law) that were the most visible symptoms of inequality in both the South and the North. As King concluded during the Montgomery Bus Boycott, the "purpose of segregation was to perpetuate injustice and inequality," not to keep the races apart.[67] Ironically, in crafting a protest that appealed to whites in the North, the organizers developed a program that allowed northern whites to solidify their supposed distinctiveness from southern whites without building their identification with southern blacks. Given that racially oppressive systems rest partly on perceptions of racial difference, the liberal white response to Birmingham inadvertently reinforced harmful racial divides. Much as the editorial decisions of liberal newspaper and magazine editors in the North limited the potential reforms of civil rights photographs, so the organizational decisions of King and the SCLC in Birmingham guaranteed that incremental change, brought by the noblesse oblige of northern whites, was the best outcome they could achieve. Only a frontal assault on white identity could bring the systemic changes needed to radically overhaul American society, but since such an approach had no chance of garnering significant white support, activists had to adopt strategies that focused on piecemeal change.

At its core, the nonviolent direct action that King practiced in Birmingham was limited by whites' values. Taking his lead from Gandhi, King privileged a strain of direct action that sought to convert the oppressor through nonhumiliating tactics; as he repeatedly stated, he wanted to win over oppressors in a battle that would have no losers.[68] Because this brand of protest worked only if it compelled oppressors to see the distance between their actions and their values—and to take or allow corrective action—the best possible outcome was the emergence of a society that embodied the highest values of the group in power. Unlike in India, where a foreign, numerically inferior group was convinced to leave, nonviolent direct protest in the United States had no chance of precipitating white withdrawal and had to focus on changing whites' treatment of blacks.

All movements for social change, regardless of their tactics, must build new social models from the flawed ruins of previous orders. But both violent revolutionary struggles that overthrow old regimes and coercive nonviolent movements that cripple the power of existing ones are better able to build new societies than are domestic nonviolent struggles that hope to convert those in power. The activism of the 1960s did not produce a racially just society largely because of the imperfect tactics black activists had to adopt to reach whites and the limited imaginations of many white allies who chose "practical" paths of reform that reinforced shopworn racial hierarchies and stereotypes, but also because of the less-than-ideal values held by

whites. A "perfect" nonviolent direct action campaign that works through conversion can take society no further than the conscience of the majority allows. Nonviolent conversion is not a route to racial justice per se but a path to the kind of society valued by those in power. While the gains attained by American blacks in the early 1960s through nonviolent direct action were undeniably great, King came to appreciate the limitations of his approach.

As the decade wore on, King gravitated increasingly toward direct action that was both more coercive and that promised to provide blacks with direct access to economic and political power. While maintaining a steadfast commitment to nonviolence, King broadened out from his early focus on dramatic sit-ins and protest marches in the South, which were staged largely to move liberal whites, to focus on rent strikes, boycotts, voter registration drives, and community-organizing drives in the North, which were equally concerned with the direct empowerment of blacks. King concluded, after years of listening to the arguments of Bayard Rustin, that the inequalities plaguing blacks required a frontal assault on the institutions of American society. Relying on sympathetically aroused whites to initiate significant reform was a plodding process that produced limited and haphazard results. As Rustin sagely noted as early as 1964, "Neither racial affinities nor racial hostilities are rooted [in the white conscience]. It is institutions—social, political, and economic institutions—that are the ultimate molders of collective sentiments. Let these institutions be reconstructed *today,* and let the ineluctable gradualism of history govern the formation of a new psychology."[69]

Period observers and historians have tended to view King's activism in the second half of the 1960s as his least successful. Moving his activities to northern communities complicated King's relationship with liberals in the region and presented him with inequalities that were harder to dramatize in front of news photographers and reporters; his focus on economic issues (and his condemnation of U.S. military involvement in Vietnam) failed to build a coalition with working-class whites and alienated many middle-class liberals; and during this period, his appeal to the most disempowered blacks was eclipsed by younger, more radical voices in the SNCC, the Black Panthers, and the Nation of Islam. By the time of his assassination in 1968, many whites and blacks had already pronounced him irrelevant to civil rights. While King's northern campaigns indeed "failed" to bring about rapid change and he lost many former white allies who had been moved by struggles in the South, King deserves credit for attacking the structural barriers standing between blacks and their rights. In confronting the most consequential impediments to black equality, his short-term failure provided a blueprint for future systemic change.

4 THE LOST IMAGES OF CIVIL RIGHTS

I wonder, God knows I wonder, what you [white people] think when you look at your papers and see the pictures of police dogs tearing at the vitals of Negroes (children included). You call this the land of the free? . . . Tell that to the children brutalized by the dogs and the Ala. Gestapo; tell it to the Negro woman with the Birmingham Storm Trooper's knee on her neck.

RUSSELL MEEK, LETTER TO THE EDITOR, *CHICAGO DAILY DEFENDER*, MAY 13, 1963

A survey of newspaper and magazine photographs taken in the 1960s reveals several narratives of the civil rights movement. Before the codification of the visual canon with which we are now familiar, the media depicted the civil rights struggle in distinctive ways for different readerships.

The journalist and historian Diane McWhorter recounts that when photographers for the *Birmingham News* brought back dramatic photographs of Connor's dogs and fire hoses in action in early May, the editor buried them in his desk. In contrast to northern newspapers, which featured such scenes on their front pages, the *News* ran its story inside the paper with none of the dramatic pictures.[1] This decision was hardly surprising. In the early 1960s, southern white papers enforced strict codes in their reporting on black life. Blacks received prominent coverage only in articles on crime, which consistently noted the race of nonwhite perpetrators. Virtually all other news reports on blacks were segregated in weekly or monthly "Negro news" pages that reported solely on community social events and familial milestones.

Northern white papers reproduced the dogs and fire hoses on their front pages once children were involved, but as we have seen, the photographs hewed closely to a narrow visual and ideological range deemed acceptable by liberal whites. Photographs and news reports that reinforced black passivity, white control, ideological divisions among whites, and the supposed social and cultural distance between blacks and whites crowded out images and articles that promoted competing narratives. In their efforts to create imagery of blacks that diffused

nonwhite challenges to the racial status quo, white media outlets in both the South and the North ignored many alternative accounts of the struggle for civil rights. The white southern impulse to boycott most scenes of black protest differed only in degree from the northern white inclination to marginalize images depicting black agency. Partly because of an altruistic desire to bring positive social change, liberal media outlets in the North censored "unappealing" narratives of black life.

Whereas the first three chapters use iconic civil rights scenes to explore the racial investment of whites, this chapter explores what the many visual absences in civil rights reporting reveal about whiteness. It considers the social contexts militating against the inclusion of particular photographs and narratives in canonical accounts of the struggle; why newspapers and magazines serving northern white readers omitted some of the most graphic scenes of white-on-black violence; and why certain photographs depicting peaceful black protest were presented in ways that excluded them from the civil rights canon. A review of the missing images, which could have expanded the picture of the black freedom struggle, is ultimately as revealing of white values as the endlessly circulating iconic scenes of civil rights.

In the spring of 1963, the country's largest-circulation black newspapers—the *Afro-American (Baltimore, MD), Chicago Daily Defender, Los Angeles Sentinel, New York Amsterdam News,* and *Pittsburg Courier*—and the national black magazines *Ebony* and *Jet* each published a dramatic United Press International (UPI) photograph of three white policemen arresting a black woman during the Children's Crusade in Birmingham (figure 45).The photograph is a closeup of Ethel Witherspoon lying supine on a sidewalk as two officers work to restrain her arms and a third kneels on her throat.[2] The *Amsterdam News, Chicago Daily Defender,* and *Sentinel* all published the photograph on the front page to illustrate their stories on Connor's violent assault on Birmingham protestors.

The *Amsterdam News* caption said, a "Negro woman is forcibly subdued by police officers recently after she refused to be taken into custody peacefully." The *Sentinel*'s reporter provided a more expansive explanation of the violent scene: "It was taken in Birmingham, Ala., in 'South' America, currently the foremost civil rights battle-ground. In the photo, you see one, lone Negro woman. She lies flat on her back. Three white Americans, wearing police guns and uniforms, are holding her down, flattening her body to the earth. One cop is kneeling in her chest and shoulder. This is first-division, championship degradation. This is segregation gone stark-raving mad. This is manliness and chivalry stabbed in the back by the most cowardly human beings alive. I have not seen such a revolting photograph, nor heard of a more revolting incident, since 19 Fort Worth cops went into action with guns to subdue one mentally-deranged Negro man."[3] Writing in 1964, the black reporter Simeon Booker credited the photograph of Witherspoon with being one of two images (the second being Hudson's photograph

45 Unknown photographer, *Arrest of Ethel Witherspoon, Birmingham, Alabama,* May 6, 1963. UPI Telephoto, © Bettmann/CORBIS, Seattle, Washington.

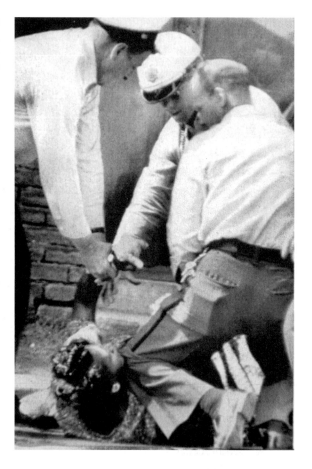

of Gadsden) that "turned the tide" in the Birmingham struggle. *Ebony* informed readers that this powerful "picture appeared on [the] front page of many American newspapers."[4]

Although the photograph appeared on the front pages of many black American newspapers, I have been unable to locate a single white newspaper that printed the photograph on its front page. It was not published—on the front page or elsewhere—in the *Boston Globe, Brooklyn Eagle, Chicago Tribune, New York Post, New York Times, New York World-Telegram and Sun, Los Angeles Times, San Francisco Chronicle, San Jose Mercury News, Washington Post,* or in the mainstream newsmagazines that covered the era's racial debates, such as *Life, Look, Newsweek,* or *U.S. News & World Report.* A different photograph of the arrest appeared on the inside pages of a handful of lesser-known white dailies, but the only large-circulation periodical that depicted Witherspoon's struggle on the ground was *Time.*[5]

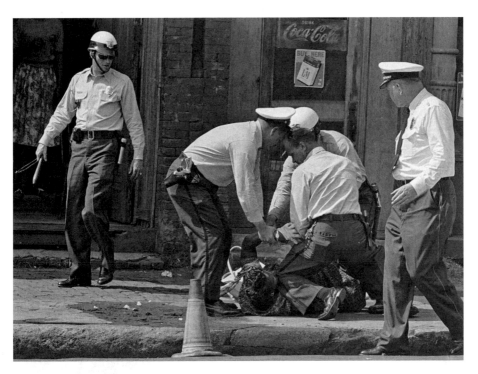

46 Unknown photographer, *Police Use Force: Three Policemen Restrain a Negro Woman on the Ground after She Failed to Move On as Ordered, Birmingham, Alabama,* May 6, 1963. AP/Wide World Photos, New York.

Time used an Associated Press photograph showing nearly the same moment of the arrest from a more distant vantage point than the photograph reproduced in the black press (figure 46). The accompanying article made passing reference to the photograph, noting, "There was the Negro woman pinned to the ground by cops, one of them with his knee dug into her throat." The caption states simply, "Birmingham Cops Manhandling Negro Woman."[6] The distinctive framing of *Time*'s photograph of Witherspoon's arrest provided both more and less context than did the version in black periodicals. More of the street scene is visible in *Time*. We see standing policemen on the right and left bracketing the huddle of arresting officers who squat and kneel in front of the door of a redbrick storefront. Cigarette and soft drink advertisements are legible above the central figures in the background, as are the legs and torso of a black woman in a doorway on the left.

While *Time*'s photograph provides more details on the setting of the confrontation, it also distances viewers from the violence of the arrest and the social dynamics of the scene. The

viewer cannot determine the sex and class standing of the figure flattened against the sidewalk or decipher the tangle of arms and legs at the center of the photographic frame. In providing additional visual details of the street, the *Time* photograph abstracts and depersonalizes the violence of the arrest. The textual and visual details "missing" from *Time* were of keen interest to black publications. Not only did *Jet* reproduce the same closeup UPI photograph found in other black periodicals, but it framed it within a sequence of shots documenting events before and after the struggle on the ground. As the captions in *Jet* explained, the first image illustrates "a neatly dressed Birmingham woman" who was "wrenched from a front porch and dragged into the street." The second shows her "hurled to the ground by force and pinned by a knee on her neck," while the third captures her as she is "pulled away in handcuffs . . . by one of three policemen."[7] Hudson's photograph of the young Gadsden was the most frequently reproduced photograph of the Birmingham campaign in the white press but appeared in just a few black publications; in turn, the UPI photograph of the three cops manhandling Witherspoon was the most reproduced photograph of the Birmingham campaign in the black press yet was essentially absent from white accounts of the conflict.[8] The most "revolting photograph" that the *Sentinel* reporter could imagine was not deemed newsworthy by whites.

Determining more than forty years after the fact why whites were reluctant to reproduce a particular image presents obvious challenges. Images absent from the photographic record tend not to leave the documentary trail produced by widely circulating photographs. Yet textual clues in the black press hint at the "problem" the photograph posed to whites. White reporters almost certainly created both the AP and UPI photographs and their descriptions, given the unlikelihood that a black reporter could have moved freely through the streets of Birmingham during the confrontations of early May and considering that the overwhelmingly white pool of photographers working for photographic services in the early 1960s were usually expected to submit captions with their work.[9] The *Amsterdam News* reprinted what it termed the photograph's "published caption," which described that the woman "refused to obey [police] orders" and be taken "peacefully" into custody. The caption for the photograph in the *Pittsburgh Courier* also claimed that Witherspoon "refused" police orders. Echoing this theme, *Ebony*'s caption printed the police claim that she "resisted arrest."[10]

The text describing the woman's spirited resistance is reinforced by the visual evidence that three police officers were needed to subdue her. The white photographer's characterization of Witherspoon as someone who resists authority clearly resonated with black editors, for not only did they reproduce the photograph and caption but they consistently highlighted the struggles of women against the police. Three weeks before the events in Birmingham became national news, *Jet* documented the arrest of other female protestors in the city. Two pendant photographs taken in April show a woman marching in handcuffs and high heels under a

47 Unknown photographer, *Woman Resisting Arrest,* Birmingham, Alabama, April 14, 1963. Michael Ochs Archives/Getty Images, Los Angeles, California.

police escort and a second woman vigorously resisting arrest (figure 47). The caption for the pair of photographs explains, "Though women were targets of much rough handling by police, one went down swinging, with five cops needed to subdue her."[11]

Interestingly, while white publications in the North shunned such complicating photographs, and mainstream white periodicals in the South were loath to devote space to scenes of black political protest, reactionary segments of white southern society seized on incidents of black women resisting arrest as evidence of all that was wrong with the civil rights movement.

48 Unknown artist, cover of *The True Selma Story: Sex and Civil Rights,* 1965. Esco Publishers, Inc. Collection of the author.

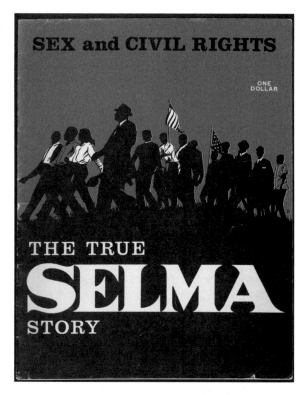

Albert "Buck" Persons, a journalist and former *Life* stringer, wrote *The True Selma Story: Sex and Civil Rights* in 1965 (figure 48). He researched and wrote the single-issue magazine while he worked for Alabama's segregationist Congressman William Dickinson, and the publication was distributed by the white supremacist National States Rights Party. With high production values and well-written text, the magazine enjoyed strong sales among southern whites, who appreciated its forceful attacks on King for his Communist sympathies and philandering; on Bayard Rustin, for his homosexuality; and on the Selma marchers, for their debauchery. According to a 1965 article in the *New York Herald Tribune, The True Selma Story* was the best-selling publication in Alabama that year.[12]

The True Selma Story included a sophisticated critique of the subjective use to which reporters and their editors at *Life* and *Time* put images of the Birmingham campaign. In the essay "How 'Images' Are Created," Persons analyzed various photographs from Birmingham—some that appeared in *Life* and *Time* and others that the magazines excluded—to show how liberal white publications constructed a false picture of "vicious police dogs" and "thug cops" arrayed against

"bleeding Negro children."[13] The essay features a photograph that the author took of Wither-spoon struggling with police. After noting that his photograph of the scene is "almost identical" to the version in *Time*, Persons provides context not reported in the mainstream press. According to his eyewitness account, the woman depicted in *Time* "came out of the doorway in the back-ground . . . spat in [a policeman's] face and struck at him. She is a very large woman. She fought and fell to the ground. She also took a large bite out of the leg of the squatting policeman. Several other officers came to his assistance. It took four to subdue her—without hurting her."[14]

On the opposite page, Persons reproduced a photograph of a second disturbance caused by a black woman in Birmingham. This image shows a different moment in the struggle of the unnamed woman seen in *Jet* (see figure 47). In Person's version, a cluster of police officers sur-rounds a solid woman who walks down the center of a street as she struggles to break free from the grip of five officers. The woman wears a dark form-fitting dress, which the tussle has evi-dently forced up above her knee, exposing a band of lacy white girdle. The caption informs readers, "The woman in the picture above was drunk on Easter Sunday afternoon in Birming-ham in 1963." We learn that during an "explosive" situation in which the police were surrounded by "more than a thousand" protesting blacks, "the woman in the picture struck out of the crowd at a police officer. He went after her. She fought. It took the five policemen pictured here to get her into a wagon and off to jail—without hurting her."[15]

We need not settle the debate about whether Witherspoon or the women in *Jet* and *The True Selma Story* were victims of police brutality who engaged in self-defense or violent ag-gressors who sought to harm and provoke restrained southern officers. We can simply acknowl-edge two points: to black publishers and readers, the understanding that black agency was both the ultimate goal of the movement and the means by which it would be achieved made scenes of black resistance to capricious white power worthy of circulation; and to white liberals and conservatives, the key point was that the women had acted in ways incommensurate with the "appropriate" passivity of well-behaved blacks. This belief encouraged liberal publications to avoid such images and conservative ones to reproduce them. Whereas the inactive-active opposition structured the emotional and intellectual response of whites to photographs of dogs and fire hoses, it effectively prevented the white public in the North from confronting disturbing photographs of women resisting arrest. In their efforts to promote "aesthetic" and "sympathetic" portrayals of black protestors for readers, white reporters and editors either excluded or marginalized images that showed blacks exerting power. As a result, the burden of building white support for a more equal distribution of power ironically rested dispropor-tionately on images that downplayed signs of blacks actually exercising such power.

Debates about the propriety of female protestors' actions were animated primarily by competing ideals of gender. Dominant standards in early 1960s America expected middle-class

white and black women to dedicate themselves to the cult of motherhood, subordinate personal needs to those of their families, distance themselves from political struggles, and support patriarchal power. They were to be demure, chaste, apolitical, and passive. Betty Friedan famously documented the limited range of options available to women in America of the late 1950s and early 1960s in *The Feminine Mystique* (1963). Her wide-ranging study marked the distance between the desire of women for personal, intellectual, and professional fulfillment and the acceptable roles available to them in mainstream society. In documenting the disenfranchisement of women from the political sphere, Friedan specifically noted the degree to which reporters and editors then deemed the "woman's world" incompatible with the politics of civil rights activism. For female activists who were black, the societal pressures to conform to dominant norms were even more pronounced than those outlined in *The Feminine Mystique*. In addition to grappling with the general societal expectations of passivity and political disengagement, black women had to navigate powerful racial stereotypes that imagined their sexually provocative and emasculating natures.[16]

In the 1950s and early 1960s, unsympathetic observers seized on activists' deviations from norms of gender (and of race, sexuality, class, and free-market capitalism) to discredit claims for civil rights. In response, movement leaders encouraged protestors to conform to most dominant ideals of identity. In early sit-ins, protest marches, freedom rides, and acts of civil disobedience, they urged the activists to display "Sunday best" dress and comportment. Rosa Parks was actually the third Montgomery woman to refuse to give up her seat on a public bus in 1955, but historians note that E. D. Nixon, the former president of the local NAACP chapter, deemed the first two insufficiently conventional in their class and gender standing to provide good test cases for civil rights court challenges. The first woman reportedly had resisted arrest and was an unmarried pregnant fifteen-year-old; the second lived in an unkempt shack with an alcoholic father. The NAACP judged Parks an excellent plaintiff because her appearance of propriety ensured that her legal and ethical claims would not be lost in debates about her moral character.[17] Protestors who appeared to uphold the gendered status quo were much more likely to move whites. By adhering to many of the key markers of dominant American identity while challenging the racial hierarchy, protestors presented less of a threat to mainstream society.[18]

In describing the photographs of women resisting arrest, *Jet* noted that the women were "neatly dressed" and "wrenched from a front porch." The "neatness" of dress signaled the dignity and decorum of the protestor, just as mention of a "front porch" conjured images of a mother or daughter violently pulled from the domestic sphere and cast into the public street. The *Sentinel* pointed out that such women were not criminals with intent "to kill, maim, or steal" but honest people "seeking . . . constitutional rights."[19] Reversing the tables on whites, who reporters knew would question the femininity of women who resist, many in the black press noted the ways in which white officers departed from norms of masculinity. The *Sentinel* reporter commented that

"this is manliness and chivalry stabbed in the back by the most cowardly human beings." An article in the black newspaper the *Tri-State Defender (Memphis, TN)* mocked Birmingham's police officers as "Brave men, armed with billies and guns. Brave men mounted on horses. Brave men sitting in cars. Brave men holding great hungry, child-eating dogs, straining at their leashes."[20] *Jet* questioned the officers' masculinity both by drawing attention to their "rough handling" of women and by emphasizing that it took "five cops . . . to subdue" one of the female protestors. In a similar vein, the caption for Witherspoon's arrest photograph in the *Pittsburgh Courier* read, "STRONG WOMAN—A powerful police officer thrusts his knee into the chest of a negro woman as two other Birmingham policemen wrest her to the ground."[21]

Persons's account predictably focused on the aberrance of women engaged in protest. In his telling, the women strike out at policemen without provocation and struggle against male authorities. Before we learn anything else about the black woman under arrest in the second Persons photograph, we are informed that she was "drunk on Easter Sunday."[22] On the most solemn day in the Christian calendar, and the Sunday on which King was arrested for ignoring a State Circuit Court injunction barring marches and protests in the city, the pictured woman chose to drink. The stereotypical black woman of the conservative white imagination is violently aggressive, intemperate, and unresponsive to white patriarchal authority, and she at times displays hints of unrestrained sexuality. Her failure to display traits of middle-class femininity made it easier to dismiss claims for her constitutional rights.

The degree to which determinations of Witherspoon's "propriety" drove white media decisions about how or whether to represent her arrest is suggested by the publication history of a much more famous photograph of a black woman struggling against the police. During a voting rights drive a year and a half after Witherspoon's arrest, Annie Lee Cooper was wrestled to the ground by deputy sheriffs in Selma, Alabama, and struck repeatedly on the head with a billy club by Sheriff Jim Clark. Most illustrated articles on the attack used a detail of a photograph taken by Horace Cort for the Associated Press (AP; figure 49). The published image of Cooper's fight shows an uncanny formal resemblance to the photographs of Witherspoon's struggle. In both instances, a black woman lying on her back resists a cluster of officers intent on making an arrest; while several officers work to restrain the woman's arms, one is glimpsed in the midst of a violent attack. Yet, despite the visual similarities of the two photographs, their publication histories present a study in contrasts. While the image of Witherspoon was nearly absent from the northern white press, the photograph of Cooper was front-page news in virtually every white daily in the North.

Mainstream descriptions of the two arrests correspond on most key points: the media consistently described the events as the manhandling of a black woman participant in a civil rights demonstration by a group of white policemen. The one significant variable in media coverage was the reported conduct of the women. Whereas Witherspoon was an assertive

woman who "resisted" police orders, Cooper was an aggressor who instigated the "attack."[23] The headline in the *Washington Post* read "Woman Slugs Sheriff," and the article reported, "Negroes seeking to register as voters lined up today [at the county courthouse in Selma] without interference from Sheriff's deputies, but one woman was jailed for slugging Sheriff James G. Clark." The *Los Angeles Times* explained to readers that Clark was "attacked" by "a 226-pound Negro woman [who] smashed him twice in the face." In the *San Francisco Chronicle,* Cooper "stepped out of the voter registration line" to hit Clark; in the *Baltimore Sun,* she "jumps out of long [registration] line, hits sheriff"; and in the *Hartford Courant,* "without warning" she "stepped out of the line and struck Clark in the left eye." Most white accounts stressed Cooper's large size and her decision to abandon her place in line in order to strike at Clark without cause. Notwithstanding the visual evidence of the photograph, its captions challenged any easy determination of the scene's depicted victim, noting that Cooper "bites and fights" and that Clark "tries to take back his billy club from Mrs. Annie Lee Cooper as she grapples with policemen."[24]

For white Americans, neither the photograph of Witherspoon nor the one of Cooper fit neatly into one of the dominant narratives of civil rights. Witherspoon's resistance to authority prevented the photograph from generating the level of white sympathy famously produced by the published images of Moore and Hudson. While whites would have recognized the image as a scene of civil rights protest, it did not read as a typical or useful image of the struggle. Given the many photographs then pouring out of Birmingham that more perfectly depicted the preferred white-black dynamic, whites had little need to see Witherspoon's arrest reproduced. Northern whites deemed the image of Cooper to be even more out of synch with the civil rights ideal, but this distance, paradoxically, made the image more appealing to reproduce. The photographs and captions of Cooper's struggle depicted a violent and aggressive black woman, who preferred striking the sheriff to registering to vote. Seeing the incident as more amusing than threatening, *Newsweek* quipped, "Mrs. Cooper wheeled on Sheriff Clark . . . and landed a solid, non-violent overhand right to his left eye," and *Time* joked that she "twice walloped Clark solidly and appeared to be outpointing him until three burly deputies came to his aid."[25] Because Cooper's photograph diffused the gravity of denying a citizen's voting rights, reinforced a timeworn stereotype of the explosive and unpredictable black female, and made the scene's white-on-black violence appear understandable, its reproduction posed no symbolic or practical threat to whites in the North.

Determinations of black decorum help explain both the reticence and eagerness of white media outlets to circulate particular images of black women manhandled by law enforcement officers; but explanations that focus exclusively on the actions of black protagonists cannot account for all the "missing" scenes of civil rights. We have seen the central role black children

49 Horace Cort, *Dallas County Sheriff Jim Clark Uses His Billy Club on Black Woman,* Selma, Alabama, January 25, 1965. AP/Wide World Photos and Horace Cort, New York.

played in the Birmingham campaign, through prompting white interest in the black freedom struggle and inviting perceptions of their innocence and vulnerability. Yet though virtually every white periodical in the North wrote about the harm suffered by the young marchers of the Children's Crusade, printing many accounts of attacks by dogs and fire hoses, virtually none published photographs that visualized the violence described in the text. The few pictures of young Birmingham marchers that were reproduced in the white media showed kids being detained in police holding cells, marching under guard to chartered buses for transport to jail (figure 50), or occasionally, taunting police. I can locate no photographs in the mainstream press of a child battered by a water hose and have found just one image showing a child bitten by a dog. The lone dog attack is, of course, the previously discussed photograph of Gadsden; yet with its depiction of a male victim who weighs 168 pounds and stands six feet tall, it is an exception that proves the rule.[26] White newspapers did not photographically document the arrest of fourteen-year-old Dorothy Yarborough, who was thrown naked into jail after fire hoses ripped off her clothing, or show seven-year-old Jennifer Denise Fancher being bitten by

50 Bill Hudson, *Policemen Lead a Group of Black School Children to Jail,* Birmingham, Alabama, May 4, 1963. AP/Wide World Photos and Bill Hudson, New York.

a police dog and rushed to medical care.[27] While photographs of southern policemen's most violent assaults on black youths survive in the archive (figure 51), they cannot be found in white media accounts of civil rights.

The absence of images depicting brutalized black children is not an anomaly of the Birmingham campaign; it is a general feature of the photographic canon of the civil rights movement. In theory, the appeal of juxtaposing the inactive and active should have ensured that depictions of the weakest and most submissive victims facing the most brutal and active aggressors would be the most effective images to catalyze white interest. Yet the innocence and vulnerability that whites ascribed to black children was insufficient to ensure the preservation of images of their physical abuse in the visual record of mid-twentieth-century America, never mind to secure the iconicity of such scenes. The idea of child victims both attracted and repelled white Americans: as we have seen, such scenes generated immediate interest, given the extent to which kids resonated as the "perfect" victims, but they also produced profound discomfort, given the racial identification that whites felt with the perpetrators of violence. Alongside the altruistic desire of liberal white editors to reproduce only those images best suited to (safely)

51 Unknown photographer, *Police Breaking Up Civil Rights Demonstration,* c. 1963. Photographs and Prints Division, Schomburg Center for Research in Black Culture, The New York Public Library, New York, Astor, Lenox and Tilden Foundations.

advance the cause of black rights was a more selfish need to quash those photographs that reflected poorly on their race. Liberal whites were ultimately as invested in the "appropriate" depiction of white roles as in that of black roles within the canon of civil rights.

The paradox is not simply that the idea of suffering black children was of greater interest to whites than visual evidence of their plight but that the modern civil rights movement was grounded on the *un*represented body of a black child. Reporters and scholars have routinely credited outrage about the 1955 kidnapping, torture, and murder of the fourteen-year-old Chicago boy Emmett Till, near Money, Mississippi, with sparking the modern civil rights movement. Amzie Moore, a pioneering civil rights activist, deemed Till's murder the "best advertised lynching" he had ever heard of and credited it with "beginning . . . the Civil Rights Movement in Mississippi."[28] David Halberstam deemed the killing an "event that . . . galvanized the national press corps, and eventually the nation" and asserted, "The murder of Emmett Till and the trial of the two men accused of murdering him became the first great media event of the

52 Unknown photographer, *Mamie Bradley and Her Son Emmett Till*, Chicago, Illinois, 1955. Library of Congress, Washington, D.C., Prints and Photographs Division.

civil rights movement."[29] Given the importance of the Till murder to the history of civil rights and the absence of visual representations of the boy's suffering in the white press, analysis of the coverage of his death provides insights into the complex symbolic work that black children performed in the white imagination.

Till was killed during a summer visit to his great-uncle, Mose Wright, in rural Mississippi. The boy's mother, Mamie Bradley sent him south from Chicago (figure 52) after consenting to Till's request to spend two weeks visiting his relatives in her native state. The murder was precipitated by a verbal exchange between Till and Carolyn Bryant, a white woman working the counter at a local general store. While the precise nature of the interaction has long been in dispute, the most plausible reports have the boy showing off to his black friends by saying "bye, baby" to Bryant as he exited the store. Whatever his words, he clearly acted in a way that upset the rigid racial etiquette then enforced by whites in the deep South. Several days after the incident at the store, Till was abducted late at night from his great-uncle's home by the woman's husband, Roy Bryant, and her brother-in-law, J. W. Milam, who sought "the nigger who did the talking."[30] The men then tortured Till for hours in a nearby barn, shot him in the head, stripped him of his clothing, and dumped his body into the Tallahatchie River, weighted down with a massive cotton-gin fan secured with barbed wire to his neck. His partially submerged and decaying corpse was found three days later with an eye hanging out of its socket, dramatic skull fractures, and a broken femur and wrists.[31]

The Till story was front-page news in black newspapers within days of the boy's abduction and grew into the most important news story of the 1950s. After the discovery of the body on

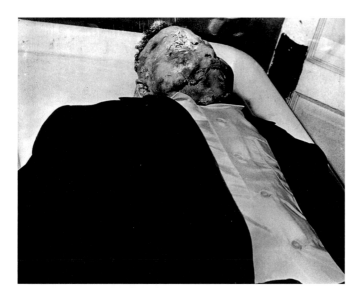

53 Unknown photographer, *Mississippi Shame,* Chicago, Illinois, September 1955. Used with the permission of the *Chicago Defender,* Chicago, Illinois.

August 31, the *Chicago Defender* ran thirty-two stories on Till during September alone. While white coverage was not nearly as extensive, northern white newspapers covered the story as soon as news of Till's abduction became known and increased their coverage when his mutilated and decomposing body was found and his funeral was held. White interest peaked with the trial and subsequent acquittal of Milam and Bryant by an all-white, all-male jury. White newspaper and magazine coverage of the Till murder was then unprecedented for the murder of an American black.

As is famously recounted, Till's mother insisted on an open-casket funeral in Chicago, against the demands of Mississippi authorities and the advice of her South Side funeral director. Bradley was determined that the world "see what they did to my boy." As she explained to a rapt audience in October 1955, "As long as we cover these things up, they're going to keep on happening. . . . The more people that walk by Emmett and look at what happened to this 14-year-old boy, the more people will be interested in what happens to their children."[32] Emmett's severely swollen and mutilated head was viewed by tens of thousands of mourners during the five days Bradley allowed for viewing and by millions more through circulating photographs taken by members of the black public and press.

Depictions of Till's corpse and/or open casket appeared in the following black newspapers and periodicals in either September or October of 1955: *Afro-American (Baltimore, MD), American Negro, Chicago Defender* (figure 53), *Crisis, New York Amsterdam News, Michigan Chronicle, Pittsburgh Courier, Philadelphia Tribune,* and, most famously, in back-to-back issues

54 David Jackson, *Closeup of Lynch Victim, Emmett Till,* Chicago, Illinois, September 1955. Johnson Publishing Company, Chicago, Illinois. Collection of the author.

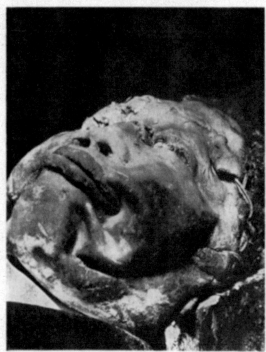

Close-up of lynch victim bares mute evidence of horrible slaying. Chicago undertaker A. A. Raynor said youth had not been castrated as was rumored. Mutilated face of victim was left unretouched by mortician at mother's request. She said she wanted "all the world" to witness the atrocity.

of *Jet* magazine (figure 54). Shortly after the funeral, additional photographs of Till's murder trial and corpse appeared in a self-published booklet by the pioneering black civil rights photographer Ernest C. Withers, who marketed it through the mail to black households (figure 55).[33] As is well documented by historians, photographs of Till aroused an outpouring of anguish and activism from blacks, particularly from young people in their teens or twenties. We have poignant testimonies on the depth of emotion generated by the images in the young Cassius Clay, Lew Alcindor (Kareem Abdul-Jabbar), John Edgar Wideman, Eldridge Cleaver, Anne Moody, and scores of others.[34] So important was Till's death for galvanizing black activism that a number of observers and scholars have labeled the youths radicalized by the photographs the "Emmett Till Generation."[35]

 Whites experienced the murder in different ways. The killing was emotional for sympathetic whites, making them feel, variously, disgust, anger, guilt, and shame. But whereas virtually every

55 Ernest C. Withers, *Complete Photo Story of Till Murder Case,* 1955. Booklet. Special Collections, University of Mississippi Libraries, Oxford, Mississippi. © Ernest C. Withers Estate, Panopticon Gallery, Boston, Massachusetts.

black American took the murder as a personal threat, understanding the race-based killing as an example of the dangers all blacks faced, whites experienced it as a sad, impersonal event. Much as with the white reaction to the use of attack dogs and hoses on black children, the Till murder elicited little fear in white Americans. Their response was conditioned by their racial identification as white but also by the absence of visual evidence of the crime. The corpse photographs that exerted a powerful effect on blacks were absent from national television reports and from white newspapers and magazines. According to one photographic historian, not until the 1987 airing of the first episode of the civil rights television documentary *Eyes on the Prize* did significant numbers of white Americans see a photograph of Till's mutilated corpse.[36]

To the extent that historians deal with the absence of Till's body in the white press, they attribute it to choices made by blacks. In their Pulitzer Prize–winning book, *The Race Beat: The Press, the Civil Rights Struggle, and the Awakening of a Nation* (2007), reporters Gene Roberts and Hank Klibanoff draw on the work of the photographic historian Vicki Goldberg and the recollections of the photographer Ernest Withers to conclude, "Few whites saw the photo [of Till's corpse], and Negroes had to buy *Jet* to see it. Johnson Publications held and exercised exclusive rights to the photograph, taken by one of its staffers, David Jackson, thus

56 Unknown artist, *Emmett Till in His Casket, Afro-American (Baltimore, MD),* September 24, 1955. Courtesy of the AFRO-American Newspapers Archives and Research Center, Baltimore, Maryland.

THIS IS THE AFRO artist's conception of how young Till, his face battered and bruised, a bullet hole in his head, one eye gouged out, and his features swollen by three days in a river, looked as his body was viewed by thousands of Chicagoans as it lay in state at a funeral parlor prior to final rites. Till's mother had the casket opened so people "Can see what they did to my boy."

keeping it out of the hands of white newspapers, television, and all but a few Negro papers that disregarded the restrictions and ran grainy reprints of the *Jet* photograph." The most recent accounts of the photographs' publication history continue to promote this interpretation, despite considerable evidence that white periodicals had every opportunity to publish Till's picture had this been their desire.[37]

First, several photographers covered the Till funeral, and more than one image of his disfigured head was produced, so both black and white newspapers were less reliant on Johnson Publications than is generally assumed.[38] Second, newspapers and magazines did not need photographs to display Till's corpse. The Baltimore *Afro-American* provided an artist's sketch of Till in his casket on its front page in lieu of a photographic reproduction (figure 56). Lack of a photographer on assignment, insufficient funds to pay for reproduction rights, refusal of the copyright holder to grant license, or even concern about upsetting subscribers need not have deprived readers of visuals if a newspaper had considered the issue of sufficient importance. Third, Till funeral photographs preserved in the archives of the white-owned *Chicago Tribune* and *Chicago Sun-Times* prove that both newspapers had photographers covering the event. An unpublished *Chicago Tribune* photograph of Till's viewing (figure 57) shows lines of well-

dressed mourners passing Till's open casket—with the boy's mutilated head clearly visible. Chicago papers interested in reproducing photographs of Till in his casket were clearly not constrained by licensing difficulties with Johnson Publications. White media outlets from outside the city or state that wished to illustrate articles on Till with funeral photographs would have found them readily available from Chicago's leading white papers.

Even if white editors had wished to print photographs of Till's ravaged body, perhaps the graphic nature of the images would have given pause. White readers would surely have voiced objections to such disturbing images in their morning newspapers. But evidence suggests the willingness of mainstream newspapers at midcentury to display upsetting pictures of death if they believed that engendering readers' discomfort could advance a worthy cause. According to the historian George Roeder, by 1943 President Roosevelt's advisors were increasingly concerned about losing home-front acceptance of the domestic privations resulting from the huge expenditures needed to fight the Second World War. They worried that the recent string of Allied military victories in Europe and the Pacific theaters would raise the public's expectation

58 George Strock, *Buna Campaign American Casualties, Papua New Guinea, Life,* February 1, 1943. Time & Life Pictures/Getty Images, Los Angeles, California.

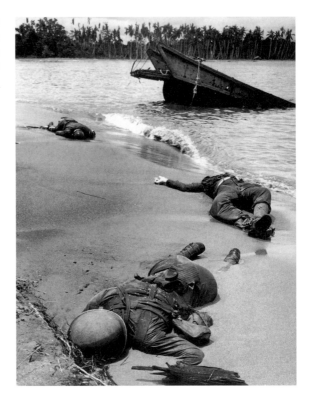

that the war would end soon and significantly lessen acceptance of sacrifices at home. They urged Roosevelt to change the government censorship policy and release graphic depictions of American war dead, of a type previously withheld from public view, to help tamp down domestic labor unrest and absenteeism and prepare Americans for increased casualties as U.S. forces drove toward the Japanese mainland.

As Roeder explains, shortly after Roosevelt agreed to the policy change, *Life* reproduced an unprecedented George Strock photograph showing three dead U.S. soldiers collapsed across Buna Beach in New Guinea (figure 58). Concerned that these first images of American corpses published in the U.S. media since the war began would stir up readers, *Life* paired the photograph with an editorial that explained, "The reason we print [the photograph] now is that last week President Roosevelt and Elmer Davis and the war department decided that the American people ought to be able to see their own boys as they fall in battle: to come directly and without words into the presence of their own dead."[39] Clearly, white-controlled newspapers did not in 1955 have a similar desire to expose their readers to pictures of "their own" fallen black boys at home.

Implicit in my criticism of the white media's reticence to use the Till photographs is my unstated belief that their reproduction was linked to a progressive racial politics. Failure to publish signified a failure to grapple with the race-based killing of blacks. Given the singularly gruesome nature of the photographs, and my argument that violent imagery performs both constructive and damaging social work, my claims for the photographs' progressive social function may appear misplaced. If, as I have argued, the much milder photographs of violence in Birmingham helped maintain racial beliefs that supported white power, how could the vastly more disturbing images of Till not perform similarly reactionary work? Without discounting how violent imagery must cut both ways, I maintain that only through a case-by-case examination of images in context can we assess the *dominant* political work of a photograph. Because context determines the social significance of images, photographs of white-on-black violence routinely possess varied social effects.

Photographs of the Birmingham campaign united progressive whites, such as Moore and the editors of *Time* and *Life,* with conservative whites, such as Connor and Persons, in the wish to make violence against blacks visible for white audiences. Given the disparate interest of these two groups, and their shared take on the virtues of publication, the fact that the images supported contradictory racial politics is not surprising. The potential of the Till photographs to positively influence white society is signaled by the consistent white *disinclination* to see them reproduced; since whites from across the political spectrum were united in their desire to see publication suppressed, circulation of the images clearly posed a threat to the status quo of whites. I believe that the singularly unified white resistance to publication offers evidence that dissemination of the Till photographs would have produced more unambiguously progressive results than the circulation of any other period photograph of white-on-black violence.[40]

Further evidence exists in the stark degree to which reaction to the Till photographs fell along racial lines. Blacks across the political spectrum desired to see what the white killers had done to a black boy: tens of thousands flocked to the South Side funeral home for the viewing (figure 59); millions read the daily diet of articles on Till in the black press; millions more saw the images in *Jet,* leading to the first sold-out issue in the magazine's history; and Langston Hughes was so moved by the crime that he wrote, "Showing just one lynched body on TV . . . seems to me long overdue."[41] Blacks consistently credited the act of looking, specifically, looking at photographs of Till, with the power to heal American race relations. In defending her decision to put the body on display, Bradley wrote that it was "important for people to look at what happened on a late Mississippi night when nobody was looking, to consider what might happen again if we didn't look out." She was convinced that the public "would not be able to visualize what had happened, unless they were allowed to see the results of what had happened. They had to see what I had seen. The whole nation had to bear witness." Ernest Withers ex-

59 Unknown photographer, *Mourners at Emmett Till Funeral,* Chicago, Illinois, September 3–6, 1955.
© Bettmann/CORBIS, Seattle, Washington.

plained that his published photographs of Till's corpse would "serve to help our nation dedicate itself to seeing that such incidents need not occur again."[42]

Recounting as fact a surely apocryphal story, the *Chicago Defender* reported that one distraught black woman, reading of the Till murder on a Chicago trolley, struck a white female passenger out of anger. According to the account, neither the injured passenger nor her fellow whites said a word. They stood transfixed by a photograph of Till's corpse in a newspaper that had dropped to the ground in the scuffle. As the *Defender* described the scene, "The careful whites simply looked at the picture of the dead boy lying face up on the floor and bowed their heads in humiliation." The article concluded, "The decision of Mrs. Mamie Bradley, mother of the slain child, to put the body on public view was more effective than the millions of words of copy written about the crime."[43] In the estimation of blacks, seeing Till's corpse was the first step to initiating racial change.

The white response was as internally consistent as the black one, but whereas blacks could not look enough, whites preferred to look away. Scores of articles in the white press noted that "the Till case haunts the national conscience" (*New York Post*) or that "the killing aroused the country" (*Newsweek*) or generated great "feeling" in the country (*Time*), and others deemed the murder trial "a national *cause célèbre*" (*Life*).[44] But white interest consistently centered on the novelty of placing southern whites on trial for the murder of a black boy, and later on the injustice of the acquittal, rather than on the death itself. In September, the *New York Times* ran more than three times as many articles on the trial as on the murder and the racial context in which it occurred; during this same period, the ratio in the *Washington Post* was five to one. In contrast, the *Chicago Defender* printed twice as many articles on the murder and on the conditions of black life in the Mississippi delta as on the trial.[45]

The murder generated just a handful of speeches in Congress and no comment from President Eisenhower. Despite enormous pressure by the black community, through petitions and many thousands of personal letters sent to the White House, the president declined to support antilynching legislation, speak out against the killing, or even issue a statement of condolence or regret. Bradley's letter to Eisenhower pleading for federal intervention went unanswered, her request for a meeting with the president's aide for minority affairs was declined, and her offer to the chair of the Senate Subcommittee on Civil Rights to testify before Congress was rebuffed.[46] By the fall of 1955, with the funeral and trial over, a white reporter noted of Till, "He's buried now, just as all news of him has been buried in the back columns of the [white] newspapers."[47]

Perhaps more remarkable than the limited and narrow nature of whites' interest in the murder is the consistency with which they suppressed its visual evidence. In a perverse twist, the Till murder brought together the editors of the most liberal northern newspapers and magazines with the killers, for all sought to prevent visual traces of the crime from circulating among whites. The killers' clumsy efforts to ensure that the corpse would never be seen were more skillfully carried out by a white media that withheld photographic evidence of the crime. As a number of historians have pointed out, the precautions taken by Milam and Bryant to commit their crimes in private (the beating and murder took place inside a barn) and to hide all evidence (they burned Till's clothing, washed out the pickup truck in which he was transported, and went to great lengths to hide the corpse) departed from the manner in which American blacks were traditionally killed by mobs.[48] In the nineteenth and early twentieth centuries, lynchings brought together groups of people to kill victims in public—for public effect. Participants and observers typically made no effort to shield their identities, even from the photographers who were at times present, and they commonly left the victim's body hanging from a tree, telephone pole, or bridge or laid it on a courthouse lawn as a warning to other blacks. Till's killers doubtlessly hoped to make a point about the place of blacks in Mississippi

society, much as did the editors of northern periodicals, but neither group sought to communicate their respective points by making a spectacle of the black boy's body.

Till's murderers did not hide his corpse simply because they feared arrest. Two weeks before Till's abduction and murder, Lamar Smith, a sixty-three-year-old voter registration activist became the second black civil rights worker publicly murdered by Mississippi whites since May.[49] Smith was gunned down in broad daylight on the lawn of the Brookhaven courthouse in Lincoln County, Mississippi, for his civil rights work. Despite the fact that the murder took place in front of several dozen white witnesses, not one would testify against the killers; a grand jury subsequently failed to indict any of the men charged, and no one was ever tried for the crime. Notwithstanding the decline in public killings of blacks by midcentury, the execution of Smith points to the impunity with which whites in many parts of the South continued to take black lives up into the 1950s.

The killers themselves also offer intriguing evidence that they did not fear being held accountable for their crimes. After the men were acquitted of murder and grand juries repeatedly failed to indict them for kidnapping, an intrepid southern journalist, William Bradford Huie, paid for the rights to their murder story for a feature film (which, tellingly, was never made).[50] In his interviews with Huie, Milam explained that with Till in the back of the pickup, he and Bryant drove in search of a weight heavy enough to keep the body submerged in a river. Knowing where an unused fan for a cotton gin was stored, the men went to retrieve it for a weight. As Milam explained: "When we got to that [cotton] gin, it was daylight, and I was worried for the first time. Somebody might see us and accuse us of stealing the fan."[51] Whether Till was still alive at this point is unclear, but what is certain is that the men drove with either a corpse in the back of their pickup truck or a severely beaten and bleeding black boy. Milam "worried for the first time" not about getting caught with Till in his truck but about being accused of "stealing the fan." Community approval of Smith's execution along with the fact that Milam was more concerned about being labeled a thief than a murderer strongly suggests that the men did not hide the body out of fear.

We may be fairly certain that Milam and Bryant concealed the body because it was the body of a boy. The popular rationale for the killing was that Till posed a sexual threat to Bryant's wife. The validity of the threat rested on acceptance of Till as a predatory and sexually mature black man, which meant that any evidence of his status as a child undermined the logic of the crime. To a remarkable degree, the defense attorneys' arguments at Milam and Bryant's trial, as well as the men's own comments after their acquittal and analyses by media outlets, pivoted on whether Till was a boy or a man. The "guilt" or "innocence" of the accused in the minds of many whites hinged less on whether or not they killed someone than on who died. The publisher of the Greenville, Mississippi, *Morning Star* summarized the debate succinctly

and crudely when he explained to a visiting reporter that too much was made of Till's youth. "He may have been only 14 but I'm told he had a dong on him like this," the publisher explained, raising his arm to suggest the improbable size of Till's penis.[52]

In a manner more subtle but no less clear to Mississippi whites, the defense attorneys for Milam and Bryant took every opportunity to picture Till as a sexually dangerous man. During their cross-examination of a state witness who oversaw the removal of Till's naked body from the river, a defense attorney asked if Till had "well-developed privates" and whether or not they were "swelled or stiff" as he was dragged from the river. Defense lawyers asked both Till's great-uncle, Mose Wright, and Carolyn Bryant to describe the boy's height and weight, which they wanted the jury to appreciate were considerable for someone of his years. When Carolyn Bryant took the stand, she not only claimed that Till had physically restrained and crudely propositioned her in the store but referred to Till as "this nigger man." When one of the defense lawyers questioning Carolyn Bryant caught himself asking of Till, "where was this boy then?" he quickly corrected himself: "or I should say, where was this man?" Black reporters and specta- tors at the trial could not have missed that Till was accorded the status of a "man" in death by the same whites who addressed every living black man as "boy."[53]

By the time Milam and Bryant granted a posttrial interview to explain their actions, their defense had broadened out from an effort to protect a female relative to one aimed at saving all white women. In Milam's improbable and self-serving narrative of events, he claimed that after he and Bryant repeatedly pistol-whipped Till, the boy spat back, "You bastards, I'm not afraid of you. . . . I've 'had' white women. My grandmother was a white woman." As Milam recalled, "Then you know what happened? That niggah pulled out his pocketbook and he had pictures of three white girls in it . . . Chicago sluts, I guess, but there they were. . . . Well, what else could I do?"[54] In order to sell their murder of a boy, Milam and Bryant worked to recast Till as an adult "race mixer" at best or a rapist of white women at worst and to present them- selves as defenders of white purity in both the South and the North. For all those who feared miscegenation and the fall of segregation, the answer to Milam's rhetorical question "what else could I do?" was clear.

In southern white papers, reporters showed a surprising degree of sympathy for Till in the first days after his corpse was found, but their tone changed dramatically when the NAACP, Bradley, and northern newspapers became vocal in their criticism of Mississippi society. As Davis Houck and Matthew Grindy have thoroughly documented, the Mississippi press closed ranks once it perceived that "outsiders" sought to cast the Till murder as a narrative of race and civil rights. Whites found particularly galling the caustic press release issued by the execu- tive secretary of the NAACP, Roy Wilkins, which read in part, "It would appear from this lynching that the state of Mississippi has decided to maintain white supremacy by murdering

children." Houck and Grindy note that many Mississippi papers never printed a word about the abduction or murder of Till and that those that did came increasingly to define the boy in threatening terms. In the southern white press, he was transformed into a "husky Negro lad," "stuttering husky Negro lad," or "northern Negro rapist."[55]

Intimations of Till's sexual nature even showed up in northern press reports. Huie published as fact Milam's description of how Till provoked the killers with his boasts about white women in a sensationalistic *Look* magazine article in 1956. The investigative reporter expanded his story in *Wolf Whistle* (1959; figure 60), a popular paperback whose cover promised that the contents were "more shocking than fiction . . . three true stories of desire, greed and deception by a fearless reporter." In *Wolf Whistle,* Huie details that Emmett's father, a private in the U.S. Army during World War II, was hanged in Italy "for a series of rape-murders" and notes that eighty-seven of the ninety-five American soldiers so hanged were black. While he acknowledges that Emmett never knew his father and that the rapes were "immaterial at the trial of Milam and Bryant," his addition of the story to his narrative appears to serve no other purpose than to suggest that there was a genetic or familial component to the younger Till's advance on Carolyn Bryant.[56]

Most northern white papers were sympathetic to Till and in synch with more progressive racial politics, despite the prominence of Huie's narratives in the North. Unsurprisingly, most accounts stressed Till's identity as an innocent boy. *Life* opened its eulogy with the direct assertion "Emmett Till was a child." Portraying him as an innocent Christlike martyr, *Life* wrote, "In the dark of the night of this deed his childish cries for mercy fell on deaf ears." In the *Nation,* Till was "a visiting Negro boy"; in *Commonweal,* he was "the boy from Chicago"; and in *Newsweek,* he was "a polite and mild-mannered" boy who enjoyed "Little League ball" and had "near-perfect attendance at Sunday School," according to those who knew him best.[57] So, too, in such papers as the *New York Times, Chicago Tribune,* and *Washington Post,* Till was consistently described as an unthreatening "boy."[58]

That progressive white editors and reporters felt compelled to generate support for Till, and disgust at the crime, by assuring readers of the harmlessness of the boy is noteworthy but hardly remarkable. Appreciating the power of the "Negro rapist" to stir white fears in the North and the South, progressive papers reflexively cast Till as a boy, which neatly sidestepped questions of intent. By describing Till as a fourteen-year-old Little League–playing Sunday school–attending boy, they placed him safely in a world that was popularly understood as without sex. Although some of the reporters who stressed Till's youth may have bought into the myth of the Negro rapist and so could vilify the crime only if they cast its victim as a boy, just as likely a sizable percentage of whites emphasized age as a pragmatic means of defusing a potent symbolic threat. That reporters perpetuated the mythology—in arguing that Till was

60 Unknown artist, cover of *Wolf Whistle,* 1959. Signet Books. Special Collections, University of Mississippi Libraries, Oxford, Mississippi.

no threat instead of refuting the stereotype itself—simply reveals the power of the myth to shape white public perceptions at midcentury.

What is remarkable, however, is the press's fixation on the murder of children. It is one thing for newspapers to make a tactical decision to desexualize Till by stressing his age and propriety, but it is quite another for northern reporters to make the involvement of children (or adults possessing childlike qualities) a near requirement for the sympathetic coverage of white-on-black violence. When a focus on the innocent and helpless precludes attention to and sympathy for the politically active and strong, then sympathy for kids becomes part of the

racial problem. The compassion and concern that northern whites showed for a black child victimized by southern whites were admirable, but their feelings were for a nonthreatening individual rather than for blacks per se. In many ways, whites were concerned for black children *despite* their race. In highlighting white concern for Till or the children of the Birmingham campaign, we risk overlooking the significant limitations of white empathy. If Emmett Till had been fifteen, sixteen, or seventeen years old in 1955, how many whites today would know his name?

By the time of the Birmingham campaign—eight years after Emmett Till's murder—the dynamics of feeling that drove the white response to the murder remained largely intact, despite the significant expansion of economic and social opportunities available to nonwhites. We have seen many documented episodes of violence against black adults that elicited little or no mention in the white press and generated no national outrage. Examples cited in this book alone include incidents in Belzoni, Brookhaven, Greenwood, and Jackson, Mississippi, in Nashville, Tennessee, and in Albany, Birmingham, and Marion, Alabama. But the same was true for much of the violence against black children, as the historian Renee C. Romano points out. Her study of how Americans remember the civil rights struggle highlights the disparate coverage accorded to female and male black youths killed in Birmingham in 1963.

Just as the accord reached by black negotiators and the white city establishment to end the Birmingham protests began to show its first tentative results, whites killed six black children in the city. On September 15, 1963, members of a local offshoot of the Ku Klux Klan killed eleven-year-old Denise McNair and fourteen-year-olds Carole Robertson, Addie Mae Collins, and Cynthia Wesley in a Sunday morning bombing that targeted worshipers in Birmingham's Sixteenth Street Baptist Church. The Klansmen aimed to provoke a black backlash against whites, hoping to create sufficient fear in moderate whites to scuttle the accord. The same day, thirteen-year-old Virgil Ware was shot to death as he rode on the handlebars of his brother's bicycle, gunned down by a white Eagle Scout returning from a segregationist rally; and sixteen-year-old Johnnie Robinson was shot in the back by police after he threw rocks at a car in the chaos that followed the bombing.

Romano points out that the deaths of the "four little girls," as the bombing victims were consistently labeled in the press, were national news while the murders of the boys were little reported. And she notes that sympathy for the female victims was encouraged by press accounts that consistently depicted them as helpless and angelic "little girls" who were in Sunday School, not protesting in the streets.[59] The point is not simply that the white media showed greater interest in and sympathy for black victims who were female (and presumably less politically active and physically threatening) but that the coverage managed to generate white emotion by downplaying the motivations for the crime. Whites were pained by the murders of McNair,

Robertson, Collins, and Wesley because the victims were "little girls," even though the Ku Klux Klan members who bombed their church selected it because its congregants were black. The often-repeated "four little girl" mantra effectively erased the part of the victims' identity that made them targets in the first place. In 1955, as in 1963, the media coverage of and white reactions to the deaths of blacks strongly suggest that white sympathy for victimized children masked a disinterest in the suffering of blacks.

One may begin to understand the ease with which white Americans accomplished their visual boycott of Witherspoon on the ground and Till in his casket by recalling their propensity to circulate only those images readily framed within mainstream accounts of the civil rights movement. Because a large pool of less controversial images was available for narrating their preferred account of the struggle, whites felt little pressure to grapple with the social and political implications of contentious photographs of black protest. The efforts of white publications to define and guide the national conversation on civil rights were complicated, however, when nonstandard photographs of blacks fighting for legal or economic rights leaked into the public sphere. From time to time, atypical photographs dealing with civil rights themes were widely reproduced because they addressed topics of undeniable interest to whites. Published in spite of their connections to civil rights, such photographs opened the door to alternative accounts of the struggle. Nowhere is this potential more in evidence than in the John Dominis photograph of Tommie Smith and John Carlos's 1968 Olympic medal protest in Mexico City (figure 61).

Readers will appreciate that the photograph of Smith and Carlos is not an obvious image for inclusion in a book on civil rights. The men look nothing like the stoic black protestors mauled by police dogs or taunted by mobs. If the photographs of Birmingham depicted safe images of respectful and inactive "Negroes," those of Mexico City show threatening scenes of resentful and aggressive blacks. For white audiences in the 1960s, the athletes' protest had associations with menacing and widely disseminated images of black power. From the late 1960s to the present, the image has been grouped with such infamous photographs as the 1967 portrait of Huey P. Newton, cofounder of Oakland's Black Panther Party for Self-Defense, seated in his thronelike chair armed with rifle and spear (figure 62); the Black Panthers roaming the corridors of the California Capitol in Sacramento with their rifles and shotguns in 1967; or the Pulitzer Prize–winning photograph of black students marching confidently with shotguns, rifles, and ammunition belts after their occupation of Willard Straight Hall at Cornell University in 1969 (figure 63).

The ubiquitous Newton portrait was staged by Eldridge Cleaver, shot by a professional (white) photographer hired by the Panthers, and subsequently turned into a popular fund-raising poster that circulated widely in both radical circles and the mainstream press. As Bobby

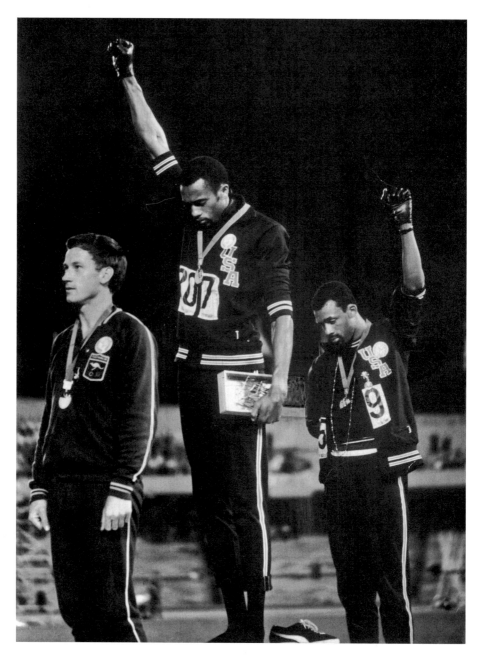

61 John Dominis, *Black Power Salute at Olympic Games,* Mexico City, Mexico, October 16, 1968. Time & Life Pictures/Getty Images, Los Angeles, California.

62 Unknown photographer, *Huey P. Newton,* 1967. Offset print on paper, 58.4 × 88.9 cm. Library of Congress, Washington, D.C., Prints and Photographs Division.

Seale explained in his history of the Black Panther Party, by showing Newton armed with Zulu shields, rifle, and spear, the portrait sought to offer the black community of Oakland a strong affirmative symbol around which to rally.[60] If the canonical images of civil rights scripted the identity of black activists as the product of violent whites, the photograph of Smith and Carlos with their medals and Newton with his weapons illustrate black men as self-fashioned and powerful agents whose identities are not contingent on the actions of whites.

But while the photograph of Smith and Carlos has the look of images of black power, its underlying strategies come straight from the civil rights movement. The athletes' tactic of pinning political buttons to their track jackets and displaying shoeless feet and black socks to visualize their political commitments and the poverty and racism that oppressed them at home

63 Steve Starr, *Heavily Armed Black Students Leave Straight Hall at Cornell University,* Ithaca, New York, April 20, 1969. AP/Wide World Photos and Steve Starr, New York.

was in keeping with the approaches of civil rights organizations in the first half of the 1960s. King and the SCLC in Birmingham, John Lewis and the SNCC in Selma, and James L. Farmer and CORE in Chicago all worked to create narratives that underscored their beliefs and the many impediments faced by American blacks. In contrast to Smith and Carlos's protest, the famous scenes of "black power" rarely highlighted the social, economic, or legal obstacles facing blacks; instead, they resolutely expressed black strength. The photograph of the Olympic athletes, with its evident links to both iconic civil rights and black power imagery, can thus be read as a transitional image that charts the decade's shifting emphasis from civil rights to black power. But considering its forceful articulation of black agency *and* the social and economic barriers nonwhites face, the image is best seen as a noncanonical expression of civil rights activism that equates black action with reform. As a well-known image that portrays assertive blacks peacefully articulating the inequalities of American society, the photograph is one of the 1960s' most progressive images of the civil rights movement.

Because mainstream media saw the agency of the athletes as incompatible with the tactics and agenda of the civil rights movement, their response to the photograph was overwhelmingly negative. With a few notable exceptions, whites issued scathing attacks. National newspapers

and magazines deemed the display "juvenile," "immature," "disgraceful, insulting and embarrassing." They accused the athletes of doing "irreparable damage" to American race relations and of "politicizing" the Olympics. Reporters frequently compared the men to storm troopers, Nazis, and, amazingly, to Hitler himself.[61] The *New York Times* summed up the sentiments of many whites: "Smith and Carlos brought their [politics] smack into the Olympic Games, where it did not belong, and created a shattering situation that shook this international sports carnival to its very core."[62] In the aftermath of the protest, the U.S. Olympic Committee (USOC) at first simply admonished the athletes for their actions, but after the International Olympic Committee (IOC) weighed in, it stripped the two sprinters of their team credentials and expelled them from the Olympic village. Avery Brundage, the deeply conservative American president of the IOC, pressured the USOC to take this harsh line in order to send a message to other athletes who might be considering protests.

As news of the expulsions spread, many in the press speculated about whether the accomplished black American sprinter Lee Evans would run his upcoming race in the 400 meters, and if so, whether he would stage a demonstration should he win a medal. Evans was known to be close to Smith, sympathetic to the aims of the protestors, and deeply troubled by the USOC's willingness to expel his teammates. Once Evans announced his intention to run, Americans anxiously awaited the competition and the medal ceremony to follow.[63] Evans won the 400-meter race in world-record time and shared the award podium with two fellow black Americans, Larry James and Ron Freeman. The three emerged for the ceremony wearing black berets and as they mounted the podium acknowledged the applause of the crowd with black power salutes (figure 64). After each runner received his medal, he stretched his arm upward in a stiff, closed-hand salute. With the raising of the flags, however, the athletes removed their berets, turned toward the U.S. flags, and stood at attention during the playing of "The Star-Spangled Banner."

The differences in the protests staged by the winners of the 200-meter and 400-meter races struck virtually all American observers as significant. In the opening to a lengthy article on Evans's victory for the *San Jose Mercury News*, "Evans Scores 'Double' Via Record, Humility," a sports reporter wrote, "San Jose's Lee Evans struck a double victory for the United States here Friday afternoon as he ran the fastest 400 meters in history (43.8) to win an Olympic Games gold medal. Later on the victory stand where he was crowned the supreme 400-meter in the world Lee accepted his honors with grace along with his teammates Larry James and Ron Freeman." As the article made clear, the "double" of its headline referred to the combination of a world record with good behavior. While the reporter mentioned the athletes' berets later in the article, he did so only to note that the caps were "doffed" during the flag raising and the national anthem.[64]

The *Los Angeles Times* provided a more complete description of the men's actions but was

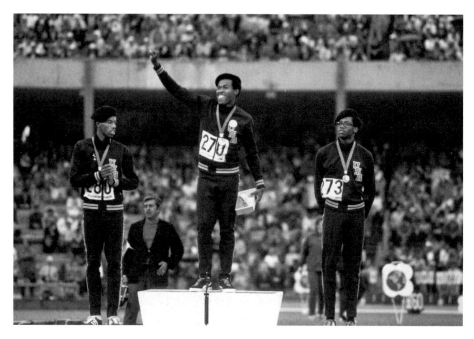

64 Bill Eppridge, *Lee Evans, Larry James, and Ronald Freeman on the Victory Stand for the 400-Meter Race at the Summer Olympics,* Mexico City, Mexico, October 18, 1968. Time & Life Pictures/Getty Images, Los Angeles, California.

just as sanguine about the scene. The reporter noted that the athletes "were wearing black berets when they appeared for the victory ceremony. Upon mounting the stand, they acknowledged the crowd's applause by raising clenched hands. But they stood at attention, with their hats off and their arms at their side, during the playing of the National Anthem. [The President of the USOC] Roby said later that their conduct during the ceremony was 'perfectly all right.'"[65] The acting director of the USOC went further, claiming, "Everything worked out fine. Lee Evans accepted his medal in fine style."[66] In its coverage of the 400-meter race, the *New York Times* maintained that the expulsion of Smith and Carlos "obviously tempered the behavior of Negro American athletes who were involved in victory ceremonies today. In accepting their medals for their one, two, three sweep of the 400-meter run, Lee Evans, Larry James and Ron Freeman wore black berets, but in no way conducted themselves in a manner to incur official wrath." Bending over backward to differentiate the protests from one another, the reporter commented, "On arriving at the victory platform and on leaving it, they did raise clenched fists, but they were smiling and apparently not defiant as they did so."[67]

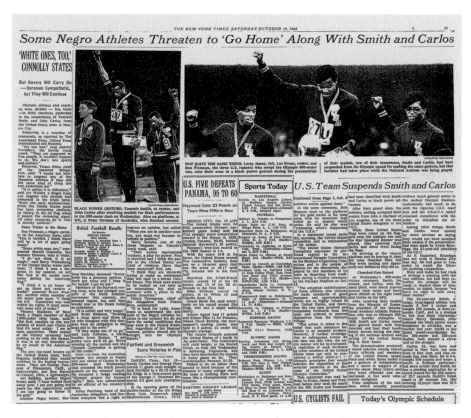

Two days later, the *New York Times* provided an even more circumspect report. After reminding readers of the political nature of Smith and Carlos's protest, the reporter suggested that their action left Evans "on the spot." Still, the reporter expressed pleasure with Evans's postrace performance, noting that the athlete "stood with chin held high during the flag-raising ceremonies a half-smile on his proud face." While dealing extensively with the issue of black power at the Olympics, the reporter made no mention of berets or salutes in describing the 400-meter medals ceremony.[68] For many Americans, the distinctions between the two protests were summed up succinctly by a third report in the *New York Times.* The article juxtaposed photographs of the two presentation ceremonies (figure 65), but whereas the caption for the

photograph of Smith and Carlos's protest began with "Black Power Gesture," that of Evans and his comrades started with "Not Quite the Same Thing."[69]

Certainly, Smith and Carlos, on the one hand, and Evans, James, and Freeman, on the other, staged distinctive protests, but the tendency of white observers in 1968 to see the latter protest as "graceful," "in fine style," even "exemplary," given its obvious formal similarities to the more disparaged display, is noteworthy.[70] Perhaps Americans were simply relieved that the 400-meter medalists had declined to ratchet up the protest. Whatever statement the second group's protest made about "black power," the athletes' decision to stand at attention during the playing of the national anthem likely struck Americans as a pulling back from the display of Smith and Carlos, who chose that moment to lower their heads and salute. In other words, the more positive reception accorded Evans and his fellow medalists stemmed from interpretations of their protest as more moderate, regardless of the statement it made. White Americans interpreted the latter ceremony as a turning point in their fears about a protest-filled Olympics; as a reporter noted with relief after the 400-meter medal ceremony, "the worst seems over."[71]

The historian Douglas Hartmann argues in his detailed study of the racial politics of athletic protest in 1968 that Smith and Carlos's demonstration unsettled white America by injecting blackness into a forum that was traditionally coded as white (and, incidentally for my argument, as middle class, Christian, and male). Hartmann claims that the protest made black bodies visible at a moment when white Americans did not expect to register their blackness.[72] Of course, whites never "forgot" what race the well-behaved black champions were; they simply allowed black athletes to stand in for an implicitly white America at their moment of Olympic triumph. Once such athletes returned home, their blackness was sufficiently visible—regardless of their behavior—for whites to refuse them service, employment, and equality of opportunity. Hartmann is correct to root the controversy in Smith and Carlos's insistence that they be seen as black, but his observations complicate efforts to explain the apparent acceptability of the protest by Evans, James, and Freeman. Even if the actions of the 400-meter victors were more palatable than those of the black 200-meter medalists, no one in the United States in the late 1960s saw the dark-skinned, black-beret-wearing men with fists raised on an Olympic medal podium as anything but black.

The historian Mike Marqusee has argued that whites saw Smith and Carlos's protest as a rejection of "the rhetoric of individual victory and national glory" and, ultimately, as a "repudiation of the United States."[73] He suggests that whites perceived the athletes to be placing their racial identities ahead of their national affiliations with the United States. Whereas whites could see the medal performance of Evans and his teammates as a sign that the athletes considered their blackness to be of secondary importance to their Americanness (given that berets and fists disappeared with the playing of the national anthem), they purportedly read the op-

posite message in Smith and Carlos's display. After all, the 200-meter medalists made their strongest assertion of blackness during the playing of their national anthem. While both protests took liberties with the traditional medal ceremony, Evans's remained within its governing logic by signaling that blackness was ultimately subordinate to his identification as American.

Smith and Carlos surely stirred emotion by seeming to elevate their race over their nation. But I am confident that this was not the protest's most controversial aspect for audiences in the 1960s. More unnerving for white Americans was the demonstration's presentation of a heterogeneous identity that undermined the racial and national identities of many whites. The problem was not simply that the athletes signaled their blackness at a moment when white audiences wished to acknowledge only the "American" aspect of their identity but that they demonstrated the possibility of being black *and* American simultaneously. In other words, the raising of clenched fists by athletes electing to wear jackets emblazoned with "USA" during the playing of their national anthem just as readily signaled blackness *and* Americanness as blackness *over* Americanness.

As the black power separatists caricatured in the press, Smith and Carlos generated unease among whites, but as the triumphant athletes of the medal ceremony, who were emphatically both black and American, they were much more destabilizing. By making blackness unmistakable during a ceremony that was popularly understood as a celebration of American accomplishment, the athletes complicated white Americans' easy conflation of "American" with "white." In the symbolism of Smith and Carlos's protest, blackness was not subordinated to Americanness but, more powerfully, was staged as Americanness. Blacks have historically faced greater danger when they have disrupted the boundaries of race than when they have marked their separation from white America. As the violent response to Till's comparatively tame interaction with Carolyn Bryant illustrates, perceived attacks on the boundaries of whiteness have long been vigorously rebuffed. This observation helps explain why a silent, peaceful protest that lasted less than two minutes generated a fever of white emotion that would follow Smith and Carlos for decades, ensuring that they paid a heavy economic, familial, and psychological price for their statement in Mexico City.[74]

Since most whites who bought into the idea of America as white did not consciously apprehend their investment or perceive how the protest complicated their belief, it is unsurprising that they failed to publicly express the root of their unease. Despite claiming that their primary concern was with the inappropriate nature of a protest they deemed "juvenile," "disgraceful," or "political," critics expended considerable energy reframing the racial identities of the athletes. Notwithstanding their assertions, detractors proceeded as if the legitimacy of the protest hinged on racial definitions.

Mainstream reporters made selective use of Smith and Carlos's words to cast the athletes into more reassuring—one-dimensional—identities. Nervous white Americans in the 1960s tended to fixate on Smith and Carlos's postrace press conference assertions of "black pride," which neatly fit with narratives then circulating about the dangers of black separatists and the black power movement. For example, in its lengthy discussion of the Olympic protest, *Time* magazine quoted only the most sensationalist snippets from the press conference. Its first direct quote from either man was Smith's comment "We are black and proud to be black."[75] The *San Francisco Chronicle* compressed Smith's explanation for the protest to the point that his argument became impossible to follow. According to the *Chronicle,* Smith said, "We are black and proud to be black. White Americans will only give us credit for being Olympic Champions, but black Americans will understand."[76] While these white reporters would have found the comparison unsettling, their presentation of Smith and Carlos showed remarkable affinity with the athletes' characterizations in the Oakland-based *Black Panther* newspaper. In a front-page tribute to the athletes, the paper acknowledged that a mere salute was hardly the kind of action that the Panthers traditionally advocated, yet it lauded Smith and Carlos for their bravery, noting that they "proved not only that they are outstanding athletes, but first and foremost—that they are black men."[77]

Negro and *black* were not interchangeable terms in 1968: the latter label carried a decidedly political charge. By the second half of the 1960s, *black* was closely associated with the Nation of Islam and the Black Panthers, and as the social scientist Tom W. Smith points out, those who embraced the label tended to hold more radical views on racial politics.[78] It was no coincidence that the most conservative white reporters used the term to describe the athletes or that they isolated the athletes' assertions of "blackness" from their larger arguments. Rather than making emergent notions of black identity intelligible to their readers, white reporters chose to discredit the athletes' complaints by linking the men to the politics of black extremists. In tying the sprinters to groups that frightened whites, and that were thoroughly demonized in mainstream culture, the press helped discredit both the athletes and the issues they risked so much to raise.

Foreign reporters, who had less at stake in the protest and greater interest in allowing the athletes to speak for themselves, provided better context. In contrast to the coverage in *Time,* the *San Francisco Chronicle,* and even the *Black Panther,* the *London Times* quoted Smith's black pride comment in the context of his larger point: "If I win I am an American, not a black American. But if I did something bad then they would say 'a Negro.' We are black and we are proud of being black. Black America will understand what we did tonight."[79] When asked the next day by the ABC sports reporter Howard Cosell if he was "proud to be an American," Smith showed consistency in his response: "I'm proud to be a black American."[80] Thus, he did

not reject the appellation of "American"; he rejected being labeled "an American" when he won and "a Negro" when he lost. He rejected the white gesture of linking him to an implicitly white America in the moment of his triumph, knowing that he'd be a Negro again (or worse) after returning to the United States. Significantly, he embraced the identity of "black American" instead.

In contrast to his portrayal in both the mainstream white press and the radical black media, Smith did not style himself solely as "black." While the loaded label of "black" allowed significant numbers of whites, and some blacks, to interpret the protest as the athletes' rejection of their nationality, the "black American" label that Smith embraced presented a more complex and emotionally fraught picture. This picture is borne out by the work of contemporary social scientists on racial identification, which notes the paucity of evidence indicating that blacks link their racial identity to opposition to whites. The white commonplace that "black" is the racial pole of "white" oversimplifies and does not do justice to the lived experience of identity for black Americans.[81]

Some sympathetic Americans saw the protest in the terms articulated by Smith. A reporter in Mexico City quoted a comment by the black American Olympic long sprinter Vincent Mathews that the protest "was in no way intended to be an insult to the American flag." His teammate the high jumper Ed Caruthers concurred, explaining that "the action of Smith and Carlos was not against the American flag, but 'a sign of black power.'"[82] While many whites in 1968 had difficulty appreciating how black power could be anything but disrespect for the flag, Mathews and Caruthers clearly saw the two as compatible. A supportive letter writer to the *New York Times* made the idea more explicit: "The arrogant attitude of the United States Olympic Committee in evicting the two black athletes from the Olympic Games in Mexico City for their gesture of black unity during an awards ceremony in which they had won medals for the U.S.A. is unforgivable. In an interview, I heard one of these athletes affirm that he was a black American. He was not disavowing the U.S.A."[83] This letter writer, at least, saw no inherent problem with "black Americans" identifying with the United States.

Years after his protest in Mexico City, Smith summed up for a reporter the complex emotional relationship that blacks in the 1960s had with their American national identity. Of his moment atop the Olympic medal podium, he said, "I never felt such a rush of pride. Even hearing 'The Star-Spangled Banner' was pride, even though it didn't totally represent the country I represented, can you see that? They say we demeaned the flag. Hey, no way man. That's my flag. . . . But I couldn't salute it in the accepted manner, because it didn't represent me fully; only to the extent of asking me to be great on the running track, then obliging me to come home and be just another nigger."[84] A sympathetic letter writer to *Newsweek* in 1968 seems to have understood this point years before Smith publicly articulated his ambivalence:

"Do we expect black athletes to bring just their talents and not themselves to the Olympics?
The black protest was fitting because it pointed up the fact that Negroes were asked to represent
a nation that does not fully represent them."[85]

A number of contemporary observers went further, noting that the protest effectively vi-
sualized the duality of black identity. After expressing distress with the U.S. Olympic Com-
mittee's decision to expel Smith and Carlos, a letter to the editor of the *Los Angeles Times*
defended the "symbolic" gesture of the athletes, which "beautifully . . . expressed the duality
of their national allegiance." The letter writer noted the irony that the "duality" that white
Americans found so upsetting in the protest "was not created by so-called black Americans;
it has been ruthlessly insisted upon by the overwhelming majority of their so-called white
fellow countrymen over 300 years of repression and disdain."[86] A white columnist for the black
New York Amsterdam News labeled the men "champions of the best of the best" and praised
their efforts to "symbolize their problems for the world to see . . . and proclaim by these small
symbols that they were black Americans bringing honor to their country." Their gesture did
nothing more, she argued, than declare "to the world, 'We are Americans who are brown
skinned.' "[87]

Had a majority of white Americans viewed Smith and Carlos's protest as a simple assertion
of black pride or black separatism or even as a condemnation of the United States, they would
not likely have reacted with such ferocity. While whites would certainly have interpreted each
of these expressions as an assault on their sense of self, such external assaults were not the most
potent threats. However, the effort to redefine "Americanness" to include blackness was an
internal attack on identity that was vastly more destabilizing. As supportive blacks and whites
and many hostile whites believed, the photograph encouraged viewers to see black Americans
as not "fully represented" by their nation as it expanded the meaning of national belonging.
For many Americans, the most radical aspect of the protest was its racial inclusiveness—its
call to imagine a flag that stood for the athletes, their black teammates, and their fellow non-
white citizens at home. Some fifteen years before the Reverend Jesse Jackson would popularize
the term *African-American* as the new *black,* Smith and Carlos performed their hyphenated
identities before millions of their fellow citizens.[88] That few whites then embraced this more
nuanced understanding of black identity has at least as much to do with their investment in
an implicitly white nationalism as with their subjective complaints about the inappropriateness
of the protest. The athletes' assertion of power was sufficient to exclude the image from the
canon of civil rights photographs, but as the complex reactions of the public suggest, this was
by no means the most contentious feature of the protest.

During the 1960s, few whites could differentiate among the diverse tactics used by black
activists in support of civil rights goals. White viewers flattened out the variety and nuance of

black protest by rigidly enforcing restrictive criteria for defining an action or image as one of "civil rights." The altruistic desire of whites to promote "appealing" or "productive" images—their predisposition to connect with certain narratives and their psychological need to avoid scenes that cast too harsh a light on their race—excluded many scenes of black activism from the canon. Once an image was ghettoized as a scene of "black power," it was much less likely to alter the racial attitudes of whites, never mind help to catalyze structural change. Thus, the power of such images rested mainly in their effect on blacks.

In reflecting on the legacy of the 1960s, the literary scholar Jerry Watts has noted the tendency of left-leaning academics to fixate on the "success" or "failure" of various reform movements to promote structural change—the gold standard of those in the academy. Watts counters that such judgments fail to account for the significant changes that the 1960s brought to the lived experience of blacks. Without glossing over the limitations of period reforms, he urges us to consider the transformations experienced by the poor black residents of Greene County, Alabama; Farmville, Virginia; or Hattiesburg, Mississippi. He asks us to consider what the civil rights movement meant to those at the bottom of the racial hierarchy in 1960s America. In Watts's estimation, the movement allowed the most powerless and victimized people in American society "to *act*": "The act of becoming politicized, of claiming a space and identity, where there had previously been only silence, was, given the historical and social circumstances of southern blacks, as radical an act as occurred in the 1960s."[89] Smith and Carlos not only acted but, by their example, showed millions of black Americans that action was a viable option for blacks. While the white media could alter or obscure many aspects of the protest, it could not hide the power of the athletes to act. It is surely this public exercise of power, more than a straightforward iconographic understanding of the men's shoeless feet, salutes, and gloves, that Smith alluded to when he said, "Black America will understand what we did tonight."

In the 1960s, Americans of all political stripes saw powerful black actors in Dominis's widely circulated photograph, yet no one credited the image with promoting white sympathy for blacks or helping to alter the underlying conditions of American society. Given this "failure," readers may question my assertion in this book that photographs of black agency hold promise for catalyzing meaningful change. Yet real-world reform requires more than upping the number of images portraying "active" blacks. Given that audiences tend to read images through their racial values, additional photographs of active blacks offer no guarantee of more productive social narratives. For Dominis's photograph to realize its transformative potential, it also required a new kind of white viewer—one who would approach the photograph with an expansive model of identity, or who would sympathetically frame the image in the public sphere.

In chapter 3, I suggest that white identification with blacks could have transformed the meanings of the Birmingham photographs. Had whites seen *their* people menaced by dogs and high-pressure water jets, the canonical images of the struggle would have performed more progressive racial work. Blacks' and whites' disparate understandings of the image of Gadsden's confrontation with the dog, deeming him an example of either activity or passivity, suggest that a more inclusive white understanding of Americanness might have reversed the social significance of the photograph for whites. Just as images of poor white farmers during the Depression or dead white soldiers during the Second World War touched American audiences by speaking to them of the plight of *their own boys,* so identification with *American* protestors in Birmingham or Mexico City could have pushed whites either to work for or to accept social and political changes for the national good.

In the mid-1960s, a handful of radical thinkers such as Bayard Rustin and Tom Kahn outlined a plan for increasing the percentage of whites who identified with the civil rights cause. Neither activist believed that whites needed to identify racially or even nationally with blacks; rather, each saw the potential of the civil rights movement to unify blacks and working-class whites by shifting the emphasis to economic equality. Rustin and Kahn argued that disempowered whites and blacks could be made to see that the economic interests they shared were more significant than the racial differences that had historically kept them apart. Noting that a broad coalition of whites and blacks worked effectively together to stage the March on Washington, pass the Civil Rights Act of 1964, and lay the basis for President Johnson's "landslide" election victory, Rustin optimistically proclaimed in 1964 that "Negroes, trade unionists, liberals and religious groups" could form "a coalition of progressive forces which becomes the *effective* political majority in the United States."[90]

Echoing Rustin's views, Kahn argued that an attack on economic barriers to equality was "in the Negro's own interest," and "open[ed] new possibilities for alliances and for social action by whites in *their* own interests." He explained, "The sympathy of whites need not be purchased by a cooling off of Negro militancy—which the objective circumstances of Negro life make impossible anyway. . . . The support of whites will finally be won and secured by militant action that tears down the structural obstacles to Negro freedom, and, in so doing, frees whites from institutional arrangements that bind them to the old order" of inequality.[91] Implicit in Kahn's assessment is the belief that the "militancy" of a protest such as Smith and Carlos's need not drive away working-class whites, provided it communicates an economic call for social justice that resonates with other disadvantaged groups.

Even for whites unable to join blacks in embracing larger, more inclusive identities, the possibility existed to diminish their fear of active blacks. Certainly, mass media outlets in the 1960s presented images of powerful blacks that reinforced white fantasies of black hypervio-

lence. Examples include the white press's presentation of Cooper struggling with police, the image of Newton armed in his chair, and the depiction of Smith and Carlos frozen in salute. In each case, popular narratives associated with strong and forceful blacks served the psychological needs of whites—rallying them together in fear of an external threat and occluding the need for meaningful reform. For such photographs to promote progressive racial reforms, they required framing—with captions, text, and companion imagery—that disrupted the predisposition of whites to see expressions of black power as aberrant and threatening. Whites needed to understand the black struggle in the terms of the activists themselves. Such an understanding could not come through liberals' speculations about black thoughts, for such fanciful leaps only confirm what the imaginer believes, but through whites' listening to black voices so that they could view the struggle from a racial perspective far from their own. As we have seen in example after example, the absence of black perspectives left both liberal and conservative whites to filter the struggle through their shared racial lens, which had nothing to do with black life.

Listening to the voices of others does not necessarily cause one to accept their views, though it remains the minimum requirement for judging the legitimacy of their claims. Nonetheless, efforts to place black actions and demands in context can pay significant dividends, compelling whites to see the complexity of black belief, enabling them to appreciate that nonwhites are driven by many of the same values all Americans share, and, ultimately, humanizing blacks in the white imagination. Since political change is frequently driven by small groups of organized, passionate, and vocal citizens, photographs of powerful blacks need not appeal to a majority of whites to prove effective. After all, iconic civil rights photographs are credited with catalyzing reforms despite the lack of sympathy many whites in the North and the South felt for the protestors' cause.

Reframing would have been the easiest way to begin rewriting the meaning of black protest, given that it did not require the invention of new contexts for seeing the virtues of black agency. Because a tiny minority of whites in 1968 read Smith and Carlos's protest as a strong and peaceful statement that visualized valid racial complaints, editors and reporters needed only to present this preexisting view with sensitivity to a broader audience. In the wake of the protest, the editors of *Life* noted that Smith and Carlos "are not separatists. They do not believe in violence. They are dedicated to . . . gaining dignity and equality for all black people"; a white reporter for the *New York Amsterdam News* saw them as "champions of the best of the best [who] stood above the crowds . . . and proclaimed by these small symbols that they were black Americans bringing honor to their country"; and a white reporter covering the Olympics for the *Christian Science Monitor* even described the photograph as "a silent but unmistakable civil rights protest."[92] The sentiments expressed by such outlier whites show that the context

then existed for draining Smith and Carlos's protest of its violent threat. Missing was the will of a critical number of white reporters and editors to place the case before millions of moderate and liberal whites. Sympathetic framing in dozens of national newscasts, newspapers, and magazines would have ignited a firestorm of controversy, but it would also have launched a substantive dialogue on race, which is the only route to peaceful and far-reaching reform.

THE AFTERLIFE OF IMAGES

The great force of history comes from the fact that we carry it within us, are unconsciously controlled by it in many ways, and history is literally *present* in all that we do. It could scarcely be otherwise, since it is to history that we owe our frames of reference, our identities, and our aspirations. And it is with great pain and terror that one begins to realize this. In great pain and terror one begins to assess the history . . . [that] has placed one where one is and formed one's point of view. In great pain and terror because, therefore, one enters into battle with that historical creation, Oneself, and attempts to recreate oneself according to a principle more humane and more liberating; one begins the attempt to achieve a level of personal maturity and freedom which robs history of its tyrannical power, and also changes history.

JAMES BALDWIN, "WHITE MAN'S GUILT," *EBONY*, AUGUST 1965

In 2002, the civil rights story of Birmingham was brought to a tidy journalistic close. In May of that year, Bobby Frank Cherry, the last living participant in the 1963 bombing of the Sixteenth Street Baptist Church, was convicted of murdering Denise McNair, Carole Robertson, Addie Mae Collins, and Cynthia Wesley and sentenced to life in prison. In the burst of publicity surrounding the arrest and trial, newspapers wrote admiringly of the new generation of southern white prosecutors eager to pursue the 1960s' most infamous unsolved cases and of the radically altered social and racial climate in the new South. Press coverage was extensive for the trial and sentencing of Cherry, and also for Byron De La Beckwith's conviction in 1994 for the murder of legendary civil rights organizer Medgar Evers, and for Edgar Ray Killen's sentencing in 2005 for the Freedom Summer executions of voter registration volunteers James Chaney, Andrew Goodman, and Michael Schwerner.[1]

White press accounts of such long-delayed civil rights cases routinely note the closing of an era and laud the distance traveled by the country's whites. As the *New York Times* editorialized in 2002, "With yesterday's conviction of Bobby Frank Cherry . . . an Alabama jury wrote the final page of one of the most heart-rending chapters in the United States' civil rights history. In a year when Gov. George Wallace stood in the schoolhouse door and Eugene (Bull) Connor sicced dogs on peaceful protestors, the bombing was the Ku Klux Klan's answer to court-ordered desegregation." The editors conclude, "It is gratifying that Alabama, which once heartily cheered Governor Wallace's vow of 'Segregation now, segregation tomorrow,

segregation forever!' has convicted the last of the 16th Street Baptist Church killers."[2] In their estimation, white Alabamans "wrote the final page" of the Birmingham story as they turned their backs on segregation and confronted its most infamous crimes.

Such coverage may sound familiar. In ticking off significant milestones of civil rights, the *Times* editorial focuses on the actions of whites—Wallace blocking the door, Connor siccing his dogs, the Ku Klux Klan setting off its bomb, and Alabamans convicting Cherry. Similarly, in lauding progress in American race relations, the editors trumpet the political divisions separating whites. Differences in belief that the northern white press demarcated in the 1960s as a geographic divide (North versus South) are preserved in the editorial as a temporal division (present versus past). This contemporary editorial is far from idiosyncratic. Media historians have shown that popular representations of civil rights are much more likely to replicate than examine the approaches of journalists from the 1960s. Recognizing the media's imperative of maximizing audience size, and the drama of the first news accounts of civil rights, scholars note that present-day accounts of the movement in exhibitions, films, television documentaries, and popular books present the same story lines, events, protagonists, and emotions that characterized accounts in the 1960s.[3]

A journalist writing in 2007 offered the following description of Walter Gadsden in the famous Hudson photograph: "Tall, thin, well-dressed, [he] leans into the dog with a look of passive calm, his eyes lowered." Echoing this characterization, twenty-first-century historians and journalists note that the youth "seems to embody 'passive resistance,'" reacts "with classic nonviolence," appears "passive, even limp," or "wears on his face a look of passive calm."[4] Readers now understand that these descriptions reflect more than the personal eccentricities of observers. Whites today see "passivity" either because their outlook is conditioned by earlier descriptions of the photograph or because they have internalized the dominant narrative for interpreting civil rights.

This framework is so powerful that contemporary Americans see black passivity even when they view civil rights photographs for the first time. In 2002, the scholar of communications Margaret Spratt completed a study of the role of iconic news photographs in constructing American history and myth. She showed more than a hundred college students a projected slide of Hudson's famous photograph and then asked them open-ended questions about the scene. The overwhelmingly white and self-described liberal sample group provided consistent interpretations of the image, notwithstanding that fewer than 20 percent of the students could recall having seen the photograph previously. According to Spratt, responses "that addressed the individual actions of the two people depicted typically identified the police officer as the attacker, representing police abuse and brutality, and the young black man as innocent, symbolizing the righteousness of the civil rights movement." Virtually all her respondents read

the photograph as an emblem of civil rights. Her study concludes, "Interpretations differed in details, but were remarkably similar in overall themes," echoing the "preferred historical and mythical meanings" that dominate both media and historical accounts. With great consistency, her undergraduate informants "saw" Gadsden's "helplessness and victimization," his "non-threatening" bearing, and his "passive" nature.[5]

Almost fifty years after the photograph was taken, Gadsden resides in the white imagination as a respectful, passive martyr to the civil rights cause. We know that the numerous descriptions of Gadsden from the 1960s that cast him as "passive" grew from the racial values of whites and were unconnected to events in the street. The narrative's survival in the face of overwhelming evidence of the activeness of the era's blacks suggests that the picture of black passivity remains compatible with the present-day beliefs of whites. Decades of reports and images highlighting the activity of whites and passivity of blacks have cemented the timeworn notion that, for better or worse, whites are the active agents spearheading both the preservation of the racial status quo and its reform. For many Americans today, the story of civil rights remains a story of white agency.

This picture of white power comes at considerable cost. Not only do the iconic photographs make black passivity look normal, but also they subtly promote the ongoing brutalization of blacks. Photographs of black passivity assume a natural air because of their ubiquity in the visual record; over time, their wide circulation helps make the depicted roles appear representative of black life. But they also seem normal because they meet the psychological needs of whites. We have seen repeatedly that formally similar images can carry opposite meanings, depending on the racial values through which the images are processed. Americans predisposed to violence against blacks are less likely to see violent images as a reproach than as validation for what they take as the natural dynamic of racial power. As President Kennedy clearly feared, the photograph of Middleton's attack on Gadsden was more likely to please racist whites than to unsettle them. For moderates and liberals who steadfastly maintain that the depicted violence is wrong, the images naturalize violence by presenting a reassuring foil. We recall that white reporters and their editors ignored the most graphic images of brutality against blacks, reproducing only those photographs that insulated their readers from identifying too closely with the perpetrators of violence. Since the published images of racist bombers, policemen, and mobs have long been key to the identity of liberal whites—demarcating what they are not—the whites most opposed to white-on-black violence retain a chilling interest in seeing it reproduced.

The white-on-black violence pictured in and promoted by the photographs is ultimately a symptom of racism and not its cause. We have seen that scenes of violence distracted liberals in the North from the real work of reform; fixated on the public spectacle of violence, many

whites equated racism with violent acts. As a consequence, the rush of reformers to diminish visible expressions of racism in the public sphere led them to overlook how the values of whiteness supported social arrangements that disempowered blacks. When we allow the "story" of civil rights to remain one of bombings, assassinations, and beatings, we risk succumbing to the 1960s' trap of defining violence as the axis around which the struggle revolved. Investigating, charging, trying, and convicting Cherry, De La Beckwith, and Killen is vastly better than allowing murderers to remain free, but these steps are ultimately smaller and less costly than grappling with the unspoken assumptions of whites that keep large numbers of nonwhites from participating equally in society today.

My concern with iconic civil rights imagery is not its failure to advance black rights. As I have been at pains to argue, the photographs supported many of the aims for which blacks struggled. At issue is the price that the photographs extracted for their promotion of reform. In order to safely move whites to either tolerate or embrace social and legislative change, the photographs occluded various racial facts, including the agency of blacks in shaping American history and the shared beliefs of reactionary and progressive whites. When we reproduce civil rights photographs today with the same framing that dominated media accounts in the 1960s, we inadvertently enforce the racial status quo. Before we can "write the final page" of the civil rights era, we must reframe the iconic photographs and develop a more progressive canon of images. Until we do so, the most significant social work of civil rights photographs will continue to be the limits they place on the exercise of black power.

NOTES

FOREWORD

1 John F. Kennedy as quoted in Arthur M. Schlesinger, *A Thousand Days: John F. Kennedy in the White House* (Boston: Houghton Mifflin, 1965), 971.

2 Stanley D. Levison to Martin Luther King Jr., April 7, 1965, as quoted in David J. Garrow, *Bearing the Cross: Martin Luther King, Jr., and the Southern Christian Leadership Conference* (New York: William Morrow, 1986), 419–20 (emphasis in Levison's original).

3 Ibid., 420.

INTRODUCTION

Epigraphs: "Evict Outsiders Says Jim Clark," *Chicago Daily Defender,* March 8, 1965, 10; Albert C. "Buck" Persons, *The True Selma Story: Sex and Civil Rights* (Birmingham, AL: Esco Publishers, Inc., 1965), 1.

1 For more on Jackson's life and death, see Jack Mendelsohn, *The Martyrs: Sixteen Who Gave Their Lives for Racial Justice* (New York: Harper & Row Publishers, 1966), 133–52.

2 For analysis of the Selma to Montgomery marches, see David J. Garrow, *Protest at Selma: Martin Luther King, Jr., and the Voting Rights Act of 1965* (New Haven, CT: Yale University Press, 1978); quote from John Lewis with Michael D'Orso, *Walking with the Wind: A Memoir of the Movement* (New York: Harcourt Brace & Company, 1998), 340; for more on the controversy, see 345–60.

Television networks also provided extensive coverage of the events in Selma. On the day of the clash, ABC interrupted its evening broadcast of Stanley Kramer's *Judgment at Nuremberg* (1961) to air scenes of the melee as soon as the news footage reached New York. Despite the undeniable power that television coverage had for the white public, I confine my analysis of iconic civil rights scenes to still photography for two reasons: first, observers in the 1960s cited the powerful impact of newspaper and magazine photographs more frequently than they mentioned television coverage; second, while raw film footage of many civil rights events is preserved, few national, state, or local newscasts survive from earlier than 1968. Given my focus on the Birmingham campaign in April and May of 1963 and my attention to how media reports framed the images they used, the expansion of my study to include moving pictures would have proved challenging. Readers interested in clips of the raw film footage can find some in *Eyes on the Prize: America's Civil Rights Movement, 1954–1985,* part 1, episode 4, "No Easy Walk," an *American Experience* television series produced by Blackside in 1987. For an analysis of the television coverage of the Birmingham campaign, see Sasha Torres, *Black, White, and in Color: Television and Black Civil Rights* (Princeton, NJ: Princeton University Press, 2003). For an overview and analysis of the state of preservation of television newscasts, see William T. Murphy, "Television and Video Preservation: A Report on the Current State of American Television," vol. 1 (October 1997), www.loc.gov/film/tvstudy.html (accessed May 7, 2009).

3 For the prominently displayed photographs of law enforcement officers beating black protestors in the white press, see Roy Reed, "Alabama Police Use Gas and Clubs to Rout Negroes," *New York Times,* March 8, 1965, 1, 20; "Negroes Routed by Tear Gas," *Chicago Tribune,* March 8, 1965, 1, 5; "Negro Marchers Clubbed: Melee in Selma," *Los Angeles Times,* March 8, 1965, 1, 3, 26; "Tear Gas, Clubs Halt 600 Selma March," *Washington Post,* March 8, 1965, 1, 3; Leon Daniel, "Police Rout Marchers in Selma with Gas, Clubs," *Philadelphia Inquirer,* March 8, 1965, 1, 3; "Brutal Attack on Negroes in Selma," *San Francisco Chronicle,* March 8, 1965, 1, 12; "Police Stop Vote March in Alabama," *Baltimore Sun,* March 8, 1965, 1, 4; "Negro Marchers Gassed, Beaten," *Boston Globe,* March 8, 1965, 1, 2.

4 Reed, "Alabama Police Use Gas," 1.

5 "Brutality Stops Ala. Vote March," *Chicago Daily Defender,* March 8, 1965, 1, 4–5. I have not found this photograph reproduced in the white press, but it also appeared in the following black newspaper articles: "Bama's Story Recorded Again for All to See," *New York Amsterdam News,* March 13, 1965, 8; "Ala. Savagery as the World Sees It," *Call and Post (Cleveland, OH),* March 13, 1965, 1. Its original UPI caption, as preserved in the Bettmann Photographic Archive at the Cleveland Public Library, reads: "SELMA.ALA.: Negroes and state troopers alike go to the ground here 3/7 as troopers moved in to break up Negro march on the state capitol at Montgomery, 60 miles away. Troopers used tear gas to finally disperse the would-be marchers."

1. THE FORMULAS OF DOCUMENTARY PHOTOGRAPHY

Epigraph: Martin Luther King Jr., *Why We Can't Wait* (New York: Harper & Row, 1964), 87.

1 The Albany police force was arguably no less violent than others in the South, but because its chief had studied King's *Stride toward Freedom: The Montgomery Story* (New York: Harper & Row, 1958), it was better prepared to counter the movement's tactics and appear civilized to the press. Pritchett worked to keep police violence out of sight and to voice publicly his displeasure with subordinates when incidents of abuse came to light. Nearly two decades after the conflict in Albany, the CBS reporter Dan Rather recalled Pritchett as "fair and polite and generally good to work with," claiming that the police chief's approach had assured King's failure. See Dan Rather with Mickey Herskowitz, *The Camera Never Blinks: Adventures of a TV Journalist* (New York: William Morrow and Company, 1977), 89–91. For Chief Pritchett's discussion of his successful tactics, see the Laurie Pritchett interview in Howell Raines, *My Soul Is Rested: Movement Days in the Deep South Remembered* (New York: G. P. Putnam's Sons, 1977), 361–66. For a historian's assessment, see Adam Fairclough, *To Redeem the Soul of America: The Southern Christian Leadership Conference and Martin Luther King, Jr.* (Athens: University of Georgia Press, 1987), 107–9.

2 David J. Garrow, *Bearing the Cross: Martin Luther King, Jr., and the Southern Christian Leadership Conference* (New York: William Morrow and Company, 1986), 209, 225–28.

3 Ibid., 237.

4 A reporter for the *New York Times* claimed that for downtown Birmingham stores, "retail sales have been off 30 percent or more" as a result of the boycott and demonstrations, and that "for the first time in a generation [retailers] had shown a net loss on their books." Philip Benjamin, "Negroes' Boycott in Birmingham Cuts Heavily into Retail Sales," *New York Times,* May 11, 1963, 9.

5 For the local clergy's criticism of King and the protests, see C. C. J. Carpenter, Joseph A. Durick, Milton L. Grafman, Paul Hardin, Nolan B. Harmon, George M. Murray, Edward V. Ramage, and Earl Stallings, "Public Statement by Eight Alabama Clergymen," *Birmingham News,* April 12, 1963, reprinted in Charles Muscatine and Marlene Griffith, eds., *The Borzoi College Reader* (New York: Alfred A. Knopf, 1976), 233–34. King spoke to John Thomas Porter, who was shocked by King's utilitarian view of the media. Quoted in Garrow, *Bearing the Cross,* 247. For analysis of the clergy's critique, see S. Jonathan Bass, *Blessed Are the Peacemakers: Martin Luther King Jr., Eight White Religious Leaders, and the "Letter from Birmingham Jail"* (Baton Rouge: Louisiana State University Press, 2001).

6 James Bevel interview in Henry Hampton and Steve Fayer, eds., *Voices of Freedom: An Oral*

History of the Civil Rights Movement from the 1950s through the 1980s (New York: Bantam Books, 1990), 131.

7 Robert J. Donovan, "Birmingham . . . U.S. Image Abroad," *New York Herald Tribune,* May 12, 1963, section 2, 1.

8 Martin Luther King Jr., *Why We Can't Wait* (New York: Harper & Row, 1964), 30. In attending to the power of images for white audiences, I do not claim that the scenes were less powerful for black Americans. I have more to say on the impact of the photographs on black viewers in chapter 2.

9 Arthur M. Schlesinger Jr., *A Thousand Days: John F. Kennedy in the White House* (Boston: Houghton Mifflin Company, 1965), 959–60. The historian Michael J. Klarman cites polls showing a dramatic rise in the percentage of Americans who deemed civil rights the "most pressing issue" facing America in the aftermath of the photographs' publication. See Klarman, *From Jim Crow to Civil Rights: The Supreme Court and the Struggle for Racial Equality* (New York: Oxford University Press, 2004), 436.

10 Eric Sevareid, *This Is Eric Sevareid* (New York: McGraw-Hill, 1964), 89. John Herbers, "Voting Is Crux of Civil Rights Hopes," *New York Times,* February 14, 1965, E5. The Georgia congressman Charles Longstreet Weltner (1963–67) noted, "All the explanations and words in the world cannot erase the force and impact of those photographs"; Weltner, *Southerner* (Philadelphia: J. B. Lippincott Company, 1966), 58. For more on Kennedy's response to the events in Birmingham, see Fairclough, *To Redeem the Soul of America,* 134–36; Garrow, *Bearing the Cross,* 265, 268–69; and Schlesinger, *A Thousand Days,* 958–71.

11 Vicki Goldberg, *The Power of Photography: How Photographs Changed Our Lives* (New York: Abbeville Publishing Group, 1993), 204; Taylor Branch, *Pillar of Fire: America in the King Years, 1963–1965* (New York: Simon & Schuster, 1998), 77, xiii; Diane McWhorter, *Carry Me Home: Birmingham, Alabama, the Climactic Battle of the Civil Rights Revolution* (New York: Simon & Schuster, 2001), 25. For other late twentieth- and early twenty-first-century accounts of the photographs' power, see Steven Kasher, *The Civil Rights Movement: A Photographic History, 1954–68* (New York: Abbeville Press, 2000), 96; Michael S. Durham, *Powerful Days: The Civil Rights Photography of Charles Moore* (Tuscaloosa: University of Alabama Press, 2002), 90; John Kaplan, "The *Life* Magazine Civil Rights Photography of Charles Moore," *Journalism History* 25:4 (Winter 1999–2000): 126–39; and Todd Gitlin, *The Whole World Is Watching: Mass Media and the Making and Unmaking of the New Left* (Berkeley: University of California Press, 2003), 243.

 The reporter Karl Fleming recalls, "Moore's dramatic photographs in *Life* magazine the next week erased what might have been any lingering national doubt that what King had been saying about the cruelty of Birmingham and southern segregation was true." In

Fleming, *Son of the Rough South: An Uncivil Memoir* (New York: PublicAffairs, 2005), 314. Howard Chapnick claims that Moore's photographs "contributed to the change in the American perception of this [civil rights] struggle, helping in the elimination of segregation laws." In Chapnick, *Truth Needs No Ally: Inside Photojournalism* (Columbia: University of Missouri Press, 1994), 155.

For the international impact of the photographs, see Mary L. Dudziak, *Cold War Civil Rights: Race and the Image of American Democracy* (Princeton: Princeton University Press, 2000), 169–78; Robert H. Estabrook, "Alabama Front Page News in Europe—with Bad Impact," *Boston Globe,* May 7, 1963, 17.

The historian David J. Garrow takes issue with the claims for Birmingham's power in the promotion of the Civil Rights Act. For his compelling argument, see Garrow, *Protest at Selma: Martin Luther King, Jr., and the Voting Rights Act of 1965* (New Haven, CT: Yale University Press, 1978), 143–50. I am less interested in determining the "actual" effect of the Birmingham images than in pointing out the broad-based acceptance of their power.

12 For descriptions and photographs of the Jackson dog attacks, see "FBI Is Probing Racial Outbreak," *New York World-Telegram and Sun,* March 30, 1961, 3; "Police and Dogs Rout 100 Negroes," *New York Times,* March 30, 1961, 19; "Dixie Negroes Clubbed: Cops Also Use Dogs in Mississippi," *San Francisco Chronicle,* March 30, 1961, 8. On the use of dogs in Greenwood, see James Forman, *The Making of Black Revolutionaries: A Personal Account* (New York: Macmillan Company, 1972), 298–99; "Dogs Again Rout Voters in Miss. City, Bite Pastor," *Chicago Daily Defender,* April 5, 1963, 1. For coverage of the Birmingham police dog attacks on Sunday, April 7, 1963, see "'Look at That Dog Go,'" *Birmingham World,* April 13, 1963, 8; "Alabama Riot Broken Up by Police Dogs," *Los Angeles Times,* April 8, 1963, 1. On the use of dogs against black protestors in Norfolk, Virginia, after a crowd gathered in response to police harassment of a black soldier, see "Use of Police Dogs Stirs Norfolk Row," *Afro-American (Baltimore, MD),* April 27, 1963, 19.

13 G. B. Hollingsworth Jr., Birmingham, AL, and Bert S. Damsky, Birmingham, AL, letters to the editor, *Time,* May 24, 1963, 9; Ralph Shaw Jr., Beverly, NJ, and Dan Griffin, Anderson, SC, letters to the editor, *Life,* June 7, 1963, 25. Such sentiments were not confined to letter-to-the-editor columns of national publications; they were expressed in Congress as well. George Huddleston Jr., a Democratic representative from Alabama's First Congressional District, stated on the floor of the House, "I am sure that there are a good many definitions of 'peaceful demonstration' but how any reasonable man could consider the unruly, inflammatory, riotous actions of the mobs in Birmingham to be classified as peaceful demonstrations is quite beyond my comprehension." He commended the police force for acting "with admirable restraint in the face of unprecedented provocations." George Huddleston Jr., "The True Facts of the Birmingham Situation," *Congressional Record,* 88th Cong., 1st sess., 1963, vol. 109, pt. 6, 8085–86.

14 "The Spectacle of Racial Turbulence in Birmingham: They Fight a Fire That Won't Go Out," *Life*, May 17, 1963, 26–36.

15 For circulation statistics for the era's most popular magazines, see "W. R. Simmons Study," *Chicago Daily News,* May 3, 1963, 36. For more on *Life* in the culture of 1960s America, see Erika Doss, ed., *Looking at Life Magazine* (Washington, D.C.: Smithsonian Institution Press, 2001). For a revealing scholarly discussion of mainstream magazine coverage of Birmingham, see Richard Lentz, *Symbols, the News Magazines, and Martin Luther King* (Baton Rouge: Louisiana State University Press, 1990), 75–112.

16 "Spectacle of Racial Turbulence," 29–30. Disagreement exists over whether Connor uttered the famous "want 'em to see the dogs work" phrase. Given the importance to my argument of Connor's desire to make inactive black bodies visible to whites, some analysis of this disagreement is warranted. Diane McWhorter notes in her study of the Birmingham struggle that Dudley Morris of *Time,* whom she credits as the first to cite the public safety commissioner uttering the phrase, purportedly did not hear the expression firsthand, according to the *Life* stringer Albert Persons. Nonetheless, the quote was reported widely, appearing in *Time, Life,* and many major newspapers. See McWhorter, *Carry Me Home,* 393. Two points on this disagreement are important. First, Persons strongly disapproved of the civil rights movement and may not be a reliable informant. In 1965, he authored a publication that sought to discredit the civil rights project and the liberal press. His thirty-three-page booklet was distributed by the National States Rights Party, an anti-Semitic, antiblack and anti–civil rights political group. See Albert C. Persons, *The True Selma Story: Sex and Civil Rights* (Birmingham, AL: Esco Publishers, Inc., 1965), and my more detailed discussion of his writings in chapter 4. Second, whether the line was uttered or not, the evidence strongly suggests that the sentiment was felt. In granting access to black protestors, Connor gave preference to whites whom he perceived to be sympathetic to the segregationist cause. Dan Rather has written that he was initially refused a request to interview King in Birmingham by the local police in 1963 but was granted access when he appealed to Connor personally, flashing an expired identification card from the *Houston Chronicle* and laying on his thickest Texas accent. See Rather, *The Camera Never Blinks,* 92–93. Moore also reported receiving greater access in Birmingham because of officials' mistaken belief that he worked for a white Montgomery paper. Moore interview with Flip Schulke cited in Joel Eisinger, "Powerful Images: Charles Moore's Photographs of the Birmingham Demonstrations," *Exposure* 33:1/2 (2000), 35; this article in turn draws the quote from Larry H. Spruill, "Southern Exposure, Photography and the Civil Rights Movement, 1955–1968" (Ph.D. dissertation, State University of New York at Stony Brook, 1983), 263.

17 "Halt New Ala. 'March,'" *New York Mirror,* May 5, 1963, 2; "Dogs and Fire Hoses Turned on Negroes: Marchers Sent Sprawling," *Chicago Tribune,* May 4, 1963, 1, 4; "Birmingham, U.S.A.: 'Look at Them Run,'" *Newsweek,* May 13, 1963, 23; "Keeping Peace in Alabama—

Police, Fire Hoses and Dogs," *New York Herald Tribune,* May 4, 1963, 1; Don McKee, "Dogs, Hoses Rout Negroes in Birmingham Bias Protest," *Philadelphia Inquirer,* May 4, 1963, 1; "Police Turn Hoses on Alabama Negroes," *New York World-Telegram,* May 3, 1963, 1; "Negro Leaders Order Halt to Birmingham Protests," *New York World-Telegram,* May 8, 1963, 1; "Birmingham: 'War,'" *New York Mirror,* May 5, 1963, 2; "Police Battle Negroes 4 Hours," *Chicago Tribune,* May 5, 1963, 1; "Fire Hoses Rip Off Negroes' Clothes in Dixie Violence," *New York Daily News,* May 4, 1963, 5.

18 Paul Hemphill, *Leaving Birmingham: Notes of a Native Son* (New York: Viking, 1993), 149. These descriptive patterns are often replicated in the accounts of late twentieth- and twenty-first-century historians. In his Pulitzer Prize–winning analysis of the civil rights struggle, the historian Taylor Branch wrote that the high-pressure hoses "made limbs jerk weightlessly and tumbled whole bodies like scraps of refuse in a high wind." In *Parting the Waters: America in the King Years, 1954–63* (New York: Simon & Schuster, 1988), 759.

19 "Races: Freedom—Now," *Time,* May 17, 1963, 23.

20 Paul Good, *The Trouble I've Seen: White Journalist/Black Movement* (Washington, D.C.: Howard University Press, 1975), 250, 255, 271; Danny Lyon, *Memories of the Southern Civil Rights Movement* (Chapel Hill: University of North Carolina Press, 1992), 42; Nicholas Von Hoffman, *Mississippi Notebook* (New York: D. White, 1964), 39. Quoted in Charles M. Payne, *I've Got the Light of Freedom: The Organizing Tradition and the Mississippi Freedom Struggle* (Berkeley: University of California Press, 1995), 394. Payne provides an excellent discussion of the press's failure to grapple with structural questions in its coverage of civil rights (391–405).

21 The airbrushed image appeared on page 2 of the article "Negroes Urge U.S. Troops in Alabama," *New York World-Telegram and Sun,* September 16, 1963, 1–2.

22 Schlesinger, *A Thousand Days,* 971.

23 David Halberstam, "The Second Coming of Martin Luther King," *Harper's Magazine,* August 1967; quoted in Jon Meacham, ed., *Voices in Our Blood: America's Best on the Civil Rights Movement* (New York: Random House, 2001), 374; also see Laurie Pritchett's assessment: "Dr. King, through his efforts, was instrumental in passin' the Public Accommodations [Act] but the people that were most responsible was 'Bull' Connor and Sheriff Clark"; quoted in Raines, *My Soul Is Rested,* 366.

24 "The Spectacle of Racial Turbulence in Birmingham," 36.

25 "Fire Hoses and Police Dogs Quell Birmingham Segregation Protest," *Washington Post,* May 4, 1963, A-1, A-4. The photograph of the knife-wielding black man was also reproduced in "Dogs and Hoses Repulse Negroes at Birmingham," *New York Times,* May 4, 1963, A-1; "Dogs and Fire Hoses Turned on Negroes: Marchers Sent Sprawling," *Chicago Tribune,* May 4, 1963, 1, 4. The *Los Angeles Times* reported on an earlier attempt by a black Birming-

ham resident to knife a police dog. See "Alabama Riot Broken Up by Police Dogs," April 8, 1963, 1.

26 For a thoughtful analysis of Warhol's *Race Riot* series (1963), see Anne M. Wagner, "Warhol Paints History, or Race in America," *Representations* 55 (Summer 1996): 98–119. In the estimation of the editors of Warhol's catalogue raisonné, the artist's lack of concern for getting the name of the city right "shows how Warhol grasped the fundamental subject of these images—Negroes, dogs, civil rights—without recalling its particular context, whether Birmingham, Selma, or Montgomery." In Georg Frei and Neil Printz, *The Andy Warhol Catalogue Raisonné: Paintings and Sculpture 1961–1963* (New York: Phaidon, 2002), 421. Others who made use of white-on-black civil rights violence in their art include Larry Rivers, in *Black Revue* from his *Boston Massacre* series (1970), and Duane Hanson in *Race Riot* (1968). Of interest is the 1965 painting and oil study by Norman Rockwell, *Southern Justice (Murder in Mississippi)*. The work was commissioned to illustrate an article in *Look* on the Mississippi murders of James Chaney, Andrew Goodman, and Michael Schwerner. In the painting, the white, but Jewish, Goodman lies prostrate and bleeding in the foreground, the white Schwerner stands erect in the center of the composition looking at unseen assailants off to our right as he grips a wounded black Chaney, who has fallen to his knees. Although the murderers are not pictured, the canvas replicates the formulaic depiction of whites common to civil rights imagery through its suggestion of white attackers and its picturing of Schwerner as a white protector. Again, the active roles are scripted for whites. See Charles Morgan Jr., "Southern Justice," *Look*, June 29, 1965, 72. For recent photographic surveys of civil rights that largely preserve this dynamic of power, see Kasher, *The Civil Rights Movement*, 96; Durham, *Powerful Days*; Bob Adelman and Charles Johnson, *Mine Eyes Have Seen: Bearing Witness to the Struggle for Civil Rights* (New York: Time Inc., 2007); Julian Cox, *Road to Freedom: Photographs of the Civil Rights Movement, 1956–1968* (Atlanta: High Museum of Art, 2008). For two that complicate the formula, see Maurice Berger, *For All the World to See: Visual Culture and the Struggle for Civil Rights* (New Haven, CT: Yale University Press, 2010); Manning Marable, *Freedom: A Photographic History of the African American Struggle* (New York: Phaidon Press, 2002).

27 Anne Moody quoted in Drew D. Hansen, *The Dream: Martin Luther King, Jr., and the Speech That Inspired a Nation* (New York: HarperCollins, 2003), 171. For the public reception of King's "I Have a Dream Speech" between 1963 and 1968, see ibid., 167–206. When King ventured to Watts in the aftermath of the ruinous 1965 riot, a resident heckled him, calling out, "I had a dream, I had a dream—hell, we don't need no damn dreams. We want jobs." Quoted in Robert Mann, *The Walls of Jericho: Lyndon Johnson, Hubert Humphrey, Richard Russell and the Struggle for Civil Rights* (New York: Harcourt Brace & Company, 1996), 479.

28 John Lewis with Michael D'Orso, *Walking with the Wind: A Memoir of the Movement* (New York: Harcourt Brace & Company, 1998), 220.

29 Olympic coverage, ABC archives, October 17, 1968, tape 16, 8:41–8:44, quoted in Amy Bass, *Not the Triumph but the Struggle: The 1968 Olympics and the Making of the Black Athlete* (Minneapolis: University of Minnesota Press, 2002), 240. For Smith's perspective on the protest, see Tommie Smith with David Steele, *Silent Gesture: The Autobiography of Tommie Smith* (Philadelphia: Temple University Press, 2007).

30 "Raised Black Fists," *Life,* November 1, 1968, 64-C.

31 Garrow, *Protest at Selma,* 133–60.

32 McWhorter, *Carry Me Home,* 374. The amateur photographer Arnold Hardy took the 1947 Pulitzer Prize–winning photograph in 1946.

33 Bill Hudson's photograph of Walter Gadsden and Dick Middleton was reproduced in many mainstream white periodicals, including Claude Sitton, "Violence Explodes at Racial Protests in Alabama," *New York Times,* May 4, 1963, A-1; "Police Dog Attacks Demonstrator," *New York Daily News,* May 4, 1963, 1; "Keeping Peace in Alabama—Police, Fire Hoses and Dogs," *New York Herald Tribune,* May 4, 1963, 1; "New Alabama Riot: Police Dogs, Fire Hoses Halt March," *Los Angeles Times,* May 4, 1963, 1; "Dogs and Fire Hoses Turned on Negroes: Marchers Sent Sprawling," *Chicago Tribune,* May 4, 1963, 1, 4; "Dogs and Fire Hoses Rout 3,000 Negroes," *Boston Globe,* May 4, 1963, 1; "Police Dogs, Hoses Smash Negro March," *San Francisco Chronicle,* May 4, 1963, 1; *Philadelphia Inquirer,* May 7, 1963, 14; "Birmingham, U.S.A.: 'Look at Them Run,'" *Newsweek,* May 13, 1963, 27.

34 Mike Gold [Itzok Isaac Granich], "Change the World," *Daily Worker,* May 26, 1963, 4.

35 "Violence in Birmingham," *Washington Post,* May 5, 1963, E-6.

36 Hemphill, *Leaving Birmingham,* 149.

37 Alvin Adams, "Picture Seen around the World Changed Boy's Drop-Out Plan," *Jet,* October 10, 1963, 26–27. On the politics of the Gadsden family, see Branch, *Parting the Waters,* 760–61.

38 For the observations on Gadsden's gripping left hand, see McWhorter, *Carry Me Home,* 374; Kasher, *The Civil Rights Movement,* 95. On the training in nonviolence that Birmingham protestors received, see James A. Colaiaco, *Martin Luther King, Jr.: Apostle of Militant Nonviolence* (New York: St. Martin's Press, 1988), 61–62.

39 Christopher B. Strain, *Pure Fire: Self-Defense as Activism in the Civil Rights Era* (Athens: University of Georgia Press, 2005).

40 Adams, "Picture Seen around the World," 26.

41 Wyatt Walker quoted in Harry S. Ashmore, *Hearts and Minds: The Anatomy of Racism from Roosevelt to Reagan* (New York: McGraw-Hill, 1982), 351; for other examples of whites' inability to distinguish black protestors, see Ellen Levine, *Freedom's Children: Young Civil Rights Activists Tell Their Own Stories* (New York: Puffin Books, 2000), 87; Bill Garrison, "Struggle!"

Muhammad Speaks, May 13, 1963, 8. In an interesting footnote, the Hudson photograph of Gadsden is currently reproduced on the Public Broadcasting Corporation's *Eyes on the Prize: American Civil Rights Movement, 1954–1985* web site, over the caption, "A civil rights demonstrator, defying an anti-parade ordinance of Birmingham, Alabama, is attacked by a police dog on May 3, 1963." See www.pbs.org/wgbh/amex/eyesontheprize/story/07_c.html#gallery.

42 For an example of how Moore's images are subjected to close readings, see Eisinger, "Powerful Images." Eisinger points out that Moore's images of Birmingham have been analyzed predominantly for their documentary evidence of history and for their efficacy in promoting legislative change. He argues for greater attention to the specificity of the images' visual evidence. While sympathetic to his aims, I believe that approaches that center on visual evidence often slight the significant discursive means by which the social meanings of images are produced.

43 For more on Civil War photographs that used "lies" to tell larger "truths," see "Photography and the Artifice of Realism," in Miles Orvell, *The Real Thing: Imitation and Authenticity in American Culture, 1880–1940* (Chapel Hill: University of North Carolina Press, 1989), 73–102.

44 The active-inactive dynamic dominating the reports of the white northern media on the civil rights movement is not an idiosyncratic relic of the 1960s; to a remarkable degree, it remains embedded in twenty-first-century culture. Writing in 2003, the historian David Chalmers claimed, "The story of the 1960s was one of how Klan clubs, bombs, and bullets made a major unintended contribution to the civil rights revolution." In Chalmers, *Backfire: How the Ku Klux Klan Helped the Civil Rights Movement* (New York: Rowman & Littlefield, 2003), 3. In much the same vein, the historian William Nunnelley gives Connor significant credit for pushing civil rights reform. See his *Bull Connor* (Tuscaloosa: University of Alabama Press, 1991).

45 "Death as a Weapon," *Los Angeles Times,* January 31, 1948, A-4; "Fast Potent Weapon for Gandhi," *Washington Post,* January 31, 1948, 8.

46 "Gandhi: He Changed World History, Yet His Power Was Not of This World," *Life,* February, 9, 1948, 32; "Beyond Rights the Issue of Human Dignity," *Life,* May 24, 1963, 4.

47 Fleming, *Son of the Rough South,* 318.

48 James Farmer, interviewed in Raines, *My Soul Is Rested,* 28. Farmer's phrase "war without violence" was drawn from the title of a book by one of Gandhi's disciples, Krishnalal Shridharani, *War without Violence* (New York: Harcourt, Brace and Co., 1939).

49 Garrow, *Bearing the Cross,* 246. For a compelling argument on the essential activity of nonviolent direct action, see Gene Sharp, *The Politics of Nonviolent Action* (Boston: Porter Sargent Publisher, 1973), 65–66.

50 In interviews with print and television journalists, King went to great lengths to describe the active, often martial nature of nonviolence. In Garrow, *Bearing the Cross,* 32, 99; King quoted in Flip Schulke, ed., *Martin Luther King, Jr.: A Documentary . . . Montgomery to Memphis* (New York: W. W. Norton & Company, 1976), 117; Karl Fleming, "I Like the Word Black," *Newsweek,* May 6, 1963, 28.

51 "Jews Score a Preliminary Victory," *Life,* May 10, 1948, 30; also see "Warfare Spreads in the Holy Land," *Life,* January 19, 1948, 26; "Jews Drive Arab Forces from Vital Positions," *Los Angeles Times,* May 11, 1948, 6; "War in Palestine," *New York Times,* May 2, 1948, 113; "Jews Capture Yehudia after All-Night Battle," *Los Angeles Times,* May 5, 1948, 8.

52 "A Typical Negro," *Harper's Weekly,* July 4, 1863, 429–30. There is evidence that the photograph was eventually reproduced by antislavery societies in Great Britain as well. For an account of the production and circulation of the image, see Kathleen Collins, "The Scourged Back," *History of Photography* 9:1 (January–March 1985): 43–45. For more on the photographic firm of McPherson and Oliver, see Margaret Denton Smith and Mary Louise Tucker, *Photography in New Orleans: The Early Years, 1840–1865* (Baton Rouge: Louisiana State University Press, 1982), 121–24.

53 The phrase is of course drawn from President Lincoln's Gettysburg Address, delivered November 19, 1863, four and a half months after *Harper's Weekly* published "A Typical Negro."

54 For a discussion of the photograph of Spotts and Bontecou's surgical and photographic process, see Kathy Newman, "Wounds and Wounding in the American Civil War: A (Visual) History," *Yale Journal of Criticism* 6:2 (1993): 63–86.

55 Susan Sontag, *On Photography* (New York: Anchor Books, 1977), 167–68.

56 William T. Martin Riches, *The Civil Rights Movement: Struggle and Resistance* (New York: St. Martin Press, 1997), 90–91; Garrow, *Bearing the Cross,* 489–525. For more on King's "failure" in Chicago, see Riches, *The Civil Rights Movement,* 90–91; and Adam Fairclough, "Defeat in Chicago," in *To Redeem the Soul of America,* 279–307. For an excellent account of the civil rights struggle in the North, see Thomas J. Sugrue, *Sweet Land of Liberty: The Forgotten Struggle for Civil Rights in the North* (New York: Random House, 2008).

57 James R. Ralph Jr. quotes Young and King in *Northern Protest: Martin Luther King, Jr., Chicago, and the Civil Rights Movement* (Cambridge, MA: Harvard University Press, 1993), 123. For other movement participants' recollections of the surprising fierceness of the Chicago counterprotests, see the interviews in Hampton and Fayer, *Voices of Freedom,* 300–319.

58 Cody's Soldier Field address is quoted in Ralph, *Northern Protest,* 146; Johnson's "all the way" quote is cited in Fairclough, *To Redeem the Soul of America,* 299.

59 Bill Wise, "Query for Southern Whites—What Now?" *Life,* May 17, 1963, 35; Carpenter et al., "Public Statement by Eight Alabama Clergymen," 233–34.

60 Moore quoted in Durham, *Powerful Days,* 28. At least one present-day observer has characterized Moore's practice as "shooting photographs from the point of view of the [white] oppressors and their evil." When we consider the photographer's positioning within a cluster of Birmingham firemen (see figure 8) who aim their fire hoses toward black protestors in the middle distance or his vantage from the Montgomery policemen's side of a booking counter as Martin Luther King Jr. is hauled roughly in for processing (see figure 18), the point seems plausible. In Paul Hendrickson, *Sons of Mississippi: A Story of Race and Its Legacy* (New York: Vintage Books, 2003), 131.

61 For more on the history of American lynching, see Philip Dray, *At the Hands of Persons Unknown: The Lynching of Black America* (New York: Random House, 2002). For more on Ida B. Wells, see Linda O. McMurray, *To Keep the Waters Troubled: The Life of Ida B. Wells* (New York: Oxford University Press, 2000); Mia Bay, *To Tell the Truth Freely: The Life of Ida B. Wells* (New York: Hill and Wang, 2009). The cultural historian of photography Shawn Michelle Smith notes that sending lynching postcards through the U.S. mail was illegal after 1908. In *Photography on the Color Line: W. E. B. Du Bois, Race, and Visual Culture* (Durham, NC: Duke University Press, 2004), 122. Despite the letter of the law, there exist many extant examples of lynching postcards created—and mailed—up through the 1930s. For a horrifying sampling, see James Allen, *Without Sanctuary: Lynching Photography in America* (Santa Fe, NM: Twin Palms Publishers, 2000).

62 It is fascinating to consider that President Kennedy's initial reading of the Gadsden photograph was that it better supported the racial values of Connor than those of King. Using recordings of Kennedy's White House meetings, the historian Nick Bryant illustrates that contrary to press reports, the image left the president more confused than "disgusted." Bryant quotes the president's taped comment that the Hudson photograph was "a terrible picture. . . . The fact of the matter: that's just what Connor wants." In Nick Bryant, *The Bystander: John F. Kennedy and the Struggle for Black Equality* (New York: Basic Books, 2006), 387–89. I have more to say on the president's reaction in chapter 2. For a sophisticated consideration of the promise and perils inherent in narratives of violence against black bodies, see Saidiya V. Hartman, *Scenes of Subjection: Terror, Slavery, and Self-Making in Nineteenth-Century America* (New York: Oxford University Press, 1997); for a discussion of political and ethical considerations in the reproduction of photographs of suffering, see Mark Reinhardt, Holly Edwards, and Erina Duganne, eds., *Beautiful Suffering: Photography and the Traffic in Pain* (Chicago: University of Chicago Press, 2007).

63 Durham, *Powerful Days,* 6.

64 Even historians today are not immune from mistaking the snapping fingers for a fist. In describing the raised hand in the SNCC poster in a 2008 article, a scholar refers to it as

"the fist of a demonstrator." See Zoe Trodd, "A Negative Utopia: Protest Memory and the Spatio-Symbolism of Civil Rights Literature and Photography," *African American Review* 42:1 (Spring 2008): 28.

65 Leigh Raiford, " 'Come Let Us Build a New World Together': SNCC and Photography of the Civil Rights Movement," *American Quarterly* 59:4 (December 2007): 1144. On the sophisticated efforts of SNCC to guide and influence media coverage of the civil rights movement, see Vanessa Murphree, *The Selling of Civil Rights: The Student Nonviolent Coordinating Committee and the Use of Public Relations* (New York: Routledge, 2006). For another example of a black photographer's representation of black agency in civil rights protests, see Cherise Smith, "Moneta Sleet, Jr. as Active Participant: The Selma March and the Black Arts Movement," in Lisa Gail Collins and Margo Natalie Crawford, eds., *New Thoughts on the Black Arts Movement* (New Brunswick, NJ: Rutgers University Press, 2006), 210–26.

66 King, *Why We Can't Wait,* 33. King conceived of the book as a moving explanation for white Americans of why blacks cannot be reasonably asked to wait for freedom.

67 J. Mills Thornton III, *Dividing Lines: Municipal Politics and the Struggle for Civil Rights in Montgomery, Birmingham, and Selma* (Tuscaloosa: University of Alabama Press, 2002), 1–19.

68 Ibid., 12, 18.

2. WHITE SHAME, WHITE EMPATHY

Epigraph: Charles E. Silberman, *Crisis in Black and White* (New York: Vintage Books, 1964), 10.

1 Arthur Schlesinger Jr., *A Thousand Days: John F. Kennedy in the White House* (Boston: Houghton Mifflin Company, 1965), 959; The *Washington Post* quoted Kennedy as "horrified," the *Chicago Daily Defender, Chicago Tribune, Los Angeles Times, New York Times,* and *Washington Post* described him as "dismayed." See "Kennedy Gives Fiscal Views to Critics in ADA," *Washington Post,* May 5, 1963, A-2; "Thousands March on Jail in Birmingham," *Chicago Daily Defender,* May 6, 1963, 1; "A.D.A. Urges Kennedy Visit to Riot Area," *Chicago Tribune,* May 5, 1963, N-2; "Birmingham Police Clash with 1,000," *Los Angeles Times,* May 5, 1963, 1; "Kennedy Said to Voice Dismay at Racial Violence," *New York Times,* May 5, 1963, 83; "1,000 Defy Police in Birmingham," *Washington Post,* May 5, 1963, A-1.

2 Nick Bryant, *The Bystander: John F. Kennedy and the Struggle for Black Equality* (New York: Basic Books, 2006), 387–89.

3 Larry L. Smevik, letter to the editor, *Time,* May 24, 1963, 9.

4 Reverend John R. Porter, letter to the editor, *Chicago Daily Defender,* May 22, 1963, 14.

5 "Outrage in Alabama," *New York Times,* May 5, 1963, 200.

6 "Violence in Birmingham," *Washington Post,* May 5, 1963, E-6; "Alabama Shames the Nation," *Philadelphia Inquirer,* May 6, 1963, 6.

7 Senator Wayne Morse, "Constitutional Rights," May 7, 1963, *Congressional Record,* 88th Cong., 1st sess., 1963, vol. 109, pt. 6, 778; "Senator Rips Use of Dogs in Ala. as 'Reprehensible,'" *Chicago Daily Defender,* May 7, 1963, 5.

8 "Javits Denounces Birmingham Police," *New York Times,* May 5, 1963, 82; Representative Augustus F. Hawkins, "Civil Rights," *Congressional Record,* 88th Cong., 1st sess., 1963, vol. 109, pt. 6, 8256. As I explained in chapter 1, many observers were unmoved by the brutality depicted in the photographs. This statement applies to members of Congress as well. For Congress's most forceful critic of civil rights protestors—and ardent apologist for the photographic evidence—see George Huddleston Jr., "The True Facts of the Birmingham Situation," May 8, 1963, *Congressional Record,* 88th Cong., 1st sess., 1963, vol. 109, pt. 6, 8085–86.

9 Schlesinger, *Thousand Days,* 959–60.

10 Silberman, *Crisis in Black and White,* 10.

11 "Whitsuntide Message to the Church," in Arthur Lichtenberger, *The Day Is at Hand* (New York: Seabury Press, 1964), 114.

12 Paul Gilbert, "What Is Shame? Some Core Issues and Controversies," in Paul Gilbert and Bernice Andrews, eds., *Shame: Interpersonal Behavior, Psychopathology, and Culture* (New York: Oxford University Press, 1998), 3–38.

13 Carson McCullers's commentary is recounted in Ralph McGill, *The South and the Southerner* (Boston: Little, Brown and Company, 1963), 217.

14 "AFL-CIO Condemns Bias in Birmingham," *Chicago Daily Defender,* May 15, 1963, 3.

15 "Rusk Says Rights Struggle Damages U.S. Leadership," *New York Times,* June 10, 1963, 44; "Outrage in Alabama," *New York Times,* May 5, 1963, 200; "The Meaning of Birmingham," *New York Times,* May 10, 1963, 32. The historian Mary Dudziak documents the degree to which President Kennedy saw Birmingham as an international crisis, chronicling the administration's considerable investment in global damage control. In Mary L. Dudziak, *Cold War Civil Rights: Race and the Image of American Democracy* (Princeton, NJ: Princeton University Press, 2000), 169–78.

16 Norman Podhoretz, "My Negro Problem—and Ours," *Commentary,* February 1963, reprinted in *Reporting Civil Rights: Part One, American Journalism, 1941–1963* (New York: Library of America, 2003), 772–73.

17 Mrs. Lessie Fowler, letter to the editor, "Shame of Birmingham," *Los Angeles Times,* May 11, 1963, B-4. The liberal white reporter Karl Fleming made this identification explicit in his memoir, writing that Connor was "a twisted caricature of the quintessential dumb and

vicious red-neck cop. When I saw him in action I didn't know whether to laugh in derision or cry in shame." In Karl Fleming, *Son of the Rough South: An Uncivil Memoir* (New York: PublicAffairs, 2005), 307.

18 "The Right of Peaceful Assembly," *Birmingham World,* May 18, 1963, 8.

19 Burke Marshall Oral History Interview, May 29, 1964, 98, Kennedy Library, quoted in Dudziak, *Cold War Civil Rights,* 170.

20 "The South Looks Ahead," *Ebony,* September 1963, quoted in Ralph McGill and Calvin M. Logue, eds., *No Place to Hide: The South and Human Rights,* vol. 2 (Macon, GA: Mercer University Press, 1984), 438. For a similar and more expansive analysis by the editor of *Ebony,* see Lerone Bennett Jr., *The Negro Mood and Other Essays* (Chicago: Johnson Publishing Company, 1964), 6–7.

21 Bayard Rustin, "The Meaning of Birmingham," in *Civil Rights: The True Frontier,* June 18, 1963, reprinted in *Down the Line: The Collected Writings of Bayard Rustin* (Chicago: Quadrangle Books, 1971), 107.

22 Arthur I. Waskow, *From Race Riot to Sit-In, 1919 and the 1960s: A Study in the Connections between Conflict and Violence* (Garden City, NY: Anchor Books, 1966), 234.

23 Diane McWhorter, *Carry Me Home: Birmingham, Alabama, the Climactic Battle of the Civil Rights Revolution* (New York: Simon & Schuster, 2001), 371. Student Nonviolent Coordinating Committee members in Nashville found the photographs so powerful that they clipped them from the local paper for use in posters displayed across the city to galvanize support for Birmingham's blacks. In John Lewis with Michael D'Orso, *Walking with the Wind: A Memoir of the Movement* (New York: Harcourt Brace & Company, 1998), 198. Andrew Marrisett, a black resident of Birmingham in the 1960s, described himself and his cohort as "not really looking at what was going on around them." Everything changed for him in May of 1963, when a detour he took driving downtown brought him to Kelly Ingram Park—ground zero for the protest struggle. As Marrisett recalled, "What really sticks *[sic]* in my mind then and sticks in my mind now is seeing a K-9 dog being sicced on a six-year-old girl. I went and stood in front of the girl and grabbed her, and the dog jumped on me and I was arrested. That really was the spark . . . a big, burly two-hundred-and-eighty-five-pound cop siccing a trained police dog on that little girl, little black girl. And then I really got involved in the movement." Quoted in Howell Raines, *My Soul Is Rested: Movement Days in the Deep South Remembered* (New York: G. P. Putnam's Sons, 1977), 146.

24 Adam Fairclough, *To Redeem the Soul of America: The Southern Christian Leadership Conference and Martin Luther King, Jr.* (Athens: University of Georgia Press, 1987), 126. The journalist and historian Douglas A. Blackmon documents the chilling preservation of de facto slavery of blacks long after Emancipation. His study of involuntary servitude

unearths many accounts of whites' use of dogs to track and torture blacks up through the early twentieth century. In *Slavery by Another Name: The Re-Enslavement of Black Americans from the Civil War to World War II* (New York: Anchor Books, 2008), 71, 91, 145–46, 191–95, 242, 300, 353. Some sources provide hints that select whites may have appreciated the historically loaded nature of using dogs to put down black freedom struggles. A May 19, 1963, front-page editorial in the *Daily Worker* ("A New Charter of Freedom") claimed that the police and dogs of Bull Connor were "trained . . . by the heirs of the slave holders." And a May 6 editorial in the *Philadelphia Inquirer* said, "But fire hoses, police dogs and—what next?—are not the answer. Not in this century" ("Alabama Shames the Nation," 6).

25 Philip S. Foner, ed., *Frederick Douglass: Selected Speeches and Writings* (Chicago: Lawrence Hill Books, 1999), 196. For Roy Wilkins's statement to Mississippi governor Ross Barnett, see "Dixie Negroes Clubbed: Cops Also Use Dogs in Mississippi," *San Francisco Chronicle,* March 30, 1961, 8.

26 Elizabeth Alexander, "'Can you be BLACK and Look at This?': Reading the Rodney King Video(s)," in Black Public Sphere Collective, ed., *The Black Public Sphere: A Public Culture Book* (Chicago: University of Chicago Press, 1995), 83.

27 "Police Dogs in Ala. Spur N.C. Protest," *Afro-American (Baltimore, MD),* June 1, 1963, 1. The *Afro-American* printed the banner headline "When Police Dog Bites: 'We Bleed All Over America,'" above the masthead of the June 1, 1963, edition. The liberal white newsman Charles Silberman wrote, "When the police dogs were unleashed in Birmingham, every Negro in America felt their teeth in the marrow of his bones" (*Crisis in Black and White,* 143). For more on the effects of Birmingham on northern black communities, see David Danzig, "The Meaning of Negro Strategy," *Commentary* 37:2 (February 1964): 41–46. Thomas J. Sugrue, *Sweet Land of Liberty: The Forgotten Struggle for Civil Rights in the North* (New York: Random House, 2008), 290–95.

28 Ruth R. Hemphill, Forest Heights, MD, letter to the editor, *Washington Post,* May 16, 1963, A-22.

29 "Are These Men Christians?" *Pittsburgh Courier,* May 18, 1963, 3.

30 Nicholas Natanson, *The Black Image in the New Deal: The Politics of the FSA Photography* (Knoxville: University of Tennessee Press, 1992), 4, 34. Stryker quoted in ibid., 4.

31 For an excellent account of the uses of photographs in the internment of Japanese Americans and the political and artistic responses of Japanese Americans, see Jasmine Alinder, *Moving Images: Photography and the Japanese American Incarceration* (Urbana-Champaign: University of Illinois Press, 2009). The Family of Man photography exhibition curated by Edward Steichen for the Museum of Modern Art in New York in 1955 did use people of color to send a universal message, but the photographs used a mass of colored

bodies (and white bodies) to signal the universality of such narratives as "birth," "love," "death," and "play." This approach worked in the totality of the exhibition's 503 photographs. No individual body of color could have then delivered such universal messages to white Americans.

32 For a period account of the access granted to white onlookers by the Birmingham police, see Len Holt, "Eyewitness: The Police Terror at Birmingham," *National Guardian,* May 16, 1963, reprinted in *Reporting Civil Rights,* 799; "Halt New Ala. 'March,'" *New York Mirror,* May 5, 1963, 2.

33 Raymond Arsenault, *Freedom Rider: 1961 and the Struggle for Racial Justice* (New York: Oxford University Press, 2006), 150; Townsend Davis, *Weary Feet, Rested Souls: A Guided History of the Civil Rights Movement* (New York: W. W. Norton, 1999), 66; Philip Dray, *At the Hands of Persons Unknown: The Lynching of Black America* (New York: Random House, 2002), 448.

34 Pamela E. Barnett, *Dangerous Desire: Sexual Freedom and Sexual Violence since the Sixties* (New York: Routledge, 2004); see also Peter J. Ling and Sharon Monteith, eds., *Gender in the Civil Rights Movement* (New York: Garland Publishing, 1999).

35 Quoted in McWhorter, *Carry Me Home,* 373.

36 For sophisticated analyses of emotion in nineteenth-century American literature, see Philip Fisher, *Hard Facts: Setting and Form in the American Novel* (New York: Oxford University Press, 1987); Shirley Samuels, ed., *The Culture of Sentiment: Race, Gender, and Sentimentality in Nineteenth-Century America* (New York: Oxford University Press, 1992); Richard Brodhead, *Cultures of Letters: Scenes of Reading and Writing in Nineteenth-Century America* (Chicago: University of Chicago Press, 1993); Karen Sánchez-Eppler, *Touching Liberty: Abolition, Feminism, and the Politics of the Body* (Berkeley: University of California Press, 1993). For studies addressing emotion in nineteenth-century American photography, see Laura Wexler, *Tender Violence: Domestic Visions in an Age of U.S. Imperialism* (Chapel Hill: University of North Carolina Press, 2000); Shawn Michelle Smith, *American Archives: Gender, Race, and Class in Visual Culture* (Princeton, NJ: Princeton University Press, 1999). For a powerful argument on the limits of empathy in fiction, see Suzanne Keen, *Empathy and the Novel* (New York: Oxford University Press, 2007).

37 Lora Romero, *Home Fronts: Domesticity and Its Critics in the Antebellum United States* (Durham, NC: Duke University Press, 1997), 6–7; June Howard, *Publishing the Family* (Durham, NC: Duke University Press, 2001), 217.

38 Helen Block Lewis, *Shame and Guilt in Neurosis* (New York: International University Press, 1971), 30, quoted in June Price Tangney and Ronda L. Dearing, *Shame and Guilt* (New York: Guilford Press, 2002), 18 (emphasis in original). Some might argue that I place too much weight on the frequency with which period observers termed their emotion

"shame" rather than "guilt." After all, the colloquial understanding of "shame" does not necessarily correspond to the clinical definition. As readers will see, however, even if period audiences were not capable of defining shame in the terms of modern-day clinical psychologists, they *reacted* in the manner that psychologists would anticipate in shamed individuals. Moreover, although laypeople are not particularly adept at distinguishing between shame and guilt, they act in internally consistent ways when experiencing the emotions. Each emotion produces the distinctive reactions predicted by psychologists, whether or not the subject can parse the clinical distinctions. In addition, psychologists have found no link between types of behaviors and the production of either shame or guilt; exposure to the photographic evidence of Birmingham, for example, was no more likely to prompt one than the other. In Tangney and Dearing, *Shame and Guilt,* 11,17.

39 Tangney and Dearing, *Shame and Guilt,* 92, 18, 80–83, 86–87, 92–95.

40 Huddleston, "The True Facts of the Birmingham Situation," 8085–86. David Garrow notes, "News reports stated that three people had been treated at hospitals for dog bites, that five black children had been injured by fire hoses or police clubs, and that one black woman bystander had accused police of knocking her down and kicking her in the stomach intentionally." In David J. Garrow, *Bearing the Cross: Martin Luther King, Jr., and the Southern Christian Leadership Conference* (New York: William Morrow and Company, 1986), 250.

41 Tangney and Dearing, *Shame and Guilt,* 154–55.

42 David J. Garrow, *Protest at Selma: Martin Luther King, Jr., and the Voting Rights Act of 1965* (New Haven, CT: Yale University Press, 1978), 144–54.

43 Harry Golden, *Mr. Kennedy and the Negroes* (New York: World Publishing Company, 1964), 228–29.

44 Robert Coles, "Who's Blocking Desegregation?" *New Republic,* June 22, 1963, 20.

45 Kerry Kawakami, Elizabeth Dunn, Francine Karmali, and John F. Dovidio, "Mispredicting Affective and Behavioral Responses to Racism," *Science,* January 9, 2009 (323): 276–78. For a more detailed discussion of the experiment's design and implementation, see www .sciencemag.org/cgi/content/full/323/5911/276/DC1.

46 Sue Thrasher, "Circle of Trust," in Constance Curry et al., *Deep in Our Hearts: Nine White Women in the Freedom Movement* (Athens: University of Georgia Press, 2000), 225.

47 Ibid.

48 The model, known as the "contact hypothesis," was formulated by Gordon W. Allport, *The Nature of Prejudice* (Cambridge, MA: Addison-Wesley, 1954). For subsequent studies that back up and refine the model, see John Dovidio, Samuel L. Gaertner, and Kerry Kawakami, "Intergroup Contact: The Past, Present, and the Future," *Group Processes and*

Intergroup Relations 6:1 (2003): 5–21; Thomas F. Pettigrew and Linda R. Tropp, "A Meta-Analytic Test of Intergroup Contact Theory," *Journal of Personality and Social Psychology* 90:5 (May 2006): 751–83.

49 Blake M. Riek et al., "A Social-Psychological Approach to Postconflict Reconciliation," in Arie Nadler, Thomas E. Malloy, and Jeffrey D. Fisher, eds., *The Social Psychology of Intergroup Reconciliation* (Oxford: Oxford University Press, 2008), 261–62. Also see John F. Dovidio et al., "Majority and Minority Perspectives in Intergroup Relations: The Role of Contact, Group Representations, Threat, and Trust in Intergroup Conflict and Resolution," in Nadler et al., *Social Psychology,* 227–53.

50 Blake M. Riek, "Does a Common Ingroup Identity Reduce Intergroup Threat?" (Ph.D. dissertation, University of Delaware, 2007), cited in Riek et al., "A Social-Psychological Approach," 262.

51 For an article that explains the intense reaction of blacks in North Carolina to the photographs of Birmingham's police dog attacks, despite "there [having] been no biting police dogs used in North Carolina," see "Police Dogs in Ala. Spur N.C. Protest," *Afro-American (Baltimore, MD),* June 1, 1963, 1. Although I make a strong argument for the desirability of whites' feeling the pain of black victims of violence, and for the ways in which blacks were united in their pain, I do not mean to suggest that black pain resulted solely from the victims' identities as black. As I argue in chapter 4, blacks of the period were able to inhabit a greater range of identities than were whites. I do not mean to imply that blacks in the 1960s were incapable of feeling the pain of white children mauled by dogs, for example. I believe that blacks retained the capacity to sympathize with such children as either fellow Americans or fellow human beings.

3. PERFECT VICTIMS AND IMPERFECT TACTICS

Epigraph: Robert Coles, *Children of Crisis: A Study of Courage and Fear,* vol. 1 (Boston: Little, Brown and Company, 1967), 334.

1 While the white public reaction may have appeared monolithic to those outside of Birmingham, its makeup was complex. For a discussion of Birmingham whites' varied political outlooks on race relations, see Lee E. Bains Jr., "Birmingham 1963: Confrontation over Civil Rights," in David J. Garrow, ed., *Birmingham, Alabama, 1956–1963: The Black Struggle for Civil Rights* (Brooklyn: Carlson Publishing, 1989), 201–13.

2 "Birmingham, a Target City?" *Birmingham World,* April 10, 1963, 6. On black protestors' fear of the stigma of jail and concern about losing their jobs, see Bains, "Birmingham 1963," 222.

3 David J. Garrow, *Bearing the Cross: Martin Luther King, Jr., and the Southern Christian Leadership Conference* (New York: William Morrow and Company, 1986), 246–47.

4 Martin Luther King, Jr., *Where Do We Go from Here: Chaos or Community?* (New York: Harper & Row, 1967), 51.

5 Adam Fairclough, *To Redeem the Soul of America: The Southern Christian Leadership Conference and Martin Luther King, Jr.* (Athens: University of Georgia Press, 1987), 125. The historian Richard Lentz claimed that Birmingham's black children threw themselves into "a crusade the adults had not won and very likely could not win alone," in *Symbols, the News Magazines, and Martin Luther King* (Baton Rouge: Louisiana State University Press, 1990), 75.

6 Taylor Branch, *Parting the Waters: America in the King Years, 1954–63* (New York: Simon & Schuster, 1988), 753. Bevel and Nash's work in the schools was also supported by Andrew Young, Bernard Lee, and Dorothy Cotton. For King's public after-the-fact description of the Children's Crusade, see Martin Luther King Jr., *Why We Can't Wait* (New York: Harper & Row, 1964), 101–5. On the harsh conditions for child and adult prisoners in Birmingham's jail and the types of abuse and torture they experienced, see "Given Sweatbox Torture," *Afro-American (Baltimore, MD),* May 18, 1963, 1; Emory O. Jackson, "Teenagers Tell of Jail Experiences, Treatment," *Birmingham World,* May 11, 1963, 1; *Birmingham World,* May 15, 1963, 1; and Horace Huntley and John W. McKerley, eds., *Foot Soldiers for Democracy: The Men, Women, and Children of the Birmingham Civil Rights Movement* (Urbana: University of Illinois Press, 2009), 5–6, 21, 48–49, 83–84, 113–14, 120–21, 128–29, 137–39, 154–55, 166–67, 196–97. For the fear of police rape, see the testimony of Jimmie Lucille Spencer Hooks in Huntley and McKerley, eds., *Foot Soldiers,* 22–23.

7 Garrow, *Bearing the Cross,* 228.

8 Branch, *Parting the Waters,* 755. Observers in the 1960s appreciated the significance of introducing children into the protests. A reporter for the *Afro-American* termed it "the most dramatic development in the century-old history of civil rights." In "Youngsters Get Credit for Truce," *Afro-American (Baltimore, MD),* May 18, 1963, 1.

9 For a photograph of a six-year-old activist being processed by the Birmingham police, see *Jet,* May 23, 1963, 33. For mention of another six-year-old Birmingham protestor, see "Birmingham School Kids Defy Police Dogs, Firemen Water Hose," *Jet,* May 16, 1963, 6–7; for an article that claims the participation of "marchers [who] appeared to be 5 or 6 years old," see Robert Gordon, "Waves of Young Negroes March in Birmingham Protest," *Washington Post,* May 3, 1963, 1.

10 M. S. Handler, "Malcolm X Terms King's Tactics Futile," *New York Times,* May 11, 1963, 9; Raymond R. Coffey, "Waiting in the Rain at the Birmingham Jail," *Chicago Daily News,* May 7, 1963, reprinted in *Reporting Civil Rights: Part One, American Journalism, 1941–1963* (New York: Library of America, 2003), 802.

11 James Forman, *The Making of Black Revolutionaries: A Personal Account* (New York: Macmillan Company, 1972), 311–12; Diane McWhorter, *Carry Me Home: Birmingham,*

Alabama, the Climactic Battle of the Civil Rights Revolution (New York: Simon & Schuster, 2001), 371. For black ambivalence on the use of child marchers, see Taylor Branch, *Pillar of Fire: America in the King Years, 1963–1965* (New York: Simon & Schuster, 1998), 77; Howell Raines, *My Soul Is Rested: Movement Days in the Deep South Remembered* (New York: G. P. Putnam's Sons, 1977), 150–51. Smiley, who was white, worked for years in partnership with blacks, and his reaction to the scenes of violence was more in keeping with black than white sentiments. Since my designation of "black" or "white" reactions refers to socially produced outcomes, the existence of whites who had a "black" response does not undermine the argument.

12 Martin Luther King Jr., "Speech at the Sixteenth Street Baptist Church, Birmingham, Alabama," May 3, 1963, reprinted in W. Stuart Towns, ed., *"We Want Our Freedom": Rhetoric of the Civil Rights Movement* (Westport, CT: Praeger Publishers, 2002), 147–51.

13 George Huddleston Jr., "The True Facts of the Birmingham Situation," May 8, 1963, *Congressional Record,* 88th Cong., 1st sess., 1963, vol. 109, pt. 6, 8086.

14 For Boutwell's comments, see Branch, *Parting the Waters,* 761–62; Foster Hailey, "Dogs and Hoses Repulse Negroes at Birmingham," *New York Times,* May 4, 1963, 1. For additional references to children as "pawns," see "600 Negro Kids Play 2nd Act of Rights Fight in Jail," *New York World-Telegram,* May 6, 1963, 2. For a sampling of reactions within Birmingham's white community, see Bill Wise, "Query for Southern Whites—What Now?" *Life,* May 17, 1963, 35.

15 "Sanity in Birmingham," *New York Times,* May 11, 1963, 24.

16 "Races: Freedom—Now," *Time,* May 17, 1963, 25; "Birmingham, U.S.A.: 'Look at Them Run,' " *Newsweek,* May 13, 1963, 27.

17 Moore quoted in Michael S. Durham, *Powerful Days: The Civil Rights Photography of Charles Moore* (Tuscaloosa: University of Alabama Press, 2002), 28; and McWhorter, *Carry Me Home,* 371.

18 Father Foley quoted in "The End of Fear," *New Republic,* May 18, 1963, 1.

19 "Robert Kennedy Warns of 'Increasing Turmoil,' " *New York Times,* May 4, 1963, 8.

20 Andrew Schlesinger and Stephen Schlesinger, eds., *Arthur M. Schlesinger, Jr. Journals, 1952–2000* (New York: Penguin Books, 2008), 198. The meeting with President Kennedy included, among others, Vice President Lyndon Johnson, Attorney General Robert Kennedy, presidential advisor Arthur Schlesinger, Roy Wilkins of the NAACP, James Farmer of CORE, A. Philip Randolph of the Brotherhood of Sleeping Car Porters, Walter P. Reuther of the United Automobile Workers, Whitney M. Young of the National Urban League, John Lewis of the SNCC, Rosa Gragg of the Council of Women of the United States, and Martin Luther King Jr. of the SCLC.

21 Ephraim Peabody, "Narratives of Fugitive Slaves," *Christian Examiner* 47 (July 1849): 61–93, reprinted in William L. Andrews, ed., *Critical Essays on Frederick Douglass* (Boston: G. K. Hall and Company, 1991), 24–27; "British Anti-Lynchers," *New York Times,* August 2, 1894, 4, referenced in Gail Bederman, *Manliness and Civilization: A Cultural History of Race in the United States, 1880–1917* (Chicago: University of Chicago Press, 1995), 258n102.

22 Huddleston, "The True Facts of the Birmingham Situation," 8086.

23 The cultural historian Steven Mintz has sketched out white middle-class concerns about juvenile delinquency in the 1950s and spoiled and rebellious youth in the 1960s. Steven Mintz, *Huck's Raft: A History of American Childhood* (Cambridge, MA: Harvard University Press, 2004), 292–96, 314–17. Each "crisis" of childhood was predicated on a foundational belief in the essential innocence of children. Commentators and parents demonstrated their beliefs in the innocence of children through their frantic searches for the social causes that turned kids bad.

24 Jack Chatfield, "Letter to a Northern Friend," *New Republic,* May 18, 1963, 13–14; Charles E. Silberman, *Crisis in Black and White* (New York: Vintage Books, 1964), 67; "The End of Fear," *New Republic,* May 18, 1963, 1, 3–5; also see Stan Opotowsky, "Birmingham Children Lead the Way to Jail," *New York Post,* May 7, 1963, 5.

25 Hannah Arendt, "Reflections on Little Rock," *Dissent* 6:1 (Winter 1959): 50; also see Hannah Arendt, "A Reply to the Critics," *Dissent* 6:2 (Spring 1959): 179–81. For an analysis of Arendt's racial investment in the plight of children, see Vicky Lebeau, "The Unwelcome Child: Elizabeth Eckford and Hannah Arendt," *Journal of Visual Culture* 3:1 (2004): 51–62.

26 *Birmingham Post-Herald* editorial quoted in "Opinion of the Week: At Home and Abroad," *New York Times,* May 5, 1963, 201.

27 King, *Why We Can't Wait,* ix–x, 103.

28 King was certainly not alone in this sentiment. The conservative editors of the *Birmingham World* noted, "It is no longer good enough for southern segregationist groups to say in effect, 'We refuse to let you exercise the constitutional right of assembly because you might provoke us to a breach of the peace.'" In "The Right of Peaceful Assembly," *Birmingham World,* May 18, 1963, 8.

29 King, *Why We Can't Wait,* 104, x. For an article that directly addresses the white liberal criticism of King's "using" children, see Alfred Duckett, "Great Man on Great Mission," *Tri-State Defender (Memphis, TN),* June 1, 1963, 6.

30 "The Spectacle of Racial Turbulence in Birmingham: They Fight a Fire That Won't Go Out," *Life,* May 17, 1963, 32.

31 Neither Moore's photographic captions in *Life* nor the accompanying essay contains a

single quote from a black spokesman, participant, or observer, though they routinely attribute thoughts to unnamed blacks. Tellingly, the essay is followed by a one-page compilation of opinions on race relations by Birmingham's white residents. See Wise, "Query for Southern Whites," 35. When white media outlets did quote black voices, they often did so to make a point about the radicalism of blacks. The right-of-center *U.S. News & World Report* quoted three Birmingham youths in its coverage of the city's protest movement, but only to give readers "an idea of the militant attitude growing among Negro youth in the south." Children made such "militant" statements as, "I marched for freedom— freedom to eat and work and go to school with whites. It's no sin to be born black" ("Tension Growing over Race Issue," *U.S. News & World Report,* May 20, 1963, 39). For an exception to this rule, see "Birmingham Teenager Ready to Go Back to Jail," *New York Post,* May 9, 1963, 5.

32 Robert Coles, *Children of Crisis: A Study of Courage and Fear,* vol. 1 (Boston: Little, Brown and Company, 1967), 178–79, 182.

33 Ibid., 109.

34 Sheyann Webb and Rachel West Nelson, *Selma, Lord Selma: Girlhood Memories of the Civil-Rights Days,* as told to Frank Sikora (Tuscaloosa: University of Alabama Press, 1979), 142.

35 Ellen Levine, *Freedom's Children: Young Civil Rights Activists Tell Their Own Stories* (New York: Puffin Books, 2000), 84–85.

36 King, *Why We Can't Wait,* 106.

37 Coles, *Children of Crisis,* 319.

38 Frye Gaillard, *Cradle of Freedom: Alabama and the Movement That Changed America* (Tuscaloosa: University of Alabama Press, 2004), 149–50.

39 John Britton, "Cute Youngster Determined 'To Make this Land My Home,'" *Jet,* May 23, 1963, 18.

40 David Halberstam, *The Children* (New York: Fawcett Books, 1998), 438–39. For a discussion of how black Birmingham teachers initiated discussions on freedom and equality with their students long before the arrival of Bevel and Nash in the schools, see Gaillard, *Cradle of Freedom,* 147.

41 James Bevel, "Speech at the Flamingo Club, Savannah, Georgia," July 12, 1963, in Davis W. Houck and David E. Dixon, eds., *Rhetoric, Religion, and the Civil Rights Movement, 1954–1965* (Waco, TX: Baylor University Press, 2006), 556.

42 Britton, "Cute Youngster Determined," 16, 15.

43 Levine, *Freedom's Children,* 81.

44 Coffey, "Waiting in the Rain at the Birmingham Jail," 801–2.

45 Britton, "Cute Youngster Determined," 18; Howard Zinn, "The Battle-Scarred Young-sters," *Nation,* October 5, 1963, reprinted in *Reporting Civil Rights,* 48–59; Levine, *Free-dom's Children,* 77–91; "Youngsters Get Credit for Truce," *Afro-American (Baltimore, MD),* May 18, 1963, 9; Alfred Duckett, "Marching Kids Dreamed of Freedom," *Tri-State Defender (Memphis, TN),* June 8, 1963, 6.

46 Coles, *Children of Crisis,* 334–35, 42, 53, 83.

47 The historian Daryl Michael Scott has shown that from the 1954 *Brown v. Board of Education of Topeka* decision until at least 1965, the dominant liberal rhetoric on race relations stressed the psychological damage that segregation inflicted on blacks. He points out that such claims were then unsupported by social science research and that studies from the 1960s actually supported the notion that blacks in segregated schools had better psycho-logical health. Apart from whites, blacks in segregated schools were better shielded from racist and inherently unequal interactions with whites. For his analysis, see Daryl Michael Scott, *Contempt and Pity: Social Policy and the Image of the Damaged Black Psyche, 1880–1996* (Chapel Hill: University of North Carolina Press, 1997).

48 John Lewis with Michael D'Orso, *Walking with the Wind: A Memoir of the Movement* (New York: Harcourt Brace & Company, 1998), 318.

49 For an analysis of the importance of children and women to King's nonviolent movement, see David A. J. Richards, *Disarming Manhood: Roots of Ethical Resistance* (Athens, OH: Swallow Press, 2005), 153–59, 169–70.

50 For mainstream press accounts of the arrest and abuse of child protestors in Selma prior to Bloody Sunday, see John Lynch, "750 More Jailed in Dixie," *New York World-Telegram and Sun,* February 3, 1965, 2; George Carmack, "Selma Conflict Spurs Drive for New Laws," *New York World-Telegram and Sun,* February 6, 1965, 1–2; John Herbers, "Dr. King and 770 Others Seized in Alabama Protest," *New York Times,* February 2, 1965, 1, 15; "Dr. King Jailed in Selma Arrests," *San Francisco Chronicle,* February 2, 1965, 1, 16; Paul Good, "Police Seize Dr. King in Selma Rally," *Washington Post,* February 2, 1965, 1, 6; Paul Good, "Selma Arrests Continue as King Remains in Jail," *Washington Post,* Februa-ry 3, 1965, 3; "Arrest King, 767 Others in Vote Drive," *Chicago Tribune,* February 2, 1965, 1, 2; Roy Reed, "165 Selma Negro Youths Taken on Forced March," *New York Times,* February 11, 1965, 1, 19; "Sheriff Puts Negroes through Forced March," *Washington Post,* February 11, 1965, 3; "400 Youthful Negroes Demonstrate at Selma," *Los Angeles Times,* February 12, 1965, 10; "400 Negro Pupils in Selma Stage Rights Protest," *Hartford Cou-rant,* February 12, 1965, C-23. For news photographs of arrested children in Selma, see "1,000 Arrested in Alabama," *Philadelphia Inquirer,* February 4, 1965, 1, 3; "Hundreds of Negroes Jailed in Alabama Rights Drive," *Baltimore Sun,* February 4, 1965, 8; "800 More Negroes Seized in Alabama," *Los Angeles Times,* February 4, 1965, 1; "LBJ Confers

on Selma—Arrests Reach 2,600," *Boston Globe,* February 4, 1965, 17; "1,000 Children Held in Alabama," *San Francisco Chronicle,* February 4, 1965, 1.

51 Leon Daniel, "Troopers Rout Selma Marchers," *Washington Post,* March 8, 1965, 3.

52 Roy Reed, "Alabama Police Use Gas and Clubs to Rout Negroes," *New York Times,* March 8, 1965, 20; "Brutal Attack on Negroes in Selma," *San Francisco Chronicle,* March 8, 1965, 1; "Police Stop Vote March in Alabama," *Baltimore Sun,* March 8, 1965, 1. Boynton's photograph also appeared in the *Hartford Courant,* March 8, 1965, 2. While many more children participated in the Children's Crusade than in the march to the Pettus Bridge, the historian David Garrow points out that children were mentioned much more frequently in congressional speeches on Selma than in those on Birmingham. Given perceptions that the marchers exhibited a set of childlike traits, children may have become more visible in Selma, or at least more significant, once their inactive, innocent, and victimized qualities were secured. See David J. Garrow, *Protest at Selma: Martin Luther King, Jr., and the Voting Rights Act of 1965* (New Haven, CT: Yale University Press, 1978), 147.

53 For a comprehensive discussion of nonviolent techniques, their processes, and outcomes, see Gene Sharp, *The Politics of Nonviolent Action* (Boston: Porter Sargent Publisher, 1973), 65–66.

54 For King's most explicit explanation of nonviolent direct action before the Albany campaign, see Martin Luther King Jr., *Stride toward Freedom: The Montgomery Story* (New York: Harper & Row, 1958), 102–7. Also see King, *Where Do We Go From Here;* Sharp, *The Politics of Nonviolent Action,* 95–97.

55 Bayard Rustin, *Down the Line: The Collected Writings of Bayard Rustin* (Chicago: Quadrangle Books, 1971), 5–7.

56 James Farmer, *Lay Bare the Heart: An Autobiography of the Civil Rights Movement* (Fort Worth: Texas Christian University Press, 1985), 90–92.

57 For the white press's historical disinclination to report on civil rights, see Gene Roberts and Hank Klibanoff, *The Race Beat: The Press, the Civil Rights Struggle, and the Awakening of a Nation* (New York: Alfred A. Knopf, 2007), 3–23; David Davies, ed., *The Press and Race: Mississippi Journalists Confront the Movement* (Jackson: University Press of Mississippi, 2001).

58 Among the other problems the SCLC pointed to in Albany were a factionalized black community, diffuse protest goals, a focus on elected officials rather than business leaders, a lack of black voting strength, and lack of federal interest. For the SCLC's analysis of the problems, see Garrow, *Bearing the Cross,* 225–29.

59 For more on the Albany Movement, see Martin Luther King Jr. and Clayborne Carson, *The Autobiography of Martin Luther King, Jr.* (New York: Grand Central Publishing, 2001), 151–69; Branch, *Parting the Waters,* 524–61; Garrow, *Bearing the Cross,* 173–230.

60 Garrow, *Bearing the Cross,* 228.

61 My summary of television coverage draws from the pioneering work of television historian J. Fred MacDonald, *Blacks and White TV: Afro-Americans in Television Since 1948* (Chicago: Nelson-Hall Publishers, 1983), 87–99. Despite the importance of the cited programs on race, MacDonald points out that between 1960 and 1963, only 1.8 percent of news and public affairs programming dealt with domestic racial conflict (92). For a more recent analysis, see Sasha Torres, *Black, White and in Color: Television and Black Civil Rights* (Princeton, NJ: Princeton University Press, 2003). On television coverage of civil rights in the South, see Steven D. Classen, *Watching Jim Crow: The Struggles over Mississippi TV, 1955–1969* (Durham, NC: Duke University Press, 2004).

62 King, *Stride toward Freedom,* 217.

63 For coverage of the Birmingham police dog attacks on Sunday, April 7, 1963, see "Alabama Riot Broken Up by Police Dogs," *Los Angeles Times,* April 8, 1963, 1.

64 Karl Fleming, chief of *Newsweek*'s Los Angeles bureau, quoted in Jack Lyle, ed., *The Black American and the Press* (Los Angeles: Ward Ritchie Press, 1968), 32. Fleming's assessment is echoed in the contemporary analysis of journalism professor Richard Lentz: "Birmingham's enduring images were stark and simple. Arrayed on one side were the forces of good—the black men and women marching by the hundreds for freedom that was their long-denied birthright as Americans. . . . Standing against King and those who followed him were adversaries representing the antithesis of American principles of equality and freedom." In Lentz, *Symbols, the News Magazines, and Martin Luther King,* 75.

65 Photographs of children were produced and circulated by American antislavery societies to promote abolition in the 1860s; by Jacob Riis to support labor and housing reform in the 1890s; by Lewis Hine and the National Labor Committee to push for labor reform in the 1910s; by Arthur Rothstein, Walker Evans, and Dorothea Lange and the Farm Security Administration to build support for federal intervention in the economy in the 1930s; and by the Art Workers' Coalition to make the case against the Vietnam War in the 1970s.

66 For the centrality of children and their place in the emotional economy of the novel, see Philip Fisher, *Hard Facts: Setting and Form in the American Novel* (Oxford: Oxford University Press, 1985), 99–114; Jane Tompkins, *Sensational Designs: The Cultural Work of American Fiction* (Oxford: Oxford University Press, 1986), 128–35. For an argument on the complexity of emotions and responses engendered by Stowe's novel that parallels my treatment of the photographs of Moore and Hudson, see Gillian Brown, "Reading and Children: *Uncle Tom's Cabin* and *The Pearl of Orr's Island,*" in Cindy Weinstein, ed., *Cambridge Companion to Harriet Beecher Stowe* (Cambridge: Cambridge University Press, 2004), 77–95. On Stowe's desire to "paint pictures" for readers, because there "is no arguing with pictures," see Joan D. Hedrick, *Harriet Beecher Stowe: A Life* (New York: Oxford University Press, 1994), 208.

67 King, *Stride toward Freedom,* 113.

68 For more on the operation of nonviolent persuasion, see Sharp, *Politics of Nonviolent Action,* 117–82.

69 Bayard Rustin, "From Protest to Politics: The Future of the Civil Rights Movement," *Commentary,* February 1964, reprinted in Rustin, *Down the Line,* 117; for Rustin's influence on King's position, see Garrow, *Bearing the Cross,* 439.

4. THE LOST IMAGES OF CIVIL RIGHTS

Epigraph: Russell Meek, letter to the editor, *Chicago Daily Defender,* May 13, 1963, 12.

1 Diane McWhorter, *Carry Me Home: Birmingham, Alabama, the Climactic Battle of the Civil Rights Revolution* (New York: Simon & Schuster, 2001), 379. For period mention of white Birmingham papers' unwillingness to publish photographs of the campaign, see Bill Garrison, "Struggle!" *Muhammad Speaks,* May 13, 1963, 8. For a discussion of how Birmingham's white radio stations refrained from reporting on the protests and how white station owners pressured all but one local black station to follow suit, see Julian Williams, "Black Radio and Civil Rights: Birmingham, 1956–1963," *Journal of Radio & Audio Media* 12:1 (May 2005): 47–60.

2 For reproductions of the UPI photograph in the black press, see "We Have Won in Birmingham," *New York Amsterdam News,* May 11, 1963, 1; "This Is America—1963," *Chicago Daily Defender,* May 7, 1963, 1; A. S. "Doc" Young, "Shame on America!" *Los Angeles Sentinel,* May 9, 1963, 1; "Dirty Tactics Used in Birmingham, Ala.," *Pittsburgh Courier,* May 18, 1963, 3; "Arrest Ala. Style," *Afro-American (Baltimore, MD),* May 18, 1963, 6; Lerone Bennett Jr., "Mood of the Negro," *Ebony,* July 1963, 34; "Turned the Tide in Birmingham," *Jet,* May 23, 1963, 24–25. The UPI photograph of Witherspoon's arrest also appears in King's *Why We Can't Wait* (New York: Harper & Row, 1964), in the photographic signature between pages 50 and 51.

3 "We Have Won," *Amsterdam News,* 1; Young, "Shame," 1, 4.

4 Simeon Booker, *Black Man's America* (Englewood Cliffs, NJ: Prentice-Hall, Inc., 1964), 150; Bennett, "Mood of the Negro," 34.

5 The UPI Witherspoon photograph appeared on the inside pages of the following white publications: "Birmingham: 'War,'" *New York Mirror,* May 7, 1963, 2; *Philadelphia Inquirer,* May 7, 1963, 14; "No Holds Barred," *New York Herald Tribune,* May 7, 1963, 12. I have located the AP version only in "Races: Freedom—Now," *Time,* May 17, 1963, 24. Both the *Boston Globe* and the *New York Daily News* reproduced photographs of Witherspoon struggling with police moments before she landed on her back. See Raymond R. Coffey, "Boy, 5, Asked for Jail, Too," *Boston Globe,* May 7, 1963, 44; *New York Daily News,* May 7, 1963, 1. The UPI version of the photograph that appeared in the black press also appeared with an

article by the black civil rights activist and communist James E. Jackson, "What Are You Doing about Birmingham?" *Daily Worker,* May 12, 1963, 12.

6 "Races: Freedom—Now," 24.

7 *Jet,* May 23, 1963, 24–25.

8 The Hudson photograph appeared in the following white publications: *Boston Globe, New York Daily News, New York Times, New York Herald Tribune, Chicago Tribune, Los Angeles Times, Philadelphia Inquirer, Washington Post, San Francisco Chronicle,* and *Newsweek;* and in the black publications *Jet* and *Muhammad Speaks.* It was not reproduced in the following black publications: *New York Amsterdam News, Afro-American (Baltimore, MD), Los Angeles Sentinel, Philadelphia Tribune, Birmingham World, Pittsburgh Courier, Chicago Daily Defender, Tri-State Defender (Memphis, TN),* or *Ebony.* For articles reproducing Hudson's photograph, see Claude Sitton, "Violence Explodes at Racial Protests in Alabama," *New York Times,* May 4, 1963, A-1; *New York Daily News,* May 4, 1963, 1; "Keeping Peace in Alabama—Police, Fire Hoses and Dogs," *New York Herald Tribune,* May 4, 1963, 1; "New Alabama Riot: Police Dogs, Fire Hoses Halt March," *Los Angeles Times,* May 4, 1963, 1; "Dogs and Fire Hoses Turned on Negroes: Marchers Sent Sprawling," *Chicago Tribune,* May 4, 1963, N-1, N-4; "Dogs and Fire Hoses Rout 3,000 Negroes," *Boston Globe,* May 4, 1963, 1; "Police Dogs, Hoses Smash Negro March," *San Francisco Chronicle,* May 4, 1963, 1; *Philadelphia Inquirer,* May 7, 1963, 14; "Birmingham, U.S.A.: 'Look at Them Run,'" *Newsweek,* May 13, 1963, 27. See also Alvin Adams, "Picture Seen around the World Changed Boy's Drop-Out Plan," *Jet,* October 10, 1963, 27; "Dogs vs. People?" *Muhammad Speaks,* May 13, 1963, 15.

9 The black photographer Chester Higgins Jr. said, "During the civil rights period, Charles Moore, being white and southern, had great advantages working in the South. I could not have done what he did." Quoted in Howard Chapnick, *Truth Needs No Ally: Inside Photojournalism* (Columbia: University of Missouri Press, 1994), 106. Ernest C. Withers made much the same point about Moore. Speaking specifically of Moore's Birmingham photographs, he told an interviewer, "Charles Moore being white, it was just a little, slight privilege to white photographers that black photographers didn't get that privilege to be that close to anything that was going on." Marshand Boone, "Oral History Interview with Ernest Withers," Syracuse University, Newhouse School, Civil Rights and the Press Center http://civilrightsandthepress.syr.edu/oral_histories.html. On the caption practices of the AP, see Julian Cox, *Road to Freedom: Photographs of the Civil Rights Movement, 1956–1968* (Atlanta: High Museum of Art, 2008), 23.

10 "We Have Won," *Amsterdam News,* 1; "Dirty Tactics," *Pittsburgh Courier,* 3; Bennett, "Mood of the Negro," 34. The UPI caption for the photograph in the archives of CORBIS reads, "BXP050607–5/6/63-BIRMINGHAM, ALA; Unidentified Negro woman is

subdued by three policemen after she refused to be arrested quietly and began scuffling with an officer. She was taken away in handcuffs."

11 John Britton, "Victory in Birmingham Can Be Democracy's Finest Hour," *Jet,* May 2, 1963, 15. The illustration reproduced in figure 47, of the anonymous woman struggling against arrest, shows slightly different action from that in the *Jet* photograph. I was unable to secure the *Jet* image for reproduction.

12 Mary Stanton, *From Selma to Sorrow: The Life and Death of Viola Liuzzo* (Athens: University of Georgia Press, 1998), 144–49. *New York Herald Tribune* article of August 22, 1965, cited in ibid., 144–45.

13 Albert C. "Buck" Persons, "How Images Are Created," in *The True Selma Story: Sex and Civil Rights* (Birmingham: Esco Publishers, Inc., 1965), 16, 18.

14 Ibid., 16.

15 Ibid., 17.

16 Betty Friedan, *The Feminine Mystique* (New York: Dell Publishing, 1984), 16, 36–37. For discussions of the stereotypes faced by black women, see Patricia Morton, *Disfigured Images: The Historical Assault on Afro-American Women* (Westport, CT: Praeger, 1991), 74–84; Maxine Baca Zinn and Bonnie Thornton Dill, *Women of Color in U.S. Society* (Philadelphia: Temple University Press, 1994), 272–73.

17 Marisa Chappell, Jenny Hutchinson, and Brian Ward, "'Dress modestly, neatly . . . as if you were going to church': Respectability, Class and Gender in the Montgomery Bus Boycott and the Early Civil Rights Movement," in Peter J. Ling and Sharon Monteith, eds., *Gender in the Civil Rights Movement* (New York: Garland Publishing, Inc., 1999), 84–86. Also see Ruth Feldstein, "'I Wanted the Whole World to See': Race, Gender, and Constructions of Motherhood in the Death of Emmett Till," in Joanne Meyerwitz, ed., *Not June Cleaver: Women and Gender in Postwar America, 1945–1960* (Philadelphia: Temple University Press, 1994), 264–65; David A. J. Richards, *Disarming Manhood: Roots of Ethical Resistance* (Athens, GA: Swallow Press, 2005), 140–41; Steve Estes, *I Am a Man! Race, Manhood, and the Civil Rights Movement* (Chapel Hill: University of North Carolina Press, 2005). For historical context, see Evelyn Nakano Glenn, *Unequal Freedom: How Race and Gender Shaped American Citizenship and Labor* (Cambridge, MA: Harvard University Press, 2002), 93–143.

18 The historian Ruth Feldstein argues that black organizers' decision to insist on dominant models of femininity among protestors advanced the cause of racial justice while reinscribing the inequalities of midcentury gender. Since women of color were forced to act out dominant gender norms that served the interests of men, they paradoxically promoted black rights partly at the expense of women's rights: "Deviations from approved . . . feminine behavior interfered with the possibility of racial progress." In Ruth Feldstein, *Mother-*

hood in Black and White: Race and Sex in American Liberalism, 1930–1965 (Ithaca, NY: Cornell University Press, 2000), 133.

19 A. S. "Doc" Young, "Shame on America!" *Los Angeles Sentinel,* May 9, 1963, 4.

20 "'Little Child Shall Lead Them,'" *Tri-State Defender (Memphis, TN),* May 25, 1963, 6.

21 "Dirty Tactics," *Pittsburgh Courier,* 3. A caption for photographs of dogs unleashed against young marchers in Birmingham, appearing on the same page of the *Courier* as the AP photograph, asks rhetorically about the animals and their handlers: "Brave Dogs and Men???"

22 Persons, *The True Selma Story,* 17.

23 On May 7, 1963, the *New York Mirror* reported that Witherspoon "failed to move on as ordered" (2), and the *New York Herald Tribune* said that she "refused to move on during protest marches . . . and resisted the officers when ordered to leave" (12).

24 "Woman Slugs Sheriff in Selma as Negroes Line Up to Vote," *Washington Post,* January 26, 1965, 2; "Negro Woman Strikes Selma Sheriff in Face," *Los Angeles Times,* January 26, 1965, 3; "Selma Sheriff Clubs Negro Woman," *San Francisco Chronicle,* January 26, 1965, 1, 8; "Fight Marks Selma Voter Registration," *Baltimore Sun,* January 26, 1965, 5; "Selma Negroes Register, Pace Slow; Sheriff Hit," *Hartford Courant,* January 26, 1965, 6; "Negro Woman Slugs Sheriff in Vote Drive," *Chicago Tribune,* January 26, 1965, 3, 9; "Woman Slugs Sheriff," *Washington Post,* 2. Cort's AP photograph of Cooper illustrates all of these articles, aside from the article in the *Baltimore Sun,* which uses a slightly different image by Cort. Black publications gave extensive print coverage to the incident but less frequently illustrated their articles with photographs; when they did so, they typically did not use Cort's photograph. Black accounts provided greater context for the violence, explaining that Clark "grabbed," "manhandled," or "removed forcibly" Martin Luther King from a registration line, and so provoked Cooper, or that he initiated a violent assault on the peaceful Cooper, to which she responded. They also report the excitement that average blacks in Selma felt in seeing Cooper's defiance and the disinterest of mainstream civil rights leaders, and the papers that supported them, in promoting such violence. See John Lynch, "Lady Slugs Sheriff in Selma Scuffle," *Chicago Daily Defender,* January 26, 1965, 3, 10; "Rev. King Back in Selma as Court Bans Registration Interference," *Philadelphia Tribune,* January 26, 1965, 1, 2; "Praise Sheriff-Slugging 'Bama Matron's Courage," *Pittsburgh Courier,* January 30, 1965, 1; "34 Arrested, Woman Beaten in Selma Negro Voter Drive," *Call and Post,* January 30, 1965, 1, 2; John H. Britton, "Selma Woman's Girdle a Big Factor in Fight with Sheriff," *Jet,* February, 11, 1965, 6–8. The only black publications to include photographs of Cooper's struggle were the *Defender* and *Jet.* The former used a UPI image that is a much less graphic depiction of violence than those used in the white press. *Jet* provided a sequence of graphic photographs of the attack but did not use Cort's.

25 "Civil Rights: Black Eye," *Newsweek,* February 8, 1965, 24; "Selma, Contd.," *Time,* February 5, 1965, 24.

26 For a description of Gadsden's size, see Adams, "Picture Seen around the World," 26.

27 John Britton documented the youngsters' experiences in "Cute Youngster Determined 'To Make this Land My Home,'" *Jet,* May 23, 1963, 18.

28 Amzie Moore quoted in Howell Raines, *My Soul Is Rested: Movement Days in the Deep South Remembered* (New York: G. P. Putnam's Sons, 1977), 234–35.

29 David Halberstam, *The Fifties* (New York: Villard Books, 1993), 431, 437. For other scholars' assessments of the foundational nature of the incident and its representation in the modern civil rights struggle, see Harvard Sitkoff, *The Struggle for Black Equality* (New York: Hill and Wang, 2008), 44; Dora Apel, *Imagery of Lynching: Black Men, White Women, and the Mob* (New Brunswick, NJ: Rutgers University Press, 2004), 181; Christine Harold and Kevin Michael DeLuca, "Behold the Corpse: Violent Images and the Case of Emmett Till," *Rhetoric & Public Affairs* 8:2 (2005): 265.

30 One of the killers, J. W. Milam, used this phrase when he questioned a black child in Mose Wright's home. He repeated it to a reporter after his acquittal. In William Bradford Huie, "The Shocking Story of the Approved Killing in Mississippi," *Look,* January 24, 1956, 48. Curtis Jones, a cousin of Emmett's who went with him from Chicago to visit relatives in Mississippi, reports that the men who came to the house asked for "the one who did the talking." Quoted in Henry Hampton and Steve Fayer, eds., *Voices of Freedom: An Oral History of the Civil Rights Movement from the 1950s through the 1980s* (New York: Bantam Books, 1990), 4.

31 Mamie Till-Mobley and Christopher Benson, *Death of Innocence: The Story of the Hate Crime That Changed America* (New York: Random House, 2003), 135–39; Federal Bureau of Investigation, report on Emmett Till murder, prepared February 9, 2006, Case ID# 44A-JN-30112 & 62D-JN-30045, 99; available at http://foia.fbi.gov/till/till.pdf.

32 Bradley's comment was widely reported in the black press. See "3rd Lynching of Year Shocks Nation," *Afro-American (Baltimore, MD),* September 10, 1955, 2. Mamie Bradley, "I Want You to Know What They Did to My Boy," speech delivered at Bethel AME Church, Baltimore, Maryland, October 29, 1955, quoted in Davis W. Houck and David E. Dixon, eds., *Rhetoric, Religion and the Civil Rights Movement, 1954–1965* (Waco, TX: Baylor University Press, 2006), 137–38.

33 Theodore Coleman, "Latest Atrocity in Mississippi Arouses Nation," *Pittsburgh Courier,* September 10, 1955, 4. The photograph in the *Courier* provides only a glimpse of Till's head. It is the least graphic of the newspaper images cited here. For other illustrations of Till's battered head, see "Lynch Trial Begins," *Afro-American (Baltimore, MD),* September 24, 1955, 1; "Thousands Mourn as Final Rites Are Conducted for Young Victim of Southern

Brutality," *Michigan Chronicle,* September 12, 1955, 2; "Mississippi Barbarism," *Crisis,* October 1955, 479; "Mass Meet on Till Murder," *New York Amsterdam News,* September 17, 1955, 1; "Mississippi Shame," *Chicago Defender,* September 17, 1955, 19; "Youth's Eye Gouged Out by Lynchers," *Philadelphia Tribune,* September 17, 1955, 1; "Nation Horrified by Murder of Kidnapped Chicago Youth," *Jet,* September 15, 1955, 9; "Will Mississippi Whitewash the Emmett Till Slaying?" *Jet,* September 22, 1955, 9; Ernest C. Withers, *Complete Photo Story of Till Murder Case* (Memphis, TN: Wither's *[sic]* Photographers, 1955). Withers printed and sold one thousand copies of his booklet. *Jet*'s photograph of Till was reprinted in the magazine on both the thirtieth and fiftieth anniversaries of the killing. See Simeon Booker, "30 Years Ago: How Emmett Till's Lynching Launched Civil Rights Drive," *Jet,* June 17, 1985, 12–15, 18; Margena A. Christian, "Emmett Till's Legacy: 50 Years Later," *Jet,* September 19, 2005, 20–25. Although I have been unable to locate the relevant copy of the *American Negro,* its editor, Gus Savage, is credited with printing the first picture of Till's corpse. The image reputedly appeared in the September 1955 edition (volume 1, number 2).

34 Muhammad Ali with Richard Durham, *The Greatest: My Own Story* (New York: Random House, 1975), 34–35; also see the "Memoirs" in Christopher Metress, ed., *The Lynching of Emmett Till: A Documentary Narrative* (Charlottesville: University of Virginia Press, 2002), 226–88.

35 For a meticulous documentary history of American reactions to the Till murder, which highlights the particular trauma that the photographs engendered in blacks, see Metress, *Lynching of Emmett Till;* and Harriet Pollack and Christopher Metress, eds., *Emmett Till in Literary Memory and Imagination* (Baton Rouge: Louisiana State University Press, 2008). Scholars variously attribute the phrase "Till generation" or "Emmett Till generation" to philosopher Lucious Outlaw, historian John Dittmer, and SNCC activist and sociologist Joyce Ladner. See Adam Green, *Selling the Race: Culture, Community, and Black Chicago, 1940–1955* (Chicago: University of Chicago Press, 2007), 198–99; Joyce Ladner, "The South: Old New Land," *New York Times,* May 17, 1979, A-23; John Dittmer, *Local People: The Struggle for Civil Rights in Mississippi* (Urbana: University of Illinois Press, 1994), 58.

36 Vicki Goldberg, *The Power of Photography: How Photographs Changed Our Lives* (New York: Abbeville Publishing Group, 1993), 201.

37 Gene Roberts and Hank Klibanoff, *The Race Beat: The Press, the Civil Rights Struggle, and the Awakening of a Nation* (New York: Alfred A. Knopf, 2007), 88. The authors cite Goldberg, *Power of Photography,* 201, and an interview they conducted with Withers. They, in turn, are cited in Cox, *Road to Freedom,* 21.

38 See Withers, *Complete Photo Story of Till Murder Case.* There is evidence that Johnson Publications did license, at least selectively, the Till photographs taken by David Jackson,

because the credit line for the reproduction of Till's battered face in the *Crisis* is "David Jackson—Johnson Pub. Co." The clarity of the image indicates that the photograph was not appropriated from *Jet* or a newspaper reprint. See "Mississippi Barbarism," *Crisis,* October 1955, 479.

39 George H. Roeder Jr., *The Censored War: American Visual Experience during World War II* (New Haven, CT: Yale University Press, 1983), 10–19; *Life* caption quoted in *Reporting World War II* (New York: Library of America, 1995), 639.

40 I would be remiss if I did not acknowledge the ways in which whites did use the *idea* of the murdered Till to further disempower blacks. The civil rights activist Anne Moody has movingly recounted how the white woman who employed her as a domestic servant when she was a child held the specter of the killing over her as a threat for misbehaving blacks. As Moody wrote in her autobiography, "For the first time out of all her trying, Mrs. Burke had made me feel like rotten garbage. Many times she had tried to instill fear within me and subdue me and had given up. But when she talked about Emmett Till there was something in her voice that sent chills and fear all over me." In Anne Moody, *Coming of Age in Mississippi* (New York: Dell Books, 1968), 125; along similar lines, William Bradford Huie, the reporter who interviewed Milam and Bryant after their acquittal, recounted that one of the killers' lawyers encouraged their posttrial confession as a means of sending a warning to blacks and pro-integrationist whites. As the lawyer explained to Huie, "There ain't gonna be no integration. There ain't gonna be no nigger votin'. And *the sooner everybody in this country realizes it, the better.* If any more pressure is put on us, the Tallahatchie River won't hold all the niggers that'll be thrown into it" [emphasis in original]. J.J. Breland quoted in Stephen J. Whitfield, *A Death in the Delta: The Story of Emmett Till* (New York: Free Press, 1988), 54.

41 Langston Hughes, "Langston Hughes Wonders Why No Lynching Probes," *Chicago Defender,* October 1, 1955, 4.

42 Till-Mobley and Benson, *Death of Innocence,* 139; Withers, *Complete Photo Story,* unpaginated preface following page 2.

43 "Reign of Horror," *Chicago Defender,* September 17, 1955, 2.

44 "Bombshell in the Till Case," *New York Post,* January 11, 1956, quoted in remarks by Representative Charles Diggs of Michigan ("The Shocking Story of Approved Killing in Mississippi") entered on January 5, 1956, *Congressional Record,* 84th Cong., 2nd sess., 1956, vol. 102, pt. 14, A248; "Mississippi: The Place, the Acquittal," *Newsweek,* October 3, 1955, 29; "The Law: Trial by Jury," *Time,* October 3, 1955, 19; "Emmett Till's Day in Court," *Life,* October 3, 1955, 37.

45 The *New York Times* ran seventeen stories on Till in September 1955, thirteen of which focused on the trial; the *Washington Post* carried six Till stories during the month, with

five dealing with the trial; the *Chicago Defender* ran thirty-two stories, with just ten of them dealing with the trial; the *Chicago Tribune,* in Till's hometown, carried a balanced ratio, with five stories on the murder and five on the trial. As indicated by the number of Till articles published in the *Defender* during September, the white press published significantly fewer Till-related articles overall.

46 David A. Nichols, *A Matter of Justice: Eisenhower and the Beginning of the Civil Rights Revolution* (New York: Simon & Schuster, 2007), 277, 116–18; Till-Mobley and Benson, *Death of Innocence,* 200–201.

47 Representative Arthur G. Klein, "Murder in Mississippi," January 31, 1956, quoting Roger Goebel, "Murder in Mississippi," *Town and Village,* Fall 1955, *Congressional Record,* 84th Cong., 2nd sess., 1956, vol. 102, pt. 16, A1905.

48 Ashraf Rushdy, "Exquisite Corpse," *Transitions* 9:3 (2000): 70–77.

49 The previous Mississippi murder was of Reverend George Lee, president of the Regional Council of Negro Leadership and NAACP worker. He was shot to death while driving alone in Belzoni, Mississippi, on May 7, 1955. No one was convicted of the crime. For more on the 1955 murders of Mississippi blacks George Lee (May 7), Lamar Smith (August 13), and Clinton Melton (December 3), and on the attempted murder of Gus Courts (November), see Charles M. Payne, *I've Got the Light of Freedom: The Organizing Tradition and the Mississippi Freedom Struggle* (Berkeley: University of California Press, 1995), 34–41. Interestingly, George Lee's widow insisted on an open casket to display her husband's battered body in May 1955, four months before Till's death.

50 William Bradford Huie interview, quoted in Raines, *My Soul Is Rested,* 389.

51 In Huie, "The Shocking Story," 50.

52 John Herbers, a United Press International reporter at the Till trial, described his interaction with the Greenville publisher in a letter to Paul Hendrickson on February 27, 2000. Quoted in Paul Hendrickson, *Sons of Mississippi: A Story of Race and Its Legacy* (New York: Vintage, 2003), 319.

53 Retyped FBI transcript of the *Roy Bryant and J. W. Milam Trial for the Murder of Emmett Till,* 176, 269, 277–78, 49; available at http://foia.fbi.gov/till/till.pdf.

54 Huie, "The Shocking Story," 46; and William Bradford Huie, *Wolf Whistle* (New York: Signet Books, 1959), 48–49.

55 Davis W. Houck and Matthew A. Grindy, *Emmett Till and the Mississippi Press* (Jackson: University of Mississippi Press, 2008), 8, 47, 74, 9, 7.

56 Huie, *Wolf Whistle,* 36. In her autobiography, Mamie Bradley notes that after news of her husband's hanging became public, black servicemen from her husband's unit in Europe told her they were convinced that he was framed. Huie's statistics indicating that eighty-

seven of the ninety-five American soldiers hanged for the rape and/or murder of civilians were black suggest either that blacks were overprosecuted or that whites were underprosecuted for the crimes. In either case, the numbers call into question the race neutrality of the era's system of military justice. In Till-Mobley and Benson, *Death of Innocence,* 203–4.

57 "In Memoriam, Emmett Till," *Life,* October 10, 1955, 48; Dan Wakefield, "Justice in Sumner: Land of the Free," *Nation,* October 1, 1955, 284–85; "Death in Mississippi," *Commonweal,* September 23, 1955, 603–4; "Mississippi: The Place, the Acquittal," 24, 29.

58 For a handful of indicative examples, see "Ask Ike to Act in Dixie Death of Chicago Boy," *Chicago Tribune,* September 2, 1955, 2; "2,500 at Rites Here for Boy, 14, Slain in South," *Chicago Tribune,* September 4, 1955, 11; "Mississippi to Sift Negro Boy's Slaying," *New York Times,* September 2, 1955, 37; "Mother to Testify: Will Appear at Trial of Two in Slaying of Negro Boy," *New York Times,* September 13, 1955, 28; "Thousands Pass Bier of Slain Negro Boy," *Washington Post,* September 4, 1955, 3; "Two Indicted in Boy-Killing Plead Innocent," *Washington Post,* September 7, 1955, 44.

59 Renee C. Romano, "Narratives of Redemption: The Birmingham Church Bombing Trials and the Construction of Civil Rights Memory," in Renee C. Romano and Leigh Raiford, eds., *The Civil Rights Movement in American Memory* (Athens: University of Georgia Press, 2006), 96–133.

60 The Black Panther poster of Newton was even reproduced in the *New York Times* and the *Los Angeles Times* to illustrate their stories on the Panthers. By 1968, the editors of the *New York Times* deemed the image sufficiently well-known to refer to it in an unillustrated article as "the picture showing Newton seated in a flare-backed chair, a rifle in his right hand and a spear in his left." The symbolic power of the poster was such that in 1968 two Oakland police officers fired more than a dozen shots at one hanging in the window of the headquarters of the Panther's Oakland branch. On the poster's use in the white media, see Sol Stern, "The Call of the Black Panthers," *New York Times,* August 6, 1967, 10–11, 62–64; Wallace Turner, "Negroes Press Nomination of Indicted Militant," *New York Times,* February 5, 1968, 70; Ray Rogers, "The Who and Why of Black Militant Leader Huey Newton," *Los Angeles Times,* April 1, 1968, 1, 6. On the police destruction of the poster in Oakland, see Wallace Turner, "Coast Police Fire at Panther Camp," *New York Times,* September 11, 1968, 37. On the creation of the photograph and its symbolism for the Panthers, see Bobby Seale, *Seize the Time: The Story of the Black Panther Party and Huey P. Newton* (New York: Random House, 1970), 182–83. For more on the imagery of Black Power, see Erika Doss, "Imagining the Panthers: Representing Black Power and Masculinity, 1960s–1990s," *Prospects* 23 (1998): 483–516. For more on the framing of the Panthers and armed blacks in the 1960s, see Jane Rhodes, *Framing the Black Panthers: The Spectacular Rise of a Black Power Icon* (New York: New Press, 2007); Simon Wendt, *The Spirit and*

the Shotgun: Armed Resistance and the Struggle for Civil Rights (Gainesville: University Press of Florida, 2007).

61 Negative characterizations of the protest appear in the following articles: Brent Musburger, "Bizarre Protest by Smith, Carlos Tarnishes Medals," *Chicago's American,* October 17, 1968, 4; "U.S. Apologizes for Athletes' 'Discourtesy,'" *Los Angeles Times,* October 18, 1968, 1; Arthur Daley, "The Incident," *New York Times,* October 20, 1968, S-2; San Jose State Associated Student Body President Dick Miner quoted in the *Spartan Daily,* October 21, 1968, newspaper clipping in the "Speed City" file in San Jose State, Martin Luther King, Jr., Library Special Collections; *Washington Post,* October 20, 1968, reprinted in the *Spartan Daily,* October 23, 1968, newspaper clipping in the "Speed City" file in San Jose State, Martin Luther King, Jr., Library Special Collections; "Olympic Protestors Draw Boos, Praise," *Chicago Daily News,* October 17, 1968, 54; "Black-Fist Display Gets Varied Reaction in Olympic Village," *Los Angeles Times,* October 18, 1968, D-2; Jim Murray, "The Olympic Games—No Place for a Sportswriter," *Los Angeles Times,* October 20, 1968, H-1.

62 Daley, "The Incident," S-2.

63 On white concern about potential protests by Evans and his teammates, see Shirley Povich, "'Black Power' on the Victory Stand," *Los Angeles Times,* October 17, 1968, C-4; and Charles Maher, "U.S. Expels Smith, Carlos from Olympic Team," *Los Angeles Times,* October 19, 1968, A-3.

64 Louis Duino, "Evans Scores 'Double' Via Record, Humility," *San Jose Mercury News,* October, 17, 1968, 65.

65 Maher, "U.S. Expels Smith," 3.

66 "Olympic Trouble Threat Eases," *News,* October 19, 1968, quoted in Douglas Hartmann, *Race, Culture, and the Revolt of the Black Athlete: The 1968 Olympic Protests and Their Aftermath* (Chicago: University of Chicago Press, 2003), 164.

67 Joseph M. Sheehan, "2 Black Power Advocates Ousted from Olympics," *New York Times,* October 19, 1968, 1, 45.

68 Arthur Daley, "Far Reaching Repercussions," *New York Times,* reprinted in the *San Jose Mercury News,* October, 20, 1968, 79.

69 "Some Negro Athletes Threaten to 'Go Home' with Smith and Carlos," *New York Times,* October 19, 1968, 45.

70 "Olympic Trouble Threat Eases," *News,* October 19, 1968, quoted in Hartmann, *Race, Culture, and the Revolt of the Black Athlete,* 164; Duino, "Evans Scores 'Double,'" 65.

71 Daley, "Far Reaching Repercussions," 79.

72 Hartmann, *Race, Culture, and the Revolt,* xv. To Hartmann's list of adjectives that coded Olympic triumph, "heterosexual" must be added.

73 Mike Marqusee, "Sport and Stereotype: From Role Model to Muhammad Ali," *Race and Class* 36:4 (April/June 1995): 21, quoted in Amy Bass, *Not the Triumph but the Struggle: The 1968 Olympics and the Making of the Black Athlete* (Minneapolis: University of Minnesota Press, 2002), 241. Bass herself notes that the protest "did not throw the iconography of America out, but rather pushed for a more inclusive politics of citizenship" (241), though she does not specify the means by which it did so.

74 For more on the price paid by the athletes, see Tommie Smith with David Steele, *Silent Gesture: The Autobiography of Tommie Smith* (Philadelphia: Temple University Press, 2007); John Carlos with C. D. Jackson Jr., *Why? The Biography of John Carlos* (Los Angeles: Milligan Books, 2000).

75 "The Olympics: Black Complaint," *Time,* October 25, 1968, 62.

76 Art Rosenbaum, "Injured Tommie Sets 200 Mark," *San Francisco Chronicle,* October 17, 1968, 51.

77 J. White, *Black Panther (Oakland, CA),* October 26, 1968, 1; along similar lines, the newspaper of the Black Muslims, *Muhammad Speaks,* titled its article on Smith and Carlos's return to the United States "Return of the Black Olympic Heroes," November 8, 1968, 33.

78 Tom W. Smith, "Changing Racial Labels: From 'Colored' to 'Negro' to 'Black' to 'African American,'" *Public Opinion Quarterly* 56:4 (Winter 1992): 499.

79 Neil Allen, "After a Race, a Racial Gesture," *London Times,* October 18, 1968, 12.

80 Howard Cosell and Mickey Herskowitz, *Cosell* (Chicago: Playboy Press, 1973), 58.

81 Mary Herring, Thomas B. Jankowski, and Ronald E. Brown, "Pro-Black Doesn't Mean Anti-White: The Structure of African American Group Identity," *Journal of Politics* 61:2 (May 1999): 365.

82 "Confusion, Shock Grip U.S. Squad after Pair Ousted," *Los Angeles Times,* October 19, 1968, 1, 3; "Olympic Walkout Unlikely," *Oakland Tribune,* October 18, 1968, 56.

83 Ernest Siegel, letter to the editor, *New York Times,* October 27, 1968, S-2.

84 Smith interview with the *Daily Telegraph* from 1993, quoted in Bass, *Not the Triumph,* 233.

85 Richard Bousquet, letter to the editor, *Newsweek,* November 11, 1968, 4.

86 Marcelle Fortier, letter to the editor, *Los Angeles Times,* October 24, 1968, C-6.

87 Gertrude Wilson, "UFT Egos—and Black Athletes," *New York Amsterdam News,* November 2, 1968, 19.

88 Smith, "Changing Racial Labels," 503. Also see Gina Philogène, *From Black to African American: A New Social Representation* (Westport, CT: Praeger, 1999), 85–88.

89 Jerry Watts, "The Left's Silent South," in Sohnya Sayers, Anders Stephanson, Stanley

Aronowitz, and Frederic Jameson, eds., *The Sixties without Apology* (Minneapolis: University of Minnesota Press, 1984), 263.

90 Bayard Rustin, "From Protest to Politics: The Future of the Civil Rights Movement," *Commentary,* February 1964, reprinted in *Down the Line: The Collected Writings of Bayard Rustin* (Chicago: Quadrangle Books, 1971), 119.

91 Tom Kahn, *The Economics of Equality* (New York: League for Industrial Democracy, 1964), 12, 9–10.

92 "Raised Black Fists," *Life,* November 1, 1968, 64-C; Wilson, "UFT Egos—and Black Athletes," 19; Bob Gates, "Protest Casts Shadow," *Christian Science Monitor,* October 19, 1968, 1.

EPILOGUE

Epigraph: James Baldwin, "White Man's Guilt," *Ebony,* August 1965, 47–48.

1 Peter Applebome, "Past Playing Star Role in 2 Mississippi Trials," *New York Times,* January 18, 1994, A-14; Ronald Smothers, "White Supremacist Is Convicted of Slaying Rights Leader in '63," *New York Times,* February 6, 1994, 1; "In Mississippi, Verdict Helps to Erase Racist, Violent Past," *Christian Science Monitor,* February 8, 1994, 2; William Booth, "Beckwith Convicted of Murdering Evers," *Washington Post,* February 6, 1994, 1; Rheta Grimsley Johnson, "In Mississippi, Justice at Last," *Chicago Tribune,* February 12, 1994, 12; James Dao, "The Murders in Mississippi: Confronting the Past," *New York Times,* January 8, 2005, 11; Dahleen Glanton, "Verdict of History: An Old Man, an Old Sin, a New South," *Chicago Tribune,* June 26, 2005, 1; Ariel Hart, "41 Years Later, Ex-Klansman Gets 60 Years in Civil Rights Deaths," *New York Times,* June 24, 2005, A-14; "Late, but Not Too Late," *Washington Post,* June 23, 2005, 26; "Slow as Molasses: Long Overdue Murder Trials and the Juneteenth Holiday," *Houston Chronicle,* June 19, 2005, 2.

2 "Belated Justice in Birmingham," *New York Times,* May 23, 2002, 30.

3 See Edward P. Morgan, "The Good, the Bad, and the Forgotten: Media Culture and Public Memory of the Civil Rights Movement," in Renee C. Romano and Leigh Raiford, eds., *The Civil Rights Movement in American Memory* (Athens: University of Georgia Press, 2006), 139; R. Bruce Brasell, "From Evidentiary Presentation to Artful Re-Presentation: Media Images, Civil Rights Documentaries, and the Audiovisual Writing of History," *Journal of Film and Video* 56:1 (Spring 2004): 3–16. For a discussion of the evolving interests served by decoupling civil rights from the movement's radical economic agenda, see Jacquelyn Dowd Hall, "The Long Civil Rights Movement and the Political Uses of the Past," *Journal of American History* 91:4 (March 2005): 1233–63.

4 Mike Feinsilber, "Civil Rights: A Different Kind of Conflict," in *Breaking News: How the Associated Press Covered War, Peace, and Everything Else* (New York: Princeton Architec-

tural Press, 2007), 198; Steven Kasher, *The Civil Rights Movement: A Photographic History, 1954–68* (New York: Abbeville Press, 2000), 95; Herbert William Rice, *Ralph Ellison and the Politics of the Novel* (Lanham, MD: Lexington Books, 2003), 106; Gene Roberts and Hank Klibanoff, *The Race Beat: The Press, the Civil Rights Struggle, and the Awakening of a Nation* (New York: Alfred A. Knopf, 2007), 318; Matt Sedensky, "Bill Hudson, 77; Photographer's Images Spurred Support for Civil Rights," *Washington Post,* June 27, 2010, C-07.

5 Margaret Ann Spratt, "When Police Dogs Attacked: Iconic News Photographs and the Construction of History, Mythology, and Political Discourse" (Ph.D. dissertation, University of Washington, 2002), 78–80, 83–84, 90. In addition, white students in her sample group "were more likely than racial minorities to report emotional reactions. While 24 (37.5%) of the white students expressed emotional responses, eight (23.5%) Asian subjects reported such feelings, and neither African American subject expressed an emotional response" (90–91).

BIBLIOGRAPHY

"3rd Lynching of Year Shocks Nation." *Afro-American (Baltimore, MD),* September 10, 1955, 2.

"34 Arrested, Woman Beaten in Selma Negro Voter Drive." *Call and Post (Cleveland, OH),* January 30, 1965, 1, 2.

"400 Negro Pupils in Selma Stage Rights Protest." *Hartford Courant,* February 12, 1965, C-23.

"400 Youthful Negroes Demonstrate at Selma." *Los Angeles Times,* February 12, 1965, 10.

"600 Negro Kids Play 2nd Act of Rights Fight in Jail." *New York World-Telegram,* May 6, 1963, 2.

"800 More Negroes Seized in Alabama." *Los Angeles Times,* February 4, 1965, 1.

"1,000 Arrested in Alabama." *Philadelphia Inquirer,* February 4, 1965, 1, 3.

"1,000 Children Held in Alabama." *San Francisco Chronicle,* February 4, 1965, 1.

"1,000 Defy Police in Birmingham." *Washington Post,* May 5, 1963, A-1.

"2,500 at Rites Here for Boy, 14, Slain in South." *Chicago Tribune,* September 4, 1955, 11.

"A.D.A. Urges Kennedy Visit to Riot Area." *Chicago Tribune,* May 5, 1963, N-2.

Adams, Alvin. "Picture Seen around the World Changed Boy's Drop-Out Plan." *Jet,* October 10, 1963, 26–27.

Adelman, Bob, and Charles Johnson. *Mine Eyes Have Seen: Bearing Witness to the Struggle for Civil Rights.* New York: Time Inc., 2007.

"AFL-CIO Condemns Bias in Birmingham." *Chicago Daily Defender,* May 15, 1963, 3.

"Ala. Savagery as the World Sees It." *Call and Post (Cleveland, OH),* March 13, 1965, 1.

"Alabama Riot Broken Up by Police Dogs." *Los Angeles Times,* April 8, 1963, 1.

"Alabama Shames the Nation." *Philadelphia Inquirer,* May 6, 1963, 6.

Alexander, Elizabeth. "'Can you be BLACK and Look at This?': Reading the Rodney King Video(s)." In *The Black Public Sphere: A Public Culture Book,* edited by Black Public Sphere Collective, 81–98. Chicago: University of Chicago Press, 1995.

Ali, Muhammad, with Richard Durham. *The Greatest: My Own Story.* New York: Random House, 1975.

Alinder, Jasmine. *Moving Images: Photography and the Japanese American Incarceration.* Urbana: University of Illinois Press, 2009.

Allen, James. *Without Sanctuary: Lynching Photography in America.* Santa Fe, NM: Twin Palms Publishers, 2000.

Allen, Neil. "After a Race, a Racial Gesture." *London Times,* October 18, 1968, 12.

Allport, Gordon W. *The Nature of Prejudice.* Cambridge, MA: Addison-Wesley, 1954.

Apel, Dora. *Imagery of Lynching: Black Men, White Women, and the Mob.* New Brunswick, NJ: Rutgers University Press, 2004.

Applebome, Peter. "Past Playing Star Role in 2 Mississippi Trials." *New York Times,* January 18, 1994, A-14.

"Are These Men Christians?" *Pittsburgh Courier,* May 18, 1963, 3.

Arendt, Hannah. "Reflections on Little Rock." *Dissent* 6:1 (Winter 1959): 49–50.

———. "A Reply to the Critics." *Dissent* 6:2 (Spring 1959): 179–81.

"Arrest Ala. Style." *Afro-American (Baltimore, MD),* May 18, 1963, 6.

"Arrest King, 767 Others in Vote Drive." *Chicago Tribune,* February 2, 1965, 1, 2.

Arsenault, Raymond. *Freedom Rider: 1961 and the Struggle for Racial Justice.* New York: Oxford University Press, 2006.

Ashmore, Harry S. *Hearts and Minds: The Anatomy of Racism from Roosevelt to Reagan.* New York: McGraw-Hill, 1982.

"Ask Ike to Act in Dixie Death of Chicago Boy." *Chicago Tribune,* September 2, 1955, 2.

Bains, Lee E. Jr. "Birmingham 1963: Confrontation over Civil Rights." In *Birmingham, Alabama, 1956–1963: The Black Struggle for Civil Rights,* edited by David J. Garrow, 155–289. Brooklyn: Carlson Publishing, 1989.

Baldwin, James. "White Man's Guilt." *Ebony,* August 1965, 47–48.

"Bama's Story Recorded Again for All to See." *New York Amsterdam News,* March 13, 1965, 8.

Barnett, Pamela E. *Dangerous Desire: Sexual Freedom and Sexual Violence since the Sixties.* New York: Routledge, 2004.

Bass, Amy. *Not the Triumph but the Struggle: The 1968 Olympics and the Making of the Black Athlete.* Minneapolis: University of Minnesota Press, 2002.

Bass, S. Jonathan. *Blessed Are the Peacemakers: Martin Luther King, Jr., Eight White Religious Leaders, and the "Letter from Birmingham Jail."* Baton Rouge: Louisiana State University Press, 2001.

Bay, Mia. *To Tell the Truth Freely: The Life of Ida B. Wells.* New York: Hill and Wang, 2009.

Bederman, Gail. *Manliness and Civilization: A Cultural History of Race in the United States, 1880–1917.* Chicago: University of Chicago Press, 1995.

"Belated Justice in Birmingham." *New York Times,* May 23, 2002, 30.

Benjamin, Philip. "Negroes' Boycott in Birmingham Cuts Heavily into Retail Sales." *New York Times,* May 11, 1963, 9.

Bennett, Lerone Jr. "Mood of the Negro." *Ebony,* July 1963, 27–30, 32, 34, 38.

———. *The Negro Mood and Other Essays.* Chicago: Johnson Publishing Company, 1964.

Berger, Maurice. *For All the World to See: Visual Culture and the Struggle for Civil Rights.* New Haven, CT: Yale University Press, 2010.

Bevel, James. "Speech at the Flamingo Club, Savannah, Georgia." July 12, 1963. In *Rhetoric, Religion, and the Civil Rights Movement, 1954–1965,* edited by Davis W. Houck and David E. Dixon, 547–59. Waco, TX: Baylor University Press, 2006.

"Beyond Rights the Issue of Human Dignity." *Life,* May 24, 1963, 4.

"Birmingham, a Target City?" *Birmingham World,* April 10, 1963, 6.

"Birmingham Police Clash with 1,000." *Los Angeles Times,* May 5, 1963, 1.

"Birmingham School Kids Defy Police Dogs, Firemen Water Hose." *Jet,* May 16, 1963, 6–7.

"Birmingham Teenager Ready to Go Back to Jail." *New York Post,* May 9, 1963, 5.

Birmingham, U.S.A.: 'Look at Them Run.'" *Newsweek,* May 13, 1963, 27–29.

"Birmingham: 'War.'" *New York Mirror,* May 5, 1963, 2.

"Black-Fist Display Gets Varied Reaction in Olympic Village." *Los Angeles Times,* October 18, 1968, D-2.

Blackmon, Douglas A. *Slavery by Another Name: The Re-Enslavement of Black Americans from the Civil War to World War II.* New York: Anchor Books, 2008.

Booker, Simeon. "30 Years Ago: How Emmett Till's Lynching Launched Civil Rights Drive." *Jet,* June 17, 1985, 12–15, 18.

———. *Black Man's America.* Englewood Cliffs, NJ: Prentice-Hall, Inc., 1964.

Boone, Marshand. "Oral History Interview with Ernest Withers." Syracuse University Newhouse School, Civil Rights and the Press Center, http://civilrightsandthepress.syr.edu/oral_histories.html.

Booth, William. "Beckwith Convicted of Murdering Evers." *Washington Post,* February 6, 1994, 1.

Bousquet, Richard. Letter to the editor. *Newsweek,* November 11, 1968, 4.

Branch, Taylor. *Parting the Waters: America in the King Years, 1954–63.* New York: Simon & Schuster, 1988.

———. *Pillar of Fire: America in the King Years, 1963–1965.* New York: Simon & Schuster, 1998.

Brasell, R. Bruce. "From Evidentiary Presentation to Artful Re-Presentation: Media Images, Civil Rights Documentaries, and the Audiovisual Writing of History." *Journal of Film and Video* 56:1 (Spring 2004): 3–16.

"British Anti-Lynchers." *New York Times,* August 2, 1894, 4.

Britton, John. "Cute Youngster Determined 'To Make this Land My Home.'" *Jet,* May 23, 1963, 14–19.

———. "Selma Woman's Girdle a Big Factor in Fight with Sheriff." *Jet,* February, 11, 1965, 6–8.

———. "Victory in Birmingham Can Be Democracy's Finest Hour." *Jet,* May 2, 1963, 15.

Brodhead, Richard. *Cultures of Letters: Scenes of Reading and Writing in Nineteenth-Century America.* Chicago: University of Chicago Press, 1993.

Brown, Gillian. "Reading and Children: *Uncle Tom's Cabin* and *The Pearl of Orr's Island.*" In *Cambridge Companion to Harriet Beecher Stowe,* edited by Cindy Weinstein, 77–95. Cambridge: Cambridge University Press, 2004.

"Brutal Attack on Negroes in Selma." *San Francisco Chronicle,* March 8, 1965, 1, 12.

"Brutality Stops Ala. Vote March." *Chicago Daily Defender,* March 8, 1965, 1, 4–5.

Bryant, Nick. *The Bystander: John F. Kennedy and the Struggle for Black Equality.* New York: Basic Books, 2006.

Carlos, John, with C. D. Jackson Jr. *Why? The Biography of John Carlos.* Los Angeles: Milligan Books, 2000.

Carmack, George. "Selma Conflict Spurs Drive for New Laws." *New York World-Telegram and Sun,* February 6, 1965, 1–2.

Chalmers, David. *Backfire: How the Ku Klux Klan Helped the Civil Rights Movement.* New York: Rowman & Littlefield, 2003.

Chapnick, Howard. *Truth Needs No Ally: Inside Photojournalism.* Columbia: University of Missouri Press, 1994.

Chappell, Marisa, Jenny Hutchinson, and Brian Ward. "'Dress modestly, neatly . . . as if you were going to church': Respectability, Class and Gender in the Montgomery Bus Boycott and the Early Civil Rights Movement." In *Gender in the Civil Rights Movement,* edited by Peter J. Ling and Sharon Monteith, 69–100. New York: Garland Publishing, Inc., 1999.

Chatfield, Jack. "Letter to a Northern Friend." *New Republic,* May 18, 1963, 13–14.

Christian, Margena A. "Emmett Till's Legacy: 50 Years Later." *Jet,* September 19, 2005, 20–25.

"Civil Rights: Black Eye." *Newsweek,* February 8, 1965, 24.

Classen, Steven D. *Watching Jim Crow: The Struggles over Mississippi TV, 1955–1969.* Durham, NC: Duke University Press, 2004.

Cleghorn, Reese. "Martin Luther King, Jr.: Apostle of Crisis." *Saturday Evening Post,* June 15, 1963, 15–19.

Coffey, Raymond R. "Boy, 5, Asked for Jail, Too." *Boston Globe,* May 7, 1963, 44.

———. "Waiting in the Rain at the Birmingham Jail." *Chicago Daily News,* May 7, 1963. In *Reporting Civil Rights: Part One, American Journalism, 1941–1963,* 801–3. New York: Library of America, 2003.

Colaiaco, James A. *Martin Luther King, Jr.: Apostle of Militant Nonviolence.* New York: St. Martin's Press, 1988.

Coleman, Theodore. "Latest Atrocity in Mississippi Arouses Nation." *Pittsburgh Courier,* September 10, 1955, 1, 4.

Coles, Robert. *Children of Crisis: A Study of Courage and Fear,* vol. 1. Boston: Little, Brown and Company, 1967.

———. "Who's Blocking Desegregation?" *New Republic,* June 22, 1963, 17–20.

Collins, Kathleen. "The Scourged Back." *History of Photography* 9:1 (January-March 1985): 43–45.

"Confusion, Shock Grip U.S. Squad after Pair Ousted." *Los Angeles Times,* October 19, 1968, 1, 3.

Cosell, Howard, with Mickey Herskowitz. *Cosell.* Chicago: Playboy Press, 1973.

Cox, Julian. *Road to Freedom: Photographs of the Civil Rights Movement, 1956–1968.* Atlanta: High Museum of Art, 2008.

Curry, Constance, Joan C. Browning, Dorothy Dawson Burlage, Penny Patch, Theresa del Pozzo, Sue Thrasher, Elaine DeLott Baker, Emmie Schrader Adams, and Casey Hayden. *Deep in Our Hearts: Nine White Women in the Freedom Movement.* Athens: University of Georgia Press, 2000.

Daley, Arthur. "Far Reaching Repercussions." *San Jose Mercury News,* October, 20, 1968, 79.

———. "The Incident." *New York Times,* October 20, 1968, S-2.

Damsky, Bert S. Letter to the editor. *Time,* May 24, 1963, 9.

Daniel, Leon. "Police Rout Marchers in Selma With Gas, Clubs." *Philadelphia Inquirer,* March 8, 1965, 1, 3.

———. "Troopers Rout Selma Marchers." *Washington Post,* March 8, 1965, 3.

Danzig, David. "The Meaning of Negro Strategy." *Commentary* 37:2 (February 1964): 41–46.

Dao, James. "The Murders in Mississippi: Confronting the Past." *New York Times,* January 8, 2005, 11.

Davies, David, ed. *The Press and Race: Mississippi Journalists Confront the Movement.* Jackson: University Press of Mississippi, 2001.

Davis, Townsend. *Weary Feet, Rested Souls: A Guided History of the Civil Rights Movement.* New York: W. W. Norton, 1999.

"Death as a Weapon." *Los Angeles Times,* January 31, 1948, 4.

"Death in Mississippi." *Commonweal,* September 23, 1955, 603–4.

Diggs, Representative Charles. "The Shocking Story of Approved Killing in Mississippi." January 12, 1956, *Congressional Record,* 84th Cong., 2nd sess., 1956, vol. 102, pt. 14, A248.

"Dirty Tactics Used in Birmingham, Ala." *Pittsburgh Courier,* May 18, 1963, 3.

Dittmer, John. *Local People: The Struggle for Civil Rights in Mississippi.* Urbana: University of Illinois Press, 1994.

"Dixie Negroes Clubbed: Cops Also Use Dogs in Mississippi." *San Francisco Chronicle,* March 30, 1961, 8.

"Dogs Again Rout Voters in Miss. City, Bite Pastor." *Chicago Daily Defender,* April 5, 1963, 1.

"Dogs and Fire Hoses Rout 3,000 Negroes." *Boston Globe,* May 4, 1963, 1.

"Dogs and Fire Hoses Turned on Negroes: Marchers Sent Sprawling." *Chicago Tribune,* May 4, 1963, 1, 4.

"Dogs and Hoses Repulse Negroes at Birmingham." *New York Times,* May 4, 1963, 1, 8.

"Dogs vs. People? *Muhammad Speaks,* May 13, 1963, 15.

Donovan, Robert J. "Birmingham . . . U.S. Image Abroad." *New York Herald Tribune,* May 12, 1963, section 2, 1, 3.

Doss, Erika. "Imagining the Panthers: Representing Black Power and Masculinity, 1960s–1990s." *Prospects* 23 (1998): 483–516.

———, ed. *Looking at Life Magazine.* Washington, D.C.: Smithsonian Institution Press, 2001.

Dovidio, John F., Samuel L. Gaertner, Melissa-Sue John, Samer Halabi, Tamar Saguy, Adam R. Pearson, and Blake M. Riek. "Majority and Minority Perspectives in Intergroup Relations: The Role of Contact, Group Representations, Threat, and Trust in Intergroup Conflict and Resolution." In *The Social Psychology of Intergroup Reconciliation,* edited by Arie Nadler, Thomas E. Malloy, and Jeffrey D. Fisher, 227–53. Oxford: Oxford University Press, 2008.

Dovidio, John F., Samuel L. Gaertner, and Kerry Kawakami. "Intergroup Contact: The Past, Present, and the Future." *Group Processes and Intergroup Relations* 6:1 (2003): 5–21.

"Dr. King Jailed in Selma Arrests." *San Francisco Chronicle,* February 2, 1965, 1, 16.

Dray, Philip. *At the Hands of Persons Unknown: The Lynching of Black America.* New York: Random House, 2002.

Duckett, Alfred. "Great Man on Great Mission." *Tri-State Defender (Memphis, TN),* June 1, 1963, 6.

———. "Marching Kids Dreamed of Freedom." *Tri-State Defender (Memphis, TN),* June 8, 1963, 6.

Dudziak, Mary L. *Cold War Civil Rights: Race and the Image of American Democracy.* Princeton, NJ: Princeton University Press, 2000.

Duino, Louis. "Evans Scores 'Double' Via Record, Humility." *San Jose Mercury News,* October, 17, 1968, 65, 67.

Durham, Michael S. *Powerful Days: The Civil Rights Photography of Charles Moore.* Tuscaloosa: University of Alabama Press, 2002.

Eisinger, Joel. "Powerful Images: Charles Moore's Photographs of the Birmingham Demonstrations." *Exposure* 33:1/2 (2000): 33–42.

"Emmett Till's Day in Court." *Life,* October 3, 1955, 36–38.

"The End of Fear." *New Republic,* May 18, 1963, 1, 3.

Estabrook, Robert H. "Alabama Front Page News in Europe—With Bad Impact." *Boston Globe,* May 7, 1963, 17.

Estes, Steve. *I Am A Man! Race, Manhood, and the Civil Rights Movement.* Chapel Hill: University of North Carolina Press, 2005.

Fairclough, Adam. *To Redeem the Soul of America: The Southern Christian Leadership Conference and Martin Luther King, Jr.* Athens: University of Georgia Press, 1987.

Farmer, James. *Lay Bare the Heart: An Autobiography of the Civil Rights Movement.* Fort Worth: Texas Christian University Press, 1985.

"Fast Potent Weapon for Gandhi." *Washington Post,* January 31, 1948, 8.

"FBI Is Probing Racial Outbreak." *New York World-Telegram and Sun,* March 30, 1961, 3.

Federal Bureau of Investigation. Report on Emmett Till murder. Prepared February 9, 2006, case 44A-JN-30112 & 62D-JN-30045, http://foia.fbi.gov/till/till.pdf.

———. Retyped transcript of the Roy Bryant and J. W. Milam trial for the murder of Emmett Till, http://foia.fbi.gov/till/till.pdf.

Feinsilber, Mike. *Breaking News: How the Associated Press Covered War, Peace, and Everything Else.* New York: Princeton Architectural Press, 2007.

Feldstein, Ruth. "'I Wanted the Whole World to See': Race, Gender, and Constructions of Motherhood in the Death of Emmett Till." In *Not June Cleaver: Women and Gender in Postwar America, 1945–1960,* edited by Joanne Meyerwitz, 263–303. Philadelphia: Temple University Press, 1994.

———. *Motherhood in Black and White: Race and Sex in American Liberalism, 1930–1965.* Ithaca, NY: Cornell University Press, 2000.

"Fight Marks Selma Voter Registration." *Baltimore Sun,* January 26, 1965, 5.

"Fire Hoses and Police Dogs Quell Birmingham Segregation Protest." *Washington Post,* May 4, 1963, 1, 4.

"Fire Hoses Rip Off Negroes' Clothes in Dixie Violence." *New York Daily News,* May 4, 1963, 5.

Fisher, Philip. *Hard Facts: Setting and Form in the American Novel.* New York: Oxford University Press, 1985.

Fleming, Karl. "I Like the Word Black." *Newsweek,* May 6, 1963, 28.

———. *Son of the Rough South: An Uncivil Memoir.* New York: PublicAffairs, 2005.

Foner, Philip S., ed. *Frederick Douglass: Selected Speeches and Writings.* Chicago: Lawrence Hill Books, 1999.

Forman, James. *The Making of Black Revolutionaries: A Personal Account.* New York: Macmillan Company, 1972.

Fortier, Marcelle. Letter to the editor. *Los Angeles Times,* October 24, 1968, C-6.

Fowler, Lessie. "Shame of Birmingham." Letter to the editor. *Los Angeles Times,* May 11, 1963, B-4.

Frei, Georg, and Neil Printz. *The Andy Warhol Catalogue Raisonne: Paintings and Sculpture 1961–1963.* New York: Phaidon, 2002.

Friedan, Betty. *The Feminine Mystique.* New York: Dell Publishing, 1984.

Gaillard, Frye. *Cradle of Freedom: Alabama and the Movement That Changed America.* Tuscaloosa: University of Alabama Press, 2004.

"Gandhi: He Changed World History, Yet his Power Was Not of this World." *Life,* February 9, 1948, 32.

Garrison, Bill. "Struggle!" *Muhammad Speaks,* May 13, 1968, 8.

Garrow, David J. *Bearing the Cross: Martin Luther King, Jr., and the Southern Christian Leadership Conference.* New York: William Morrow and Company, 1986.

———, ed. *Birmingham, Alabama, 1956–1963: The Black Struggle for Civil Rights.* Brooklyn, NY: Carlson Publishing, 1989.

———. *Protest at Selma: Martin Luther King, Jr., and the Voting Rights Act of 1965.* New Haven, CT: Yale University Press, 1978.

Gates, Bob. "Protest Casts Shadow." *Christian Science Monitor,* October 19, 1968, 1.

Gilbert, Paul. "What Is Shame? Some Core Issues and Controversies." In *Shame: Interpersonal Behavior, Psychopathology, and Culture,* edited by Paul Gilbert and Bernice Andrews, 3–38. New York: Oxford University Press, 1998.

Gitlin, Todd. *The Whole World Is Watching: Mass Media and the Making and Unmaking of the New Left.* Berkeley: University of California Press, 2003.

"Given Sweatbox Torture." *Afro-American (Baltimore, MD),* May 18, 1963, 1.

Glanton, Dahleen. "Verdict of History: An Old Man, an Old Sin, a New South." *Chicago Tribune,* June 26, 2005, 1.

Glenn, Evelyn Nakano. *Unequal Freedom: How Race and Gender Shaped American Citizenship and Labor.* Cambridge, MA: Harvard University Press, 2002.

Gold, Mike [Itzok Isaac Granich]. "Change the World." *Daily Worker,* May 26, 1963, 4.

Goldberg, Vicki. *The Power of Photography: How Photographs Changed Our Lives.* New York: Abbeville Publishing Group, 1993.

Golden, Harry. *Mr. Kennedy and the Negroes.* New York: World Publishing Company, 1964.

Good, Paul. "Police Seize Dr. King in Selma Rally." *Washington Post,* February 2, 1965, 1, 6.

———. "Selma Arrests Continue as King Remains in Jail." *Washington Post,* February 3, 1965, 3.

———. *The Trouble I've Seen: White Journalist/Black Movement.* Washington, D.C.: Howard University Press, 1975.

Gordon, Robert. "Waves of Young Negroes March in Birmingham Protest." *Washington Post,* May 3, 1963, 1.

Green, Adam. *Selling the Race: Culture, Community, and Black Chicago, 1940–1955.* Chicago: University of Chicago Press, 2007.

Griffin, Dan. Letter to the editor. *Life* June 7, 1963, 25.

Hailey, Foster. "Dogs and Hoses Repulse Negroes at Birmingham." *New York Times,* May 4, 1963, 1, 8.

Halberstam, David. *The Children.* New York: Fawcett Books, 1998.

———. *The Fifties.* New York: Villard Books, 1993.

———. "The Second Coming of Martin Luther King." *Harper's Magazine,* August 1967, 39–51.

Hall, Jacquelyn Dowd. "The Long Civil Rights Movement and the Political Uses of the Past." *Journal of American History* 91:4 (March 2005): 1233–63.

"Halt New Ala. 'March.'" *New York Mirror,* May 5, 1963, 2.

Hampton, Henry, and Steve Fayer, eds. *Voices of Freedom: An Oral History of the Civil Rights Movement from the 1950s through the 1980s.* New York: Bantam Books, 1990.

Handler, M. S. "Malcolm X Terms King's Tactics Futile." *New York Times,* May 11, 1963, 9.

Hansen, Drew D. *The Dream: Martin Luther King, Jr. and the Speech That Inspired a Nation.* New York: HarperCollins, 2003.

Harold, Christine, and Kevin Michael DeLuca, "Behold the Corpse: Violent Images and the Case of Emmett Till." *Rhetoric & Public Affairs* 8:2 (2005): 263–86.

Hart, Ariel. "41 Years Later, Ex-Klansman Gets 60 Years in Civil Rights Deaths." *New York Times,* June 24, 2005, A-14.

Hartman, Saidiya V. *Scenes of Subjection: Terror, Slavery, and Self-Making in Nineteenth-Century America.* New York: Oxford University Press, 1997.

Hartmann, Douglas. *Race, Culture, and the Revolt of the Black Athlete: The 1968 Olympic Protests and Their Aftermath.* Chicago: University of Chicago Press, 2003.

Hawkins, Representative Augustus F. "Civil Rights." May 9, 1963, *Congressional Record,* 88th Cong., 1st sess., 1963, vol. 109, pt. 6, 8256.

Hedrick, Joan D. *Harriet Beecher Stowe: A Life.* New York: Oxford University Press, 1994.

Hemphill, Paul. *Leaving Birmingham: Notes of a Native Son.* New York: Viking, 1993.

Hemphill, Ruth R. Letter to the editor. *Washington Post,* May 16, 1963, A-22.

Hendrickson, Paul. *Sons of Mississippi: A Story of Race and Its Legacy.* New York: Vintage, 2003.

Herbers, John. "Dr. King and 770 Others Seized in Alabama Protest." *New York Times,* February 2, 1965, 1, 15.

———. "Voting Is Crux of Civil Rights Hopes." *New York Times,* February 14, 1965, E-5.

Herring, Mary, Thomas B. Jankowski, and Ronald E. Brown. "Pro-Black Doesn't Mean Anti-White: The Structure of African American Group Identity." *Journal of Politics* 61:2 (May 1999): 363–86.

Hollingsworth, G. B. Jr. Letter to the editor. *Time,* May 24, 1963, 9.

Holt, Len. "Eyewitness: The Police Terror at Birmingham." *National Guardian,* May 16, 1963. In *Reporting Civil Rights: Part One, American Journalism, 1941–1963,* 799. New York: Library of America, 2003.

Houck, Davis W., and David E. Dixon, eds. *Rhetoric, Religion and the Civil Rights Movement, 1954–1965.* Waco, TX: Baylor University Press, 2006.

Houck Davis W., and Matthew A. Grindy. *Emmett Till and the Mississippi Press.* Jackson: University of Mississippi Press, 2008.

Howard, June. *Publishing the Family.* Durham, NC: Duke University Press, 2001.

Huddleston, George Jr. "The True Facts of the Birmingham Situation." May 8, 1963, *Congressional Record,* 88th Cong., 1st sess., 1963, vol. 109, pt. 6, 8085–86.

Hughes, Langston. "Langston Hughes Wonders Why No Lynching Probes." *Chicago Defender,* October 1, 1955, 4.

Huie, William Bradford. "The Shocking Story of the Approved Killing in Mississippi." *Look,* January 24, 1956, 46–50.

————. "What's Happened to the Emmett Till Killers?" *Look,* January 22, 1957, 63–66, 68.

————. *Wolf Whistle.* New York: Signet Books, 1959.

"Hundreds of Negroes Jailed in Alabama Rights Drive." *Baltimore Sun,* February 4, 1965, 8.

Huntley, Horace, and John W. McKerley, eds. *Foot Soldiers for Democracy: The Men, Women, and Children of the Birmingham Civil Rights Movement.* Urbana: University of Illinois Press, 2009.

"In Memoriam, Emmett Till." *Life,* October 10, 1955, 48.

"In Mississippi, Verdict Helps to Erase Racist, Violent Past." *Christian Science Monitor,* February 8, 1994, 2.

Jackson, Emory O. "Teenagers Tell of Jail Experiences, Treatment." *Birmingham World,* May 11, 1963, 1

Jackson, James E. "What Are You Doing about Birmingham?" *Daily Worker,* May 12, 1963, 12.

"Javits Denounces Birmingham Police." *New York Times,* May 5, 1963, 82.

"Jews Capture Yehudia after All-Night Battle." *Los Angeles Times,* May 5, 1948, 8.

"Jews Drive Arab Forces from Vital Positions." *Los Angeles Times,* May 11, 1948, 6.

"Jews Score a Preliminary Victory." *Life,* May 10, 1948, 30.

Johnson, Rheta Grimsley. "In Mississippi, Justice at Last." *Chicago Tribune,* February 12, 1994, 12.

Kahn, Tom. *The Economics of Equality.* New York: League for Industrial Democracy, 1964.

Kaplan, John. "The *Life* Magazine Civil Rights Photography of Charles Moore." *Journalism History* 25:4 (Winter 1999–2000): 126–39.

Kasher, Steven. *The Civil Rights Movement: A Photographic History, 1954–68.* New York: Abbeville Press, 2000.

Kawakami, Kerry, Elizabeth Dunn, Francine Karmali, and John F. Dovidio. "Mispredicting Affective and Behavioral Responses to Racism." *Science,* January 9, 2009 (323): 276–78.

Keen, Susan. *Empathy and the Novel.* New York: Oxford University Press, 2007.

"Keeping Peace in Alabama—Police, Fire Hoses and Dogs." *New York Herald Tribune,* May 4, 1963, 1.

"Kennedy Gives Fiscal Views to Critics in ADA." *Washington Post,* May 5, 1963, A-2.

"Kennedy Said to Voice Dismay at Racial Violence." *New York Times,* May 5, 1963, 83.

King, Martin Luther Jr. "Speech at the Sixteenth Street Baptist Church, Birmingham, Alabama." May 3, 1963. In *"We Want Our Freedom": Rhetoric of the Civil Rights Movement,* edited by W. Stuart Towns, 147–51. Westport, CT: Praeger Publishers, 2002.

————. *Stride toward Freedom: The Montgomery Story.* New York: Harper & Row, 1958.

————. *Where Do We Go from Here: Chaos or Community?* New York: Harper & Row, 1967.

———. *Why We Can't Wait.* New York: Harper & Row, 1964.

King, Martin Luther Jr., and Clayborne Carson. *The Autobiography of Martin Luther King, Jr.* New York: Grand Central Publishing, 2001.

Klarman, Michael J. *From Jim Crow to Civil Rights: The Supreme Court and the Struggle for Racial Equality.* New York: Oxford University Press, 2004.

Klein, Representative Arthur G. "Murder in Mississippi." January 31, 1956, *Congressional Record,* 84th Cong., 2nd sess., 1956, vol. 102, pt. 16, A1905

Kotz, Nick. *Judgment Days: Lyndon Baines Johnson, Martin Luther King Jr., and the Laws that Changed America.* New York: Houghton Mifflin Company, 2005.

Ladner, Joyce. "The South: Old New Land," *New York Times,* May 17, 1979, A-23.

"Late, but Not Too Late." *Washington Post,* June 23, 2005, 26.

"The Law: Trial by Jury." *Time,* October 3, 1955, 18–19.

"LBJ Confers on Selma—Arrests Reach 2,600." *Boston Globe,* February 4, 1965, 17.

Lebeau, Vicky. "The Unwelcome Child: Elizabeth Eckford and Hannah Arendt." *Journal of Visual Culture* 3:1 (2004): 51–62.

Lentz, Richard. *Symbols, the News Magazines, and Martin Luther King.* Baton Rouge: Louisiana State University Press, 1990.

Levine, Ellen. *Freedom's Children: Young Civil Rights Activists Tell Their Own Stories.* New York: Puffin Books, 2000.

Lewis, Helen Block. *Shame and Guilt in Neurosis.* New York: International University Press, 1971.

Lewis, John, with Michael D'Orso. *Walking with the Wind: A Memoir of the Movement.* New York: Harcourt Brace & Company, 1998.

Lichtenberger, Arthur. *The Day Is at Hand.* New York: Seabury Press, 1964.

Ling, Peter J., and Sharon Monteith, eds. *Gender in the Civil Rights Movement.* New York: Garland Publishing, 1999.

"'Little Child Shall Lead Them.'" *Tri-State Defender (Memphis, TN),* May 25, 1963, 6.

"'Look at that Dog Go.'" *Birmingham World,* April 13, 1963, 8.

Lyle, Jack, ed. *The Black American and the Press.* Los Angeles: Ward Ritchie Press, 1968.

Lynch, John. "750 More Jailed in Dixie." *New York World-Telegram and Sun,* February 3, 1965, 2.

———. "Lady Slugs Sheriff in Selma Scuffle." *Chicago Daily Defender,* January 26, 1965, 3, 10.

"Lynch Trial Begins." *Afro-American (Baltimore, MD),* September 24, 1955, 1–2.

Lyon, Danny. *Memories of the Southern Civil Rights Movement.* Chapel Hill: University of North Carolina Press, 1992.

MacDonald, J. Fred. *Blacks and White TV: Afro-Americans in Television Since 1948.* Chicago: Nelson-Hall Publishers, 1983.

Maher, Charles. "U.S. Expels Smith, Carlos from Olympic Team." *Los Angeles Times,* October 19, 1968, A-3.

Mann, Robert. *The Walls of Jericho: Lyndon Johnson, Hubert Humphrey, Richard Russell and the Struggle for Civil Rights.* New York: Harcourt Brace & Company, 1996.

Marable, Manning. *Freedom: A Photographic History of the African American Struggle.* New York: Phaidon Press, 2002.

Marqusee, Mike. "Sport and Stereotype: From Role Model to Muhammad Ali." *Race and Class* 36:4 (April/June 1995): 1–29.

"Mass Meet on Till Murder." *New York Amsterdam News,* September 17, 1955, 1, 2.

McGill, Ralph. *The South and the Southerner.* Boston: Little, Brown and Company, 1963.

McKee, Don. "Dogs, Hoses Rout Negroes in Birmingham Bias Protest." *Philadelphia Inquirer,* May 4, 1963, 1, 5.

McMurray, Linda O. *To Keep the Waters Troubled: The Life of Ida B. Wells.* New York: Oxford University Press, 2000.

McWhorter, Diane. *Carry Me Home: Birmingham, Alabama, the Climactic Battle of the Civil Rights Revolution.* New York: Simon & Schuster, 2001.

Meacham, Jon, ed. *Voices in Our Blood: America's Best on the Civil Rights Movement.* New York: Random House, 2001.

"The Meaning of Birmingham." *New York Times,* May 10, 1963, 32.

Mendelsohn, Jack. *The Martyrs: Sixteen Who Gave Their Lives for Racial Justice.* New York: Harper & Row Publishers, 1966.

Metress, Christopher, ed. *The Lynching of Emmett Till: A Documentary Narrative.* Charlottesville: University of Virginia Press, 2002.

Mintz, Stephen. *Huck's Raft: A History of American Childhood.* Cambridge, MA: Harvard University Press, 2004.

"Mississippi Barbarism." *Crisis,* October 1955, 479–81.

"Mississippi Shame." *Chicago Defender,* September 17, 1955, 19.

"Mississippi: The Place, the Acquittal." *Newsweek,* October 3, 1955, 24, 29–30.

"Mississippi to Sift Negro Boy's Slaying." *New York Times,* September 2, 1955, 37.

Moody, Anne. *Coming of Age in Mississippi.* New York: Dell Books, 1968.

Morgan, Charles Jr. "Southern Justice." *Look,* June 29, 1965, 72–73.

Morgan, Edward P. "The Good, the Bad, and the Forgotten: Media Culture and Public Memory of the Civil Rights Movement." In *The Civil Rights Movement in American*

Memory, edited by Renee C. Romano and Leigh Raiford, 137–66. Athens: University of Georgia Press, 2006.

Morse, Wayne. "Constitutional Rights." May 7, 1963, *Congressional Record,* 88th Cong., 1st sess., 1963, vol. 109, pt. 6, 778.

Morton, Patricia. *Disfigured Images: The Historical Assault on Afro-American Women.* Westport, CT: Praeger, 1991.

"Mother to Testify: Will Appear at Trial of Two in Slaying of Negro Boy." *New York Times,* September 13, 1955, 28.

Murphree, Vanessa. *The Selling of Civil Rights: The Student Nonviolent Coordinating Committee and the Use of Public Relations.* New York: Routledge, 2006.

Murphy, William T. "Television and Video Preservation: A Report on the Current State of American Television." Vol. 1 (October 1997): www.loc.gov/film/tvstudy.html.

Murray, Jim. "The Olympic Games—No Place for a Sportswriter." *Los Angeles Times,* October 20, 1968, H-1.

Musburger, Brent. "Bizarre Protest by Smith, Carlos Tarnishes Medals." *Chicago's American,* October 17, 1968, 4.

Muscatine, Charles, and Marlene Griffith, eds. *The Borzoi College Reader.* New York: Alfred A. Knopf, 1976.

Natanson, Nicholas. *The Black Image in the New Deal: The Politics of the FSA Photography.* Knoxville: University of Tennessee Press, 1992.

"The Nation." *Time,* March 19, 1965, 23–28.

"Nation Horrified by Murder of Kidnapped Chicago Youth." *Jet,* September 15, 1955, 6–9.

"Negro Leaders Order Halt to Birmingham Protests," *New York World-Telegram,* May 8, 1963, 1.

"Negro Marchers Clubbed: Melee in Selma." *Los Angeles Times,* March 8, 1965, 1, 3, 26.

"Negro Marchers Gassed, Beaten." *Boston Globe,* March 8, 1965, 12.

"Negro Woman Slugs Sheriff in Vote Drive." *Chicago Tribune,* January 26, 1965, 3, 9.

"Negro Woman Strikes Selma Sheriff in Face." *Los Angeles Times,* January 26, 1965, 3.

"Negroes Routed by Tear Gas." *Chicago Tribune,* March 8, 1965, 1, 5.

"Negroes Urge U.S. Troops in Alabama." *New York World-Telegram and Sun,* September 16, 1963, 1–2.

"New Alabama Riot: Police Dogs, Fire Hoses Halt March." *Los Angeles Times,* May 4, 1963, 1, 8.

"A New Charter of Freedom." *Daily Worker,* May 19, 1963, 1.

Newman, Kathy. "Wounds and Wounding in the American Civil War: A (Visual) History." *Yale Journal of Criticism* 6:2 (1993): 63–86.

Nichols, David A. *A Matter of Justice: Eisenhower and the Beginning of the Civil Rights Revolution.* New York: Simon & Schuster, 2007.

"No Holds Barred." *New York Herald Tribune,* May 7, 1963, 12.

Nunnelley, William A. *Bull Connor.* Tuscaloosa: University of Alabama Press, 1991.

"Olympic Protestors Draw Boos, Praise." *Chicago Daily News,* October 17, 1968, 54.

"Olympic Walkout Unlikely." *Oakland Tribune,* October 18, 1968, 56.

"The Olympics: Black Complaint." *Time,* October 25, 1968, 62–63.

Opotowsky, Stan. "Birmingham Children Lead the Way to Jail." *New York Post,* May 7, 1963, 5.

Orvell, Miles. *The Real Thing: Imitation and Authenticity in American Culture, 1880–1940.* Chapel Hill: University of North Carolina Press, 1989.

"Outrage in Alabama." *New York Times,* May 5, 1963, 200.

Payne, Charles M. *I've Got the Light of Freedom: The Organizing Tradition and the Mississippi Freedom Struggle.* Berkeley: University of California Press, 1995.

Peabody, Ephraim. "Narratives of Fugitive Slaves." *Christian Examiner* 47 (July 1849). In *Critical Essays on Frederick Douglass,* edited by William L. Andrews, 24–27. Boston: G. K. Hall and Company, 1991.

Persons, Albert C. "Buck." *The True Selma Story: Sex and Civil Rights.* Birmingham, AL: Esco Publishers, Inc., 1965.

Pettigrew, Thomas F., and Linda R. Tropp. "A Meta-Analytic Test of Intergroup Contact Theory." *Journal of Personality and Social Psychology* 90:5 (May 2006): 751–83.

Philogène, Gina. *From Black to African American: A New Social Representation.* Westport, CT: Praeger, 1999.

Podhoretz, Norman. "My Negro Problem—and Ours." *Commentary,* February 1963. In *Reporting Civil Rights: Part One, American Journalism, 1941–1963,* 762–74. New York: Library of America, 2003.

"Police and Dogs Rout 100 Negroes." *New York Times,* March 30, 1961, 19.

"Police Battle Negroes 4 Hours." *Chicago Tribune,* May 5, 1963, 1.

"Police Dog Attacks Demonstrator." *New York Daily News,* May 4, 1963, 1.

"Police Dogs, Hoses Smash Negro March." *San Francisco Chronicle,* May 4, 1963, 1, 12.

"Police Dogs in Ala. Spur N.C. Protest." *Afro-American (Baltimore, MD),* June 1, 1963, 1.

"Police Stop Vote March in Alabama." *Baltimore Sun,* March 8, 1965, 1, 4.

"Police Turn Hoses on Alabama Negroes." *New York World-Telegram,* May 3, 1963, 1.

Pollack, Harriet, and Christopher Metress, eds. *Emmett Till in Literary Memory and Imagination.* Baton Rouge: Louisiana State University Press, 2008.

Porter, John R. Letter to the editor. *Chicago Daily Defender,* May 22, 1963, 14.

Povich, Shirley. "'Black Power' on the Victory Stand." *Los Angeles Times,* October 17, 1968, C-1, C-4.

"Praise Sheriff-Slugging 'Bama Matron's Courage." *Pittsburgh Courier,* January 30, 1965, 1.

"Preventing Riots." *Chicago Tribune,* August 10, 1966, 22.

"Races: Freedom—Now." *Time,* May 17, 1963, 23–25.

Raiford, Leigh. "'Come Let Us Build a New World Together': SNCC and Photography of the Civil Rights Movement." *American Quarterly* 59:4 (December 2007): 1129–57.

Raines, Howell. *My Soul Is Rested: Movement Days in the Deep South Remembered.* New York: G. P. Putnam's Sons, 1977.

"Raised Black Fists." *Life,* November 1, 1968, 64-C.

Ralph, James R. Jr. *Northern Protest: Martin Luther King, Jr., Chicago, and the Civil Rights Movement.* Cambridge, MA: Harvard University Press, 1993.

Rather, Dan, with Mickey Herskowitz. *The Camera Never Blinks: Adventures of a TV Journalist.* New York: William Morrow and Company, 1977.

Reed, Roy. "165 Selma Negro Youths Taken on Forced March." *New York Times,* February 11, 1965, 1, 19.

———. "Alabama Police Use Gas and Clubs to Rout Negroes." *New York Times,* March 8, 1965, 1, 20.

"Reign of Horror." *Chicago Defender,* September 17, 1955, 2.

Reinhardt, Mark, Holly Edwards, and Erina Duganne, eds. *Beautiful Suffering: Photography and the Traffic in Pain.* Chicago: University of Chicago Press, 2007.

Reporting World War II. New York: Library of America, 1995.

"Return of the Black Olympic Heroes." *Muhammad Speaks,* November 8, 1968, 33.

"Rev. King Back in Selma as Court Bans Registration Interference." *Philadelphia Tribune,* January 26, 1965, 1, 2.

Rhodes, Jane. *Framing the Black Panthers: The Spectacular Rise of a Black Power Icon.* New York: New Press, 2007.

Rice, Herbert William. *Ralph Ellison and the Politics of the Novel.* Lanham, MD: Lexington Books, 2003.

Richards, David A. J. *Disarming Manhood: Roots of Ethical Resistance.* Athens, OH: Swallow Press, 2005.

Riches, William T. Martin. *The Civil Rights Movement: Struggle and Resistance.* New York: St. Martin's Press, 1997.

Riek, Blake M. "Does a Common Ingroup Identity Reduce Intergroup Threat?" Ph.D. dissertation, University of Delaware, 2007.

Riek, Blake M., Samuel L. Gaertner, John F. Dovidio, Marilynn B. Brewer, Eric W. Mania, and Marika J. Lamoreaux. "A Social-Psychological Approach to Postconflict Reconciliation." In *The Social Psychology of Intergroup Reconciliation,* edited by Arie Nadler, Thomas E. Malloy, and Jeffrey D. Fisher, 255–75. Oxford: Oxford University Pres, 2008.

"The Right of Peaceful Assembly." *Birmingham World,* May 18, 1963, 8.

"Robert Kennedy Warns of 'Increasing Turmoil.'" *New York Times,* May 4, 1963, 8.

Roberts, Gene, and Hank Klibanoff. *The Race Beat: The Press, the Civil Rights Struggle, and the Awakening of a Nation.* New York: Alfred A. Knopf, 2007.

Roeder, George H. Jr. *The Censored War: American Visual Experience during World War II.* New Haven, CT: Yale University Press, 1983.

Rogers, Ray. "The Who and Why of Black Militant Leader Huey Newton." *Los Angeles Times,* April 1, 1968, 1, 6.

Romano, Renee C. "Narratives of Redemption: The Birmingham Church Bombing Trials and the Construction of Civil Rights Memory." In *The Civil Rights Movement in American Memory,* edited by Renee C. Romano and Leigh Raiford, 96–133. Athens: University of Georgia Press, 2006.

Romero, Lora. *Home Fronts: Domesticity and Its Critics in the Antebellum United States.* Durham, NC: Duke University Press, 1997.

Rosenbaum, Art. "Injured Tommie Sets 200 Mark." *San Francisco Chronicle,* October 17, 1968, 51.

Rushdy, Ashraf. "Exquisite Corpse." *Transitions* 9:3 (2000): 70–77.

"Rusk Says Rights Struggle Damages U.S. Leadership." *New York Times,* June 10, 1963, 44.

Rustin, Bayard. *Down the Line: The Collected Writings of Bayard Rustin.* Chicago: Quadrangle Books, 1971.

"Sabotage of Chicago." *Chicago Tribune,* August 18, 1966, 22.

Samuels, Shirley, ed. *The Culture of Sentiment: Race, Gender, and Sentimentality in Nineteenth-Century America.* New York: Oxford University Press, 1992.

Sánchez-Eppler, Karen. *Touching Liberty: Abolition, Feminism, and the Politics of the Body.* Berkeley: University of California Press, 1993.

"Sanity in Birmingham." *New York Times,* May 11, 1963, 24.

Schlesinger, Arthur M. *A Thousand Days: John F. Kennedy in the White House.* Boston: Houghton Mifflin Company, 1965.

Schlesinger, Andrew, and Stephen Schlesinger, eds. *Arthur M. Schlesinger, Jr., Journals, 1952–2000.* New York: Penguin Books, 2008.

Schulke, Flip, ed. *Martin Luther King, Jr.: A Documentary . . . Montgomery to Memphis.* New York: W. W. Norton & Company, 1976.

Scott, Daryl Michael. *Contempt and Pity: Social Policy and the Image of the Damaged Black Psyche, 1880–1996.* Chapel Hill: University of North Carolina Press, 1997.

Seale, Bobby. *Seize the Time: The Story of the Black Panther Party and Huey P. Newton.* New York: Random House, 1970.

Sedensky, Matt. "Bill Hudson, 77; Photographer's Images Spurred Support for Civil Rights." *Washington Post,* June 27, 2010, C-07.

"Selma, Contd." *Time,* February 5, 1965, 24.

"Selma Negroes Register, Pace Slow; Sheriff Hit." *Hartford Courant,* January 26, 1965, 6.

"Selma Sheriff Clubs Negro Woman." *San Francisco Chronicle,* January 26, 1965, 1, 8.

"Senator Rips Use of Dogs in Ala. as 'Reprehensible.'" *Chicago Daily Defender,* May 7, 1963, 5.

Sevareid, Eric. *This Is Eric Sevareid.* New York: McGraw-Hill, 1964.

Sharp, Gene. *The Politics of Nonviolent Action.* Boston: Porter Sargent Publisher, 1973.

Shaw, Ralph Jr. Letter to the editor. *Life* June 7, 1963, 25.

Sheehan, Joseph M. "2 Black Power Advocates Ousted from Olympics." *New York Times,* October 19, 1968, 1, 45.

"Sheriff Puts Negroes through Forced March." *Washington Post,* February 11, 1965, 3.

Shridharani, Krishnalal. *War without Violence.* New York: Harcourt, Brace and Co., 1939.

Siegel, Ernest. Letter to the editor. *New York Times,* October 27, 1968, S-2.

Silberman, Charles E. *Crisis in Black and White.* New York: Vintage Books, 1964.

Sitkoff, Harvard. *The Struggle for Black Equality.* New York: Hill and Wang, 2008.

Sitton, Claude. "Violence Explodes at Racial Protests in Alabama." *New York Times,* May 4, 1963, 1.

"Slow as Molasses: Long Overdue Murder Trials and the Juneteenth Holiday." *Houston Chronicle,* June 19, 2005, 2.

Smevik, Larry L. Letter to the editor. *Time,* May 24, 1963, 9.

Smith, Cherise. "Moneta Sleet, Jr., as Active Participant: The Selma March and the Black Arts Movement." In *New Thoughts on the Black Arts Movement,* edited by Lisa Gail Collins and Margo Natalie Crawford, 210–26. New Brunswick, NJ: Rutgers University Press, 2006.

Smith, Lillian. *Killers of the Dream.* New York: W. W. Norton & Company, 1961.

———. "The Moral and Political Significance of the Students' Non-Violent Protests" (April 21, 1960). In *The Winner Names the Age: A Collection of Writings by Lillian Smith,* edited by Michelle Cliff, 91–99. New York: W. W. Norton & Company, 1978.

Smith, Margaret Denton, and Mary Louise Tucker. *Photography in New Orleans: The Early Years, 1840–1865.* Baton Rouge: Louisiana State University Press, 1982.

Smith, Shawn Michelle. *American Archives: Gender, Race, and Class in Visual Culture.* Princeton, NJ: Princeton University Press, 1999.

———. *Photography on the Color Line: W. E. B. Du Bois, Race and Visual Culture.* Durham, NC: Duke University Press, 2004.

Smith, Tom W. "Changing Racial Labels: From 'Colored' to 'Negro' to 'Black' to 'African American.'" *Public Opinion Quarterly* 56:4 (Winter 1992): 496–514.

Smith, Tommie, with David Steele. *Silent Gesture: The Autobiography of Tommie Smith.* Philadelphia: Temple University Press, 2007.

Smothers, Ronald. "White Supremacist Is Convicted of Slaying Rights Leader in '63." *New York Times,* February 6, 1994, 1.

"Some Negro Athletes Threaten to 'Go Home' with Smith and Carlos." *New York Times,* October 19, 1968, 45.

Sontag, Susan. *On Photography.* New York: Anchor Books, 1977.

"The South Looks Ahead." *Ebony,* September 1963. In *No Place to Hide: The South and Human Rights,* vol. 2, edited by Ralph McGill and Calvin M. Logue, 438. Macon, GA: Mercer University Press, 1984.

"The Spectacle of Racial Turbulence in Birmingham: They Fight a Fire that Won't Go Out." *Life,* May 17, 1963, 26–36.

Spratt, Margaret Ann. "When Police Dogs Attacked: Iconic News Photographs and the Construction of History, Mythology, and Political Discourse." Ph.D. dissertation, University of Washington, 2002.

Spruill, Larry H. "Southern Exposure, Photography and the Civil Rights Movement, 1955–1968." Ph.D. dissertation, State University of New York at Stony Brook, 1983.

Stanton, Mary. *From Selma to Sorrow: The Life and Death of Viola Liuzzo.* Athens: University of Georgia Press, 1998.

Stern, Sol. "The Call of the Black Panthers." *New York Times,* August 6, 1967, 10–11, 62–64.

Strain, Christopher B. *Pure Fire: Self-Defense as Activism in the Civil Rights Era.* Athens: University of Georgia Press, 2005.

Sugrue, Thomas J. *Sweet Land of Liberty: The Forgotten Struggle for Civil Rights in the North.* New York: Random House, 2008.

Tangney, June Price, and Ronda L. Dearing. *Shame and Guilt.* New York: Guilford Press, 2002.

"Tear Gas, Clubs Halt 600 Selma March." *Washington Post,* March 8, 1965, 1, 3.

"Tension Growing over Race Issue." *U.S. News & World Report,* May 20, 1963, 39.

"This Is America—1963." *Chicago Daily Defender,* May 7, 1963, 1.

Thornton, J. Mills III. *Dividing Lines: Municipal Politics and the Struggle for Civil Rights in Montgomery, Birmingham, and Selma.* Tuscaloosa: University of Alabama Press, 2002.

"Thousands March on Jail in Birmingham." *Chicago Daily Defender,* May 6, 1963, 1.

"Thousands Mourn as Final Rites Are Conducted for Young Victim of Southern Brutality." *Michigan Chronicle,* September 12, 1955, 2.

"Thousands Pass Bier of Slain Negro Boy." *Washington Post,* September 4, 1955, 3.

"Till Case Trial Opens Sept. 19." *Chicago Defender,* September 17, 1955, 1.

Till-Bradley, Mamie. "I Want You to Know What They Did to My Boy." Speech at Bethel AME Church, Baltimore, Maryland, October 29, 1955. In *Rhetoric, Religion and the Civil Rights Movement, 1954–1965,* edited by Davis W. Houck and David E. Dixon, 132–45. Waco, TX: Baylor University Press, 2006.

Till-Mobley, Mamie, and Christopher Benson. *Death of Innocence: The Story of the Hate Crime That Changed America.* New York: Random House, 2003.

Tompkins, Jane. *Sensational Designs: The Cultural Work of American Fiction.* Oxford: Oxford University Press, 1986.

Torres, Sasha. *Black, White, and in Color: Television and Black Civil Rights.* Princeton, NJ: Princeton University Press, 2003.

Trodd, Zoe. "A Negative Utopia: Protest Memory and the Spatio-Symbolism of Civil Rights Literature and Photography." *African American Review* 42:1 (Spring 2008): 25–40.

"Turned the Tide in Birmingham." *Jet,* May 23, 1963, 24–25.

Turner, Wallace. "Coast Police Fire at Panther Camp." *New York Times,* September 11, 1968, 37.

———. "Negroes Press Nomination of Indicted Militant." *New York Times,* February 5, 1968, 70.

"Two Indicted in Boy-Killing Plead Innocent." *Washington Post,* September 7, 1955, 44.

"A Typical Negro." *Harper's Weekly,* July 4, 1863, 429–30.

"U.S. Apologizes for Athletes' 'Discourtesy.'" *Los Angeles Times,* October 18, 1968, 1.

"Use of Police Dogs Stirs Norfolk Row." *Afro-American (Baltimore, MD),* April 27, 1963, 19.

"Violence in Birmingham." *Washington Post,* May 5, 1963, E-6.

Von Hoffman, Nicholas. *Mississippi Notebook.* New York: D. White, 1964.

Wagner, Anne M. "Warhol Paints History, or Race in America." *Representations* 55 (Summer 1996): 98–119.

Wakefield, Dan. "Justice in Sumner: Land of the Free." *Nation,* October 1, 1955, 284–85.

"War in Palestine." *New York Times,* May 2, 1948, 113.

"Warfare Spreads in the Holy Land." *Life,* January 19, 1948, 26.

Waskow, Arthur I. *From Race Riot to Sit-In, 1919 and the 1960s: A Study in the Connections between Conflict and Violence.* Garden City, NY: Anchor Books, 1996.

Watts, Jerry. "The Left's Silent South." In *The Sixties without Apology,* edited by Sohnya Sayers,

Anders Stephanson, Stanley Aronowitz, and Frederic Jameson, 261–63. Minneapolis: University of Minnesota Press, 1984.

"We Have Won in Birmingham." *New York Amsterdam News,* May 11, 1963, 1.

Webb, Sheyann, and Rachel West Nelson, as told to Frank Sikora. *Selma, Lord Selma: Girlhood Memories of the Civil-Rights Days.* Tuscaloosa: University of Alabama Press, 1979.

Weltner, Charles Longstreet. *Southerner.* Philadelphia: J. B. Lippincott Company, 1966.

Wendt, Simon. *The Spirit and the Shotgun: Armed Resistance and the Struggle for Civil Rights.* Gainesville: University Press of Florida, 2007.

Wexler, Laura. *Tender Violence: Domestic Visions in an Age of U.S. Imperialism.* Chapel Hill: University of North Carolina Press, 2000.

"When Police Dog Bites: 'We Bleed All Over America.'" *Afro-American (Baltimore, MD),* June 1, 1963, 1.

White, J. *Black Panther (Oakland, CA),* October 26, 1968, 1.

Whitfield, Stephen J. *A Death in the Delta: The Story of Emmett Till.* New York: Free Press, 1988.

"Will Mississippi Whitewash the Emmett Till Slaying?" *Jet,* September 22, 1955, 8–12.

Williams, Julian. "Black Radio and Civil Rights: Birmingham, 1956–1963." *Journal of Radio & Audio Media* 12:1 (May 2005): 47–60.

Wilson, Gertrude. "UFT Egos—and Black Athletes." *New York Amsterdam News,* November 2, 1968, 19.

Wise, Bill. "Query for Southern Whites—What Now?" *Life,* May 17, 1963, 35.

Withers, Ernest C. *Complete Photo Story of Till Murder Case.* Memphis, TN: Wither's *[sic]* Photographers, 1955.

"Woman Slugs Sheriff in Selma as Negroes Line Up to Vote." *Washington Post,* January 26, 1965, 2.

"W. R. Simmons Study." *Chicago Daily News,* May 3, 1963, 36.

Young, A. S. "Doc." "Shame on America!" *Los Angeles Sentinel,* May 9, 1963, 1, 4.

"Youngsters Get Credit for Truce." *Afro-American (Baltimore, MD),* May 18, 1963, 1, 9.

"Youth's Eye Gouged Out by Lynchers." *Philadelphia Tribune,* September 17, 1955, 1.

Zinn, Howard. "The Battle-Scarred Youngsters." *Nation,* October 5, 1963. In *Reporting Civil Rights: Part Two, American Journalism, 1941–1963,* 48–59. New York: Library of America, 2003.

Zinn, Maxine Baca, and Bonnie Thornton Dill. *Women of Color in U.S. Society.* Philadelphia: Temple University Press, 1994.

ILLUSTRATIONS

ACKNOWLEDGMENTS

Linda Bowen, Vicky Gwiasda, Michael Koetting, Stephanie Shaw, and Chris Sterba read the manuscript in its entirety, providing thoughtful and detailed feedback. Their comments proved invaluable, and I thank them for giving so generously of their time. As every academic knows, we have no more valuable a commodity to offer.

David Garrow, one of the University of California Press's two readers, provided more insightful commentary, suggestions, and support than I could have hoped for. His generosity to a civil rights outsider was remarkable.

Friends, colleagues, and strangers who put their own work on hold to help me track down sources and images include Jasmine Alinder, Maurice Berger, Karen Bucky, Elisabeth Cameron, Erika Doss, Laurie Glover, Christopher Metress, Tanya Sheehan, and Pamela Williamson. To each of them I'm indebted.

At the University of California Press, I benefited from the skillful editing and sage counsel of my longtime editor, Stephanie Fay. Her recent retirement is a loss for the press, me, and the hundreds of authors with whom she has worked for more than two decades. Eric Schmidt, assistant editor, proved efficient and droll in shepherding the manuscript toward production. I have also benefited from the skill of my production editor, Jacqueline Volin, and her excellent copy editor, Adrienne Harris. Each helped me simplify my language and hone my thoughts.

I completed most of the research for and writing of this book while on fellowships at the Stanford Humanities Center during the 2008–09 academic year and the Sterling and Francine

Clark Art Institute during the fall of 2009. Both institutions provided idyllic environments in which to work.

At Stanford, my year was enriched by meals and conversations (intellectual and otherwise) with Harriet Chessman, Nicole Coleman, Guoqiang Dong, Karen Rapp, Judy Richardson, Matthew Tews, Marie-Pierre Ulloa, Carolyn Winterer, and Bryan Wolf. I am particularly indebted to Johanna Drucker, I. A. Rachamimov, and Tami Spira for their warmth and support. The Rachamimov household offered a sea of chaos around the calm of Palo Alto in which I always felt at home.

My residency at the Clark was enhanced by a wonderful cohort of fellows—Holly Clayson, Thierry de Duve, Abdellah Karroum, Hagi Kenaan, Branko Mitrovic, and Mary Roberts. Outside of work, I benefited from the conversation and camaraderie of Marc and Fronia Simpson, Carol Ockman and Peggy Waller, Michael Ann Holly and Keith Moxey, Marc and Lauren Gotlieb, Marc Ledbury, Michael Lewis, and Vered Lev, Ilil, and Renana Kenaan. The music of Ilil and the art of Renana enlivened my semester.

I am indebted to Sarah Van Anden, my graduate research assistant at the Clark, who showed imagination and perseverance, no matter how obscure my request.

I thank the Arts Research Institute at the University of California at Santa Cruz, and its director, Lyndy Dean, for financial support of my work on civil rights. The institute paid for several research trips and financed nearly all of the illustrations in the book. The new dean of the arts at Santa Cruz, David Yager, has reinvigorated the division, making Santa Cruz an even more interesting academic home. He, along with my colleagues in the History of Art and Visual Culture department, have been gracious in their personal support. To all of them, I'm grateful.

INDEX

DESIGNER Madeleine Ward

TEXT 10/14 Adobe Garamond

DISPLAY Berthold Akzidenz Grotesk Medium

COMPOSITOR Integrated Composition Systems

INDEXER Kevin Millham

PRINTER AMD BINDER Thomson-Shore, Inc.